ORGANIC

ORGANIC

FARMERS AND CHEFS OF THE HUDSON VALLEY

PHOTOGRAPHS BY
Francesco Mastalia

INTRODUCTION BY
Gail Buckland

FOREWORD BY
Mark Ruffalo

PREFACE BY
Joan Dye Gussow

pH **powerHouse Books** Brooklyn, NY

Foreword

BY MARK RUFFALO

My great grandfather was an Italian immigrant and his entire backyard was his garden. In it he grew several kinds of tomatoes, onions, garlic, eggplants, black kale, spinach, broccoli, zucchini, rhubarb, grapes, and tomatillos, and would grow squash and greens in the fall. He had a big twisted plum tree and a small apple tree. Between every row were elevated planks of wood on bricks. I was taught these elevated bridges that criss-crossed the patches of deep green were to keep the soil from getting compacted under foot and ruining the homes of the worms. I got my fanny clapped more then a few times for wandering off the planks to seize a tomato or a hunk of rhubarb. I would watch my gardening grandpa in his white shirt and hat, his hanky around his neck while he piled his compost, picked and pinched and tied, trellised. I marveled at his knowledge, how he knew that the "tomatoes loved-a-da basils." He was a magician to me, and knew secrets that were age-old and profound. Secrets that mystified me and gave great meaning to his life. "Grandpa, why do you put the rotted food back into the garden? Everyone else throws it in the garbage." "No" he exclaimed, "that is food for the worms and the little bugs that feed the plants and make them strong and green, now get off the earth and on the wood before I clop you." The dirt of his garden was the deepest black, flecked with white bits of egg shells, and was always sweet and moist. I wish I could get my clay soil of Upstate New York to be near the structure and filled with the life that his composted and egg-shelled soil had way back then!

This book isn't primarily about the concept of organic, although there is plenty to learn here on that front. It is really a celebration of those who live it and engage it. Organic is not a label, but rather a way of being within a living system and a way of working within that system that uses all of the different relationships therein to one's greatest advantage. The people in this book speak a special language that has been developed between the land, the living organisms in that land, and the person growing or raising food there. The organic farmer and those people who are artists of food, the organic chefs, hold an ancient kind of wisdom. They are artists and teachers. The revolution they are leading of the new regional organic farm carries within it a store of knowledge that was all but wiped out by the industrial farming craze that swept

our nation and left our waters polluted, our food poisoned, and our lands depleted of nutrients and viability.

Like every other discipline of modern man, from medicine to energy, our understanding has brought us to see the value in the sustainable processes of life. We find ourselves learning more by observing nature and understanding her processes then by trying to dominate her and bend her to our will. We are beginning to see that nature is not our enemy but our saving grace and that there is a holistic balance and observable connection to all things living and inanimate that we do well to preserve. Farming, like every other aspect of our lives, is in the process of being reinvented and the people you see in this book are the front line of that new wave of developing technology. This technology strangely enough is in large part one that is reflective as well as progressive. It is gentle and subtle and puts the natural processes of sustainability at it's core and ancient in its beginnings.

The prevailing agricultural technologies of the past 50 years have put man deeply into conflict with the rest of his surroundings, and so our surroundings have becoming increasingly conflicted with man. These people remind us of the benefits and and healing qualities of being part of an integrated system. Their food is better, their lands are healthier and more adaptable, and they and their workers aren't dying from fertilizers, pesticides, and herbicides!

The people on these pages, captured so beautifully and rawly in Francesco's large-format images, display the very qualities of the farms they support and pick their ingredients from: complex, diverse, weathered, natural and honest, integrated and sound. Yes, these people exist today. They are part of an expanding network that is growing and diversifying every year. They are on the rise and have something to teach us all about a better way to grow, eat, work, and live in a world that we are part of and is part of us. They need to be lifted up, listened to, and celebrated, and Francesco has done just that in these pages. To organic and all of our organic mentors!!

Organic Matters

BY GAIL BUCKLAND

Organic matter matters.

Living organisms. Living well.

Slow food. Slow photography.

Local food. Local Hudson Valley photographer.

The Hudson Valley is fertile terrain for farmers and for master photographer Francesco Mastalia. There are riches here, in the soil and in the people.

Artist. Craftsman. Modern-day magician. Mastalia is all three. (When William Henry Fox Talbot announced in 1839 his invention of photography, he called it "a little bit of magic realised [sic], of natural magic.")

Mastalia, like Talbot before him, realized that photography has an uncanny relationship with time. It doesn't stop time; it works with time. It takes time for millions of light rays to delicately form an image on a light-sensitive surface. And light works on objects and chemicals in mysterious and unpredictable ways. Mastalia uses the forces of nature (not electronics, not pixels) to capture on his wet-collodion glass plates, people whose lives are also connected to natural forces. Farmers, chefs, and photographer all respect the Earth and its rich bounty.

Sunlight and patience with a dash of love. What is true for the farmer is true for the photographer.

Organic: Farmers and Chefs of the Hudson Valley is focused on the idea of integrity in the production and preparation of food. The individuals (and they are individuals!) encountered in this collection are less concerned with USDA certification and government issued labels than in knowing they are creating healthy food, grown and prepared in traditional ways, food that is wholesome, sustainable, and chemical-free.

Francesco Mastalia makes photographs the same way photographers did 150 years ago; the farmers in the book are growing vegetables and raising cattle in basically the same way their forebears did 150 years ago. A sense of kinship between photographer and subject permeates the book and elevates it. Like food produced with pride for flavor and texture, these are photographs to savor.

Opening the book, one immediately sees that the photographs are different. They hearken to a previous era. Each portrait is from an ambrotype made by hand. Dirt under the fingernails of farmers; collodion lifting off the edges of the glass plates. The people we meet in these photographs and the process itself (described below) have an elemental, honest, "small scale" quality about them.

In the mid 19th century, when the ambrotype was popular, people understood their time with the photographer was precious. Quite possibly, never again would they have their countenance captured. Strangely, in a world of excess exposures and way too many photographs, the men and women who sit for Mastalia seem to understand that their time with him is significant. Mastalia doesn't speak, as 19th-century photographers did, of capturing the soul. But he does want to capture what grounds them to the soil, to tradition, to the rhythms of nature.

Francesco Mastalia made the critical choice to photograph 136 organic farmers and chefs (103 appear in the book) with a reproduction of a large antique plate camera and a truly classic 19th-century lens. No camera tilts or swings here. The camera is back to basics. It is modeled on a camera manufactured by E. & H.T. Anthony, the company that supplied Mathew Brady and his team of Civil War photographers with their cameras and chemicals.

The lens is an original Dallmeyer 3B from the 1870s. What a beauty! Julia Margaret Cameron, one of the greatest photographers of the 19th century, also used a Dallmeyer. Upon receiving it as a gift from her daughter, she wrote: "From the first moment, I handled my lens with a tender ardour, and it has become to me as a living thing." Mastalia's portrait of

chef James Haurey, in front of dense foliage, pays homage to Cameron's photograph of Alice Liddell, the inspiration for *Alice in Wonderland*, posed against a similar background.

There is nothing "standardized" about the wet-collodion process. Exposure times vary from five to fifteen seconds depending on many variables: the light, the humidity, the age of the chemicals, the temperature. Mastalia mixes collodion with iodide and bromide salts and leaves it to mature for a week before using it. When first mixed, it is a straw yellow color; as it begins to ripen it turns to a rich amber hue, and over time to deep ruby red. The color indicates the age and speed of the collodion. With time the contrast will increase while its sensitivity to light will decrease. Each color of the collodion mix requires a different exposure time. A little like cooking.

In order to turn a piece of glass into a photographic negative or a positive (an "ambrotype"), it is necessary for the itinerant photographer (i.e. Mastalia) to travel with a lot of "stuff": chemicals, trays, a specially designed box to transport the fragile glass, a "darkroom" of his own design to sensitize and develop the photographs and, of course, a camera and tripod. The skill it takes to make a photograph is enormous, the dedication to craft extremely rare in the age of iPhones and digital cameras. Every plate Mastalia makes is different, just like every meal prepared by a master chef.

In brief: Mastalia chooses the location for each sitter. He sets up the big bellows camera on a tripod. He arranges his subject. He goes under the black cloth, looks at the ground glass, and sees the entire scene upside down and reversed. He focuses the lens on the eyes. He then starts the meticulous process of making a 6 ½ x 8 ½ inch piece of black glass light sensitive. Carefully, with gloved hands, he deposits the viscous collodion mixture on the glass, titling the plate back and forth, from corner to corner, and then pours the excess liquid back into the glass bottle. He then goes into the dark box he constructed for the purpose of sensitizing his plate and immerses the plate in a silver bath for three minutes. The now-light-sensitive glass plate is carried in its holder to the camera—speedily because the plate must remain wet for this photographic process to work. Focus is checked once more. The plate holder is put in the camera, the dark slide lifted to permit light to hit the plate, the lens cap is removed and the seconds are counted as the exposure is made. The dark slide is then dropped down and Mastalia lifts the plate holder out of the camera. He goes back to the darkroom and develops the plate

immediately. Fixing can be done in the light while washing and varnishing are left until he gets home. From start to finish (after setting up and focusing the lens) the process takes about ten minutes. Then he does it all again, coming in closer or moving further away, or changing backgrounds entirely. He tries to leave with at least five portraits of each sitter.

Nothing alive remains perfectly still in a Mastalia ambrotype. Wind in the trees pays no mind to the photographer. Everything is in flux. You can feel the life force in each sitter – just as they feel the life force in every sprout and stalk.

Time. Nature. Photography.

The wet-collodion process is UV light sensitive, meaning that the blue end of the spectrum appears lighter than expected; red appears black. Backgrounds as well as skin tones and clothing have another worldliness to them. They appear strange to our modern sensibility.

But herein lies the magic of Mastalia's photography. We are in a place we have never been before. These portraits are not about defining a person but describing an encounter. They are a fertile field to plant our imagination. Something of value will grow. A 1/1000th of a second exposure won't take us to the same aesthetic realm.

Organic. Alive. The value of living things.

In our fast paced world, we are often running toward unexamined goals. This book teaches us to slow down, smell the roses, and eat good food.

Each portrait in the book is accompanied by an interview with the subject of the photograph. These short statements and observations about farming and cooking are the perfect compliment – or condiment – to the main (photographic) course. Mastalia feels if you want to learn the truth about a subject, in this case the meaning and implications of the word "organic" as it relates to food production, speak to the people most intimately involved. Whether "certified" organic or not, each farmer knows he or she is not poisoning the earth or animals with pesticides or an unnecessary use of antibiotics. "Trust the farmer and the chef" seems to be the battle cry of each and every one whose presence is felt on the pages of this most dignified and beautifully produced publication.

It is impossible to reproduce ambrotypes on paper; their power is, in part, from their tactile quality, their absorption of light, their physicality. And, because ambrotypes are one-of-a kind, fragile, difficult to exhibit, and have no negative, Mastalia has mastered a way of making beautiful prints on exquisite art paper from the original plates. There is a sensual quality to these works on paper that is quite different from the shiny glass surface of the ambrotype: palatable beards, wrinkles like rivers on faces, clothing draped as delicately as in Renaissance paintings.

The book opens with Brother Victor-Antoine looking towards the heavens, allowing the holy light to fall upon him. It is one of the finest portraits in this compendium of superb, strong portraiture. Incidentally, it was the longest exposure time, too, a full 30 seconds (try it – hold still for 30 seconds). One feels humbled by the power of nature to form this image on the glass plate. Brother Victor-Antoine holds a bottle of his prized vinegar in one hand, a hoe in the other. Mastalia's images have such an organic feel that it looks as if the monk is tilling the collodion floating on the plate.

Eugene Wyatt looks like he is resting on clouds when in reality he is surrounded by sheep and sitting on an old milk can. Only wet-collodion can give this vaporous effect, a result of the chemistry and long exposure time. We see that ghostliness again in the portrait of Ashley Loehr. Her German Shepherd looms behind the window of the old pick-up, a spirit from the netherworld.

We are so used to slick commercial portraiture that when the photograph reveals its chemistry and "flaws," as it does over and over again in this body of work, we feel connected to the artist and privy to his creative process.

Some faces speak to us as if from a previous century, such as John Gorzynski's. Mastalia focuses on his eyes—the eyes that take us back to generations of farmers. The well-earned creases on his cheeks lead directly to those knowing eyes—"the window to the soul." He bares his "soul" not only in his portrait but also in his words: "I can look back and know I did no harm and I'm leaving things better then I found them."

Organic: Farmers and Chefs of the Hudson Valley is a magnificent, important book. These strong, elegant, and mysterious photographs are the antidote to the gluttony which is the billions of cell phone and other fast pictures overwhelming our world. Why stuff yourself when you can savor true quality?

Francesco Mastalia's ambrotypes are among the finest being made in the world today. His prints, equal in beauty and power to the ambrotypes themselves, are sensual and stunning. Many of the farmers and chefs talk of the "taste" of a vegetable or fruit grown from organic seeds and without harmful chemicals. Mastalia's photographs are made to relish, to digest. They are nourishing and life affirming. Just like good, wholesome food.

Preface

BY JOAN DYE GUSSOW

The farmers and chefs who will gaze back at you as you move through this astonishing volume, embody—in a way not fully captured even in their own words—what the term "organic" really implies. Each of them speaks about what it means to be an "organic" grower—someone who coaxes from the rich soils of the Hudson Valley plants and animals nourished by the beneficence of Nature—or what it means to be an "organic" chef who transforms the substance these farmers produce into meals that celebrate all the integrity of the original foods. We need these strong faces, and their bearers' deeply-felt responses, to help hold uncorrupted the real meaning of organic, for we live in a time when words are easily undermined.

Forty years ago, the term "organic"—connected to food and agriculture—was too often derided by critics as either meaningless or fraudulent. Meaningless because the dictionary's take on the term, "a class of compounds containing carbon," allowed for critics' claim that all living things were organic because all contained carbon. Fraudulent because those farmers who called themselves "organic," couldn't prove in numbers that their produce was different simply because it was grown with loving attention on soil not abused by synthetic chemicals.

The relative few who were actually growing or eating "organic foods" in those days, believed the term meant something importantly different. Not only did it insist on careful, synthetics-free farming, producing foods that were probably—if not provably—more healthful, but, as one sympathetic participant wrote in the mid 90s, the word's lack of specific definition allowed many of us to associate it with important characteristics of scale, locality, control, knowledge, nutrition, social justice, participation, grower/eater relationships and. . .connections with schools and communities.

So now that foods bearing organic labels can be found on the shelves of the world's largest food marketer, leaving behind all the values of community, scale, grower-eater relationships, and the like, how can we understand what the term "organic" really means?

The memorable faces and voices in the volume you are holding provide the richest possible answer to that question. Ask these chefs and farmers to define the term organic, and a range of feelings and beliefs emerge. Sometimes they are quite spiritual: "It is. . . the way the earth did it for millions of years," says Chris Harp. For Brother Victor-Antoine, "Organic is the old, ancient, natural way that was predestined from all eternity for us to grow our own food." It's "agriculture as nature has intended," asserts Jean-Paul Courtens. And what does nature intend? For Mimi Edelman "organic is about . . . using what comes from the land to vitalize it and always putting back. It's using nature's intelligence to work harmoniously with the growing season."

"It really comes down to loving and caring" insists Cheryl Rogowski. "It starts from the land, the soil, and onto the seed that you plant and how you take care of that plant as it matures, how you handle it when you harvest, how it gets put on the truck." And it also starts with the region.

"This is some of the richest soil in the country right here," says Hugh Willliams. "Throughout the Hudson Valley there are nutrient rich glacial till, and when we develop the inner fertility of those soils through biological weathering, the potential to produce is just stupendous." Paul Alward agrees. "Not every place is as lucky as the Hudson Valley. . .There are a lot of cool farmers doing different things up here, growing different crops and pioneering different methods. There's a real sense of community." That community is organic, part of a national movement. "Here in New York there's beautiful soil all over the place," says James Haurey. "We can just grow

here, keep the money here, and help the community instead of shipping it out to Guatemala or China, where nothing is regulated and you have no idea what chemicals are going into the food."

Chemicals aside, some of these passionately organic folk chafe at how the word for what they practice has been distorted: "I have always wondered, even before the USDA got involved, why they chose the world organic," remarks chef Sam Ullman. "It's an old term, much older than this whole emphasis on being conscious of what inputs are going into our food production. It is carbon-based chemistry and carbon-based molecules. All the chemicals we don't want on our food, half of them or better are organic. It's semantics."

"Organic?" asks Joan Harris. "I would like it to mean the way nature intended for the earth to be treated and food to be grown. I don't know if it means that to everyone." Amy Hepworth agrees. "The problem is, when I say organic, it means a lot of things that I don't want it to mean anymore."

"The first thing that comes to mind when I think of organic," says Jack Algiere, "is. . .healthy animals and healthy people. But now in reality, the word has been swallowed. And while it's an assurance, it's hard to say what it's an assurance for."

When "organic" was certified, John Gorzynski growls "there was no way I was going to validate or lend it my credibility— that of my farm and my 20 years worth of work towards making the word organic mean something. I totally withdrew my name from the word." But "I can look back and know I did no harm and I'm leaving things better than I found them."

Indisputably, organic is good for the planet: To produce healthy food, Anne Eschenroeder explains, "'sustainable' has to encompass a lot of different realms. Like not using synthetic pesticides and fertilizers, and working with land in a naturally beneficial way so that you are getting crops out, but the land is actually improving."

And what's produced is gratifying to chefs. "As chefs, and as eaters, we have a responsibility to support the health of this living landscape," says chef Dan Barber. "We need to…celebrate

every part of the 'organism'—an integrated system of grains, vegetables, legumes, and livestock. You've heard of a nose-to-tail approach to the pig? Well this is a nose-to-tail approach to the whole farm. And it represents the future of delicious food." "The organic I am looking for is honest and authentic," says Wesley Dier. "There needs to be a face behind the product."

Sometimes "organic" is about what it means to farmers and eaters to grow that way. "One of the benefits of organic is that I don't have to ride a sprayer," says Guy Jones. "There's no farmer in the world that wakes up the morning and says, 'Oh boy I get to spray today.'" Ron Hayward says, "I wanted my daughter to be able to walk out into our field or into the greenhouse, pick something, put it into her mouth, and feel really good about it."

Any other kind of farming, says Steffen Schneider, does not do "justice to all the living creatures that we work with. . . I think the art of the farmer is to try to orchestrate all these various realms of nature—the mineral realm, the plant realm, the animal realm. . .in a way where they are harmoniously interacting and creating, you could say, a symphony." Says Jean-Paul Courtens, "I feel like every year I am a performance artist, and I'm painting these fields. It's this expression that you give to the land, helping an animal or plant grow and develop."

There is no score for that symphony, no formula for that painting. These achievements cannot be captured in rules, except the overriding rule that nature must be respected. Organic is something you either understand, or don't, or think you understand, and only perhaps do. What is without doubt is that Francesco Mastalia's lustrous, archaic, stunningly deep portraits have captured organic in the fullest meaning of the word. See for yourself.

BROTHER VICTOR-ANTOINE D'AVILA-LATOURRETTE

Our Lady of the Resurrection Monastery, Lagrangeville, NY

Organic is the old, ancient, natural way that was predestined from all eternity for us to grow our own food. In other words, organic is basic; it's the earthy, clean food that is in the Bible. At the very beginning of Chapters in The Book of Genesis, God orders Peter, "Go and plant gardens, and eat the fruits of what you plant and what you cultivate."

So, it's like a divine order from God. God always intended for us to eat healthy, to live healthy, and to produce healthy food, food that has no contamination and has not been treated in any way. We have to have respect for the soil and the land. It should be kept clean and pure. And we are comforted by the food that comes from the earth, which to us is holy.

Here we live under the Rule of Saint Benedict, a life based on the Gospel dating back to the fifth century. We retain the old wisdom of living with the cycles of the seasons and of the Earth.

Nature tells you what to eat, what to consume, and we reap the benefits of that. Once you go against nature and you're eating artificial things, sooner or later, it does have its consequences.

We don't always use the word organic. The idea was always to cultivate the natural way, the natural method of not using any kind of artificial pesticide or chemical.

Our vinegars are fermented the old-fashioned way. It's an old custom in France and Italy. The wine that is going sour is kept in containers in the cellar, breathing, so it will turn into vinegar.

We don't put anything artificial in them and they have a lot of natural flavor. If you taste our vinegars they taste clean and pure. Our production is small; we make eight varieties of vinegar. We make red wine vinegar and white wine vinegar out of organic wines made here in the Dutchess County. There are no sulfites or chemicals in the wine, so they're pure organic. We make apricot vinegar, sherry vinegar, apple cider vinegar, and then there is raspberry. You taste the raspberry, you can taste the apple in the cider, you can taste the apricot in there, because it is natural and clean and it retains the natural flavor.

I have written cookbooks and spiritual books. I must have six, seven cookbooks in English, and several in other languages. The cookbooks are simple vegetarian, monastic cooking, inspired by the garden. My first cookbook *From a Monastery Kitchen* has sold well over two million copies. And my second one, *Twelve Months of Monastery Soups*, has sold well over two and a half million copies worldwide.

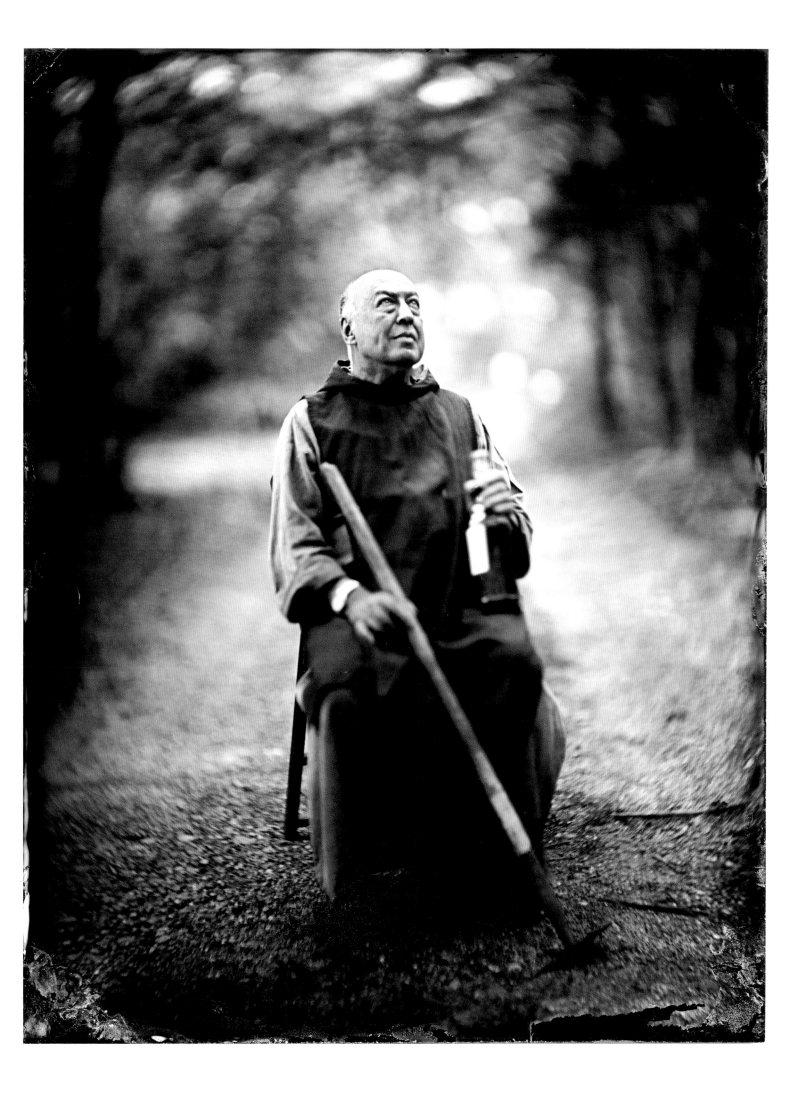

GUY JONES

Blooming Hill Farm, Blooming Grove, NY

Back in the 70s I ran a storefront law office based out of Albany. I worked all over the country, all alternative stuff, civil rights and anti-war. One of the things I did was work with Cesar Chavez of the United Farm Workers. I spent a little time working with Chavez and as part of that you had to work out in the field with the people you were trying to organize.

I've been a gardener all my life, even when I lived in the city I would always find a place to garden. I like growing things, and I decided I needed to be doing more outside. I went to the Ag School at Cornell University for a while, took a lot of courses, and did that for a couple of years. Unfortunately, while there I learned that the agricultural system isn't quite as lily-white as you might think. I worked on non-organic farms and it wasn't what I was interested in doing. I needed to do something on my own.

We're growing 200–300 varieties of different things. You can't grow a lot of one thing and be organic. You run into trouble.

Organic farming is a tremendous amount of handwork. We're growing a lot of things in one field and they all need different types of care. We pick everything by hand—we're not using any machines—and are planting all the time. It's the first of December and we're still planting.

One of the benefits of organic is I don't have to ride a sprayer. There's no farmer in the world that wakes up in the morning and says, "Oh boy I get to spray today." You have to put on all that gear and you're working with nasty chemicals. Then, of course, there are no earthworms and you're killing the birds.

We were certified for years but when the federal government took over the program we dropped out. I didn't see why they had to run it the way they wanted to run it. The USDA organic program is driven by the big guys.

We sell mostly to restaurants in Manhattan and Brooklyn—we have about 50 on our list—we have a CSA, we sell at the farm, and at farmers markets.

I've been farming almost 30 years. I like what I'm doing. I try to be honest and do the right thing. I've got aches and pains, but luckily I didn't miss a day's work this year.

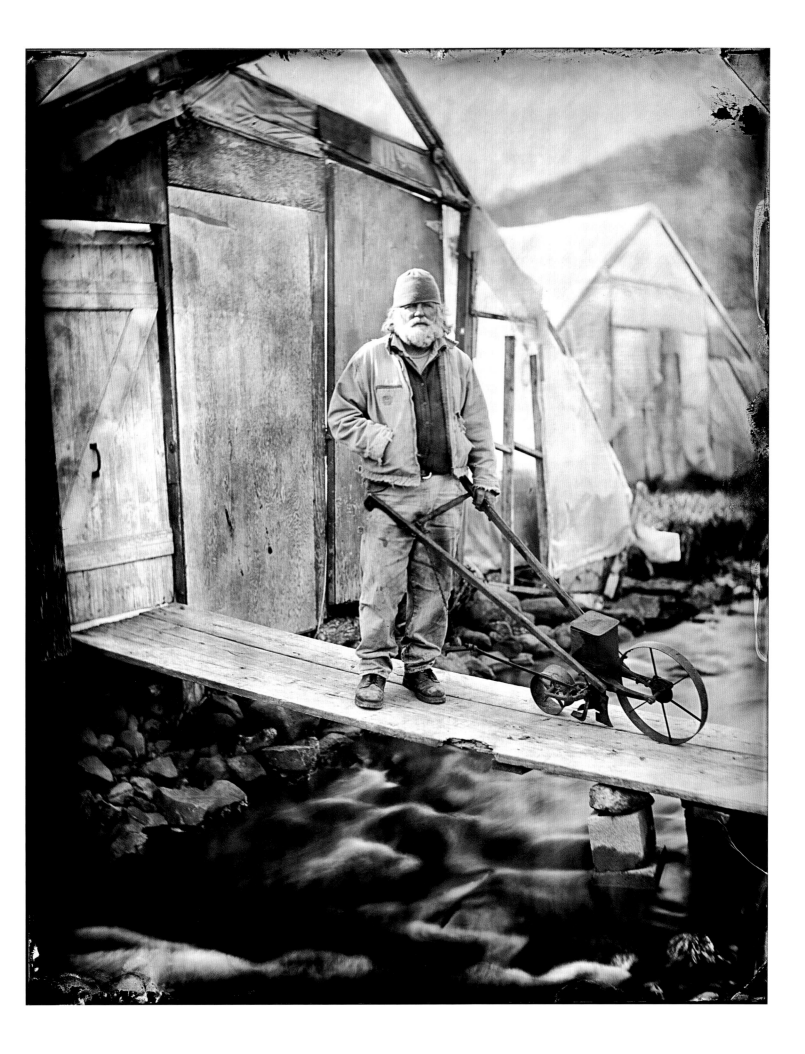

JEAN-PAUL COURTENS
Roxbury Farm, Kinderhook, NY

I started farming in Holland, in 1978. I thought I was destined to be an artist. When I went to school I realized it wasn't for me. I couldn't be inside. I really enjoyed the physical activity of farming—that's what I fell in love with.

When Lord Northbourne, an anthroposophist, had to describe the way in which Sir Albert Howard was expressing his form of agriculture, he gave it the name "organic agriculture": agriculture as nature has intended.

That word was in relationship to the word organic, in the context of Goethe. During his time, in the early 1800s, people knew him only as a poet, but he was also a philosopher and a scientist. He inspired people to think in more organic ways. Thinking organically, thinking the way that nature is reflecting.

I think the word organic has lost its meaning. The original philosophy where Sir Albert Howard came from, just like Rudolph Steiner, was inspired by peasant farmers; not only their agricultural methods, but also their lifestyle and sense of community. It was really this holistic approach that Sir Albert Howard emphasized, whereby the farm is a living organism.

The original principles—this whole sense of community and social relationships—are very important in the original foundation of organic farming. It's not only that we treat the soil and the animals the way that was intended by nature, but also treat the people how it was intended by nature. We really have taken the whole thing out of context. We made it a commodity and it was never intended to be a commodity.

These days if you go to a supermarket, or talk to a large organic farm in California, to them organic means following the guidelines of the USDA. It is an input/output system. The farm is not a living organism.

Our particular farm is based on anthroposophy. Our growing practices are in conformity with the standards of Demeter. They are the ones that provide the biodynamic standards. We have 375 acres and provide food to over 1,000 families through our CSA.

I feel like every year I am a performance artist, and I'm painting these fields. It's this expression that you give to the land, helping an animal or plant grow and develop.

You have to go back to where the word originally came from.

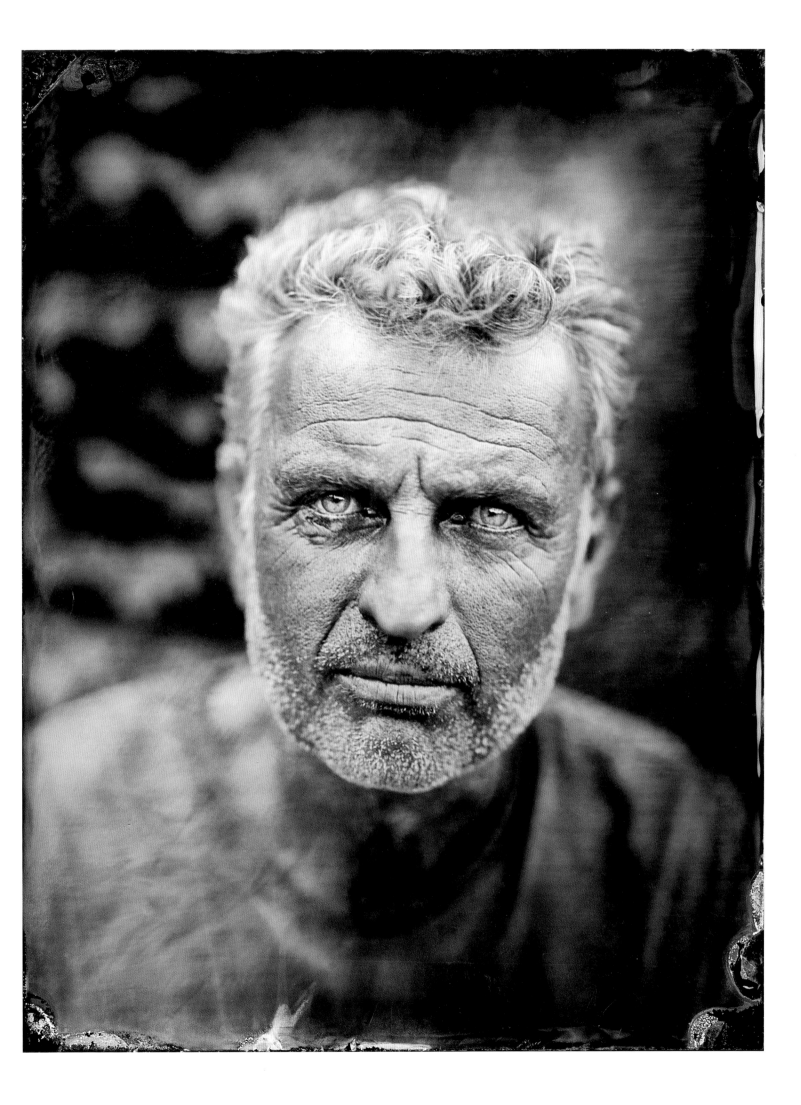

ASHLEY LOEHR

Sparrowbush Farm, Hudson, NY

When I was 13, I started working on farms. I worked on a big vegetable farm in Massachusetts, and then on farms in New Hampshire and around New England.

The reason I'm a farmer is because I think our industrial food system is very destructive and has far-reaching impacts beyond our country. Some of my most motivating experiences were when I was traveling in Mexico and meeting the farmers who lived there. They basically had no livelihoods because of commodity corn or agricultural practices that were dumping on their market. The strong message I got from those people was, "Go home and start making alternatives." The industrial food system is negatively affecting so many people's lives in so many places.

Now when I think of organic, I think of organic matter—the soil. It is something I'm always trying to create and foster. It's the basis of what microbes in the dirt eat, which makes plant life possible and abundant. I think of the soil chemistry context and less of the label.

Learning about soil inspired me to keep it alive and that means not applying chemicals that will cause soil organisms to die or perish.

The things I admire most are careful management and intelligent ecological notions, which are not necessarily certified practices. I'm not interested in organic certification; I would never spray conventional pesticides. For me it's about reinvesting in the land that I'm taking from and making sure it's here for future generations in a better state then it was when I got there. So I have found, over and over again, that the lines between conventional and organic are blurred because there are many certified organic pesticides that are quite similar to conventional pesticides. Accountability is a word I'm more interested in.

I don't have a say in this farm equally, even though I designed most of it and put it in the ground. It has a life of it's own. The farm's organisms develop with their own complete character and it's really defined a lot by the characters of the humans who manage it. But it has it's own thing, which is special and humbling.

My main marketing outlet is a winter CSA that runs from November through May; and it's a full-diet CSA that includes vegetables, meat, cheese, milk, bread, all those things.

The way you can have a voice in it, as a consumer, is to make other choices.

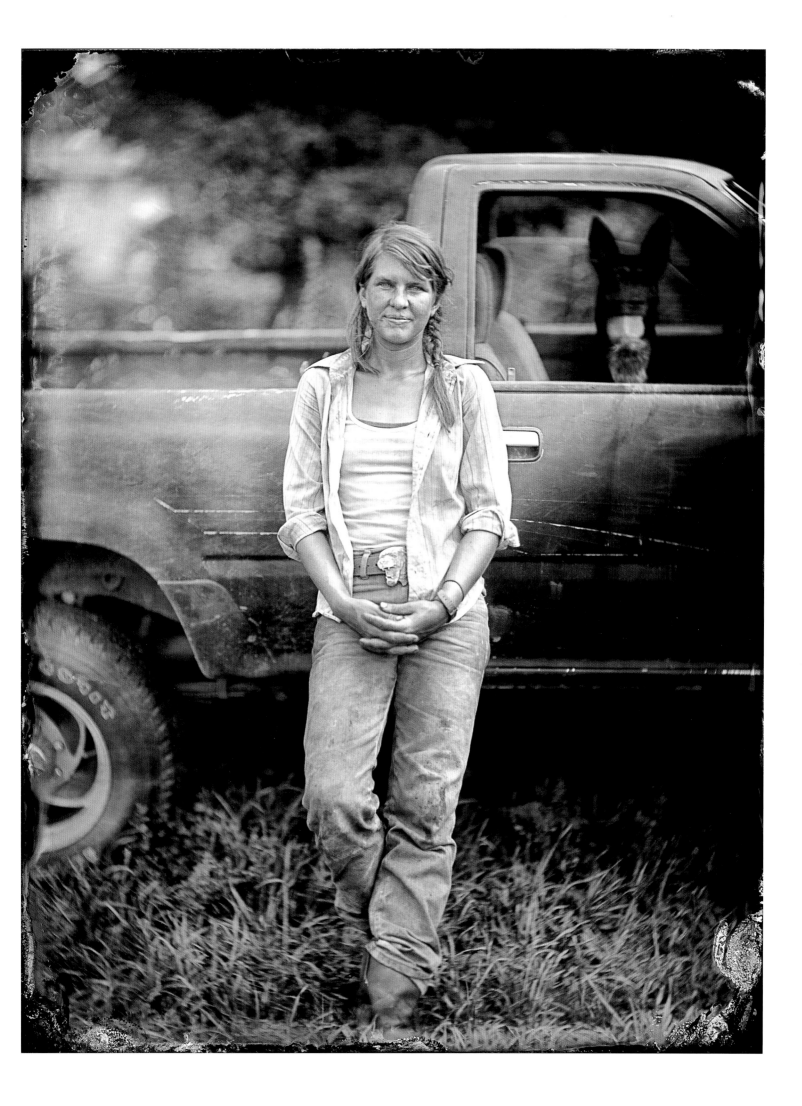

JEFF BIALAS
J&A Farm, Goshen, NY

I grew up on a farm, a conventional farm. It was as far from organic as you could get. I was five or six years old when I started farming. It's been over 30 years now.

My grandfather was in the generation that went from having no sprayers or fertilizer, to having those as tools and taking advantage of them. Over the years I looked into organic farming and it really felt like that was the way to go. It was a safer way to farm.

When we started this farm we couldn't afford the chemicals and fertilizers to begin with. I started plowing and all these giant worms started coming up, which is a great thing. The life in the field is just amazing, and it's such a drastic change from a conventional farm.

I think organic is a great thing. But the publicity surrounding the word, the branding, is unfortunate. I don't think the two match up. What people think of the word organic, and what organic is, is not necessarily the same thing. People have this halo around the word, they think that everything is perfect. Organic is the way people did things 100 years ago, 150 years ago, 500 years ago. It is the way it was done then, and it's how we should do it now.

We grow an enormous variety here, about 150 to 200 different vegetables. If something happens to come in and affect one crop, it's not going to affect another. If you get too much rain it's good for one thing, but not for another. It is a much safer way to farm and protect yourself.

There are definitely more organic farms in the Hudson Valley now. I feel like the organic ideas are definitely taking root.

We're not certified organic. One thing for me is the work involved in being certified and maintaining that certification. If I had 10 hours a week to do that, I would rather spend those 10 hours every week with my family.

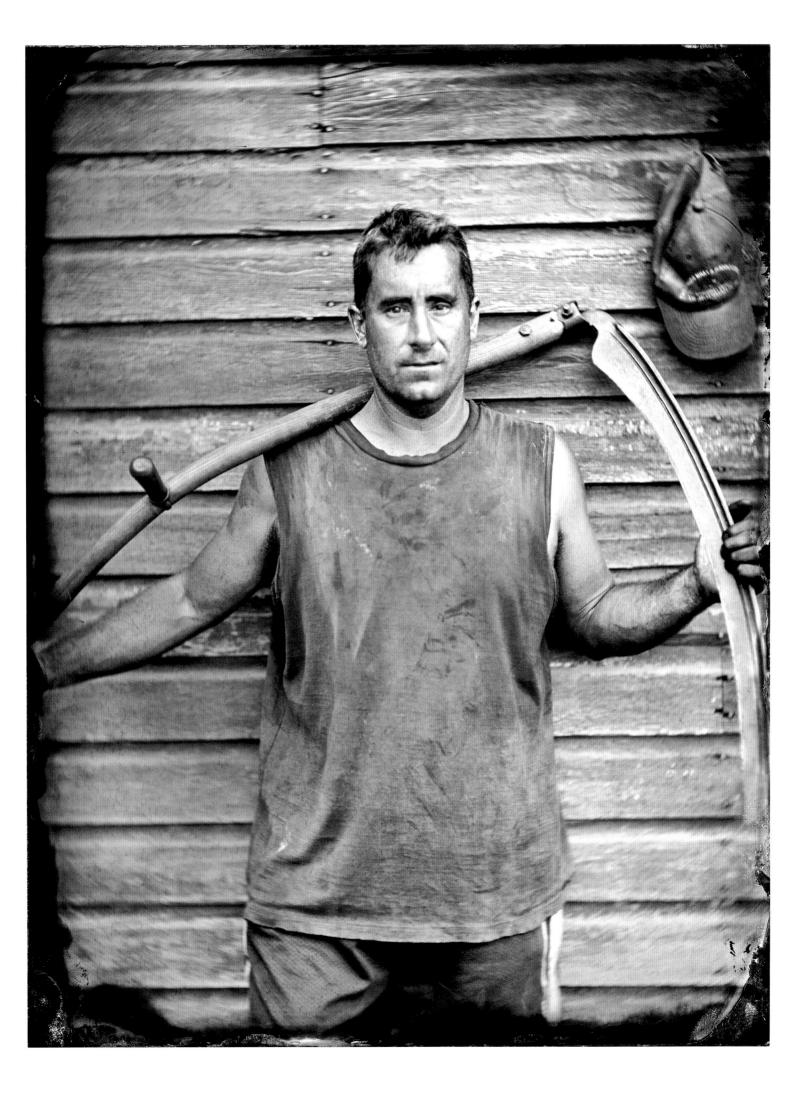

DAN BARBER
Blue Hill at Stone Barns, Pocantico Hills, NY

Blue Hill Farm is my family's farm in the Berkshires. Today it's a grass-fed dairy operation, but, back when my grandmother owned it, the farm raised beef cattle. I spent my summers there haying the fields, and I think that, quietly, it gave me a sense of responsibility about the land. It's also what inspired me to cook in the first place. Somewhere along the line, the ideas of cooking, agriculture, and preserving open space sort of came together on a plate of food. And that became the philosophy behind Blue Hill restaurant.

Blue Hill at Stone Barns is about supporting the ecology that surrounds us—the fields and pastures just outside the dining room, and also the larger ecology of the Hudson Valley. That means more than just sourcing local ingredients. It means trying to create a real cuisine based on what the landscape can readily provide, which is a much bigger idea.

When we envision good food, we tend to think about "organic." But our understanding of that word is too simplistic. For most of us, it simply denotes a farming method. (If you don't use chemical fertilizers or pesticides, then you're organic.) But organic really refers to the organism of the farm; that's the true origin of the word. It's about treating the system as a whole—plants, animals, even the biology of the soil.

So the question is, what's a chef's role in all of this? As chefs, and as eaters, we have a responsibility to support the health of this living landscape. We need to diversify what's on our dinner plates, and celebrate every part of the "organism"—an integrated system of grains, vegetables, legumes, and livestock. You've heard of a nose-to-tail approach to the pig? Well this is a nose-to-tail approach to the whole farm. And it represents the future of delicious food.

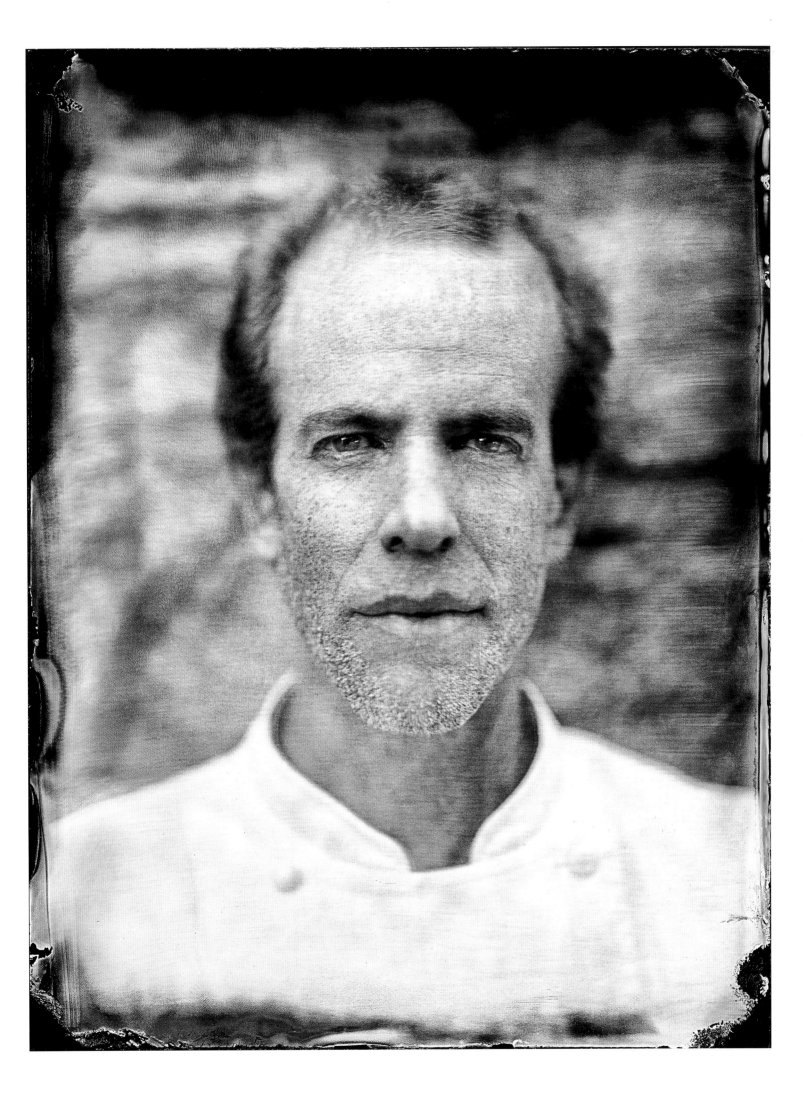

HANNA BAIL
Threshold Farm, Philmont, NY

I grew up on a farm in Bavaria, in Southern Germany. My parents had a dairy farm, and I said I was never going to be a farmer.

I realized farming was going to be my life in my early 20s—that was in the late 80s, early 90s. I loved to be outdoors and in the mountains, and with the dying of the forests and all the environmental issues, there was a big concern. That's what made me think things over. First I worked in a nursery in Bavaria for a week and really loved working with plants. Then I decided to do an apprenticeship and went back to agricultural school.

My apprenticeship in Germany was conventional. It wasn't vegetables, it was indoor plants, balcony plants. But I had to put on a suit with filters in the back, mixing up different poisons. I did that consciously because I wanted the exposure, and I realized this is just not right. Of course nobody ate the plants, but I was exposed to it and of course it leaches into the ground water. After that, I knew if I did agriculture it was only going to be organic.

I came here on a trip around the world volunteering, like WWOOFing basically. I went to California and checked out farms. I went to Canada and volunteered on different farms there. They were always organic farms.

Organic is what we do here. You really work with the forces of nature, and try to heal the soil and build it up, and we also bring different animals in, because they bring a different element into the farmscape. We build the soil to make it much more drought resistant, and more flood resistant, and for the past few years we have had extreme weather patterns. This year we didn't irrigate once, and the vegetables came out great.

The goal of a biodynamic farm is to create a self-sustainable entity, so that you have enough animals to produce enough compost to spread it out onto your fields. So you don't bring anything in from outside the farm.

We use particular preparations that we bring out on the soil, and when I did it for the first time I felt like a priest. You walk the land; you actually look and see it. It was like christening the soil. It was a very strong feeling.

We are not certified here. We just don't believe in the certification. We have nothing to hide, and people can come up any time. If they have any questions, we just tell them flat out what we do. You can be better than the organic certification, I am sorry to say, but that's just how it is.

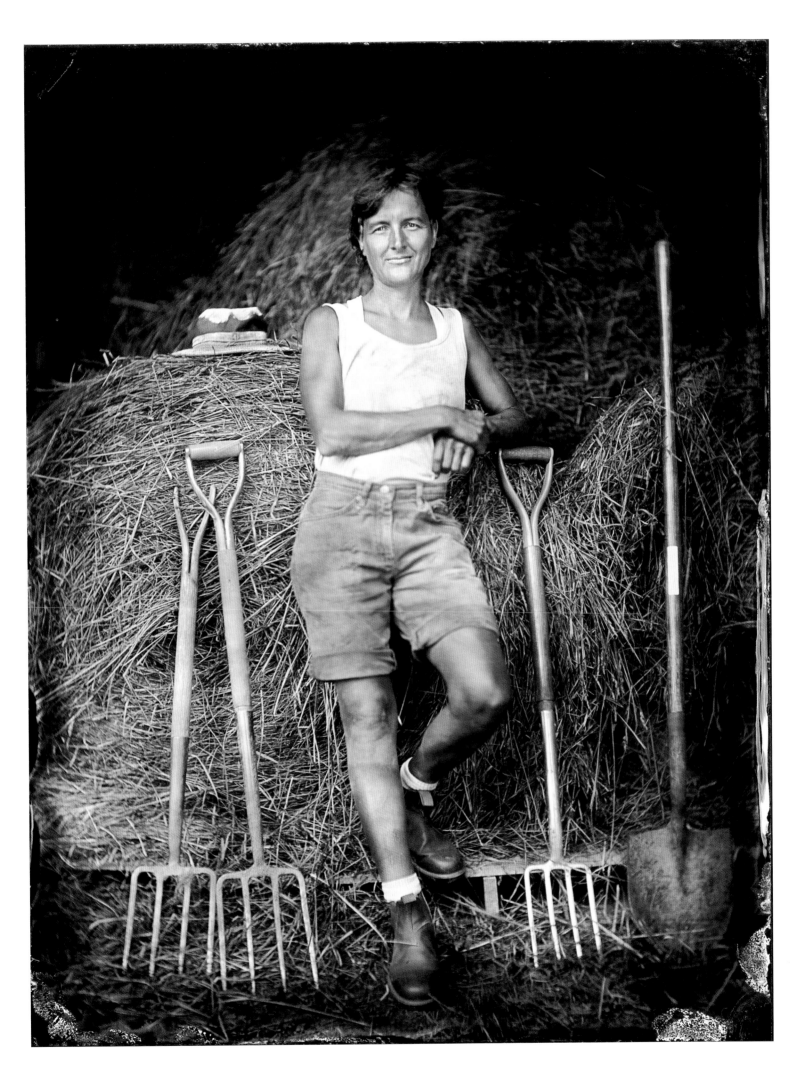

LYNN FAURIE
B&L 4E Farms, Milton, NY

My grandfather bought the farm in 1910. They used it as a summer residence. When my father came here as a boy he fell in love with the farm and he wanted to live here. In those days it was a fruit farm.

In the 1940s, my father got his first cow and that was the end of the fruit. The first thing I learned was how to milk the cows. Then in 1999 my dad says, "I think we should switch to beef, you're not going to want to be milking cows twice a day when you're 70 years old." So that's when we started to switch to beef. My father milked his last cow in March and he died in December of a heart attack in that barn upstairs, feeding out hay to the cows. He lived his life exactly the way he wanted and he died exactly the way he wanted.

It starts with the soil. If you don't have healthy soil, you don't have healthy grass, and if the grass isn't healthy, you won't have the product you want in the end. We spent a lot of time, when we were first going into this business, having our soils tested, mending our soils, adding calcium, all organic fertilizers, and now we've got it to the point where we're doing rotational grazing so the cows are actually spreading their own manure and our pastures are so much healthier now.

We use no corn for our cows; they're finished on grass. We do our own breeding and we do artificial insemination to improve the genetics. Their rumens are based on what they should be eating, which is grass. We don't believe in a monoculture. All of our pastures are whatever grows naturally. The weeds bring all of the minerals out from deep in the soil rather than just having a field of clover or a field of alfalfa. Alfalfa doesn't grow here naturally so we don't have alfalfa.

There's a whole issue over raw milk. You're not allowed to buy raw milk, but you can get cigarettes that can kill you, you can get all of the alcohol you want, but they're going to prohibit you from buying raw milk. Now there's something wrong with that picture. I grew up on raw milk and I'm healthier because of that.

I know all the issues going on—we're members of Cornucopia—we hear how things are getting diluted. I'm sorry to see what's happening with the big corporations taking over. They're milking 5,000 or 6,000 cows and calling it organic when the cows have no access to pasture. It's disheartening but we know what we do and that's all that we can control.

I hope I die like my father died, right up in that barn, throwing hay out. That's a beautiful way to go, with your animals around you.

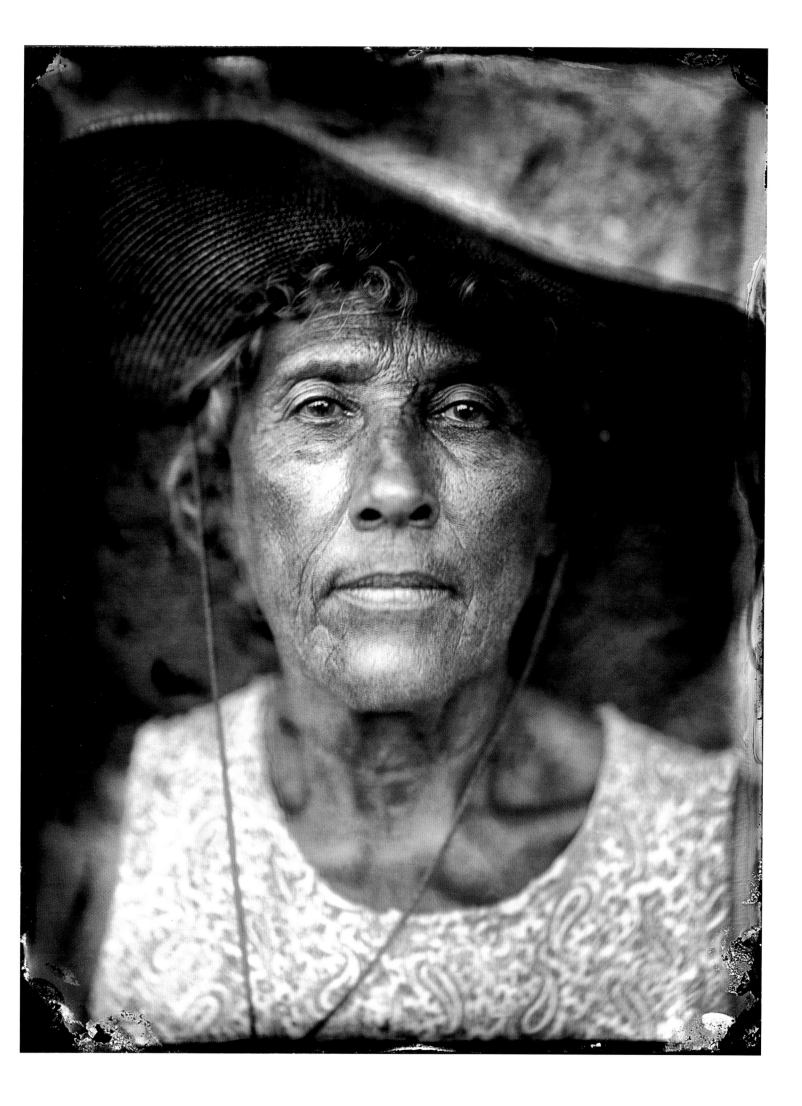

EUGENE WYATT
Catskill Merino Sheep Farm, Goshen, NY

I grew up in an agricultural region of California. I've been a foodie since the 70s. To become a vegetarian then was a way to rebel against the conventional. In the old days there was a tremendous amount of labor on the farm. Then the Green Revolution came around. The Green Revolution was basically the introduction of chemicals. They spray herbicides, they spray pesticides, and there is no hoe on the farm.

The government owns the word organic. If I say that my sheep are organic or my garlic is organic, whether they are or not, if I am not certified they can fine me to the degree of $10,000 per instance. I don't think the government can own a word, they can't take the word from people and say, "Look, we own it now. If you want to use it, you have to be certified by us otherwise we are going to fine you."

For 26 years I have been farming sheep. We just had about 300 lambs, so we have about 800 now. I used to be certified organic. I rescinded my certification two years after the USDA took over. I don't like the word now because it's branding. What they have done is taken the word and made it like "natural" or "whole," so I don't use it. People ask me if my sheep are organic, and I respond by saying, "Even more so, because the federal government is not involved in my sheep. They are more pure than what you think."

The intention is so important. Whether certified organic or not, it's a question of how does a farmer farm. I wanted to produce something that was good, do something that was correct, and produce food that I was proud of, food that was pure.

At the farmer's market people know me, and they know my philosophy. They want to know where their food comes from, and how it was raised. Even after I gave up my certification, people continued to buy from me because it was local, it was small, and you could talk to the farmer, me. It's an old fashioned way of doing business—where you have a relationship with your farmer, and your farmer has a relationship with the people he grows for.

I am very lucky to do what I do.

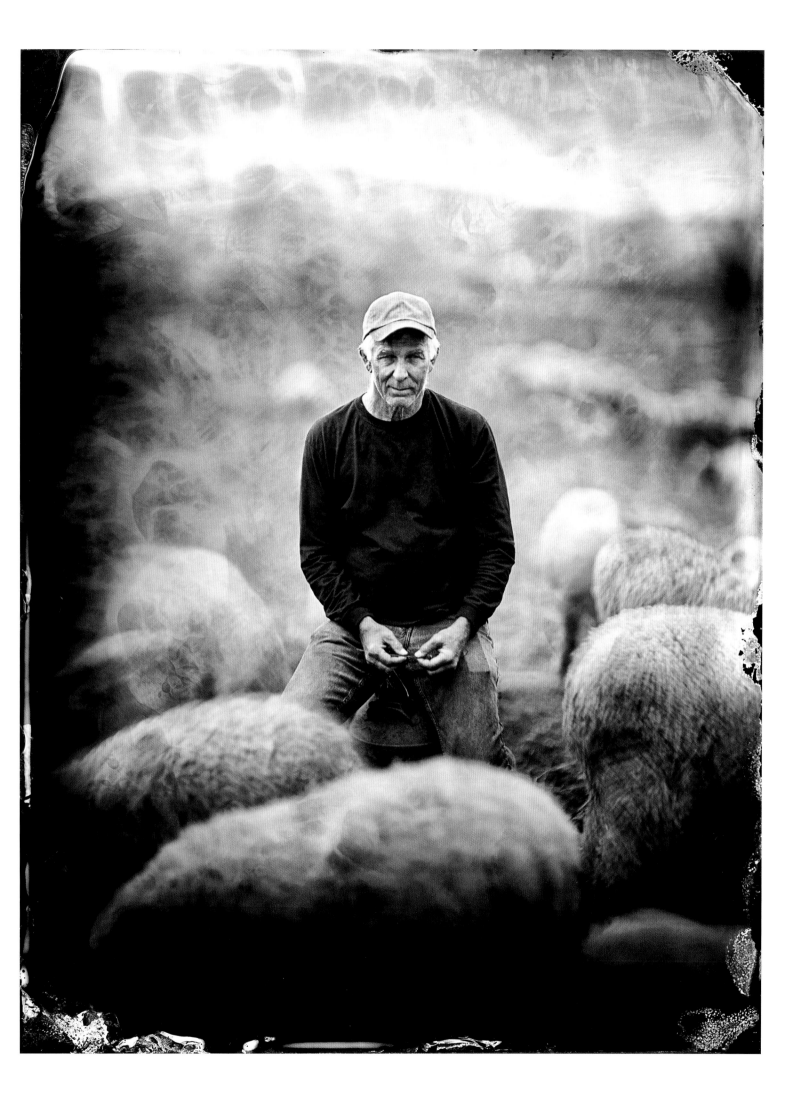

RAY BRADLEY

Bradley Farm, New Paltz, NY

For 13 years I worked in the restaurant business at Bouley, Le Cirque, and Polo. When I was at Polo, Daniel Boulud was the sous-chef, Thomas Keller was there, and Bill Yosses, who is the pastry chef at the White House.

I was in the business so long I wanted to do something different. The guy I used to buy my produce from for the restaurant was a Green Market farmer and he said, "Why don't you come work for me?" and I did. I learned what to do, what not to do. Back then no one was doing organic, so it was another way to get into the market.

I don't think the word "organic" is used properly to tell you the truth. Since the USDA took over, everybody is putting the word up and they are not really organic. They just say they are, so it's false advertising. To really be organic, certified organic, there's a lot of work. You have to document everything, you have to weigh what you bring in and what you take out, it's really intense.

I always farmed organic, but I'm not certified by the government. I am Certified Naturally Grown. But, you are either organic or you're not. My father always had a garden, my grandfather had garden, and they never sprayed anything. I want to make the product the way it was back in the old days. It's all about the flavor, and the ground makes a big difference.

I always try to take care of my soil; good cover crop. When I first came here I planted some stuff and it grew like Mount St. Helen. It was huge, and an old timer said, "It's always good the first year because its never been farmed, but after that its going to go down unless you keep working the soil, and take care of it, and building it up." So I did that. That's what I think is key for me.

We don't put chemicals or fertilizers on to push it, so it grows a little slower. Anyone can grow a carrot, but to grow a good carrot, or something that's very tasty, or know when to pick it, that's another thing. It's not just to have it to sell, but to have it to sell so it has the best flavor.

There are 27 acres here. About 18 are workable, and on the other side I have green houses. I've got pigs, black pigs, large blacks, and eggs from chickens. I am doing some meat birds too. Heirloom tomatoes are my big crop, and the garlic, French grey shallots, a lot of cut herbs, celery root, and carrots.

Every day I can find something to do. It's not like its work, its fun.

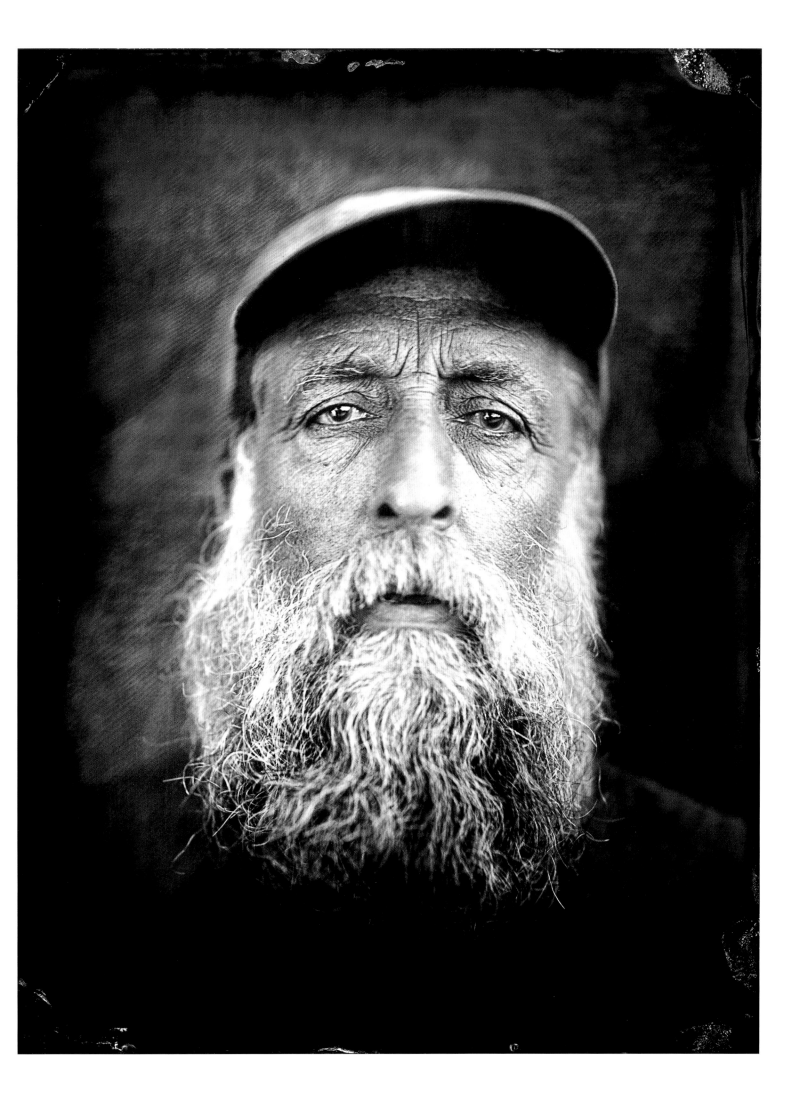

JACOB DIAZ
Slow Roots Farm, Kingston, NY

Three days after I finished college I went to work on an organic farm and have been farming ever since. That was Keith Stewart's farm in Westtown. Once there, it had all of the elements I needed in my life. It was outside, I was working physically, working mentally, and then you have this beautiful, tangible product.

Organic has come to mean my relationship with food. Two words that come to mind are health and trust. By me saying my food is organic, and saying it to someone buying my food, they are trusting me. It's about producing the healthiest food possible: healthiest for the people buying it, healthiest for the land, the animals, the community, and for the planet. It's me, as a farmer and steward of a piece of land, deciding what that is, and not a third party saying it's the healthiest for all those entities.

Organic has become a way to label things. I am not certified organic. On my scale, on the intimacy that I sell my food, I don't need it. I don't need a way to classify my food. I talk directly to the people who buy from me.

Industrialized food is an interesting thing. As a society we've been steered in this direction of monocropping. I understand how that happened but it doesn't mean it's a good thing for a farm, a farmer, for a farm family, a farm community, for a planet. Strength lies in diversity and the more diverse a farm is, a place is, a community is, the more vital, strong, and beautiful it is.

From the minute I wake up in the morning, I'm ready to go. It's in part because I'm really excited to get out there and solve a problem, or pick food, or just to see what's going on. It's exciting to be a part of a living place and sculpting it in the ways that you can.

In organic farming you've got to put in the work if you want the results. It's not like a computer where you can plug in numbers and things come out. It's such an alive thing. It's not guaranteed that the harder you work, the better the results, but over a lifetime, I hope the harder I work, the better the results.

That's a beautiful thing when you're dealing with food, and community, and people. What a gift to have a relationship with all of those things, and enjoy it.

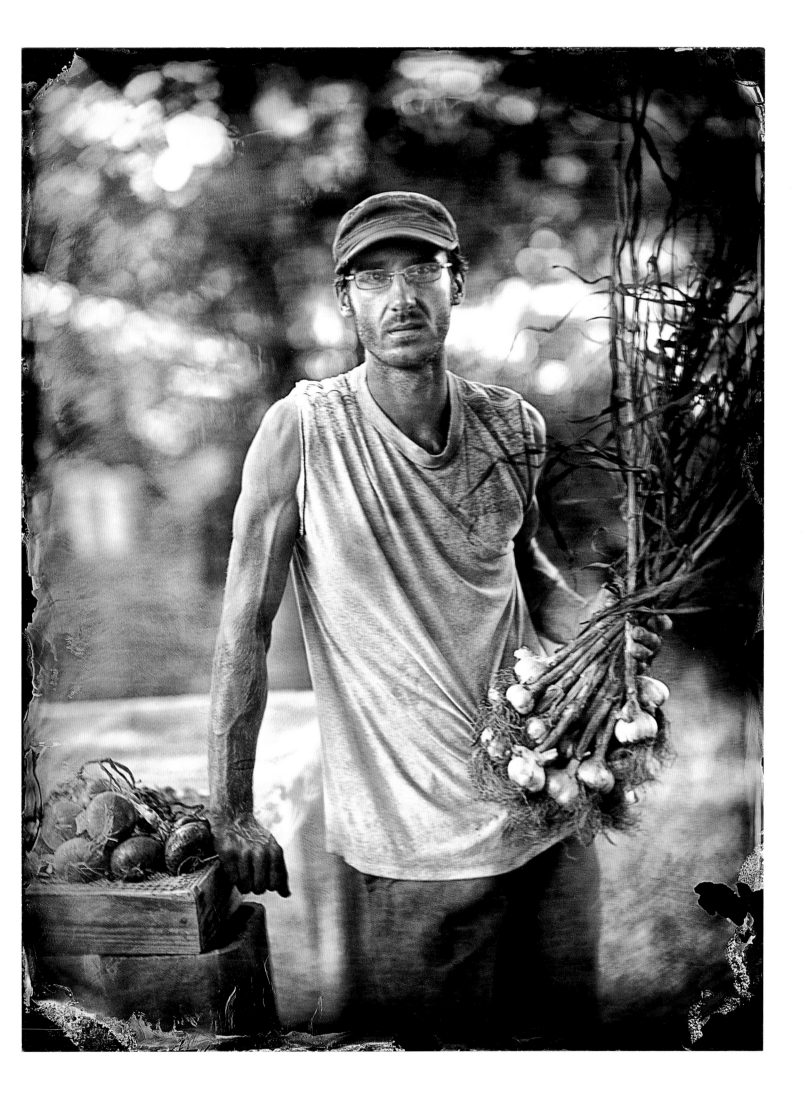

ANNE ESCHENROEDER
Big Little Farm, New Paltz, NY

It started with the sense that there was a lot wrong in our society, and how we were living and interacting with the natural world. I wanted to try to do my part to change that. Whatever I do has to stem from my own life and the immediate community that I interact with, and hopefully that spreads out. It began with a very conceptual idea of, "everyone eats"; it's a very basic way of interacting with the natural world.

It has taken a lot of different forms for me. I started out doing urban gardening and garden education. Every farm I have been involved with has been educational in nature; either non-profit or at an educational institution. I started doing more gardening and it transitioned into production farming.

I have never worked on a conventional farm. When I was in Portland I worked under Oregon Tilth, an organic certification company. I was part of their education program. I managed an urban garden and taught kids and adults about organic farming.

Since I was part of this certification company I feel the certification serves a purpose. But I don't find myself using the word organic very much unless I am talking to someone like family members that are not around farms. I think it's a pretty tricky word.

There are a lot of things about an organic farm that people do not realize. I feel like the word organic can give people the sense that "this is good food." But I think there is danger in not actually knowing your farmer and knowing the processes they use, because organic can encapsulate a lot of different ways of farming.

To produce healthy food, "sustainable" has to encompass a lot of different realms. Like not using synthetic pesticides and fertilizers, and working with land in a naturally beneficial way so that you are getting crops out, but the land is actually improving.

Farming has become something that I love and am addicted to. It sustains me and it also allows me to try and create change. If this wasn't my job, this is what I would be doing anyway.

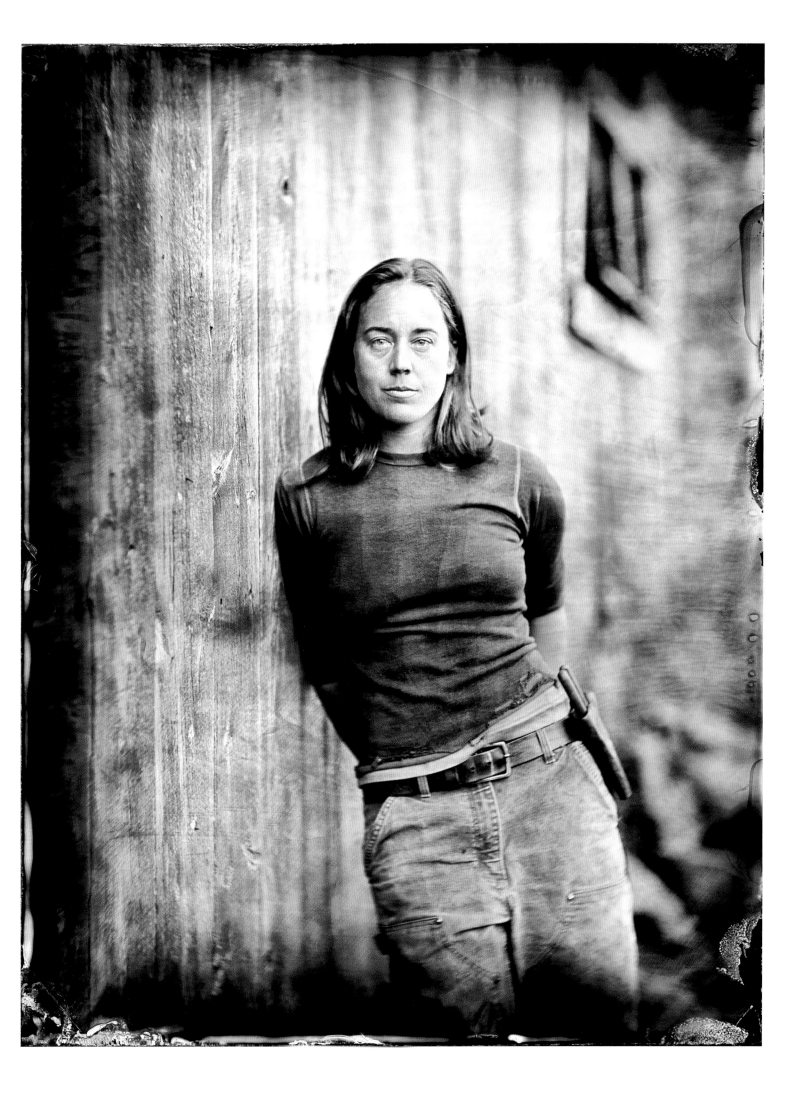

HUBERT MCCABE

5lbs of Dirt Farm, Montgomery, NY

I always wanted to be a farmer, it just took me a long time to figure it out.

I grew up in Connecticut, on the coast, but my father is an immigrant. When we were younger, my brothers and I would all go back to Ireland. The town my father was from was small, and there was nothing to do, so we would work on the dairy farms. That's what we did in the summers for fun, and I always thought it was the coolest thing in the world.

While living in Brooklyn I worked as a social worker in the South Bronx. I was pretty burned out, and was going to take a year off from it. I had no intention of leaving the profession. There were a lot of nuns that worked with us, and they had land in Goshen where they had a garden. I started working there a few days a week, and within three weeks I rediscovered the whole thing I loved about it as a kid. After three months of doing it I realized it was the greatest thing ever.

I always farmed organically. I don't even know how to use chemicals. It's unfortunate that what started as a very grassroots way of farming and producing food has become a marketing ploy. It has become, for the lack of a better phrase, sold out.

A lot of folks have never really seen what industrialized food looks like. It's monocropping. It's so symmetrical and it looks really pretty, but it's not real. It's food that's meant to look a certain way and it doesn't seem to matter how it gets there, or what's in it, and there's no taste to it. The whole industrial system is like that: they're factories in the fields. It's producing commodities, not producing live food. If you go through an industrial farm you don't hear birds, you don't see deer, there are no bugs, everything is just dead.

We're at this crossroad, where the demand is there, and there are a fair amount of young people coming into farming, but who can't afford to buy land. Land that's good for growing food should not grow houses, and should not grow factories. Food-production land should not be on the market.

The key to producing healthy food is diversity. Grow as much different stuff as you can. If you want to eat a healthy diet, eat as much different stuff as you can. Food, and food production, cannot be broken down into individual components, especially organic—it's a whole ecosystem.

I never had a day when I didn't want to go to work.

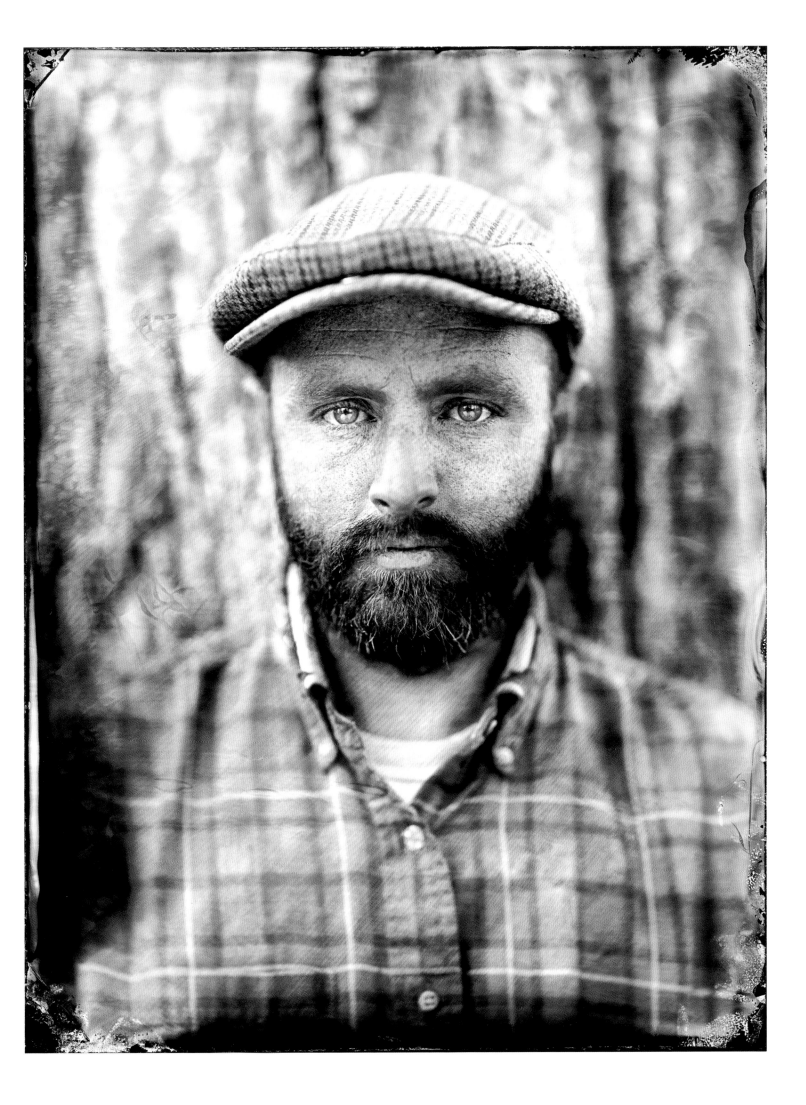

WILL BROWN
Lowland Farm, Warwick, NY

Prior to farming I was a bank economist in New York City. It's a big change from sitting at a desk and giving presentations to people to being outside and hardly talking to anyone all day.

I drifted into farming gradually. I started 15 years ago doing hay, then having a few cows, then having more cows, so it's been a gradual process. We've been doing grass-fed beef, and now pastured pork, for about six years.

I love the animals, but really what I like most is farmland. I love the land. Not wild woods, but this combination between partly natural, partly man-made, open farmland. I just have a real weakness for it, that's why we bought this place. The great thing about cows is they need a lot of land, they're very land intensive. So, you're out there over a large area of farmland and you are managing it. That's really what attracts me to farming most.

At the beginning we were just grazing the cattle, and doing a cow-calf operation. Then we thought about expanding the business, and that's when we decided to do the grass-fed.

We have about 140 cows now, after calving we probably have about 165. When you're doing grass-fed you have a least three generations on the farm. You have your cow, your yearling calve, and your two-year-olds. So you have three, and sometimes even four, generations on the farm at one time.

We're not certified in any way, we have not gone down the organic certification route. As far as cows are concerned, they're just naturally in the fields. We don't fertilize, we don't plow, we don't plant. We are managing our pastures with the animals themselves. We wouldn't have to change anything to be organic. What we do is holistic grazing; it's a way of managing your pasture with the animals. We move the cows every day. The main herd gets a two-acre section in the morning, and the next morning we move them to the next two-acre section. It's more of an art than a science.

We listen to our customers. Our customers like the grass-fed aspect. It's important to them how we treat the animals, and also having it local. We're not hearing a whole lot of, "Is it organic?"

All the grasslands in the U.S. were not there by themselves, they were there with big herds of animals going across them. It was the interaction between the animals and the grasses that was successful.

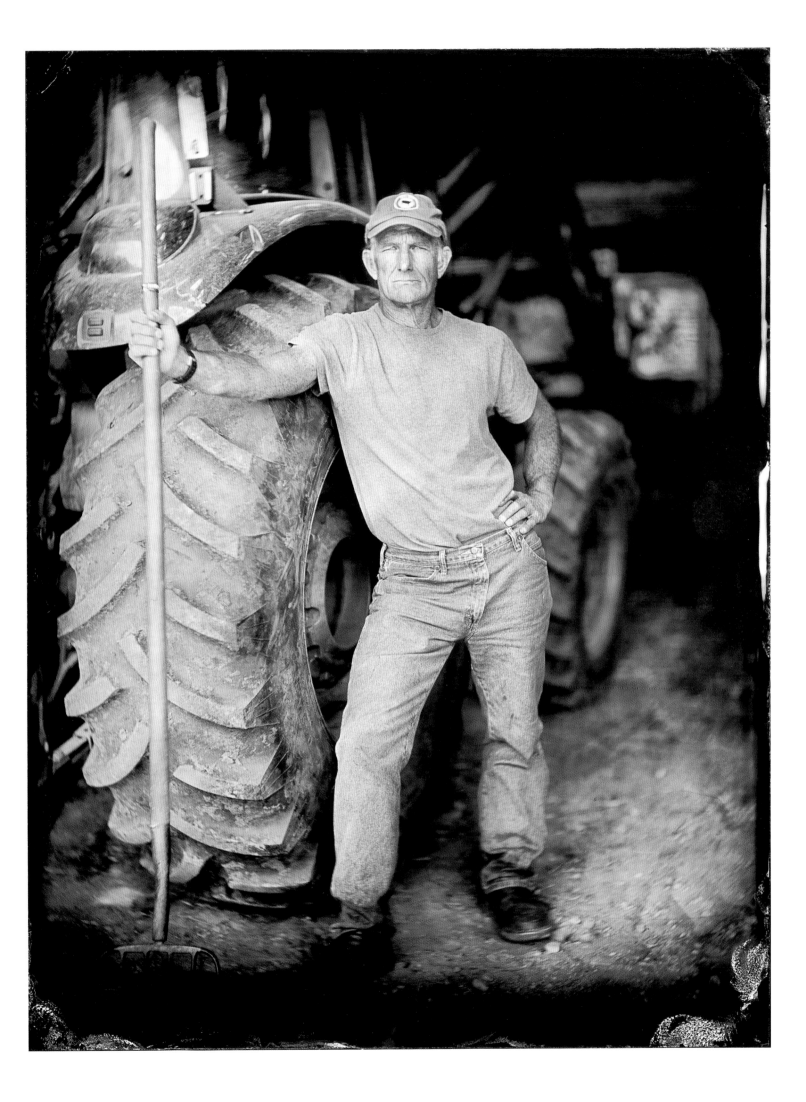

DWAYNE LIPUMA

St. Andrew's Cafe, Culinary Institute of America,
Hyde Park, NY

My grandparents owned a supermarket in the Bronx and I used to go there every day with my mom. I have been immersed in food, in some manner, all my life.

In high school I worked in delis, and later in a number of restaurants to help get me through college. I went to the University of New Mexico and studied environmental science. I became a professional chef when I graduated from the Culinary Institute of America in 1986, and I launched my career at the River Café in Brooklyn. Later I worked at Colavita, then I moved to American Bounty, and now I'm at St. Andrew's Café.

I am a chef-instructor here. My role is to teach the students about sustainable and organic food, and get them ready for the industry.

As the weather is changing, they can see our menu change, and it gets them thinking about flavor profiles and the beauty of the ingredients. When eating a tomato, I want to taste a tomato. When eating an eggplant, I want the flavor of eggplant. Simple is better, think about what's in there.

I asked my students what organic means, they replied, "Organic means sustainability, it means all-natural, nothing synthetic or synthesized by man." When I think of the word organic, I think about nature, doing the right thing with the planet. I think about something more flavorful, and about sustaining the community, and employment.

It's an art. You have to commend the farmers for being out there from sun up to sun down, as well as the chef who enjoys and understands the beauty of how they grow their vegetables and raise their animals. To just harvest a carrot, and give it to me, and let it sit in my walk-in for three days—I might as well just buy something off the supermarket shelf. But to take that simple carrot and make something beautiful with it, shave it or pickle it, serve it at that moment, and reduce the time from farm to table, where all you have to do is drizzle a little something on it. It's an art.

The Hudson Valley is a Mecca. It's like the Garden of Eden up here with the farmers markets.

I think people have to sit down and figure out what is best for the planet. People are changing and they want more sustainable, local food. It's a great thing and I don't see an end in sight.

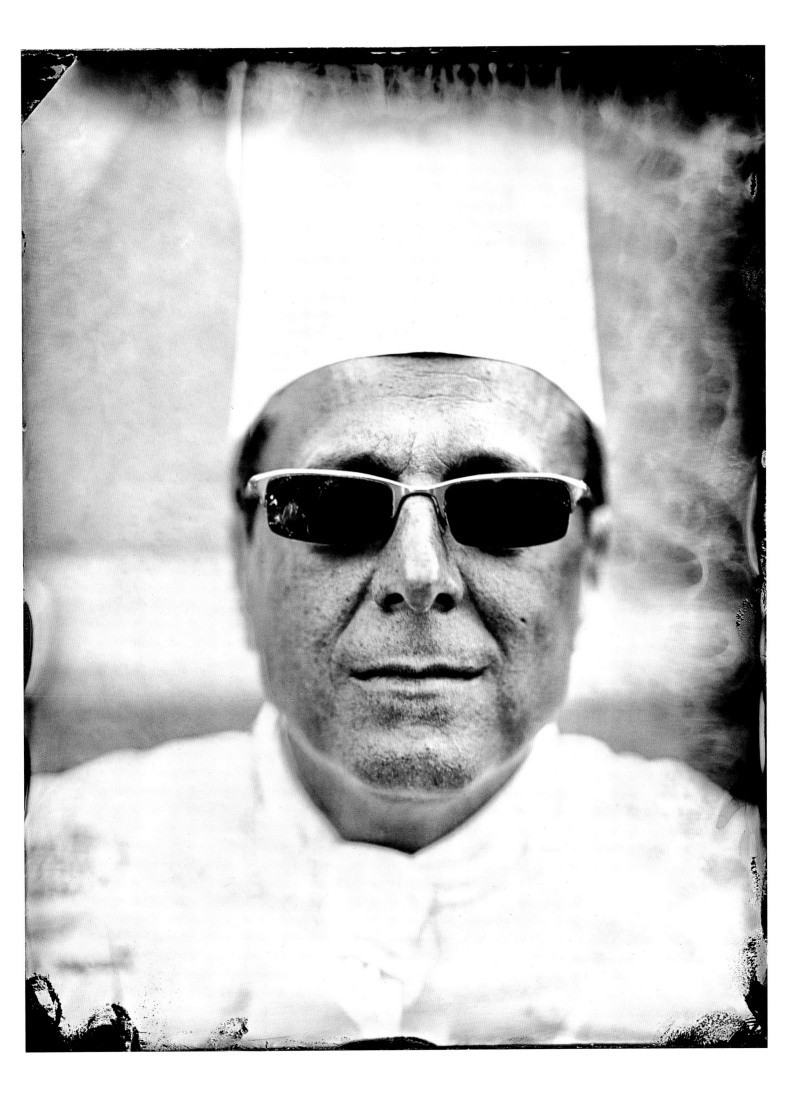

DON MCLEAN
Thompson-Finch Farm, Ancram, NY

I grew up in Vermont next to a small farm and apple orchard. As a teenager I worked there on and off. I got really interested in farming and caught the bug.

We'd been organic farmers in Vermont before we moved here in 1981. We came from a place that looked at organic farming as a philosophical, ethical life choice. We think of ourselves as trying to create realistic workable alternatives to conventional farming and always wanted to show how it can be done. For years, we've been doing things that people said can't be done.

It was 1986 or 1987 when we got certified. The decision to certify back then was because we were expanding our capability to grow—the amount we could grow, the varieties we could grow—and we were tapping into the local wholesale market. So, we needed some sort of third-party certification to enter that marketplace. If you're going to start selling stuff directly through CSA sales, farm markets, and pick your own, it wouldn't matter. We have our reputation and it's solid. It started because we were selling to places where they, rightly, wanted some certification. We support that concept and we recognize its value.

Now, organic includes huge industrial corporate farming and it's unethical regarding what we want organic to be, and what we think organic farming should be. We have a system that's making people sick, and making them obese, and giving them diabetes, and we're actively supporting this as a nation. The whole thing seems to revolve around corporate interests and corporate power.

When it went to the federal level the certified organic agencies out there had enough variability in their standards that people were realizing there was a need to have some kind of national standard. I think it was good in that sense, but bad in the sense that the way it is now is a reflection of the corporate interests that have basically usurped that facet of our government.

The Hudson Valley is one of the greatest places to be doing this: great farmland, great farm markets, and really educated customers. I think it's pretty clear that the Hudson Valley is heading towards being an international food destination.

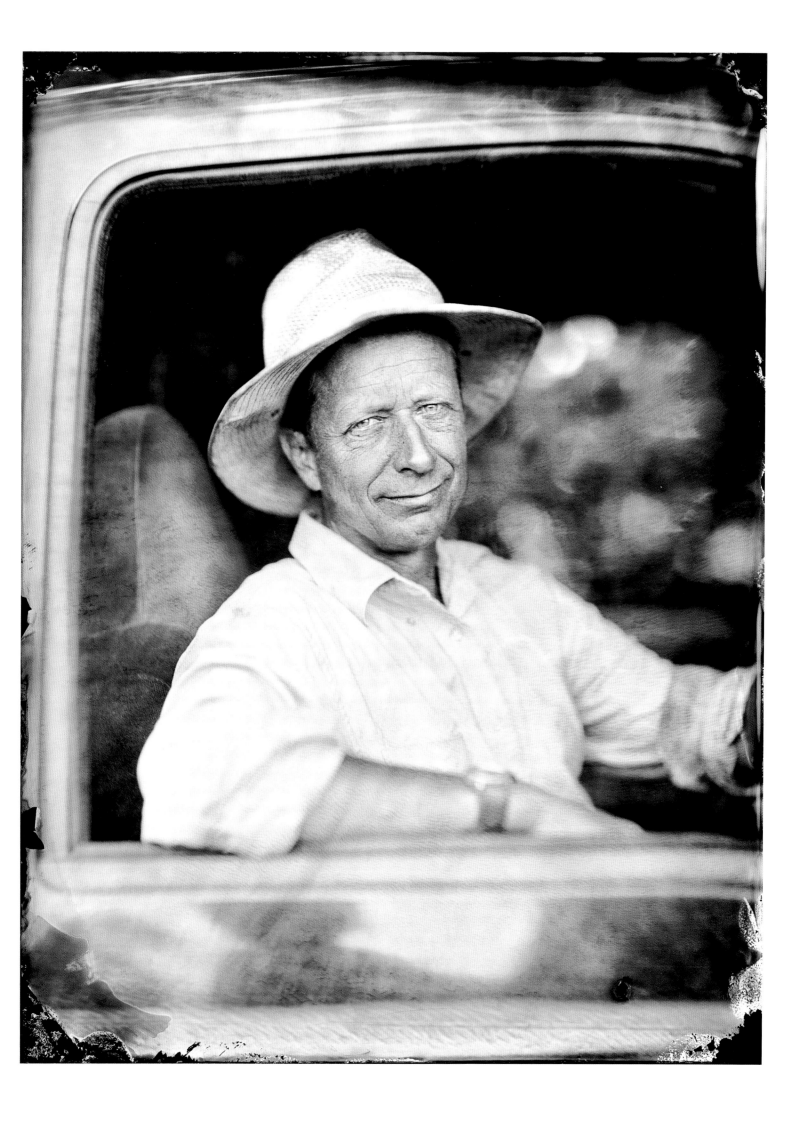

DAVID ROWLEY
Monkshood Nursery, Stuyvesant, NY

Since 2003 I have been farming on this farm. I first stepped foot in a greenhouse at 12 years old, and I've been doing this ever since.

When I first started I was working at a local nursery and doing what I was told: put this with this, put this fertilizer on, go ahead and spray. I went to school in Kent in the U.K., and studied commercial horticulture, and learned about the proper applications and usage of different chemicals in agriculture.

From 17 years old I was a conventional grower using herbicides and pesticides to grow food. I was growing food, suited, booted, with a respirator and gloves, and using very highly scientific spray applications to produce food out of season. It was plants growing in fertilizer solutions to produce food, and I was continuously spraying. After a few days it's picked and put into a box, and then off it goes to the supermarkets. We're talking about two to three tons of tomatoes a week.

The year 2000 was the end of me working with chemicals because I got sick. I had pesticide accumulation in my liver and kidneys. So I went to see a homeopathic doctor, they told me straight up, "It's time for some serious lifestyle changes, you need to have a look at what you're doing."

Organic, should be clean food. If we go back 20 to 30 years, we see the picture of organic as a weedy field with a bunch of people working really hard to produce clean food, with no fertilizers or pesticides on them whatsoever.

Today, I am certified organic by NOFA New York. I decided to certify because I want to be able to be at farmers markets and stand behind a table of food, and when somebody asks me, "Could I feed this to my children, are you organic?" I can say, "Yes." Even though there might be a product out there that's approved for certified organic production, I will not be putting it on food; I refuse.

When I drive by some of these huge fields, and see the industrial Green Revolution crops, and look at the soil, I can see it's collapsing. There are only so many more times that those tractors are going to go around that field before that cycle is done. It's finite.

The Hudson Valley is a great place to be. There are so many great people growing really good food. The foods are just amazing. It's drawing people, and those people are creating, distributing, or at least eating, very good food.

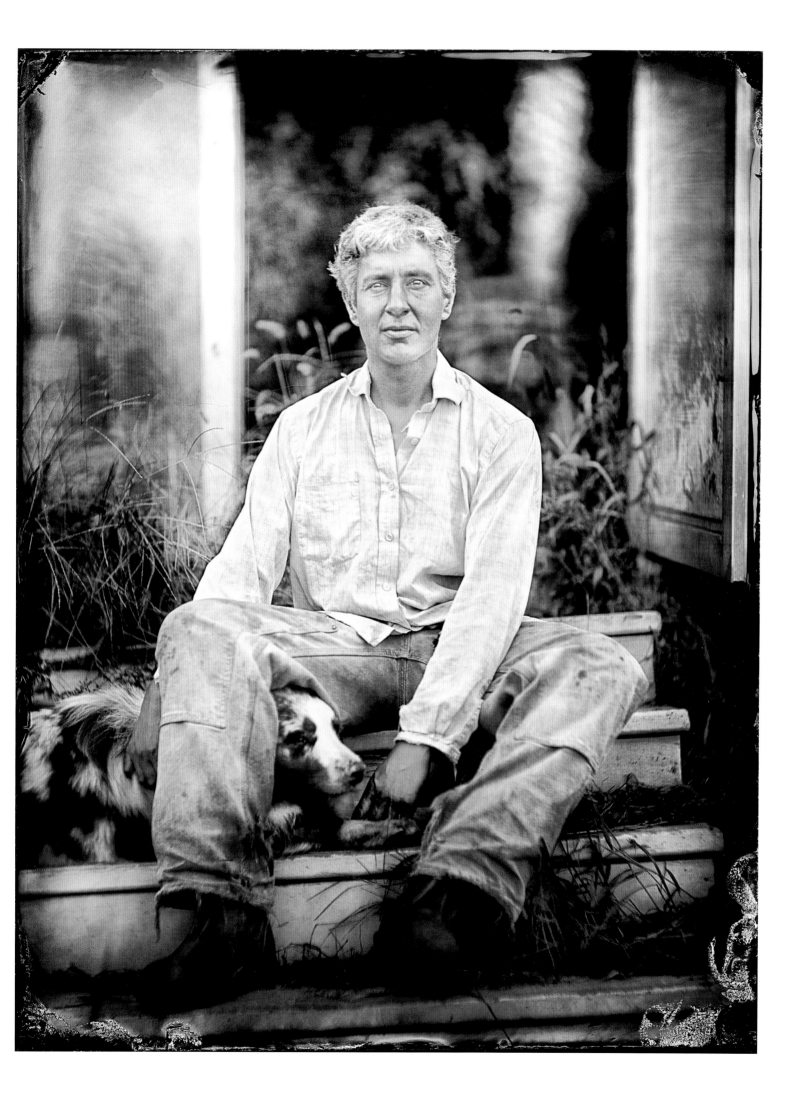

JOHN GORZYNSKI

Gorzynski Ornery Farm, Narrowsburg, NY

I remember when I was five or six years old, I wanted to be a farmer. My grandfather had a farm in Oradell, New Jersey, and my great-grandfather had a farm where the Bronx-Whitestone Bridge is. Farming is in my blood. I always wanted to farm.

My folks bought a place in Wantage, New Jersey. Within the first year I tripled the size of the garden. I was doing it as a hobby, but very quickly it turned into an economic statement that we were saving taxes and that we were feeding the family.

I went to school for forestry and got a job with the shade tree department in the town of Oradell. Within six months I was promoted to foreman. It was right during the peak of the gypsy moth infestation, so spraying chemicals was a large part of the job. Most of what we sprayed were highly toxic pesticides. Being exposed to the chemical industry, I got to see people with different levels of cancer and sicknesses, and what it did to the ecosystem.

When I started farming in 1976 it didn't take me long to put two and two together, and I arrived at the conclusion that organic was the way to go. I have been farming organic from day one.

In 1982 I formed—along with quite a number of other farmers from New York State— NOFA New York, which was a grassroots organization. I was selected as chairman for the first couple of years, and towards the end of my reign we decided as a board that we should form our own certification agency that would certify organic farmers. We proceeded to set up standards that were among the strictest, if not *the* strictest, in the organic industry in this country.

The first 20 years of my farming life I was certified, from 1979 up until the USDA took over. As soon as the USDA became involved the definition was diminished to the point where I would no longer be certified. It didn't come near to my standards of what I felt organic should be, and there was no way I was going to validate or lend it my credibility—that of my farm and my 20 years worth of work towards making the word organic mean something. I totally withdrew my name from the word.

A number of smaller organic farmers in the NOFA chapters got together and sat down and brainstormed and isolated 63 issues with the USDA regulation. The one that's the easiest for me to convey is the synthetics allowable in production, processing, handling, and storage. To date there are 142 synthetics that are allowable, and in my definition of organic, synthetics don't exist.

This farm is 52 acres, we farm about 23 to 24 of them. In a normal year we'll grow about 600 varieties of vegetables and herbs, and we have about 300 varieties of fruit on the farm.

I can look back and know I did no harm, and I'm leaving things better then I found them.

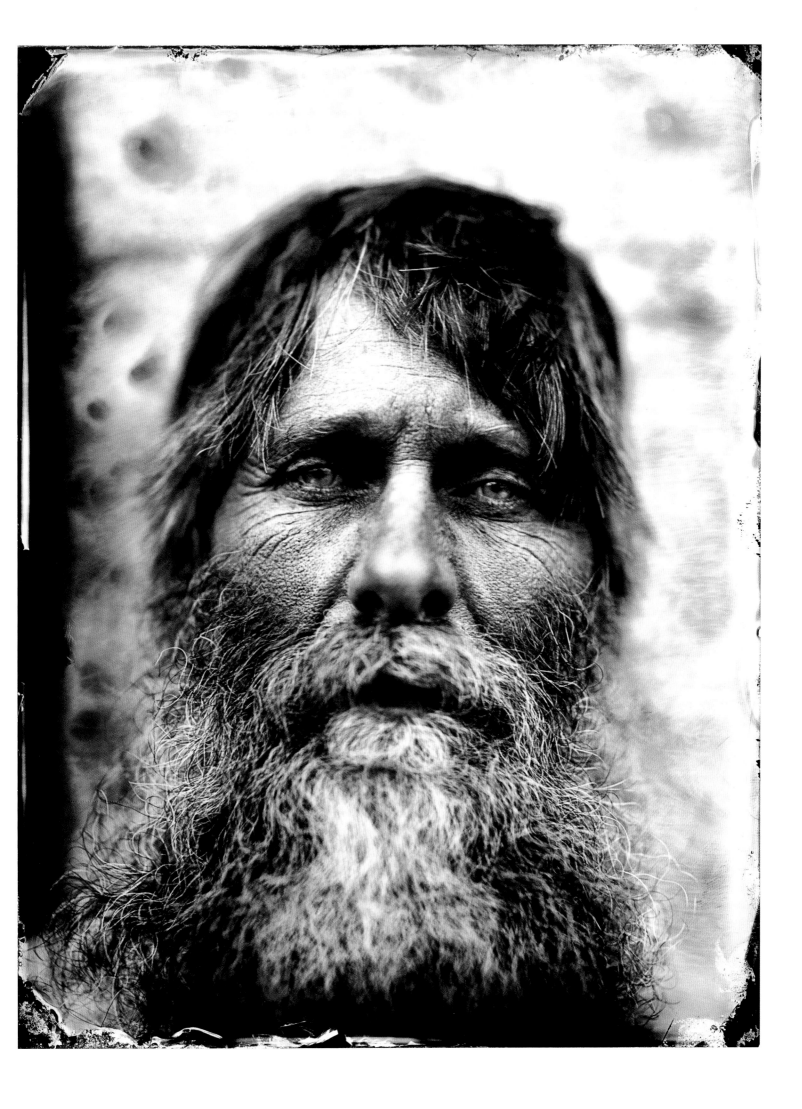

AMY HEPWORTH
Hepworth Farms, Milton, NY

It has been Hepworth Farms since 1818; I'm the seventh generation. In order to be around that long you have to adapt and change. My family has been very into quality produce, so it's been engrained in our business—quality, quality, quality, if in doubt, throw out.

For generations all of us have attended Cornell, but we have more of a progressive bent on farming, it's been handed down. I've been practicing organic agriculture, and I studied bio-dynamic farming. When we did it in the 80s, we scientifically knew that we could do better than organic in an ecological way. To be able to have a sustainable farm, to be able to have a farm that will go on past you, you have to take care of the land.

The reason and purpose of organic agriculture is to take care of the soil and rejuvenate it in a natural way to stimulate all of the biologicals. We've been through various stages of certi-fication. When you're organic, there's a certain protocol you follow.

Organic makes me feel that you're trying to do the right thing by the soil, by making it as healthy as possible and making a more natural lifestyle. The problem is, when I say organic, it means a lot of things that I don't want it to mean anymore.

In 1980 I was growing apples. I wasn't certified organic, I grew them organic—that's the difference. There's no glory in doing something and not doing what you're saying. We've been doing it for a long time because we're trying to de-chemicalize the food industry and we were organic because it just seemed like it would be a good way to get out of what was seemingly starting to create a lot of problems with the chemicals.

We do things and it doesn't matter how much it costs if that's the best agricultural protocol. Meaning, to stimulate biological activity in the soil. Even if I wasn't organic I still wouldn't put herbicide between my rows. I like having soil that has weeds; I like having a living system.

Organic or not, I would still follow a holistic, or a whole-alive, farm approach, a system that is focused on creating as much positive and the least amount of damage as possible.

There are a lot of things to worry about, so if you buy local, fresh, organic fruits and vege-tables, that's what's going to make you healthy.

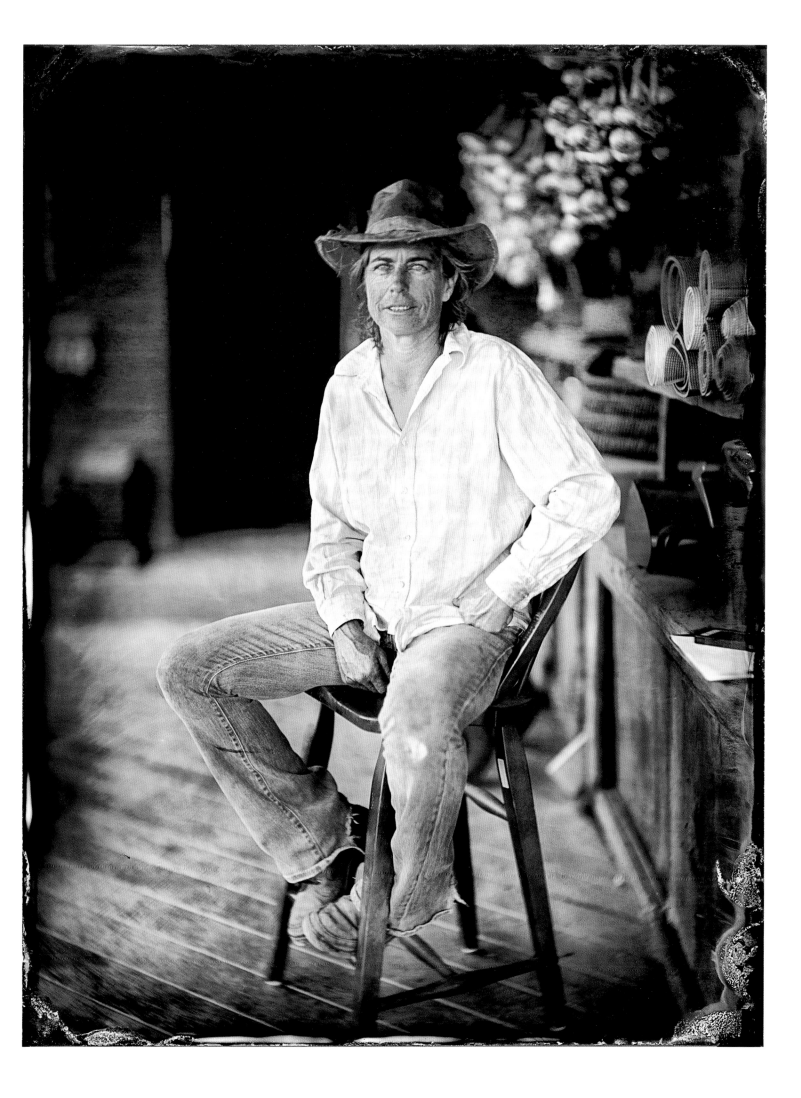

VINNY D'ATTOLICO

D'Attolico Organic Farm, Pine Island, NY

My mom and dad bought the farm in 1976. They decided to start an organic farm because of economics. They were both born in the depression, and having four kids, they both agreed we would at least be able to eat. I was 13 at the time—I hated it. I had to go to the black dirt every day and weed or do whatever.

Back in the day, mom and dad were one of the first to start the Warwick Farmers Market, and we've been at the Union Square Green Market since 1982.

I started feeling different about farming because of the needs of people who are chemical sensitive, who can't eat anything but pure food. Ours doesn't have any chemicals on it, not even organic chemicals that are allowed by our certification. Our certification allows organic chemicals they say are safe to use, but we don't use any of them.

My wife Denise and I farm together, and when our daughter Clairice was two and a half, she had her very own kale plant, and she would rip a leaf off and eat it. We didn't have to say, "Oh no! Don't eat that, it's not washed, there's chemical residue on it," because it was pure.

There are different levels of organic. There are hardcore organic people, like us, and there is organic industry, which allows a bunch of different chemicals for use. From World War II to 1996, there were 500 billion gallons of chemicals dumped on America alone. 500 billion! There are apple farms that I know of, that can't be sold unless the top four inches of soil are removed because it's laced with arsenic. Imagine that. How many apples have you eaten?

We have been USDA certified organic since they started the process, and it's a catch 22, because their standards aren't like ours, we feel ours are higher. It's pure as pure could be.

Part of the Hippocrates diet is you let food be your medicine. The seeds of sprouts—of which we have nine different types—have energy, and when introduced to water, the enzyme is released. Wheatgrass, which is very high in chlorophyll, is also very good for your body. Sprouts and wheatgrass are two of the best foods you can eat, because they're live food. A box of broccoli sprouts, which is 12 ounces, is equal to eating eight pounds of broccoli, as far as the sulforaphane, which is the cancer fighter in broccoli.

Patience is a farmer's virtue. If you don't have that, don't do it because you will lose your mind. What we do is not easy, farming takes dedication, 110,000 percent dedication. It's good times, it's bad times, it's very, very challenging mentally and physically, but we like it too much.

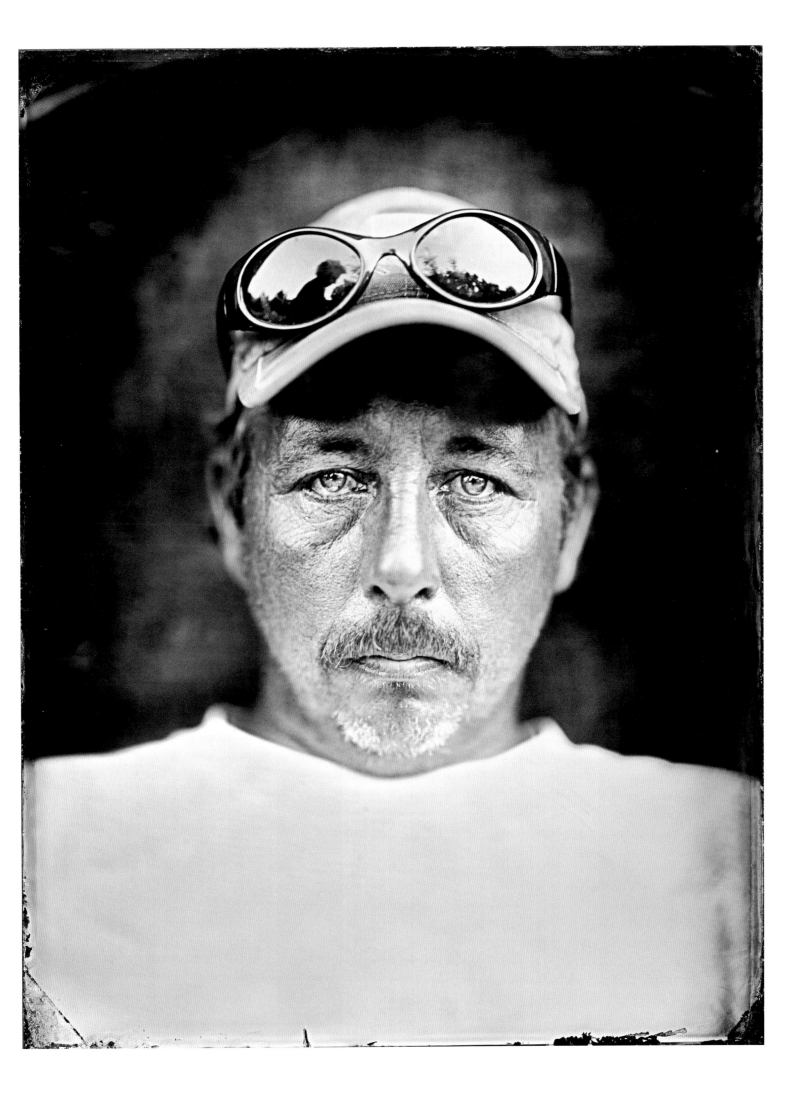

DANIEL LEADER

Bread Alone, Boiceville, NY

You know when you hear some music you've never heard before, and you're just completely moved, like, "Oh my God, what is that?" It was like that when I first met bread makers.

That was in 1979, and I was working as a chef. I worked at a bunch of fancy restaurants: La Grenouille, The Water Club, Raoul's. I worked at a place called Regine's, The Palace, and I used to moonlight with Italian bakers.

I modeled Bread Alone after organic bakeries I saw in Europe. From the very beginning, long before the organic certification was on the table, we were using organic flours. Our philosophy is to make simple, handcrafted, European-style, artisan breads.

To me organic is a process, it's unfiltered, and you are not dealing with the questions of pesticides, herbicides, and fungicides. You're dealing with food as it should be in its natural state.

People say that industrialized food is cheaper. I don't buy the argument that it provides cheap food for the masses. If money is an issue, buy a 50-lb bag of brown rice, buy dried beans, buy fresh vegetables. You can't eat any cheaper than that. Stop eating processed, packaged, corn-based food. Look at the food pyramid, there's whole wheat, bread, dried legumes, vegetables, and a little bit of meat.

We're baking 60 to 70,000 pounds of bread per week. We have three retail stores, we sell at 45 farmer's markets a week, and have over 300 outlets for our breads.

I've seen the Hudson Valley go up and down, and there is certainly a resurgence of food producers now, whether it's cheese, bread, vegetables, meats, ciders, or maple syrup. One of our focuses is to support local people whenever possible.

I've been here for 30 years now; I'm not going anywhere.

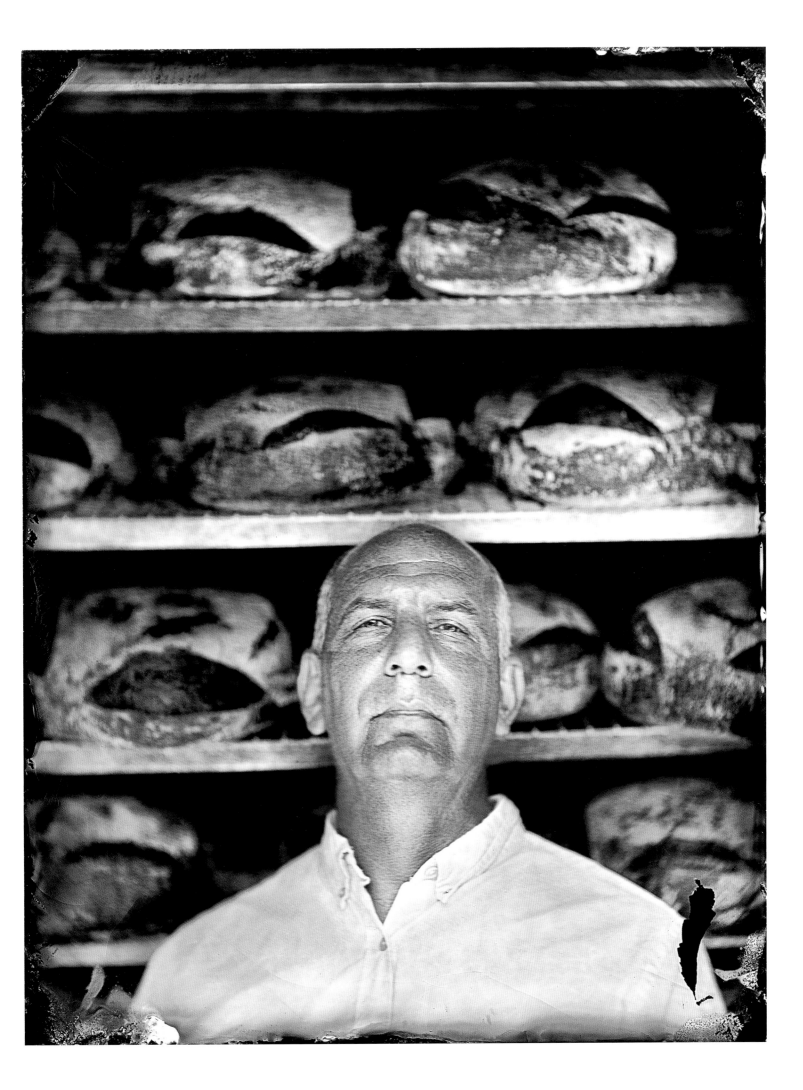

CHRIS HARP

HoneybeeLives, New Paltz, NY

An average hive has 40,000 bees. Nobody tells any individual bee what their job for the day will be, but they all know it and do it with the most absolute perfection. It's fascinating.

People call us all the time about buying honey, but we don't sell honey. My job is to keep the bees alive, because without the bees, we'd have no food. 70 percent of the trees above us would not be here if the bees hadn't pollinated them.

One of the greatest hits on the bee industry are genetically modified organisms, GMO food. I consider it ingenious—they took the gene of a trout, spliced it into the tomato plant so the tomato could handle the cold better, stay red longer on the store shelf, and become a better selling commodity. Now my bee goes to that tomato flower, brings back the pollen. Pollen is what they use as flour to make the bread to feed their larvae. Now they're feeding this baby bee the gene of a trout. They never dealt with that for millions of years; not until the past 50 years, when we have been doing all this engineering of life.

What the USDA considers to be organic and what I believe is truly organic are two different factions. Organic to me is heirloom. It is a plant that has been around for hundreds of thousands of years without changing its molecular structure. It is something that does not come into contact with man-made petroleum based fertilizers, herbicides, pesticides, and fungicides. It is something that is truly of the earth; the way the earth did it for millions of years. These pesticides were used in chemical warfare. When the war stopped they had all these chemicals, they diluted them and now they kill bugs instead of people.

Honey was finally approved by the FDA to be prescribed by doctors in 2007. Honey is used on wounds and burns because it creates hydrogen peroxide and it completely disinfects the area. It also spores the genes in your body, the regenerative genes to heal it. They're using propolis right now as one of the main studies for treatment of human HIV/AIDS. Propolis has also been found to be the sole cure for sleeping sickness. Raw honey is also used for people who have allergies because you're building your immune system to deal with the allergies that you might have.

Everything a honeybee comes in contact with is benefited in a positive manner—even when you get stung by a honeybee.

I love this work. I love the energy of the bees.

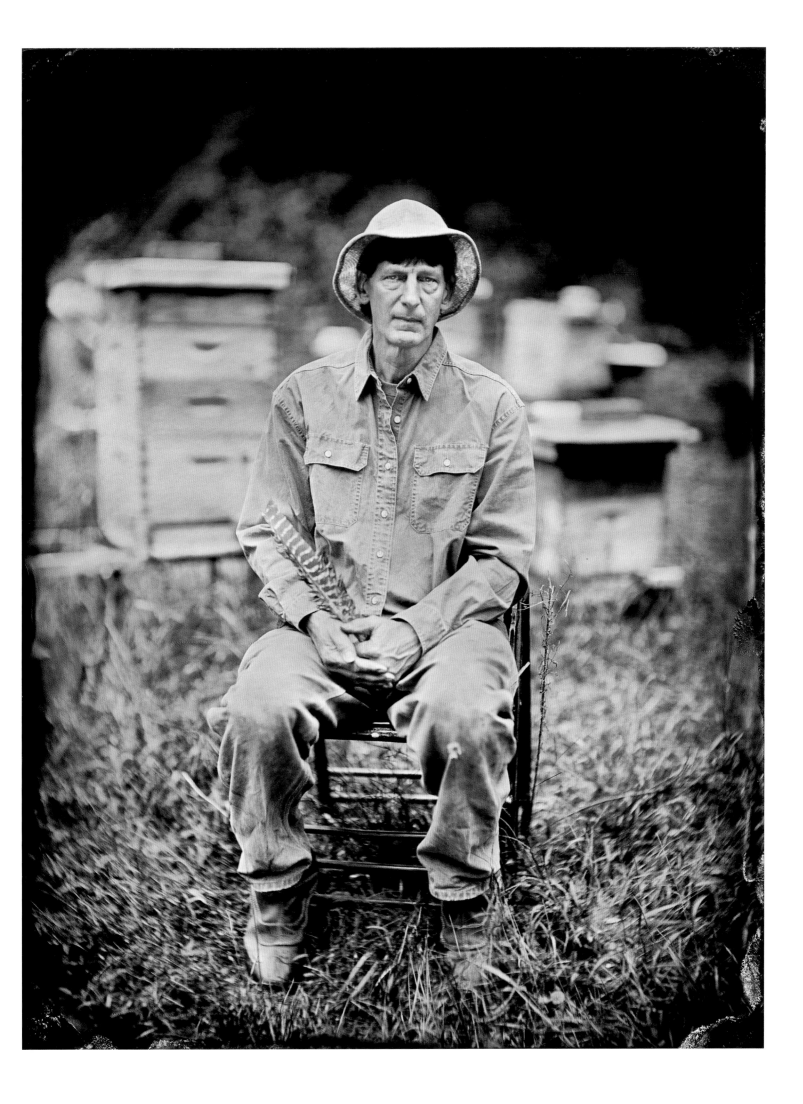

JODY BOLLUYT

Roxbury Farm, Kinderhook, NY

My summer job has always been farming, since I was 13 years old. I grew up in Iowa, and a lot of the farms needed help in the summer, so as teenagers, that's what we did. We de-tasseled corn, we sprayed beans with herbicides; I did that through high school.

My grandparents had a farm. It was sort of that classic farm story that you hear: they had an orchard, dairy cows, beef cows, they grew all their own food. They always told stories about the community around the farm and the life of farming.

I couldn't imagine working on my uncle's 1,500-acre grain farm, farming soybeans. I just didn't think it was possible to make a living as a farmer. As I got older my uncle talked about how they couldn't drink the water out of their well anymore because of all the chemicals in it. Babies couldn't drink the water anymore because there was so much nitrogen pollution.

There used to be small farms there, then they all closed and we lost a lot of the community that we used to have. After seeing what happened to the landscape, I didn't really want to go back to the old ways of farming.

Organic on our farm means that we do things in the best way possible so that we can do this for generations. The way we treat our soil, the way we treat our animals and the plants, it's something that we could go on doing for a long time.

You have to treat your soil with respect, it's not a commodity, it's something you have to take care of just like you take care of your animals. You need to take care of the people who work the land too. You have to provide for your farm workers and farmers so that they can continue to do the work with dignity and feel like they are respected for the work they do. I think you should treat your animals the way animals should be treated, and allow them to express who they are. They need to express their own inner nature.

We have chosen not to be certified because we direct-market everything to our community supported agriculture families. They can come to our farm whenever they want, to see what we do. We have a direct communication with them about everything we do here. So, we felt the certification was not a necessary step we needed to take.

I can't think of anything else I'd rather do.

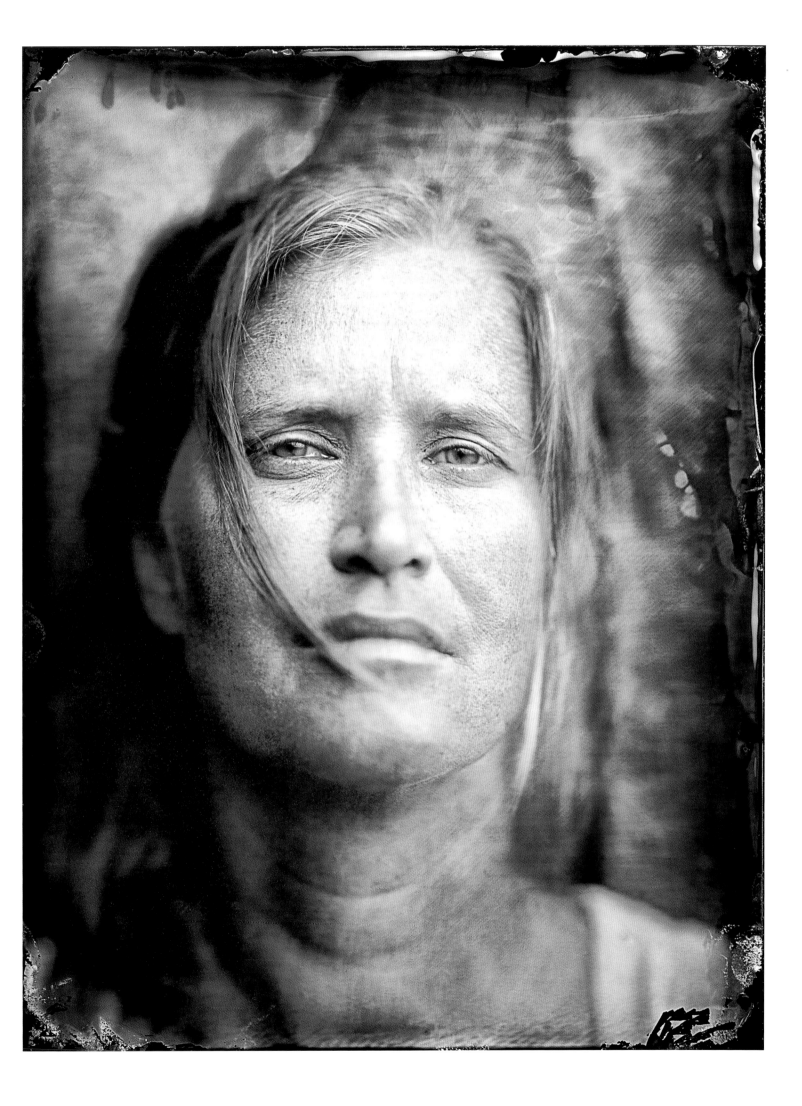

GIANNI SCAPPIN
Market Street, Rhinebeck, NY

I started working in kitchens when I was 14 years old, at first in my father's Trattoria. For me the inspiration was to be able to make money very quickly to help my family. It was a way to contribute.

The way we eat in Italy is very much a local, regional cuisine. I am from the Veneto. This part of Italy has a lot of influence from Venetian cuisine. Venice was one of the biggest ports, where all the spices would come in from all over the world, and then spread throughout Europe, so it has a very cosmopolitan palate. In Italy we have been doing good agriculture for 400 years, sustainably. Sustainability today is a big word; everybody is using it. But it has been practiced for hundreds of years throughout Spain, France, and Italy. If a crop went bad, the farmers learned what caused it. Farming was done naturally. They would use smoke to get rid of the insects. Organic has always been a big practice in Italy, and it still is, not because it's a trend, but because it's a way of life. They love the land, and they don't want to pollute it because they eat from it every day. I still have a great memory of my father's strong belief in not putting anything in the soil that doesn't belong in the soil.

When I came to the United States it was upsetting. It was upsetting because there was not much accessibility to clean, natural or organic food, as it was difficult to source or at least understand the source of the food, and of course it was expensive. Today it is becoming more approachable, but some farmers, even though they practice organic or better farming, cannot afford the organic certification.

My cooking style is very simple. We try to let the food speak for itself—minimal stuff—we don't use too many sauces. I strongly believe it's all about the ingredients. Good ingredients should never be muddled too much. The philosophy is to keep it simple. It's mama's food, but with a little bit of sophistication.

I own this restaurant, Market Street, Cucina in Woodstock, and Gusto in Poughkeepsie. I also teach at the Culinary Institute, and I've authored four cookbooks. I came to America when I was 24 years old. It was supposed to be for six months and the next thing you know, I have been here for 30 years, and I'm still discovering the bounty that the Hudson Valley has to offer. I like feeling like I'm part of a movement. It's happening and I like being involved in the process.

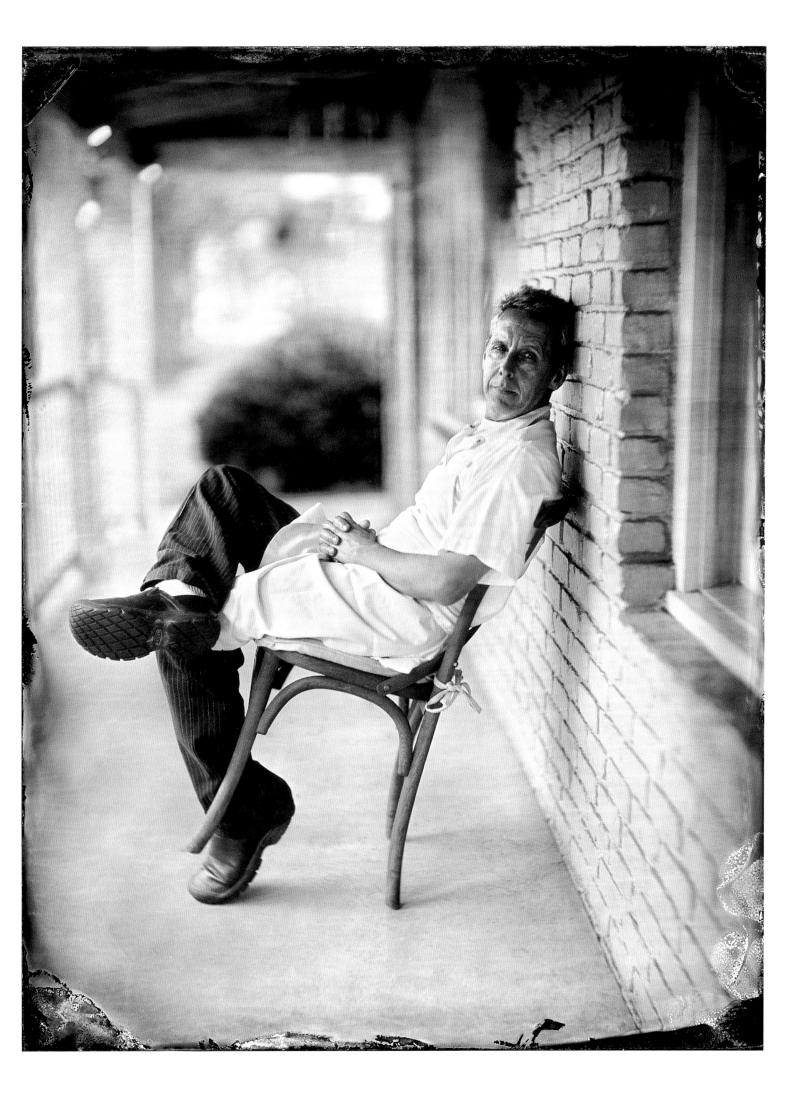

CHRIS REGAN

Sky Farm, Millerton, NY

I always farmed organically. I wouldn't have done anything else. It seems like the honest way to farm, and using synthetic pesticides or chemicals is the opposite of the way to do it. This is my 19ᵗʰ season farming. The 15ᵗʰ year at Sky Farm, and I farmed four years up in the Berkshires.

Organic is working with nature, not telling it what to do, not demanding of it things it can't do. You're allowing Mother Nature to do the hard work, and you're facilitating that. You're not introducing things that are unnatural. You're not introducing chemical pesticides and such. It's a straightforward way, and it's also management. You're doing a lot with the land, and it's your responsibility to be treating it well, so it's also husbandry. You're actually trying to make the soil better and dealing with your fields in a way that improves them.

I'm not certified. I've been certified a couple times, early on, before the federal switch over to the standards. It was expensive then, and it's more expensive now. I'm working with chefs that don't really ask if it's organic. They're not really concerned about the certification, they're interested in quality. The key is respect: respect for the product and the land.

Farming in the Hudson Valley has been great. It has allowed me to do what I wanted to do because there is enough demand for quality, locally produced, organic food. That's the thing—the market has grown every year. I'm going a 50, 60-mile radius to sell all my food. It used to be that I had to go to the city or sell through a distributor, but now I can sell it all locally. There are a lot of chefs supporting farmers now and providing us with a way to make a living. They are also providing their customers with the best possible ingredients.

It's growing every year, people's awareness of it is growing, and chefs are playing a role in that. Also, with the spread of farmers markets and CSAs, it's getting bigger.

I think the movement towards local is very omnipresent at this point, certainly at high-end restaurants. It's almost a requirement to get your vegetables locally, and now they can.

I still value the word organic myself. I know what it meant 20 years ago, and that's what I still think of it as meaning.

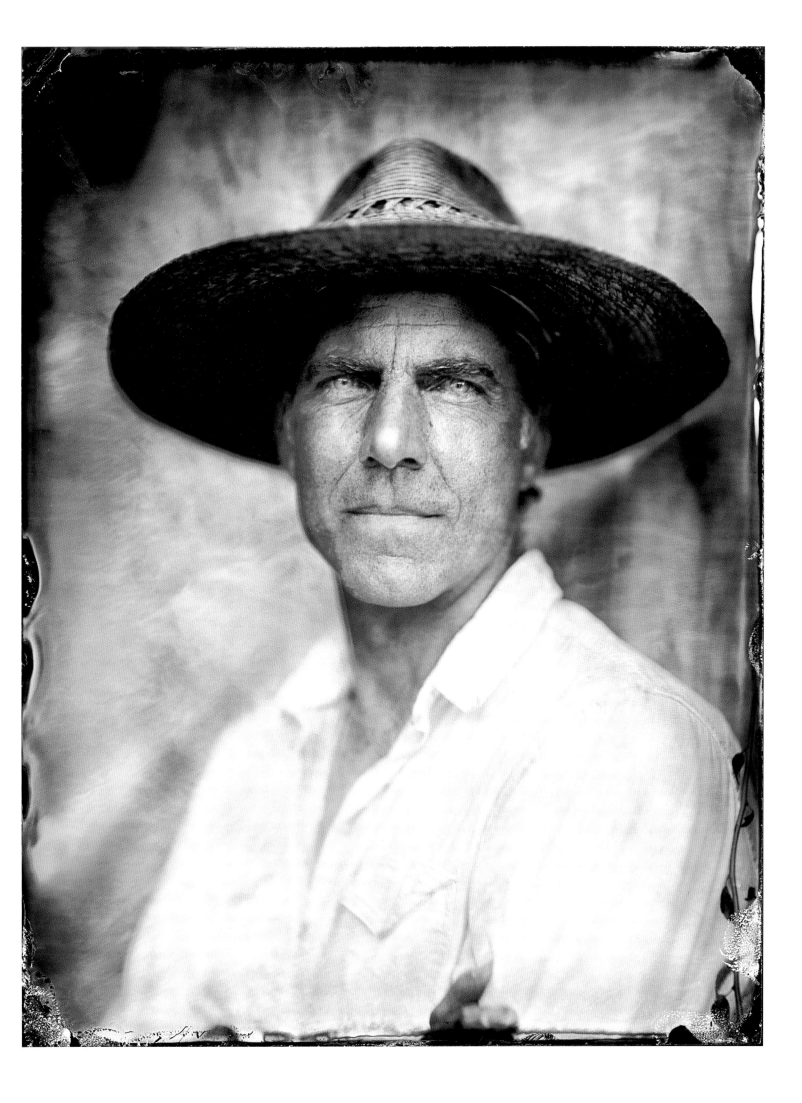

WILLY DENNER

Little Seed Gardens, Chatham, NY

I had a lifelong interest in farming, but it was something that everyone I respected advised me not to do. I had a great-uncle who was a produce grower in South Jersey, and everybody said, "Don't end up like your uncle Gene." My grandfather and great-grandfather both had big vegetable gardens. So, I always gardened from my early youth, and always had a dream of farming. It took a long time to decide it was worthwhile to do.

When we started, even our farming neighbors were just dumbfounded, and for the first ten years when I would say, "I am an organic farmer," people would respond, "Oh, that's a lot of work."

My inspiration had something to do with reconciling human separation from the rest of reality, and trying to understand that through meeting some of my own needs directly through contact with the earth. I thought that was the best way to pursue the discomfort I had; in recognizing my humanity and trying to integrate that with early consciousness of things that were hard for me to accept about humanity. Farming has been a process of trying to have insight into that, how to live humanely.

Life is the thing that defines organic farming for me, allowing life. I have the thought that all human need is met with contact with the earth. Farming came out of trying to feed myself, and the people I cared about. So, that sense of nourishment that I was looking for was from a connection with my own needs, with my human needs.

We are a commercial farm, and the organic certification has a lot to do with our marketing. But it's kind of a catchall, it has a way of creating definitions, barriers, separations, and groups. And of course there are all the rhetorical dangers that any term can take on. I like to think the process I'm engaged in is more holistic.

I love to feed people, including myself, and I love to enjoy the fruits of my labor. I look forward to things coming into season, and then on top of that, it is a wonderful gift to be involved in, immersed in the process of life.

Farming is a place where you get to directly connect with people and the social difficulty of experiencing abundance, of recognizing the ampleness of the gifts of the earth and our ability to connect with them.

My hope is to continue a life in farming. If I succeed in that, I will have met all my objectives.

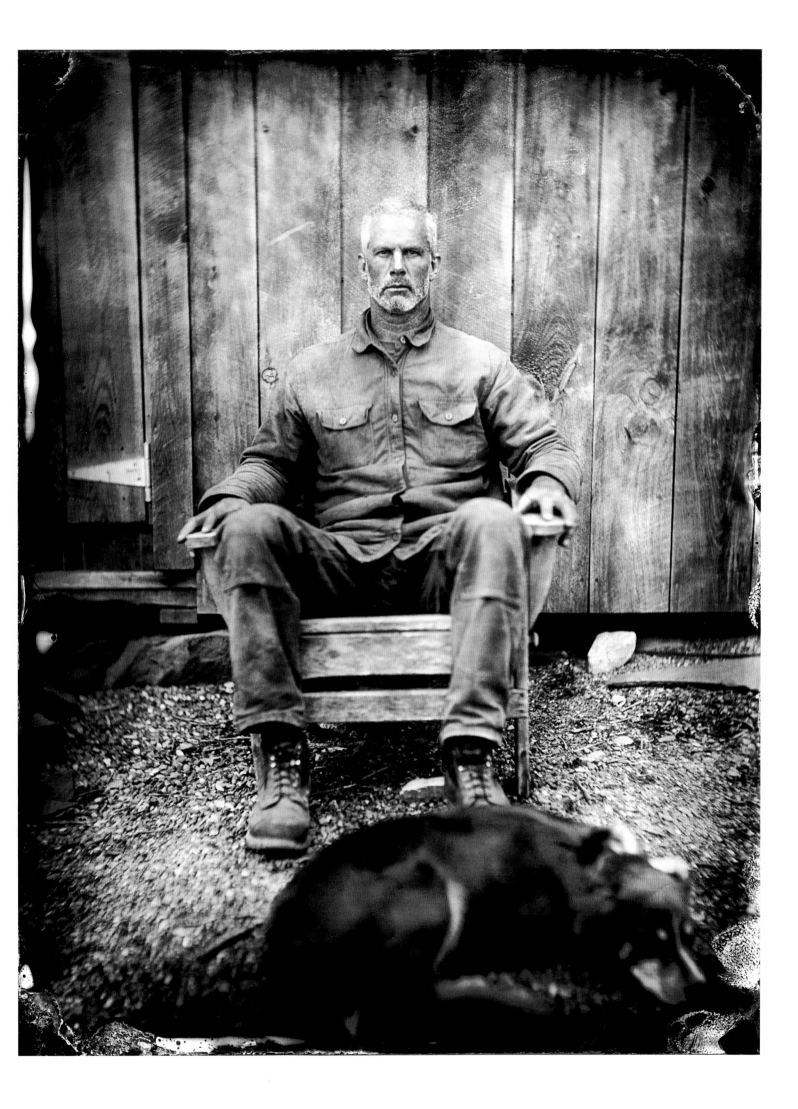

BARBARA LAINO

Midsummer Farm, Warwick, NY

Growing up we always had an organic garden. We never bought tomatoes or cucumbers and things like that in stores and supermarkets.

I studied biodynamic farming and took what I knew about organic from growing up and brought it all together. It was never a consideration to start addressing problems through dumping poisons and killing things. It was always working with the natural processes to create health in the plants and the environment around us, and to be thoroughly organic. And the flavor is so much better when it's organic.

It's kind of an artistic endeavor for me—I want it to be an art. I think there is a more elegant and graceful way for us to produce food. If you have an intention of how you want it to come out in the end, you end up with a high quality product. In general, just go with the flow; go with the phases of the bugs coming in; you don't have to spray, they will go away. Care for the land and behave in a respectful way, have enough diversity, keep it very circular, very sustainable. It works out perfectly when you let it.

When we first started we had a little farm stand and we started a CSA. I thought I was going to have to advertise wildly, convince people, market it, but we got inundated. We couldn't handle the number of people who wanted to join.

We have five acres in all, and farm about two. This year we did 36 different types of tomatoes, the same number of different types of peppers, 100 varieties of lettuces. We grow a lot of herbs, about 300 varieties. I'm obsessed with that. We also do eggs the correct way; the birds are outside and we only use organic feed, so we are not using any genetically modified soy. In the fall we run out of eggs because we don't use light bulbs and keep them locked up. There is an egg season in natural life. We also have organic seedling sales; there has been so much interest from people who are looking for plants that are healthy from the start, that aren't the big box store plants.

There is something cool about the small farm environment. It lets you do things that you couldn't do with a big farm. When I'm out there in nature amongst the weeds and bugs and dirt, it's great. I just love it.

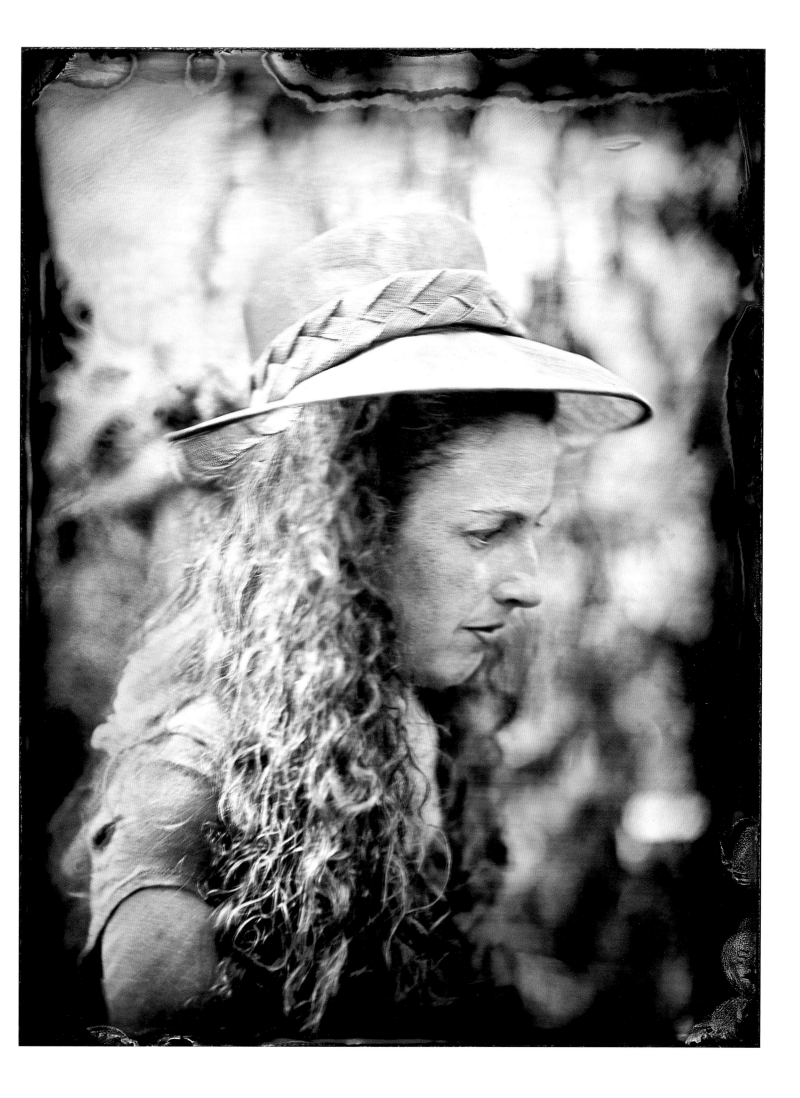

MARCUS GUILIANO
Aroma Thyme Bistro, Ellenville, NY

At 18 years old I realized what I wanted to do. In college I was reading a cookbook more than my accounting book. I always wanted to know how to cook well. And then working in the restaurant industry and seeing the action, I wanted to be a part of that. My aspirations grew from there.

While working at a country club I would see the Sysco and Kraft trucks out there every morning. Later, while working for Pierre Koffmann at La Tante Claire in London, the farmers would show up with the food. This was different then what I was used to in the states, where the delivery truck would come in, and now it's the farmer. That's really where the wheels started turning for me.

I was 28 years old when my wife was pregnant with our first child. I was overweight, asthmatic, had high blood pressure, high cholesterol, and my acid reflux was so bad they wanted to operate. It was pretty scary.

One day on PBS I saw *Get Healthy Now* by Gary Null. He was talking about detoxifying, eating a balanced diet, meditating—everything involved in a healthy body and mind. I thought, "This guy makes so much sense." I bought the book, started reading it, and when I got to page 67 everything just dawned on me. Within 90 days I lost 40 pounds, chronic acid reflux gone, high cholesterol gone, high blood pressure gone, my asthma was gone. Now I see what's happening, I'm having real food, I see the direct correlation. Now, how do I take this real food and transfer this to my customers?

I have a list of organic things that we won't serve. I don't serve organic butter, because we don't use butter. I don't serve organic sugar, because we don't use sugar. Organic salmon is totally self-regulated. People are shocked when I tell them about organic self-regulated things. They have no idea. When people read the list of organic foods that we don't serve, it raises eyebrows. It gets back to what organic means and what it should mean, and everyone has a different opinion.

If you take the word organic, it means more then just putting a seal on something and saying, "I met these guidelines." Our main goal at the restaurant is to only serve food that we would eat personally. I want to make sure I am in touch with the production of the food, and be able to communicate with the person who's producing it. Everything ethically produced, nothing demoralized, things produced from people who love their job.

If you see the sign out front it says, Support Your Local Farm Here.

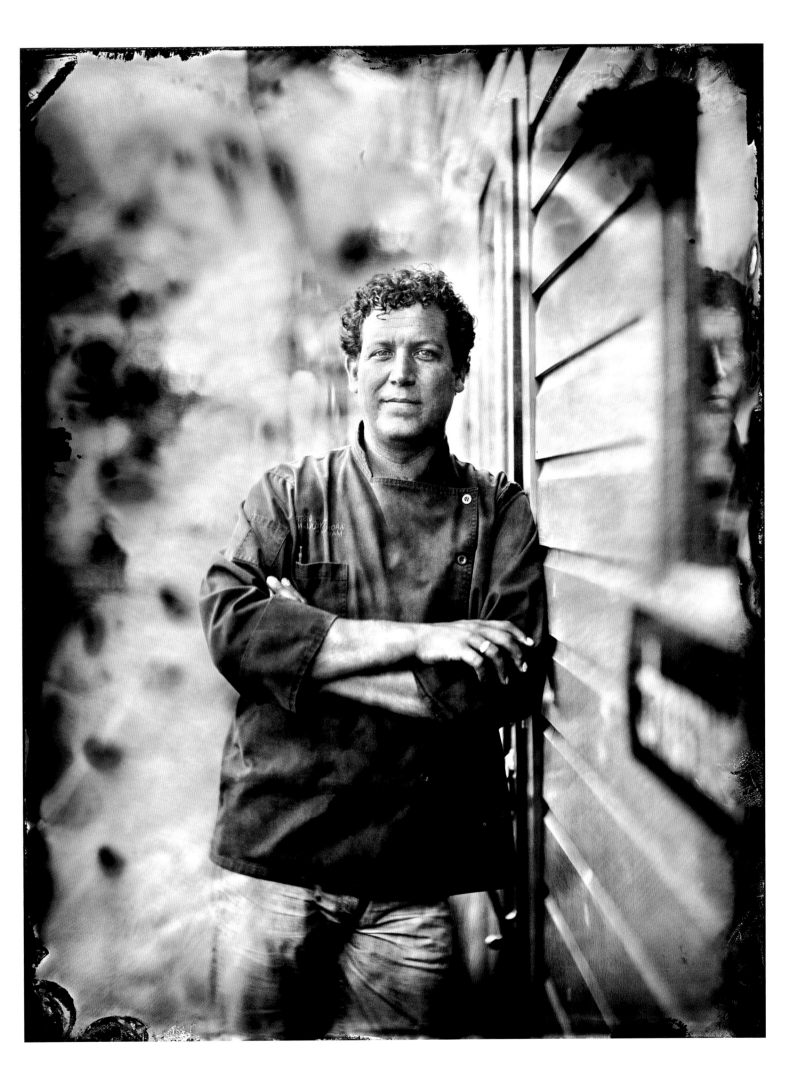

ZAKARY PELACCIO
Fish & Game, Hudson, NY

It started when I knocked on the door of Restaurant Daniel and asked if I could learn how to cook. They said, "Fine, but we are not going to pay you." It was Daniel Boulud's place in the Surrey Hotel on the Upper East Side. I would drive in every day and get to the restaurant at five in the morning. I learned how to make duck confit, I did a lot of dicing and cleaning mushrooms, all the laborious prep work. That was my real intro to the kitchen. After that I went to Malaysia, and ended up cooking in Kuala Lumpur for a year.

I'm always interested in the way ingredients respond to each other. My interest is always elevating a flavor, and creating combinations that work together, where one element heightens the other. What I discovered was the beauty and art of it, and it's such a temporal art. I can't recreate the exact same flavor that I had yesterday, I could try, but there's always a slight variation, the temperature, the ingredients change, and I may have a stroke of brilliance and cook something beautiful, and then its gone, and only a small number of people get to appreciate it.

When sourcing ingredients I like to understand the philosophy of the people that I'm working with and buying from. In the strict sense of the word, organic now, the regulation, the certification, I don't ask my farmers if that have that. If somebody doesn't have organic certification I'm not going to turn them away from my door. For me it's celebrating a community, and organic is the development of that. I respond to what I like and what feels good, and a lot of that is relationships.

Think about food that's inexpensive, and where it's coming from, and if it is supporting the community in which you live. We focus on our community, and celebrate and indulge ourselves in what is going on around us.

I think what's going on in the Hudson Valley now will intensify. There are going to be more people opening up restaurants and taking advantage of the local resources. There's so much bounty, and its incredibly fertile here. More and more people are moving up from the city, and the more people that move up, the more restaurants will open. Hopefully it doesn't become the Hamptons.

When you cook you are totally immersed in the moment, immersed in the seasons, and in your surroundings. That's what I get out of this, the total immersion in the moment.

Being in the Hudson Valley, I couldn't be happier.

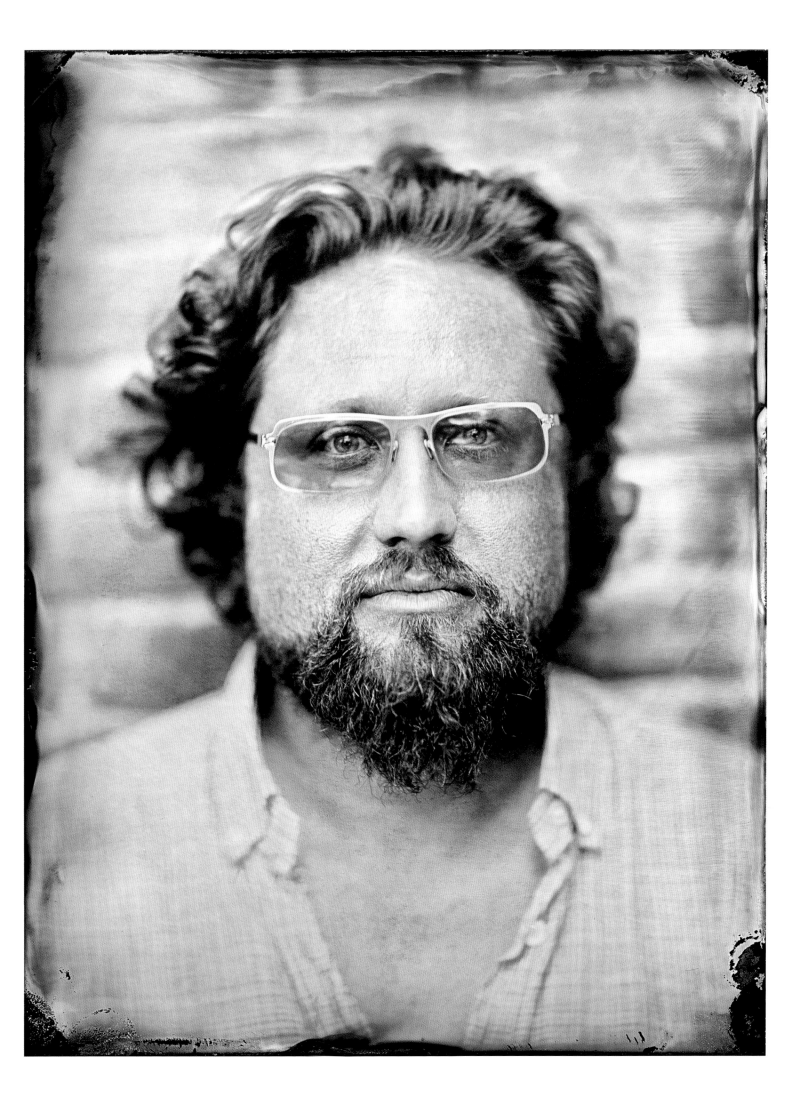

FRANCESCO BUITONI

Mercato Osteria Enoteca, Red Hook, NY

Somehow I was obsessed with cooking from a young age; I don't know what it was. Even when I went to camp, I was behind the campfire cooking. My grandmother loved to cook and I would watch her. It just happened—cooking chose me.

I grew up in Rome and my family had a farm about 45 kilometers northwest of the city. I would spend almost all my free time there. My grandmother raised chickens, and she had a big *orto*, which had all the vegetables. The shepherds would give us lamb. So, I always grew up eating food grown from home, and we knew where everything came from.

We're obsessed with food in Italy. At breakfast we're already thinking about what we are going to have for lunch, at lunch we're thinking about dinner. It's very giving, very nurturing. If I have something that is delicious, I want you to taste it too. We want other people to experience the same thing. My family used to make Perugina chocolates and Buitoni pasta. They were steeped in tradition. So, I have strong feelings about being very authentic in how a dish is represented.

The simplicity of the ingredients has always stuck with me. So simple, but so good, and you don't have to do much to them. When the ingredients are good, a little olive oil, *basta, finetto*. It's all about the ingredients. If something has been in the ground, and you get it within 24 hours, you know it's fresh, and you know it's going to last longer than everything else. It hasn't been sitting on a shelf in California for a week. When a carrot comes out of the ground, it already starts to lose its flavor. The sooner you get it out of the ground and onto the plate, the better.

I feel like organic is run by big companies. It's a term they use which I don't believe means organic. With all the GMOs, it's crazy to think what they're doing to farming. It's such a big country that at some point people thought, let's be efficient, let's carry the industrial revolution into farming, and we see what happened. We forgot the purpose of food. It's about nurturing people, making them healthy, keeping them healthy.

My favorite days are when I am running around to the farms. That direct contact, that's organic. That's the most important thing to me.

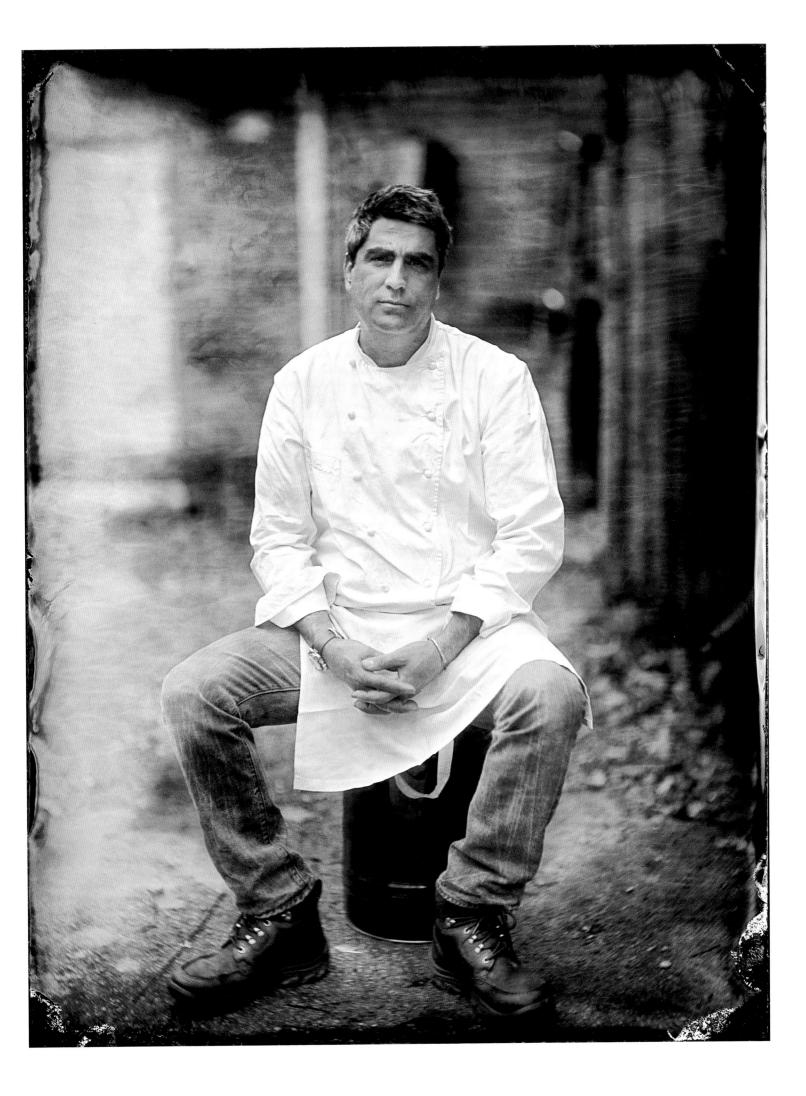

KIRA KINNEY

Evolutionary Organics, New Paltz, NY

It started as a college project, an independent study for school because they didn't have a real agriculture program. So I worked on a farm for a year.

The first farm was in Wisconsin. I grew a tiny bit of stuff, went to the Madison farmers market, and would go home with enough money to get through the week.

Now I'm growing over 100 different varieties on 20 to 25 acres. I have 30 varieties of hot peppers, 30 kinds of winter squash, 30 or more types of tomatoes, and then all these little salad greens. It's just to diversify everything.

If you're growing 100 acres or more of just one thing, you can't afford to lose it because it's the only thing you've got. So they go at it and spray, spray, and spray to take care of it. My thing is that I want it to be good, taste good, and if I lose something because of pest or disease, it's okay, because I grow so many things.

I have always farmed organic; there was no way I would do the other stuff. I wouldn't know how to do it, and I wouldn't be comfortable doing it. Using chemical sprays and stuff like that just doesn't make any sense. I wouldn't do this if I had to grow that way, I would be doing something else.

I stopped being certified organic once the USDA took over the whole thing. I was certified from 1995 up until then. I just didn't think that their interests reflected what I do. This was small farms doing things in a small way, and their idea was to make it easier for big farms to be in the game and sell across the country and the world. The same companies that have 1,000 acres of organic carrots also have 2,000 acres of heavily sprayed carrots. I didn't want to be a part of that. Now I am Certified Naturally Grown. It's small—grassroots.

When I grew up here there were a lot of dairy farms. They're pretty much all gone. The dairy guys were conventional growers and they are gone too. A lot of the new growers on small farms are organic—maybe not the certified type—that's the interest here.

Some people ask, "What if you hit the lottery?" I would just pay the people who work for me better and have a little less stress about what I'm doing. I'm not going to stop farming. I'll farm until I physically can't do it.

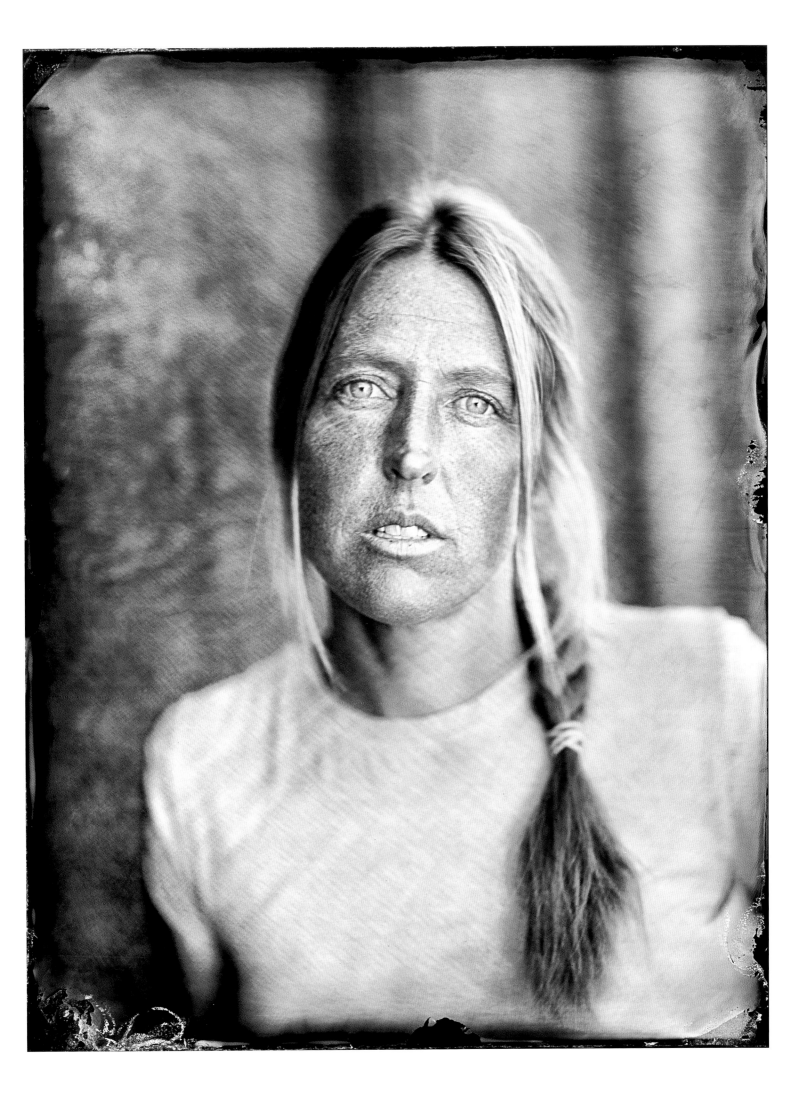

RICHARD BIEZYNSKI
Northwind Farms, Tivoli, NY

We bought this place in 1981. I was a florist before that, third generation. My grandparents opened up a florist shop in 1913. I was born in Brooklyn, grew up in Brooklyn, had the business in Brooklyn, and then we lived in Bayside, Queens.

I always had a love for animals. My great grandmother had a farm in Bell's Pond. So, as a child I would come up here for summer vacations and I fell in love with the Hudson Valley.

When I rode around the area there was nobody raising poultry. So when I started out I raised chickens. Now we have cattle, we raise pigs, but our major business is poultry—chicken is king.

My belief from way back was that we shouldn't have antibiotics in our food. We have an all-natural label, which I did many years ago before the USDA would allow an organic label, and we haven't changed that. People are welcome to come to the farm and see, and you can tell that my corn doesn't have herbicide in it for the weeds. I do that not because the public wants it, I do it because I don't want to deal with the chemicals. I'm kind of selfish that way. We should think of things in a more healthy and natural state and go for quality. That's been my philosophy, whatever animal I raise.

This industry is really into numbers, how much can you get out of an acre. It's not the numbers you do, it's the quality. I like animals, so the animals have to be raised right. I tell people, "I don't care what you want, the animal has to be raised in a comfortable way, a clean way, a protected way." I see free-range chickens in the store and can tell just by the legs that the chicken never saw the daylight, I can tell right away.

Organic doesn't mean that there's no spray on it, organic means that it's a spray that will break down in the environment. To me, the organic label means nothing. From way back I've said, "The further you are from the source, the less likely you're getting what you think you're getting." You know, everyone puts a label on things, but although I'm not organic in theory, because I'm not certified, I don't even have a sprayer. The sun nurtures my plants, the plants nurture my animals. It's a big circle.

If I decided to retire and bought a place just north of Miami, before long I'd be seeing if I could get a cow in there, in the condo, raise a couple of chickens. I know that would happen.

You can't get any better than the Hudson Valley.

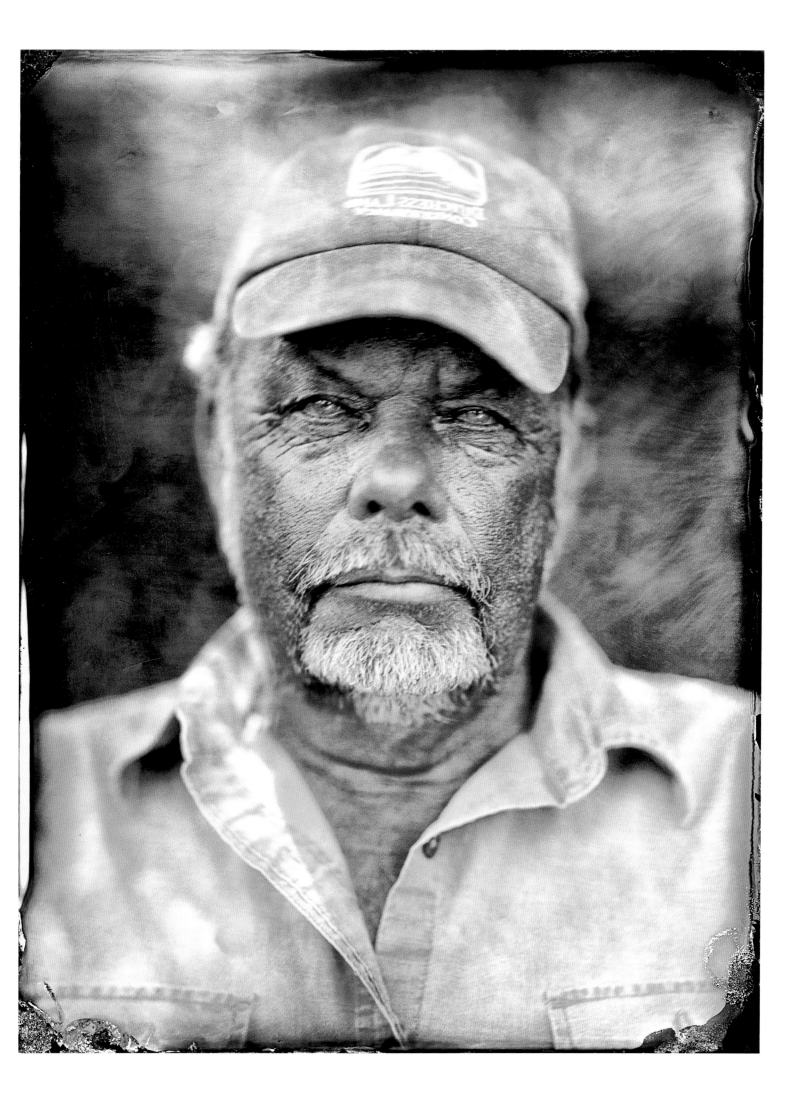

TALITHA THURAU
Edgwick Farm, Cornwall, NY

I was a lawyer for 20 years, a corporate lawyer in Manhattan, and then I had my own practice. But I was raised on a farm in Massachusetts, and I have been farming here with goats since 2005.

I realized I wanted fresh food for my children, the kind of food I grew up on. In particular, my youngest son was a picky eater, but when he went to his grandmother's house he would drink the raw goat's milk. I thought if I could get raw goat's milk into him, at least he'd be getting one good thing. I got a few goats and started making cheese because I had too much milk. I started with three and bred them. You have to breed them every year to bring them into lactation. The next year all girls were born, and then I had eight, and that was too much milk.

We try to be as natural as possible but we can't be organic and keep our animals healthy, because we'd be prohibited from giving them antibiotics when they were sick, and that's crucial to us. We don't use antibiotics or hormones in their feed in a routine manner, we only use it when they are sick. We get them out on pasture, we follow all the other rules.

We want to produce the best milk, so we give them the best food. We don't cut any corners on their diet. I say, "Come to our farm, see how we do things, see our animals, and see that they are healthy."

I think our industrial food system is very broken and more and more people are becoming aware of that and are trying to shy away from it. I think the more we become responsible for our own food, the more we realize we should eat less, we should waste less, and we should buy local.

People are very committed to local foods in our community. We sell all the cheese we make, and we sell licensed raw milk. Our milk has not traveled in a big tanker from somewhere else. The milk comes from that room and it travels 10 feet to that room, and within a day of when it came out of the goat it gets made into cheese.

Cheese making is more of an art then you realize, because the milk quality changes with the season, with what the goats are eating, and with the weather. Every batch is different. The cultures and the bacteria are always shaping the taste. People eat our cheese and go, "Wow, this taste so good," and it's because it's fresh milk. These goats are out on Hudson Valley grass, and we have Hudson Valley terroir.

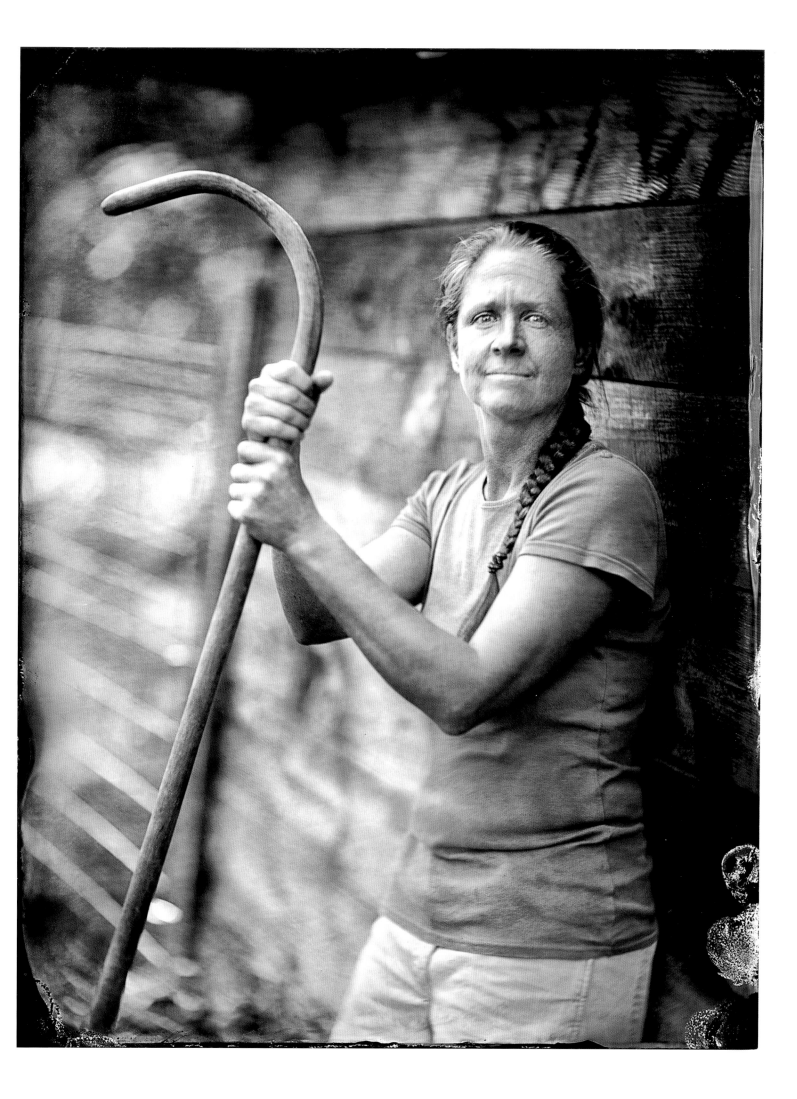

MARTIN STOSIEK
Markristo Farm, Hillsdale, NY

I have always been involved in agriculture in one form or another, either working or studying. We started farming around 1988.

I studied agriculture at Cobbleskill, and then Ohio State. I worked in Europe for a while on a farm. Then, I was in the Peace Corps for two years, in the Philippines, and did a lot of agriculture there.

My background, growing up here, has been growing organically, even though we didn't use the word. I did spread chemicals and fertilizers for a company, but I was never comfortable using that stuff. When we started farming here, we knew we were going to do it organically.

Organic is using natural inputs, manures, cover crops, and things like that, but it's also how you treat the land. It's using land and maintaining the soil biology and the wildlife in the area. Organic farming also has something to do with the markets, how you work with your customers, how you treat your help. We also take on interns in order to further that sharing of knowledge.

We are certified organic. In 1992, we did it mainly to give us another level of credibility with our customers, not that they required any paperwork, but it meant something to them.

Really, the biggest reason why I'm organic is that I don't like working with the chemicals. I don't like spraying stuff, mainly because I want to keep things in balance as much as possible. I can look at a conventional field and there is nothing happening in the soil. There are no earthworms, nothing. Then in the organic soils, there is all sorts of activity, there are earthworms, there's microbiology in there. The land is so much healthier.

I think there is a real disconnect in our industrial food system. The farmer doesn't know who the customer is, and the end user doesn't know who's growing the food. Part of our success is we always know who the customer is, and the customer always knows who we are.

Twenty years ago, the word organic had a certain stigma, it was dirty, it was buggy, and it was low quality. In the beginning we left the word organic out, even though we were certified. But the quality is actually what sold, because it was so fresh.

I went into the field the other day by myself, and said, "Man, I love this, I really love what I do." So, what more could you ask?

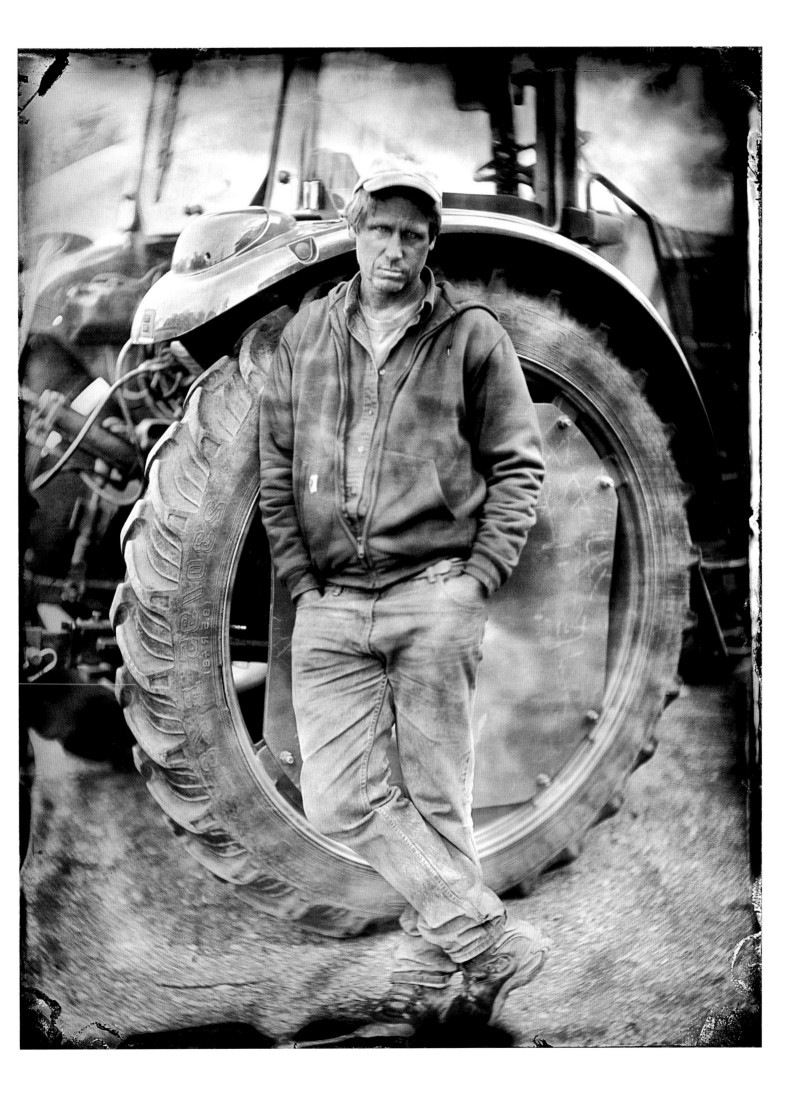

PAUL ALWARD
Veritas Farms, New Paltz, NY

During most of my teenage years I fished commercially in Alaska, but most of my life has been farming. I grew up and worked on a farm in Massachusetts for about 15 years.

We use organic methods here. I'm not used to saying that word because the government owns it. But I'm Certified Naturally Grown. It's always been our practice. Everything we do is what people think of with organic.

I think most farmers inherently just want to produce food and raise animals the best way they can, but sometimes situations dictate what they can do. Every farmer makes that decision for themselves and their land. For me, it's the way you interact with the environment, how you raise the animals and grow your vegetables. Veritas is Latin for truth, it speaks of transparency and the way we approach farming.

There are about 120 acres here. We have 18 in vegetable production and 40 to 60—depending on the year and time of year—with livestock. We raise grass-fed beef, Scottish Highland, Devon, Large Black, Gloucestershire Spot pigs, laying hens, meat chickens, turkeys, ducks, a little bit of everything.

We sell on the farm and at farmers markets. We've been working with one restaurant for about eight years now, Bywater Bistro, with chef Sam Ullman. Everyone wants pork chops or filet, but he works with the whole animal. We've done some nose to tail dinners at the restaurant.

Chefs like Sam and the other guys in your book have a different relationship with the farmer. They have always found a respect for the ingredients and they really want to represent that. It's neat when they want to respect the vegetable and flavor, and have it present itself in the simplest, truest form so that the flavor comes across.

Not every place is as lucky as the Hudson Valley. The consumer here knows what they want and they want to know where it comes from. There are lot of cool farmers doing different things up here, growing different crops and pioneering different methods. There's a real sense of community.

The one common thread among men and women who do this is that you can't do anything else. Farming is a tough business. Every day is a very humbling experience, no matter what you do or what you've learned. You have an early frost or it doesn't rain, or it rains too much, or an animal is sick—it's very humbling that way, but there's nothing else I'd rather do.

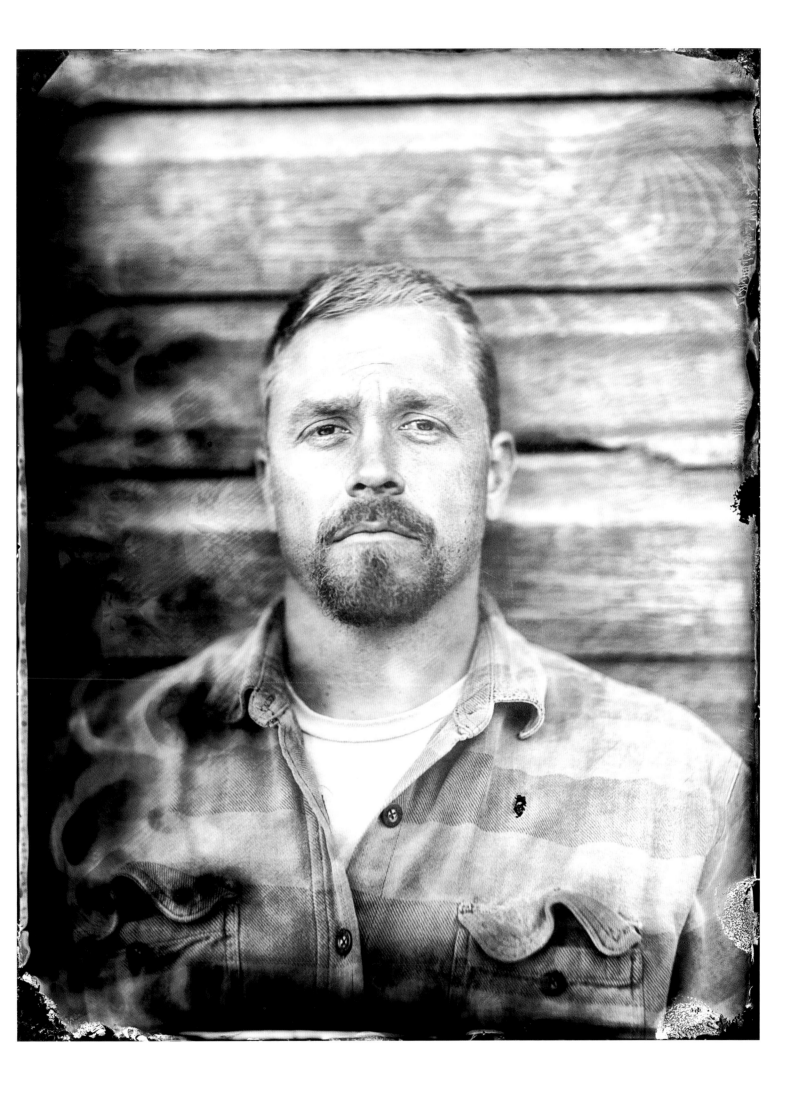

AMY LAWTON
Murray's, Tivoli, NY

I grew up eating poorly and never knowing what good food was. We had a garden in our yard, but my mother was never able to cook anything well. But I always knew these vegetables in the garden could be delicious. In Rhode Island where I grew up, I was aware of the CSAs. This was when I saw all these vegetables growing, and chickens running around on the farms. I stopped by a farm one day and asked, "What could I do to be more a part of this?" So they took me on as a volunteer and made me the vegetable washer, then harvester; I was barely 20 years old.

During that time at the farm, I started eating really well. Everything I ate was simple, but I felt so good. It wasn't until then that I realized how poorly I felt eating bad foods; not necessarily junk food, but food I thought was natural food.

I started to get really inspired by vegetables and fruits that I'd never heard of, and I began to experiment with them. Every time I made something that someone had never seen or heard of before, and they enjoyed it, it was like fuel on the fire. "Okay, lets try it again, lets do something new."

To put it simply, at this point, organic is pretentious. I feel like it's modeled to be like that, but really the word doesn't have a lot of meaning to me. If it came down to me choosing to buy something on that word alone, no way.

A lot of the things that we use here are organically raised by default. What I like to serve and what I like to see coming into my hands is way beyond organic. They are things from deep in the woods, and from farmers that would never think of using any chemicals on their food; approved or unapproved.

I look at food as energy. When you think of food as a whole circle and not just the dish you're going to make, and the execution of it, it's actually somebody's fuel. You don't want to water down their fuel with things that their body is going to have to process.

Although we work with a lot of organic farmers, I don't feature that as the type of restaurant we are. I want a farmer whose farm I can go to and talk to them about their vegetables. Organic is such a loaded word at this point because it is being run by large corporations. People don't stop to think that it doesn't have to be certified organic to be organic. That's why it's such a loaded word.

I am very driven to feed people well; I don't want to stop doing that.

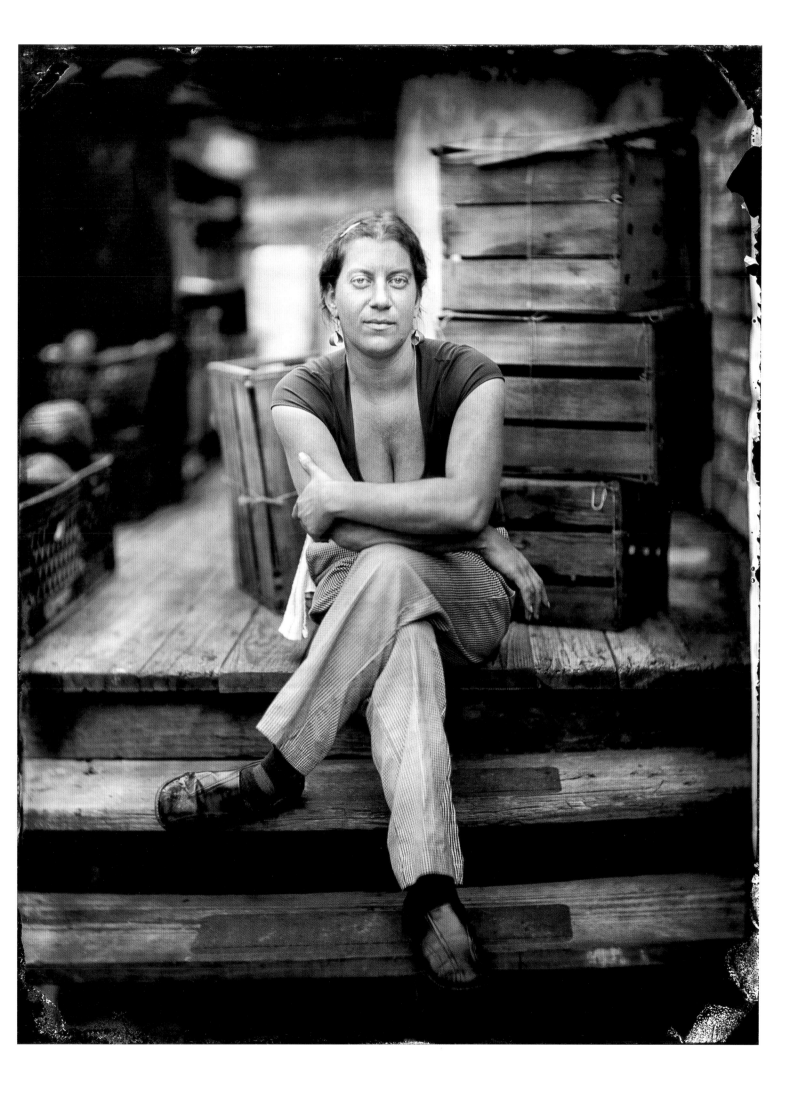

MORSE PITTS
Windfall Farms, Montgomery, NY

Since I could remember I always wanted to be a farmer. My father inherited this farm and my garden basically got bigger and bigger until it became a farm.

Since 1980, I've always farmed organic. I learned mostly by trial and error, because I found the information I was reading in books was wrong and misleading. Once, I did try rotenone. It was made from plants and was completely acceptable, but I later learned that wasn't a good thing. There are a lot of naturally occurring things that are deadly that you still have to watch out for. I decided I just wouldn't use anything, because I never thought I should use poisons on food that I was growing for myself or anybody else.

Organic is a wonderful thing—sustainable—it can support lots of people. But then, the federal government took it, twisted it around, and made it for corporations. It's even more so in other parts of the world. It takes people's farms away, or forces them to grow certain crops on it. It destroys the soil and their livelihood.

Our industrialized food system is just unsustainable. What works is when there are a lot of people growing smaller amounts of food, in a lot of places. That's pretty safe. When you have all the food concentrated on one big industrial farm and there is a glitch in the weather there are going to be big problems.

I stopped being certified when I was at a conference in California and realized what was happening. I called the farm and said, "Take organic off our sign."

We don't use any chemical fertilizers, pesticides, herbicides—nothing. You find out what plants need, you pay attention to them, and grow lots of different things. The plants will grow if you let them. By spraying and killing all your beneficial insects you are making a larger problem for later.

My favorite way to explain farming is, "A farmer wins the biggest lottery there has ever been, trillions of dollars, and media from all over the world are there pointing cameras at him asking, 'What are you going to do with all this money?' The farmer goes, 'I'm just going to keep on farming until it's all gone.'" That's the way it works, farmers love farming, they love producing food.

I just want to keep farming.

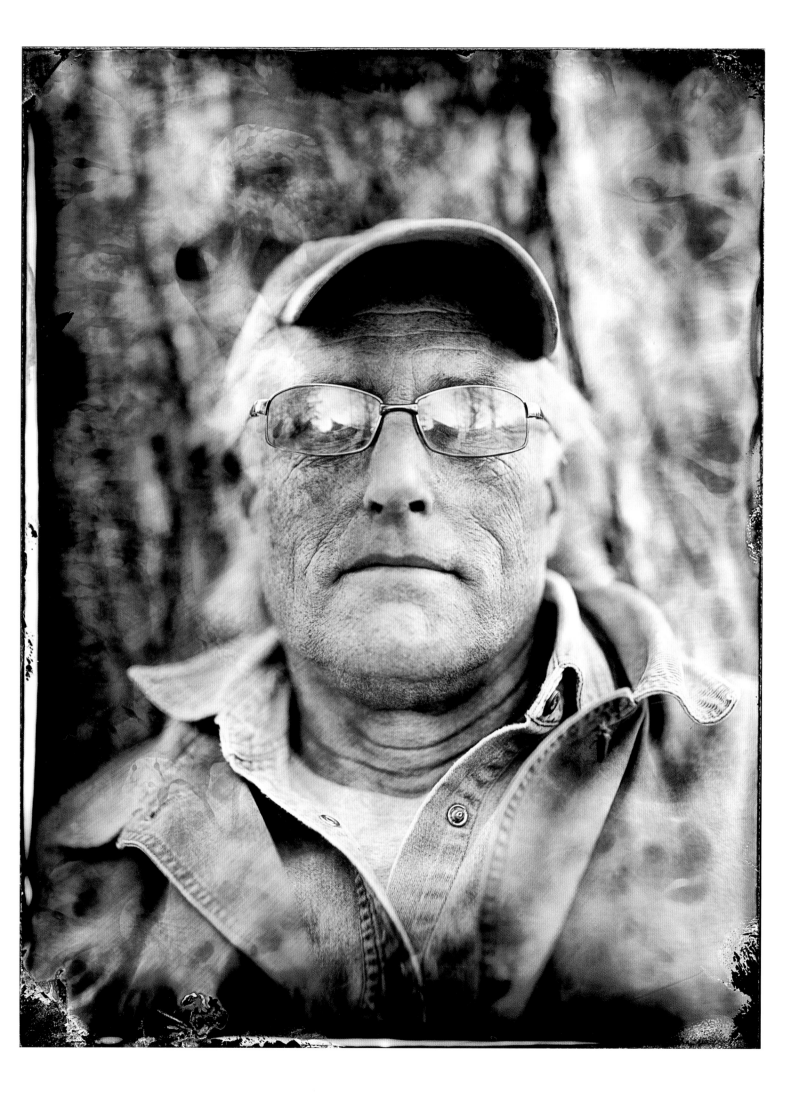

SAM WILDFONG

Obercreek Farm, Hughsonville, NY

I fell in love with the physicality of farming, and not just the idea of growing food.

Organic is a lot of healthy growing, it is building community, building the soil, it's building deep roots; whether those are deep roots in the community, or with your plants. It's more of a holistic take on food. Hearing the word organic I think of something way more wholesome, whole foods, being nourished, and whole people. We use organic practices here, but we are not certified organic. We rely on the fact that our customers know us.

To produce healthy food you have to start with someone who is dedicated to producing healthy food. Someone committed to growing organic, mindfully grown food, natural, whatever you want to call it. Growing healthy food you have to start from the soil up, you have to know what capacities your soil has. We are really working to build the soil and to grow healthy nutritious food, and that means that we are not putting any chemicals on the ground or the crops, so that when people ingest it, they're not getting any of that.

Being certified organic is a lot of paperwork and it's a lot of money, and we don't have the time to do the paperwork or the money to spend on it, and we don't need it for marketing purposes. Usually when we are selling our produce we're there to explain it.

These big 1,000-acre farms aren't going to last. I think they have a lot of changing to do because of their monoculture. It's not diverse, we need diversity to sustain ourselves.

Every day is a new thing, it's challenging, that's what's exciting to me and that's why I do it. You have to know your land, you have to approach every crop and every situation like, "What can I learn from you first?" You have to be humble every day. It's the hardest thing I have ever done, not only physically, but I have never challenged my brain as much.

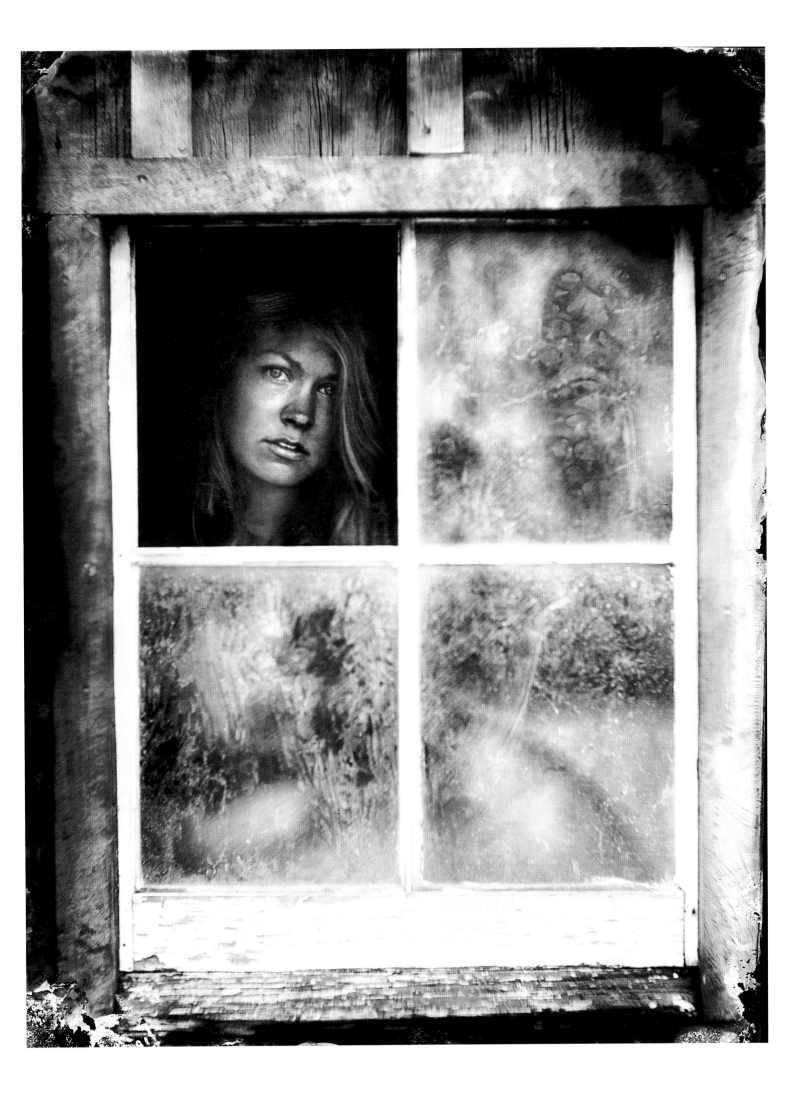

KEN GREENE

Hudson Valley Seed Library, Accord, NY

When I started this project I was a librarian at the Gardiner Library. The seeds were a side project that was focused on saving local, whole varieties, and also teaching people how to be seed savers.

I started thinking about seeds the same way I was thinking about books and information. There are all kinds of stories and ideas, imagination and information, and genetic stories—which are sort of the nonfiction of 12,000 to 15,000 years of co-evolution with humans. So, when you're planting a seed, you're growing that genetic story. And then there are all these other stories: there are anecdotes, there are myths, there are tall tales, there's romance and tragedy, and the history of all these stories that come with the seeds.

I think there are a lot of misconceptions about the word organic. Sometimes I get a negative reaction, "Oh that's USDA, that's the government, we can't really trust it." But when it comes down to it, if you're certified organic, you are using practices on your farm that are better for the soil, better for the water, better for the planet, and better for people's health.

It's much more challenging to grow organically, and it's more labor intensive. I feel there should be a lot of respect for farmers who are committed to using organic practices, whether that's certified organic, Certified Naturally Grown, Farmer's Pledge, or whatever it is. I don't care that much about the label, but for us, for seeds, it was important to have the label because certified organic farmers who are growing food for people are supposed to do due diligence in finding certified organic seeds, and there've been so few choices out there for them.

In the seed industry there aren't the same regulations for chemical applications as there are for food crops, because they are not directly consumed. The seed industry is actually using tons and tons more chemicals. It's a much more harmful farming process—for the environment, for our health, and for the future—than chemical agriculture for food.

For me, the story of genetic engineering is a story that I don't think should be in our backyards or on our farms. When I look at seeds, I look at each seed as a living organism. The way we grow and process seeds, everything is done by hand. We are caring for seeds and their life in a way that when you look at these big seed companies, whether genetic engineering or hybridizing or whatever, they're viewing seeds purely as a commodity, as inanimate.

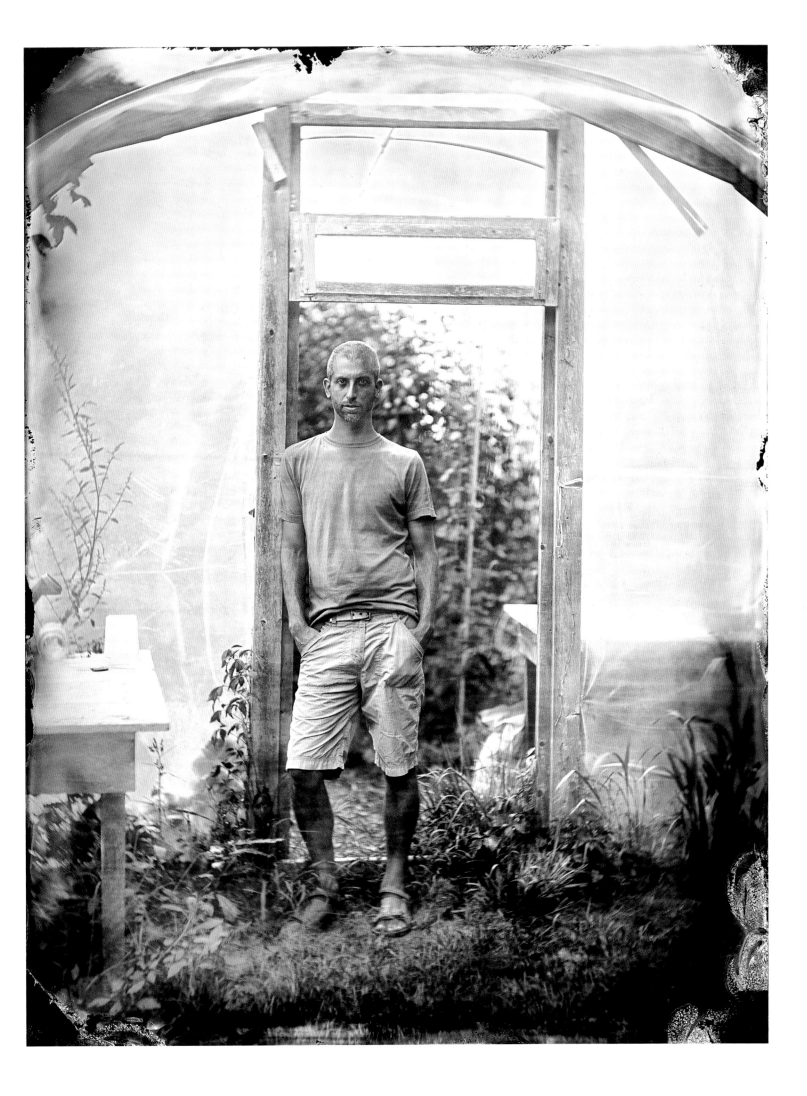

STEFFEN SCHNEIDER

Hawthorne Valley Farm, Ghent, NY

I've been a farmer for almost 30 years now. I was going to become a vet, but then a presentation by a biodynamic farmer in Germany convinced me that I actually wanted to do agriculture. I got my degree and have been farming ever since.

As soon as I decided I wanted to farm there was really never a question; it was going to be organic or biodynamic agriculture. Nothing else does justice to all the living creatures that we work with in farming. I'm glad I was never put into the paradox where you deal with living substances and you create food which sustains life, then you have these toxic things on your farm that kill. It doesn't make any sense.

The cosmology of my personal view of life and evolution is very much influenced by Steiner's view. Producing healthy food is about respecting and recognizing the integrity of all living systems. I think the art of the farmer is to try to orchestrate all these various realms of nature—the mineral realm, the plant realm, the animal realm—and compose your farm in a way where they are harmoniously interacting and creating, you could say, a symphony.

Really for me, at the base is what Rudolf Steiner calls a "farm organism." A farm has organs like we have organs, and they all make sense in the wholeness of the farm. Having that as a goal is what has driven me and has become the base for growing healthy food. Once you can see the world in larger strokes, you realize that what we see with our five senses is not all of reality. When you get a feel for that, then anything other than organic farming doesn't make any sense.

Hawthorne Valley Farm was started 40 years ago by a group of educators, farmers, and artists. They felt there was an inherent synergy between agriculture, education, and the arts, and they created a community to play out these dynamics.

The farm encompasses 400 acres. We are very diversified and mostly grow for our CSA groups, which have about 300 members. We also have 60 cows and we grow all of their feed on our land.

The local food movement in the Hudson Valley is very much based on the original organic principals, and is becoming tremendously vibrant. We are very fortunate in this part of the world to have some of the best markets. It's very unique farming here and it's really a privilege to farm here.

I think I have the best job of all jobs, because you get to work with nature and you get to work with people. Farming offers you that. It's direct, it's real, it's about as real as it can get. I think it is just beautiful.

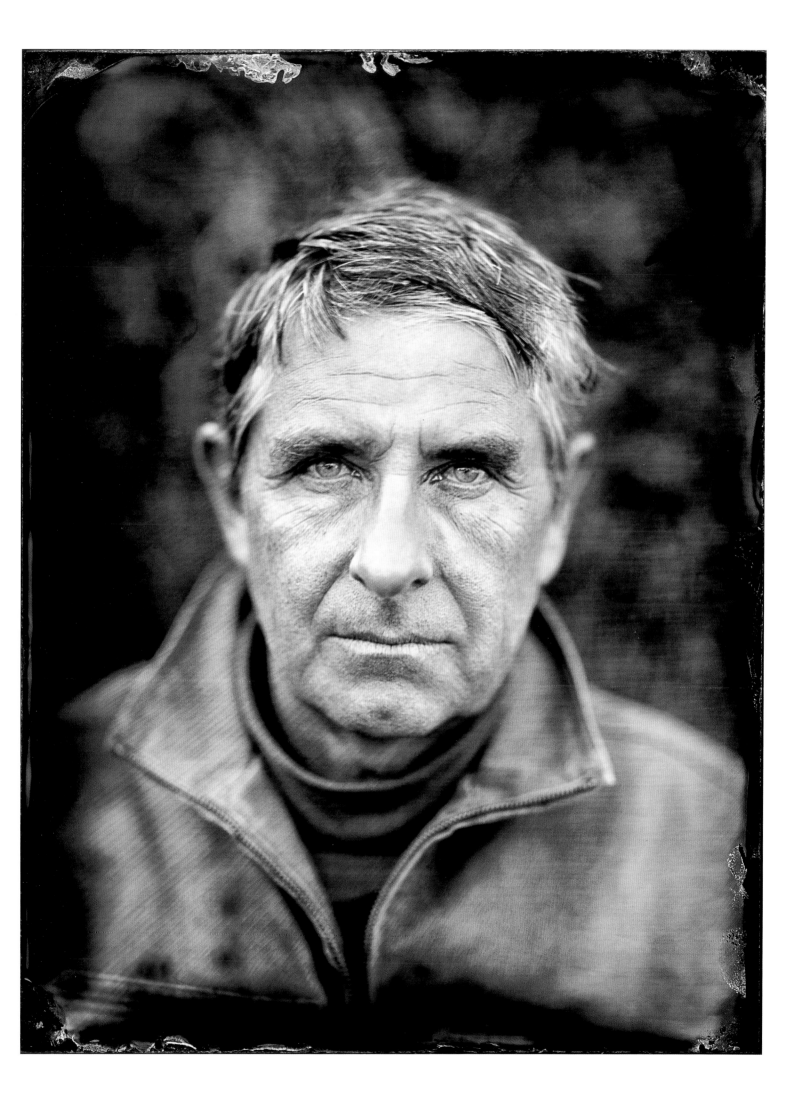

JAY UHLER
Peace & Carrots Farm, Chester, NY

This is our first year farming here. I felt farming was something that connected me back to the land, and something I could do with my hands and produce something. I was looking for something to do that was outside, and I wanted to do something I felt had value to it, something that I could feel was real work and feel that it had meaning and purpose to it.

I don't really understand, as a farmer, how growing something conventionally even makes sense. I feel like farming by spraying chemicals on your plants just goes against the whole thing. I don't understand how you can be a steward of the land, and taking care of it, and then poison everything you don't want here. It doesn't make any sense. I don't see how you can be a farmer and not do it organically.

Organic is when you plant something in the ground and you don't mess with it. You just let it grow and it comes up. You don't need to add anything to it, just sun and water, and care for it. Just get out there and tend to the field, pull out the weeds, and do all you can without messing with the genetic structure of anything.

Anything that has to do with the meat, dairy, or egg industry is really frightening. I don't like that it's so hard to get vegetables that taste like anything in the supermarket. I haven't eaten tomatoes in years, because every time I get one, it's this pinkish, grainy matter, and it doesn't really taste like anything. I don't like that vegetables aren't fresh, and have no flavor, and I don't know where they come from or what is done to them to get them here. When I think about tomatoes being picked when they are green and sprayed with gas to make them look red and ready to eat, I don't really get that. I'm glad I can play a part in separating myself from that. I'm not trying to change the world or anything, but I know that I do something that works and doesn't do anything negative to the environment or economic structure, or anything negative to my community. I like feeling good about what I'm doing.

It's just awesome to be out in the field, working, being able to eat fresh stuff—that feels so good. You get to work outside all day, play in the mud, eat the best food that you can possibly eat. You get to look back at the day and see that you did something useful for eight, ten, twelve hours, or however long it is. It's hard, and your body feels tired, and your skin is burnt from the sun, or wet from the rain, but you feel that you accomplished something and don't feel like you wasted any time. Every day after I finish work, I feel that it was a good day.

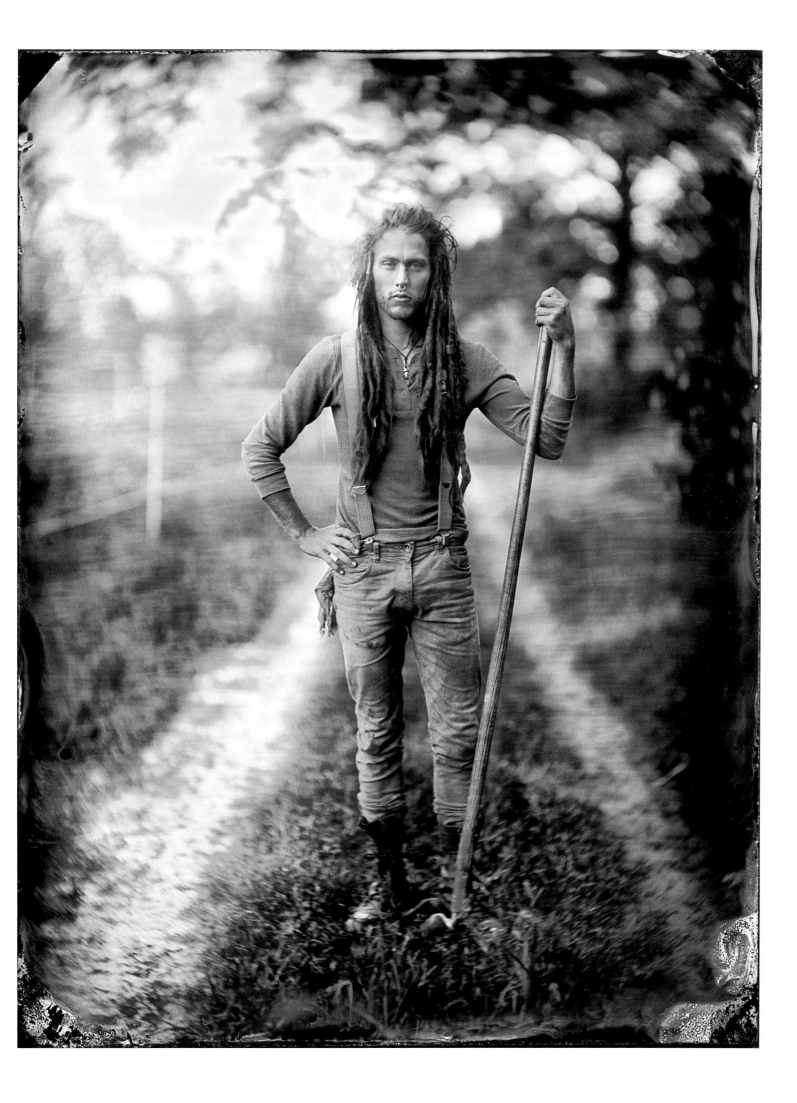

JOHN NOVI

Depuy Canal House, High Falls, NY

While I was going to school I worked in my parents bakery. Then I bought the Canal House in 1964, and opened in '69. I've been here about 45 years now.

My family is from the south of Naples. Before I opened, I spent a year in Italy working on a farm. I would wake up at four in the morning to pick peas and tomatoes. It was a big tomato town. Then I went to work in four different hotels in Sorrento.

Pretty much from the very beginning I was working with farmers. I tell the story of going up to Davenport's fruit stand and discovering four yellow tomatoes on the shelf—they're low acid and I really like them. So, I went to Davenport's Farm, and also Gill Farm, and asked if they could grow yellow tomatoes the following year. I said, "I guarantee you I will buy a case a week," and that was the beginning.

The farm scene around here wasn't great back then. I was also getting things out of the Catskills. A woman by the name of Annie Farrell was probably one of the first people to grow miniature vegetables and lettuces, and there was also a guy up there growing mush-rooms. They would always go to the New York market, and on their way they would stop by here because they knew I would buy from them. I never refused any farmer that came to my door.

I won a grant to do a video on the history of specialty farming in the Hudson Valley. It starts out with cows being loaded onto trailer trucks. That was when the government bought out our local farms; this is going back about 25 years. It was the alternative farms that had given up their cows and were then starting to grow vegetables. Many of the farms did that, but many of them sold, because they couldn't afford the taxes on their land. It was a terrible happening during that time.

You know, I really never got too involved in looking specifically for organic, because I know it's so confusing. Maybe eventually once the air clears and what is declared organic is really organic, then maybe I will seek it out. But there are people locally that I'm buying from. What I've done on our menu is state that I purchase from farmers that are members of the Roundout Valley Growers Association; there are about 80 farms involved, and many of them are organic.

I have worked with over 300 students from the CIA doing their externship here. The taste of the food is important to me, but the line and design—what the plate looks like—is also extremely important.

Cooking is an art to me.

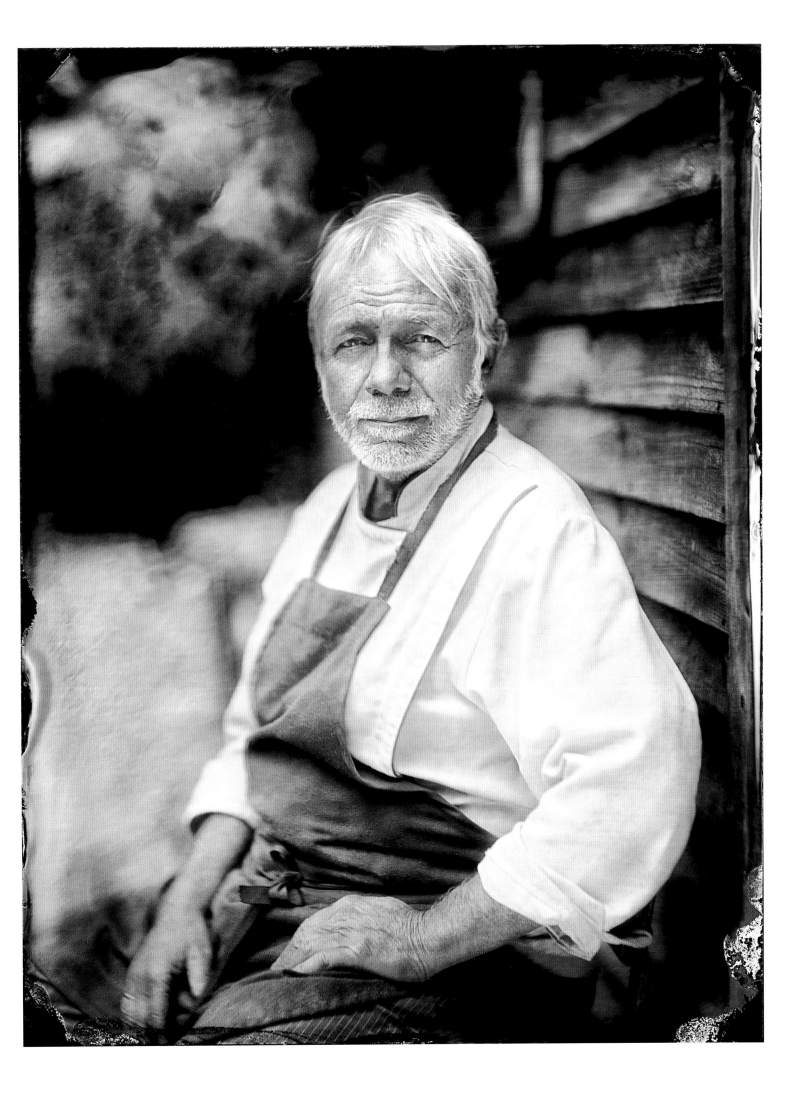

KELLY O'HEARN
Hawthorne Valley Farm, Ghent, NY

My dad's family had a farm; they were growing conventional corn and soybeans. Whenever I went there, I thought, who would want to do this? I never thought about farming then.

For 25 years I had a career as a psychiatric nurse. When my partner and I both turned 40, since we both liked to garden and we really wanted to get some land, we said, "Lets go apprentice somewhere, so when we find land we'll know what to do."

I had been reading Steiner and his philosophy for a while, so that's what inspired me to get into farming. I started apprenticing at the Farm at Miller's Crossing and Roxbury Farm. I did that for three years and then Hawthorne Valley needed someone for winter milking, and I just really liked it.

I've always been interested in natural processes. That is what really attracts me to organic farming, and particularly biodynamic farming. You really have to pay attention to what's happening. You have to look beyond what you can physically see to understand the natural process. To me, it's the difference between biodynamic and other kinds of farming, but it's also the difference between organic and conventional farming. In conventional farming you're just putting a band-aid on things, you're not dealing with the situation that causes that symptom to happen. When you're treating bugs or a disease, you're only dealing with the symptom. A biodynamic farm looks at a farm as a whole thing or being, as opposed to just vegetables and animals. It's looking at everything and the processes behind it. The interesting thing about farming is it's a living process. You never know what's going to happen each day.

A quote that comes to me is from Dominic from Moon in the Pond Farm, when someone asked him to compare organic agriculture and conventional agriculture, he just said, "Look, at some point in your life you just decide you don't want to put any poison on the land."

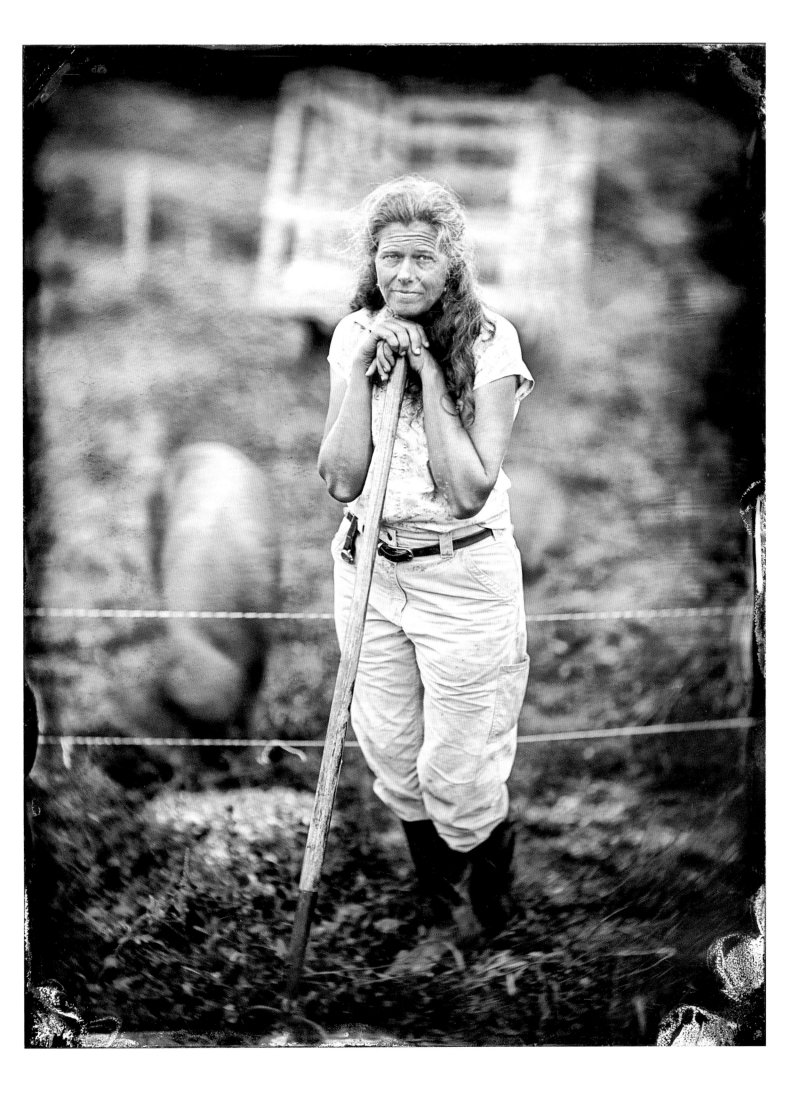

RICH FOCHT
Hummingbird Ranch, Staatsburg, NY

Bees always fascinated me. I remember going to a fair and seeing this guy with a gazebo screened in with bees in it. I begged him to let me in to see, but he wouldn't. Ever since then I've been fascinated with them.

I was born down in Yonkers and I never liked the city. I remember I was five, six years old, and every Saturday morning *The Modern Farmer* was on TV. I used to get up at five o'clock in the morning to watch it.

To me, the word organic means it's grown naturally, not using any process or adding any chemicals. You're letting it take its natural course.

I went out and bought a book on beekeeping, I learned everything from there. When I was putting the first package of bees in, I had Debbie sitting in the truck with the phone ready to call 911 just in case, because I didn't know what to expect. There are like 3,000 bees in the package.

I could certify my honey, but think about it, a bee will travel 3 miles from a hive, that means that every plant, every bush, every piece of grass has to be tested to see if it's ever had chemicals on it. I have hives all over the place. I can't afford to do that.

Commercial beekeepers, migratory beekeepers, travel from place to place. They'll put the bees on your property and fertilize your apple trees, your blueberries, but they also put it on squash, and pumpkins, things like that. So, when they put their bees on plants that don't have any nectar, they have to feed them, and they feed them corn syrup. It's tough on the bees, it really stresses them out. It destroys the quality, and they die really quickly.

Occasionally people ask if it's organic. I think a lot of that shift is gone. I'd say locally grown is more important than organic.

The bees are amazing. You always learn something from them.

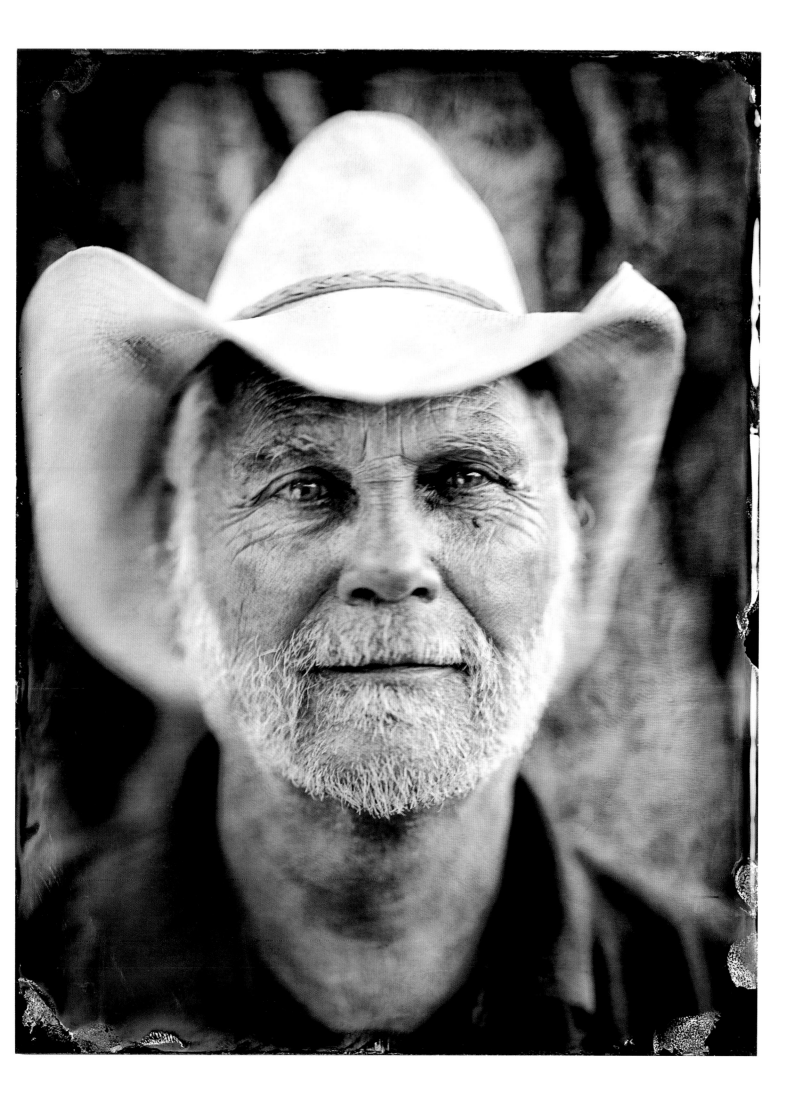

ETHEL BARONE

Red Hook Farm, Red Hook, NY

When I lived in the city as a kid, I always liked growing things. On the windowsill, I would try to germinate apple seeds or whatever else I was eating. It was always in me, I just never had the space.

When I got this place, I was like a kid in a toy store. I was like, "Whoa! Where do I go first? There are stones, there are trees, there are woods, and there's dirt, too many things to play with." It was so much fun.

I like small farming because you can do things humanely. You can do things that are not as harsh on the soil, and you don't have to use all those chemicals—the pesticides and herbicides. In the beginning we tried using pyrethrum and it didn't really work. We used to pick off the bugs. I just didn't want to eat anything that I sprayed anyway. Early on I decided, let me see what grows well without spraying, and why it is getting these bugs, and what I can do to prevent it.

People know me. They know I won't sell anything if it's sprayed. I just can't see doing it. I would rather buy it from the store; it's cheaper. Why do it if you're going to spray?

Herbicides really spook me. I grew up in the age of Agent Orange, and boys that came back from Vietnam would get cancers. It was horrible. For many, many, decades the government denied that they used anything dangerous. Now when they say anything is safe I question it.

I think genetically modified foods are dangerous. They are not doing enough studies on it. We raise our meats, and for me to feed my animals stuff that's genetically modified, or produces a toxin so that weeds don't grow near it, that really bothers me. I don't like to feed it to my animals, because eventually it's going to get into me. Common sense tells me that if you can kill a bug with a pesticide—and they are so hard to kill—then it must be doing hell to us.

Almost every day I see a different insect, or amphibian, or animal that I've never seen before. So, my mind is always getting all these wonderful treats. I smell something different every year. Oh! The hay is getting cut. It's like endorphins. Could they bottle this? The smell of sweet hay—there's nothing like it.

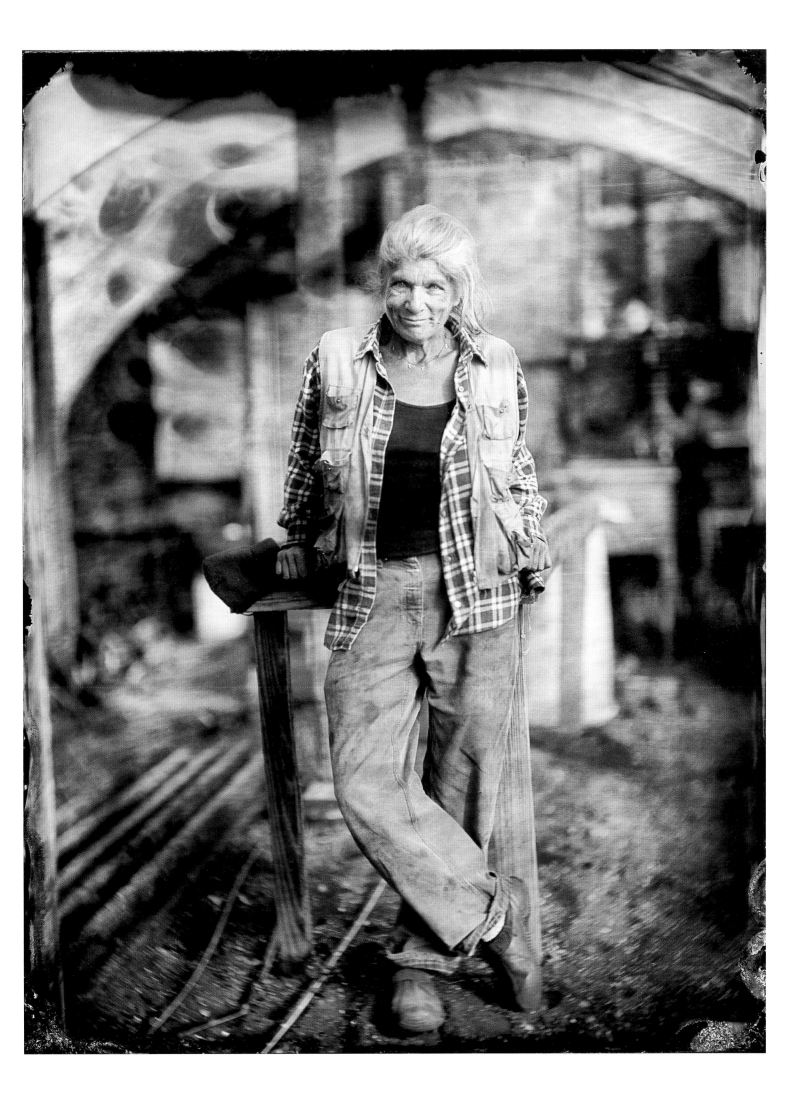

PETE TALIAFERRO
Taliaferro Farms, New Paltz, NY

Since I was a teenager I've been working in the industry. When my wife and I bought this farm in 1995, we had already made the conscious decision that whatever we did, it was going to be organic.

Up to that point, I worked in the commercial production ag-industry on a managerial level for several large farms in the valley. That's where a lot of my experience came from. I worked for some really great farmers, and learned a lot. I got out of commercial production farming and worked in the irrigation industry for a big outfit out of Michigan. I was in charge of Eastern New York State and Northern Pennsylvania.

I sold an irrigation system to a fellow named Jackson Baldwin down in Marlboro. He had this very interesting little farm. It was very diverse, and at that point, around 1992 when I met him, organic was just starting to come on the rise, and it was just breaking out of its bottom grassroots. He was my inspiration to take a real hard look at what we are doing with agriculture and where agriculture was going. He is an amazing man, at nearly 100 years old he is still farming. That's how I got into the whole organic thing.

We are USDA certified. It's really about caring about what you do, how you do it, and how it affects people. By leaving out the chemicals and things that aren't any good for the environment, or us, there is a whole holistic picture. You're trying to maintain the loop that goes on with us using the land, and us giving back to the land.

The organic movement in the Hudson Valley is definitely spreading and catching on. Even the conventional guys are getting away from herbicides and doing more cultivating and they're trying to be more conscious. It's here to stay. It's not going away.

I would like to see people who run CSAs do as good a job as they can to make their customers more aware of what farming is all about: the trials and tribulations, the realities of farming, the science, and business of farming. The more people know about it, the more they are going to care, and the more they are going to want to buy and support local.

I love growing food. I love the interaction with the people. I love the fact that we are doing something really constructive. We're feeding people and trying to keep the land healthy.

Our footprint is a good footprint.

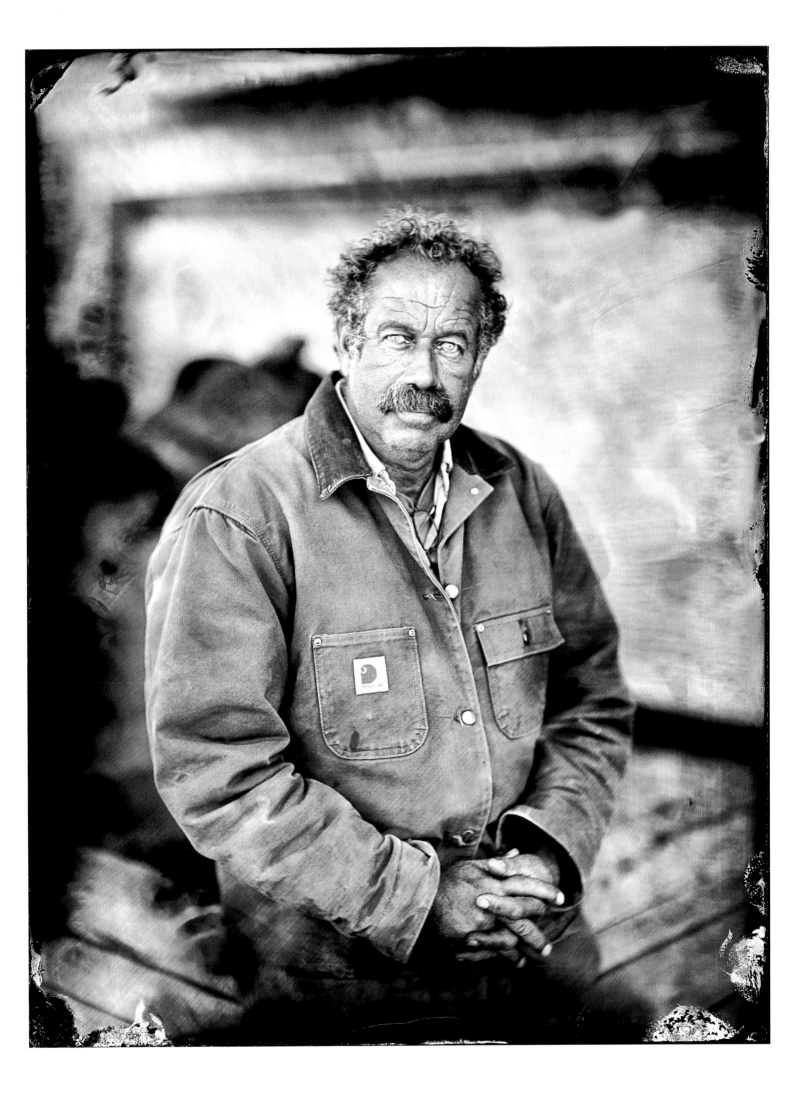

RAY MCENROE
McEnroe Organic Farm, Millerton, NY

My entire life I've been farming. I grew up on a dairy farm. When my father passed away in 1983, my wife and I bought the farm from my mother. Then in 1987, I decided to sell a parcel of land to reduce our debt load, and Douglas Durst bought it. He was a prominent real estate person in New York. He came with a farmer from Vermont to start an organic vegetable and compost business. I became very interested in it and in 1989 I became a partner in the operation.

In 1994, with the legalization of the Bovine Growth Hormone rGBH's use in dairy cows, I decided I would sell my cows, and dispersed them. It's really strange to me that today we talk about athletes who have used steroids—and most of it is human growth hormone—and we spend millions of dollars fighting these athletes in courts. But then we feed cows the bovine growth hormone, and now little kids in the United States are getting extra bovine growth hormone in their milk. It's really strange to me that that's OK.

You have all these people who try to find a way to get around things. They call it natural or grass-fed. I don't see how you can technically raise a beef animal in the north that's completely grass-fed. The cows have to have some energy to get through the winter. What a lot of people are doing is going out and buying feeder calves in the spring that are a year old and have been on grain since the day they were born. Then they put them on grass, and are calling them grass-fed, and selling them in the fall. And nobody regulates it. When you're certified organic, it's regulated. Inspectors are in here all the time.

Organic is clean food. I don't know any other way to say it. I've been certified since the beginning. I don't know any other way to farm. If somebody told me to go grow broccoli conventionally I wouldn't know how.

When the USDA took over the program I thought it was going to be better. I'm very disappointed. I spend a lot of money and time to do it. The record keeping is a lot of work. If I added it all up it would probably be one full-time man for the entire year to do all of the paper work. We're farming over 1000 acres. The records that we have to keep are just unbelievable to be certified organic.

I love the taste of the food. When you eat food from a farm it's fresh, it hasn't been stored somewhere, and the taste is impeccable.

When you're born into this and it's in your blood you just don't get it out.

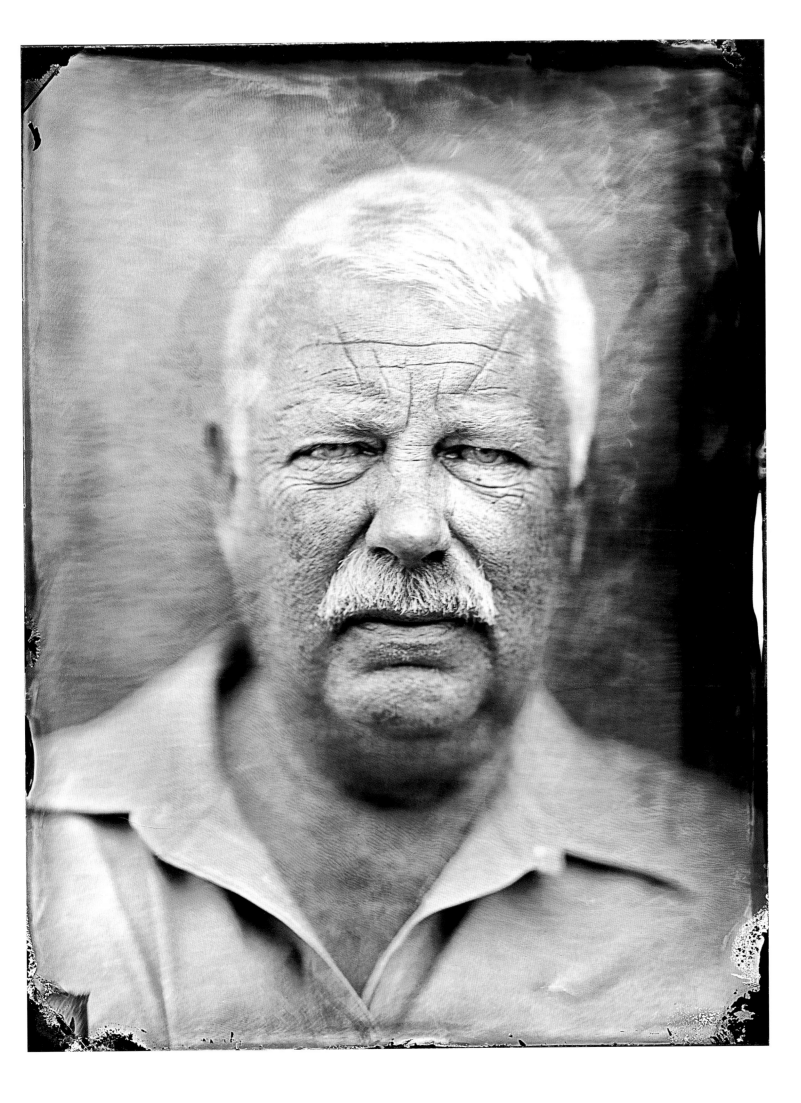

JOAN HARRIS
Harrier Fields Farm, Schodack Landing, NY

I grew up on a farm over the mountains, in Delaware County. My father lost his first farm in the Depression. When I was born he was working on an estate. Then we moved into the city where he worked in a war plant so that he could earn money to buy another farm. Even those early years, when I wasn't on a farm, it's as if I was, because that's the only focus the whole family had: getting back to a farm.

After the war was over we lived at the edge of the city where we could have horses, and we moved to where farming was a community affair; you helped each other. We got there in September and all the neighbors came and helped put hay in with their horses. This was a short time before agriculture began to change in 1946, right after the war.

Back then they did things together. They would have dinners where all the men came, and all the neighbors were there. It is a wonderful time to remember. But then the tractor came and people began to just work for themselves. Now we can't really work with our neighbors because they are industrial, there's nothing we can share with people who buy machines that cost more than the whole farm does.

Organic? I would like it to mean the way nature intended for the earth to be treated and food to be grown. I don't know if it means that to everyone. We are not certified organic anymore, when the USDA got into it, we got out.

It's about healthy soil. Our energy mostly comes from the sun for the grass. We don't till up a lot of land—we're building the grass—and the cows move through a rotational graze. Every day they get moved into a new room of grass, or twice a day. It's called intensive rotational grazing. All together we have about 100 heads now, counting calves and bulls.

The Devon can fatten on grass alone, their genetics have not been changed to meet the specifications of a feedlot. We had one that had a calf at 19, which is really old. Our oldest one now is probably 13. The industrial dairy cattle live for one-and-a-half lactations—that's about four years old—and they're old and decrepit. This healthy soil and healthy life is not only good for the people who eat that meat, or drink that milk, but it's real important for the creatures.

In my family we have a three-volume set of farming books from about 1882, my mother made sure I got them. I wore out the one with cows and horses. So much of the old ways of doing things, we're still using now.

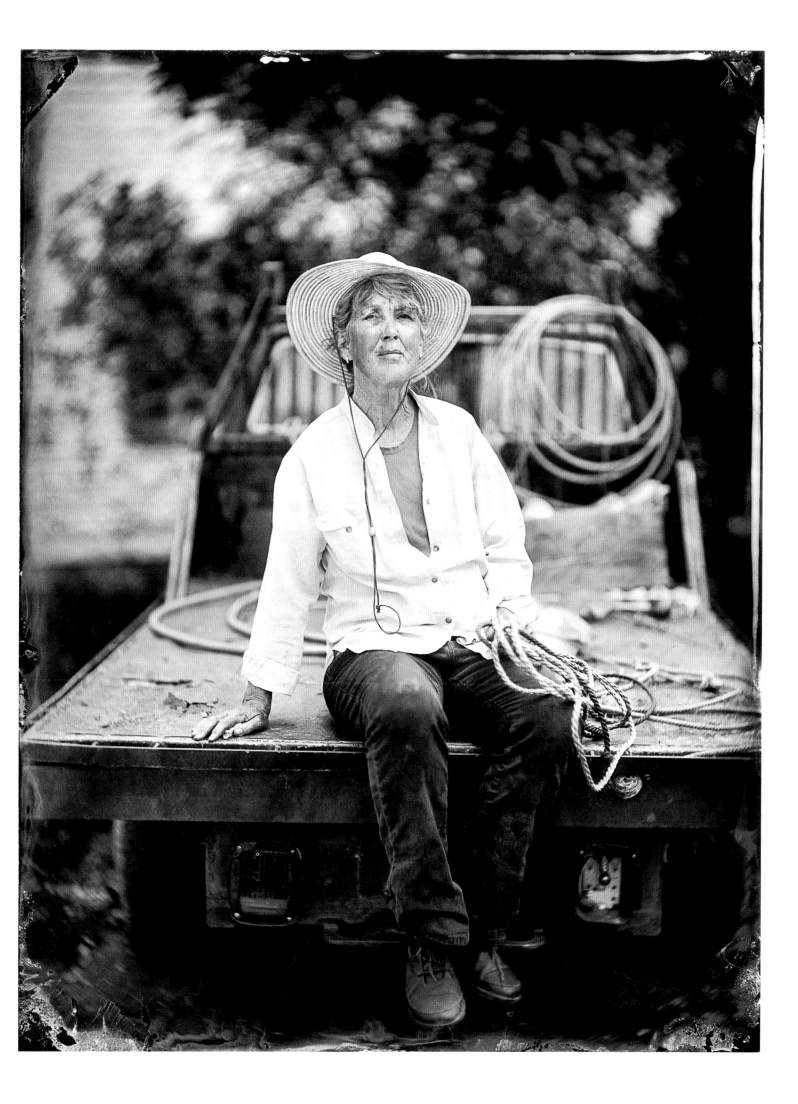

JAY ARMOUR
Four Winds Farm, Gardiner, NY

It's kind of a long story as to how I got started farming. I read a book called *Food First* that talks about food politics and about starvation in the world. I had this misconception that people starved because there isn't enough food. The real issue is that people are starving because they don't have access to food.

That inspired me to learn about where my food is coming from, and I ended up working for a farmer on Long Island. I eventually wanted my own farm, and when I met my wife she wanted to farm too. So, we came up to this area to look for a farm to buy.

I farmed organic from the beginning. Well, there's organic and there's organic. We were certified back when it was NOFA doing the certifying. Originally, we sought out the certification because we felt it would help us in terms of marketing our vegetables. So, by me saying that my vegetables are organic—and I can't make that claim unless I am certified—customers that are buying from me have some idea of what that means.

We farm a little differently than everybody else. We are no-till; we don't plow or till our land. We use a permanent bed system. I make our compost and put that on top of the beds, and then plant into the compost. We use the compost as a way of controlling the weeds. We have good healthy vibrant living soil that's producing healthy vegetables.

I like the idea that I am taking dirt and farming it into a valuable and health-giving product. So, when I am selling my produce, I'm selling something I know is healthy, tastes really good, and is appreciated.

What's going on now is a local food movement. People are growing organically because that's the way to do it. I think what's helping so many small farmers in this area is a growing awareness about supporting local farms and buying local produce. That's the big movement going on.

A big issue now is affordability of land. There are people who want to farm, but they can't afford to buy land. The demand is there because more and more people are looking for local produce. The problem is the way we value land. But how do we change that? I think the future for agriculture is small farms.

We've been here since 1988, I can't imagine not farming.

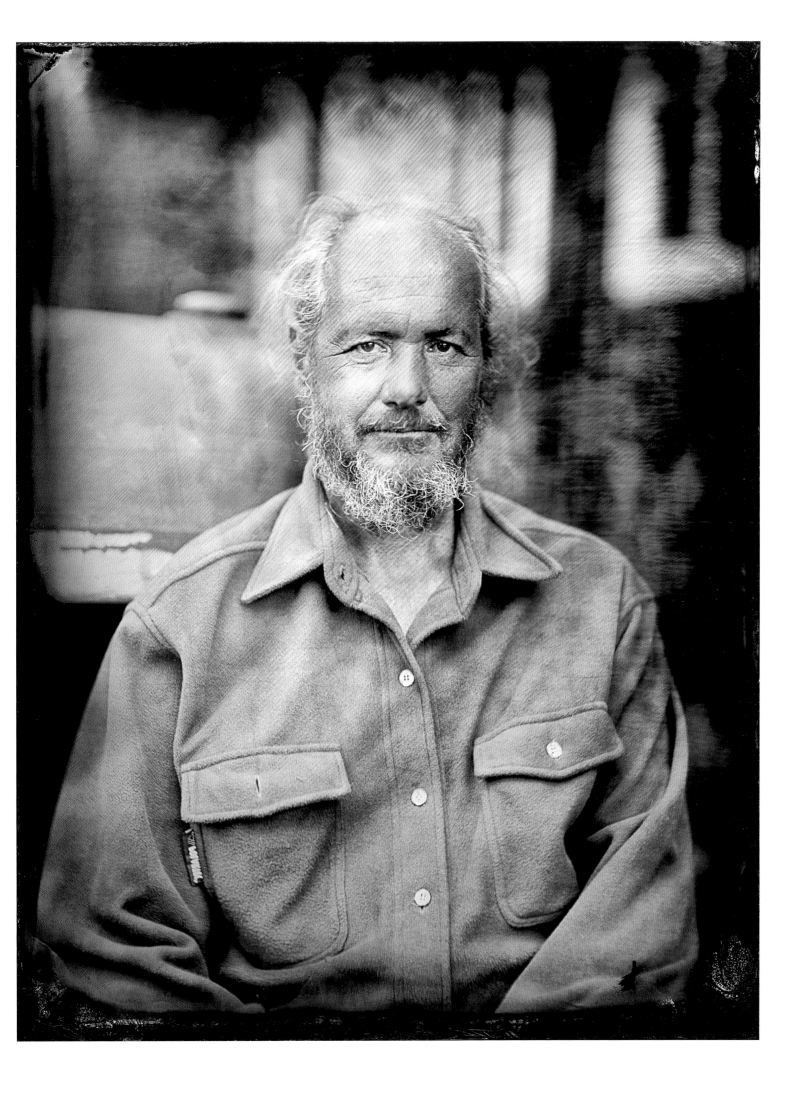

COLIN MCGRATH

Sprout Creek Farm, Poughkeepsie, NY

It just kind of happened, the right place, at the right time. When I came here I was 20 years old, and I was still in school at the Culinary.

I started reading Harold McGee, *On Food and Cooking.* One of the chapters I got into was fermentation. I became intrigued, and wanted to know more.

And so it just happened. I don't have any classic training and I think that's the biggest thing we have going for us here. We think differently, we think organically. Even with the way we make cheese now, when we develop a new cheese, a lot of the methods we use have already been done, because cheese goes back 10,000 years. But we don't really follow any book, or guidance, other than what works for us and the cheese we're producing.

We have 200 acres that our animals are raised on. They are all pastured here and all the milk we produce goes into cheese. It's 100 percent farmstead. I use goat and cow milk, and typically work with milk that is anywhere from 12 hours to 60 hours old. The majority of the cheeses we make are made from raw milk, so I'm not pasteurizing it.

I start out the process by creating an environment that is conducive to the growth of certain bacteria that I am looking to have flourish. Those begin to ferment the milk, break lactose to lactic acid, and end up shaping the entire process. It's about completely feeling the product you're producing, and a lot of the time just letting it do its thing. It's all the things that you don't see that are happening in the milk. At the end of the day, realizing that you're working with something that's alive, there's only so much you can do. You can never really own it; the cheese owns you.

The whole organic thing, people were so fixated on that label without really knowing the meat behind it, and now it's finally coming out. A few years ago, when that meant so much to people, it would determine whether or not they were going to buy a product. I was asked all the time if it was organic, now I'm not.

The people who come here see what's going on. All of our doors are open, you can look right through the window and see exactly what we are doing. You see me producing the cheese and right next-door you see the cows being milked. That's kind of as organic as it gets. I think the local movement is the new trend people are going after.

You have to love what you're doing, and I put every ounce of everything I have into what I'm producing. It's something that's always on my mind, always.

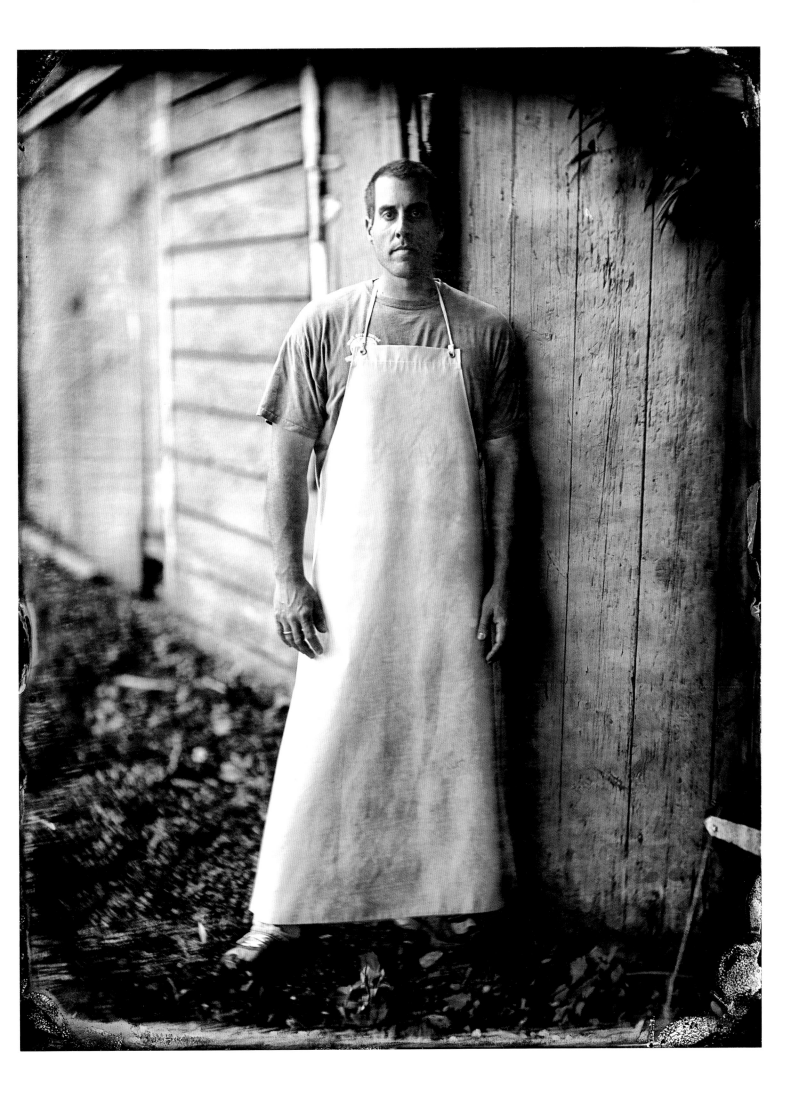

DON LEWIS

Wild Hive Farm Community Grain Project, Clinton Corners, NY

My parents were farmers. From about 18 years old I lived on farms and worked in agriculture pretty much the whole time. It was important to me—that lifestyle—and to be close to the food system.

Organic is an approach to producing food in a manner that is safer for the consumer and the environment. It's about the approach to the stewardship of the land. When I think of real organic, it's about the method to me, and not about the certification so much; that's the politics of it. In the process you put back into the soil, and you have a rotation, and you help build the soil. Those are the really important things, so you don't just take from the soil.

The Wild Hive Community Grain Project is really focused on reintroducing grains for human consumption in the Hudson Valley. There had been an 80-year hiatus on grains for human consumption being grown here. When I started, I met Alton Earnhart. He was growing grains for animal consumption and had just started growing wheat. He gave me a bag of flour that he milled and said, "Here, check this out, maybe you can do something with it." I stuck my hand in it, and that was it. I just knew this had been missing, and it's special.

When I was in a position to be certified, the politics changed, and the USDA had taken over the certification process. I felt as though it lowered the standards to allow larger producers to enter the market, and those were sacrifices to the concept. So politically I didn't want to align myself with that.

I hear, "Is it organic?" a lot. I explain to people that it's not certified organic. So the answer is, "No, it's not certified organic, but the product is produced and grown with organic methods." But still, I can't put it on my labels.

Everyone has a right to farm, and rights are important to me. That's one of the reasons why I've done what I've done; it's about politics, food politics. You need to have availability, you need to have resources, you can't just have a few things offered to you and that's it. I always thought it was really important to have a choice in our food system.

I've been producing agricultural products and making my livelihood from them for most of my life. Since the early 80s I've noticed how it's changed and grown, and education has been a key component.

We're now milling 130 tons of grains annually and that's up from the first harvest of 5,000 pounds.

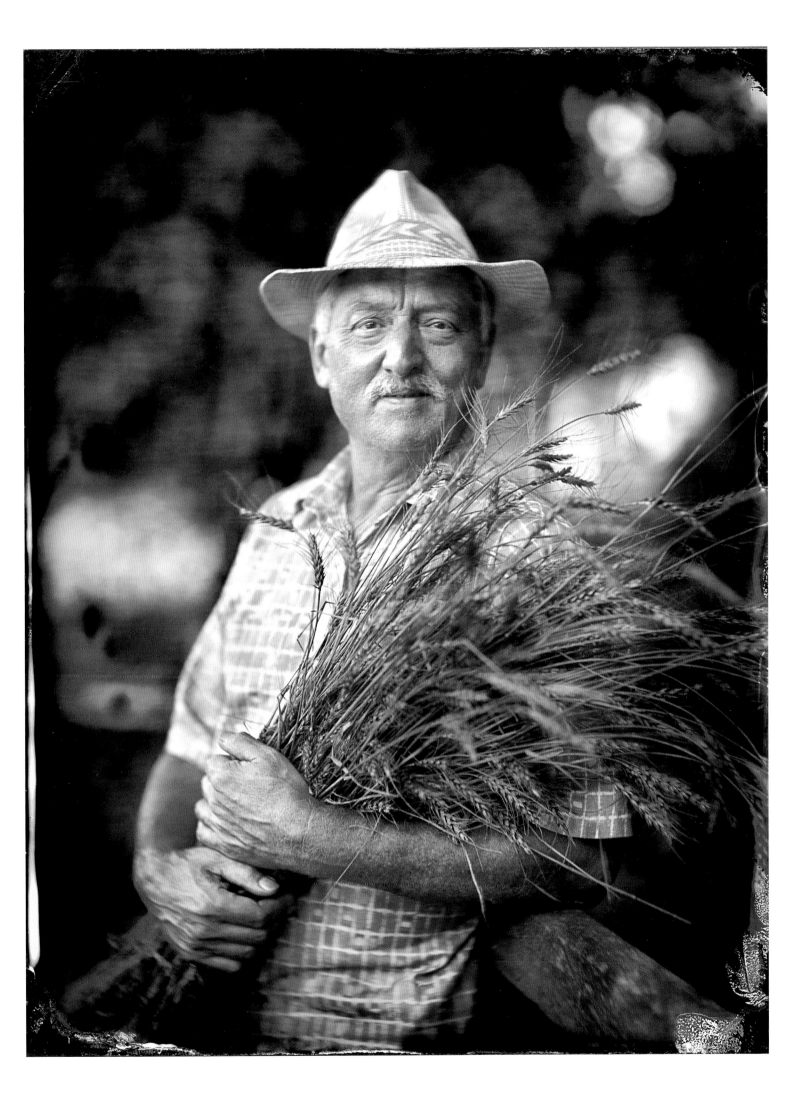

LAURA PENSIERO
Gigi Hudson Valley, Red Hook, NY

I'm a person who sees a lot of angles with food. I enjoy being a nutritionist as much as I enjoy cooking and writing. But really, when you put it on the plate, you bring it all home. Anything that I would tell someone to do nutritionally as a clinical dietician, I can show them on a plate.

As a registered clinical dietician, I always had a passion for food. I worked in acute health care in two different ways: with people who were very sick and needed nourishment intravenously or tube feeding, and with people who were very sick from years of dietary neglect, like cardiac disease or diabetes. I'm at their bedside 20 years after their diet has put them in this situation, and they probably didn't get the right tools many years before. That led me to cooking school. I went to the French Culinary Institute.

There is a lot of confusion with the word organic. To me it means natural—like organic compounds. In terms of food, I don't think the consumer fully understands the gray area of organic, and there is a lot of gray area. I buy from a lot of organic farms that use organic practices but can't get certified organic for a variety of bureaucratic reasons. Maybe they don't want to pay all of the fees and go through all of the time and paperwork to do that.

I say it's seasonal and local more than I say organic, because for me, that's a bigger priority. I believe the Mediterranean diet is the most pleasant way to eat healthy. The fact that it is supported in scientific literature as a very sound eating pattern for prevention of cardiac disease, cancer, and other chronic diseases, means there's no disputing it. I like to take food from the Hudson Valley to do Mediterranean cooking.

I always use my public health hat when it comes to this. People need to know that they should eat more fruits and vegetables in the season that they're grown, preferably locally, because they taste better and travel less. They're going to have a connectedness to the food because they're going to know the people that grow it, and they're going to connect their kids to that food, and that's the big picture.

If you celebrate food, the people that grow it, and the people that put it on the plate, you're going to create followers. I think this is an epicenter of what's going on. There are so many elements that can make the Hudson Valley a standout model for the natural food system.

I promote the farmers that I use—on blogs, menus, websites, all of my promotional materials, everywhere.

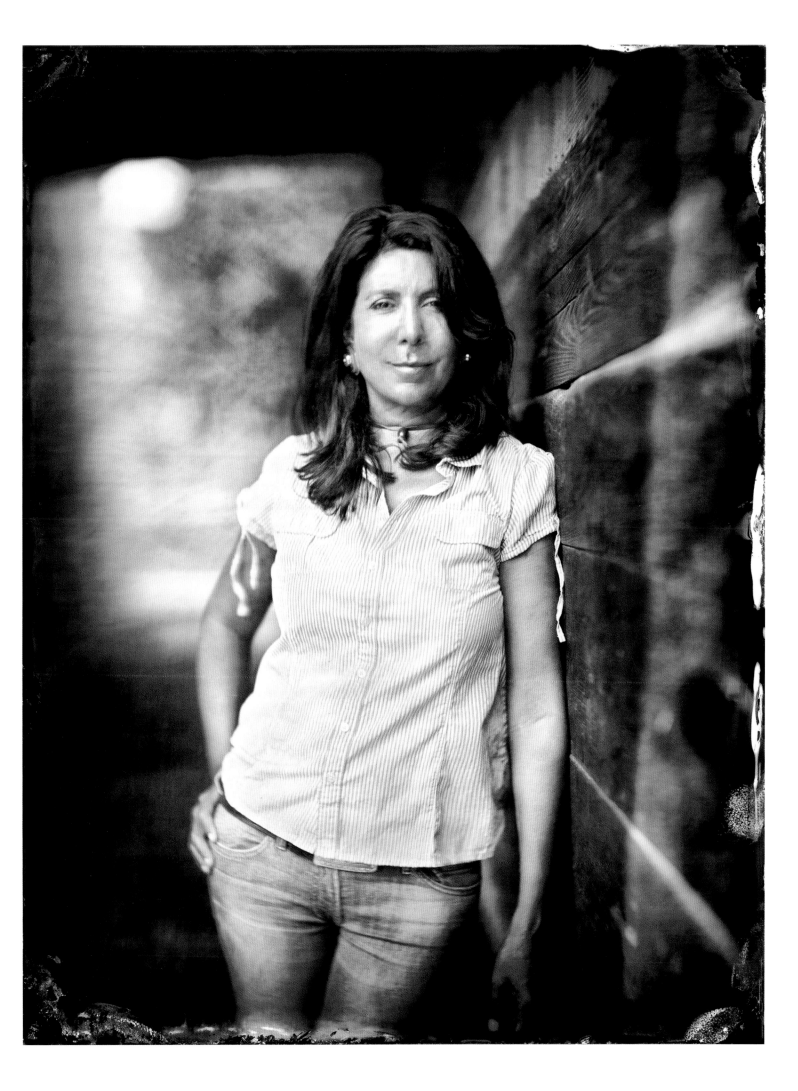

RON KHOSLA

Huguenot Street Farm, New Paltz, NY

My wife Kate said, "I wish I could have a farm," but I thought it was impossible. At that time we were losing about 25,000 small farms a year.

We both went to the Ag School at Cornell. I studied rural sociology and Kate, plant science. Kate started farming right out of school, and I started a publishing company and two high-tech Internet companies. I ditched what I was doing and told Kate I would help her farm for two years and then I'd go back to my normal job. But it was so much fun, and now I could never go back to that normal job.

After we bought this farm, we couldn't afford anything. Naturally, we couldn't afford a walk-in cooler. So, I figured out a way to convert a household air-conditioner into a unit for a walk-in storage cooler. It's called the Coolbot. It's a little brain that cycles the compressor on in just the right way to get the temperature down to 35 degrees with no problem, and it uses less electricity. We also have an alternative way to heat the green houses that uses 90 percent less fossil fuel then the conventional way. Then there is the solar electric tractor. I put the instructions up on the web for free, so tons of people have made those on their own.

For me, organic is different then saying it is a list of rules of how you want to grow. It is more about sustainability and growing healthy food, and that doesn't necessarily correlate to what by-the-book organic is. There is such a technique to growing good tasting food. I like the complexity of figuring out different rotations and complimentary plantings, instead of just spraying and killing the bugs. There are a lot of things about organic that people don't necessarily know about, or they would say, "That can't be organic!"

I became the International Organic Certification Consultant to the United Nations Food and Agriculture Organization, I designed a new organic certification program for India, which is now being used in Sri Lanka, and Nepal has also adapted it. For years I was with IFOAM, the International Federation of Organic Agriculture Movement. In 2002 I started this alternative certification called Certified Naturally Grown, a grassroots program used by hundreds of farmers around the United States. It's stricter then the USDA organic.

Every day we're doing something completely different, it's a new challenge, a new problem, and a new chance for improvement.

I feel it explodes my brain. It's too much fun.

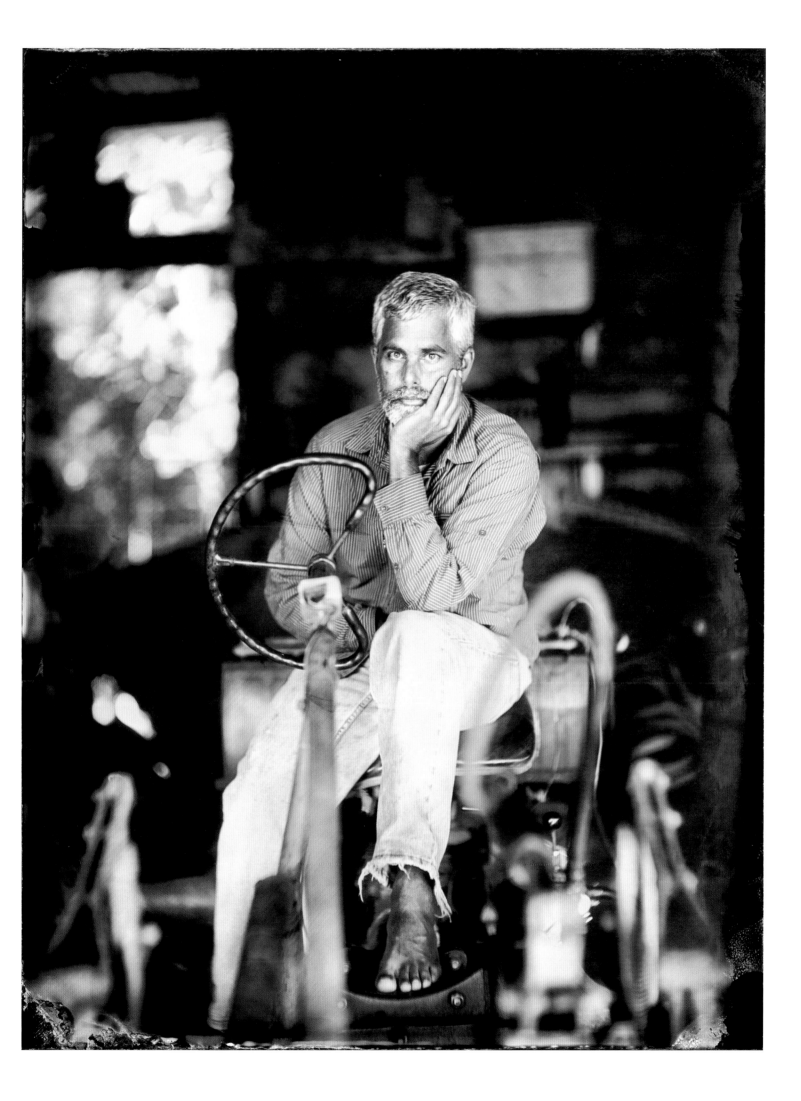

DR. SAM SIMON
Hudson Valley Fresh, Pleasant Valley, NY

I was born and raised on a dairy farm in Middletown, New York. I've been working actively in farming since I was 10, so it's 55 years that I've been farming.

What's important for me as a dairy farmer is how you take care of the cow. You are a steward of the land, and you are a steward of the cow. If you give her comfort, give her good nutrition and good hydration, she will live a long time and produce a quality product.

I am not an organic farmer, and do not buy into that, because it has nothing to do with the quality of milk you're producing or the care of the animals. We are not certified in any way, but we are tested for the quality of our milk by DHIA, a national organization that comes to every farm to test the quality of the milk of each cow. The industry standard for truly premium milk is 200,000 sematic cell count. That's the reason we get the designation of super milk. That's unheard of in the industry, whether you're organic or generic. Organic does not have those kinds of quality standards. The organic standard of acceptable quality is the same as generic—that's a fact.

We feed our cows 15 pounds of hay a day. The average cow in this country, in industrial farming, gets two pounds. Instead, they feed them a lot of fermented feed, which is not natural for the cow's digestive system. They're not built to eat fermented feed all the time. They need fiber.

It says something when they came out and ultra-pasteurized milk. What they do with ultra-pasteurization is cook the milk to 280 degrees for a few seconds. The reason for doing that is they break down the enzymes lipase (that breaks down fat) and protease (which breaks down protein). Those are the main ingredients in milk that determine the shelf life. Once you kill those enzymes, the shelf life extends remarkably. But in so doing, you are also breaking down the proteins of the milk itself, the nutritious part. In contrast, our milk is pasteurized for 20 seconds at 164 degrees, the minimum, so we don't alter the quality. But it still has a shelf life of two weeks or a little more.

The average gallon of milk in this country travels 1,100 miles from the cow to the consumer. The average gallon of Hudson Valley Fresh milk travels 30 miles, from the farmer to the processer, and the furthest distance is 80 miles to the consumer in New York. Whose is going to be fresher?

I love the cow, I love watching the different generations being born, I love their docile demeanor. To me the dairy cow is a form of art.

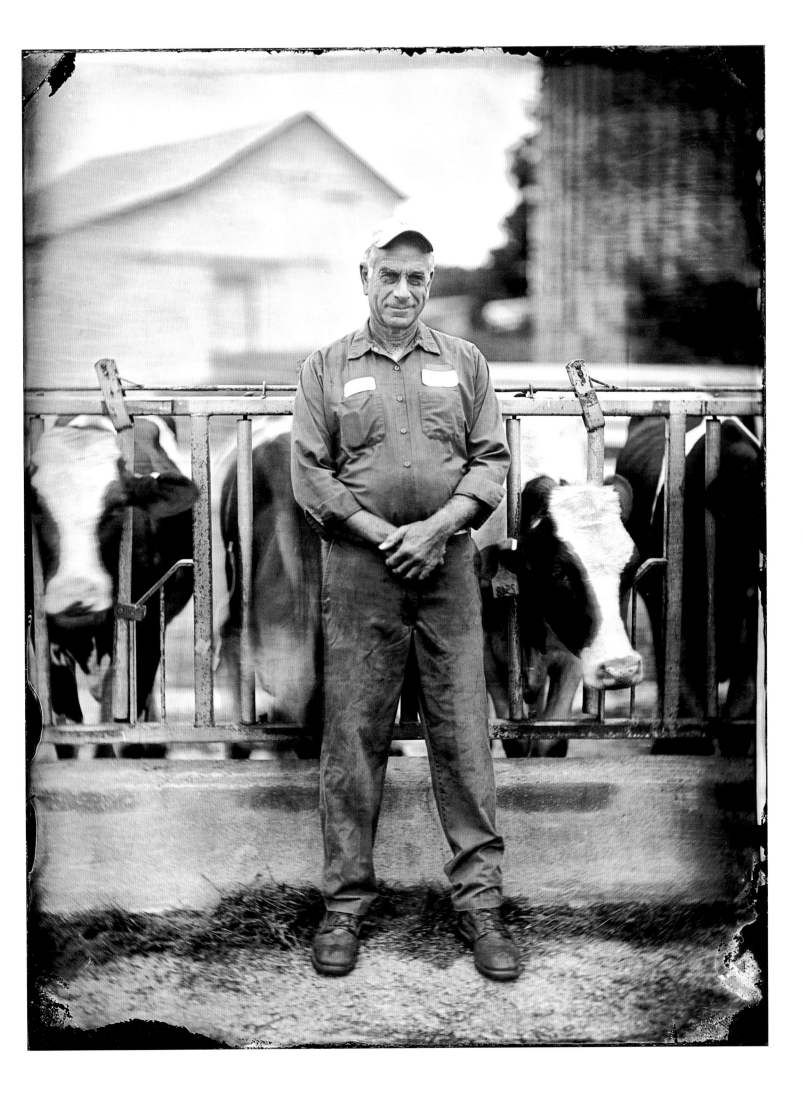

LIZ TAGGART
Amba Farms, Bedford Hills, NY

I've been growing since I was five years old. I grew up in a farm community. My grandfather and his brothers emigrated from Slovenia to the east side of Cleveland. They all bought properties near each other, and each one of them specialized in different things. Whether it was orchards, produce, poultry, bees—we had a vineyard—and then we all shared.

My father was a chef. So, when I first started Amba Farms I thought, "Well, I know the growing side, and I know the cooking side, so I think I can grow for chefs."

To me, organic is about the soil, because that's what we have to understand with some wisdom. Soil isn't dirt. Soil is a living ecosystem of all different sorts of life. In particular, we have to restore the bio-life back to the soil so that we are harnessing the microbial life to help make organic nutrients. So much of soil is science, and I find myself studying the periodic table and learning about chemistry. It's interesting because soil science is moving to a level of quantum science. It is miracle after miracle of what can happen when you're giving the soil and the plants what they need.

I was in my kitchen one day, and I looked at the vitamin bottle for my teenage son and noticed all these micronutrients, the sulphur, boron, magnesium, and all these different minerals. I looked at my soil report; I had the two hand in hand. It read like a one to one correspondence of the micronutrients we want to be putting back into our soil, and the micronutrients our bodies need. And we have to take vitamin pills to get them. So, if we can rebuild healthy soil then it would just be of part of our daily diet.

I really want to make one point about the USDA study that came out about produce. It tracked the nutrition in all the major families of vegetables from 1940 until 2010. Most of our vegetables have lost between 50 to 70 percent of their nutritional value in those 70 years.

We are also extremely careful about where we buy our seeds, because there is an emerging issue about the deterioration in the DNA of whole-weight seeds. Aanother problem with conventional farming is that some seeds weigh half of what they used to, and you are not getting the full genetic stream. So, you have to look for full-weight and full-size seeds.

This area is becoming a mecca for talented chefs, and I have to take it back to the consumer, that's what consumers want.

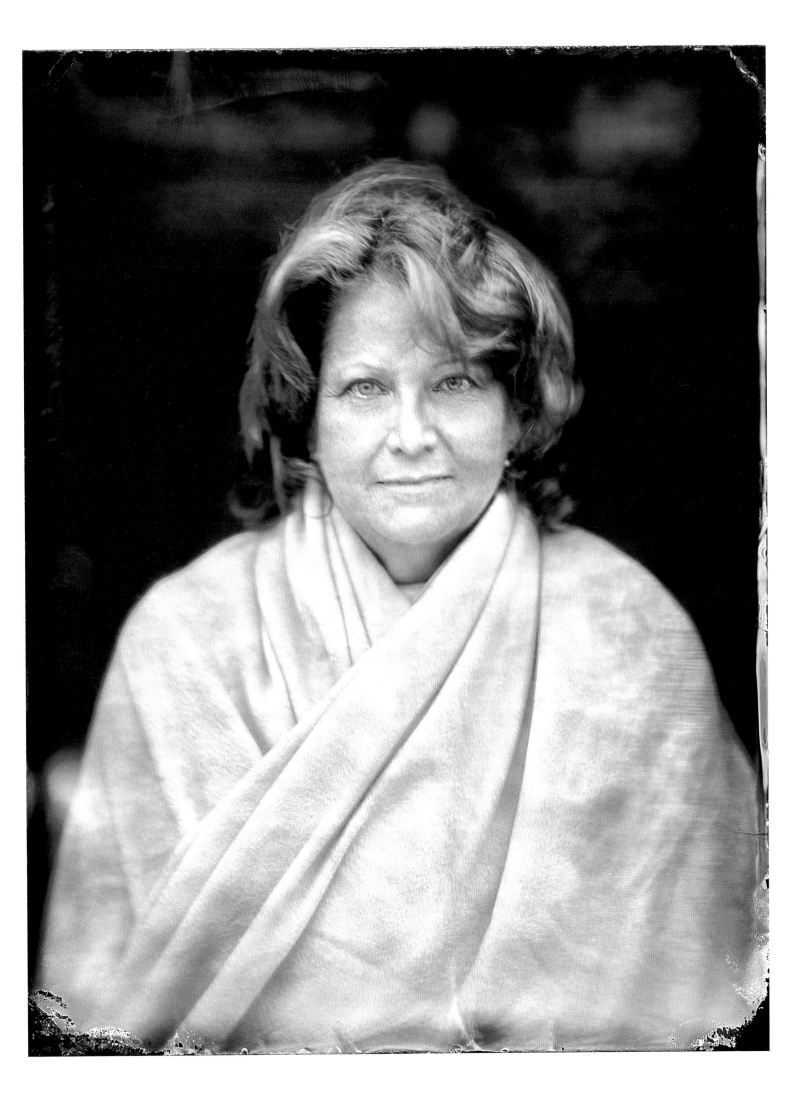

JAMES HAUREY

The Grange, Warwick, NY

I have been cooking for over 25 years now. I started when I was 14.

To me, organic is more about the earth than anything else, because the concept is to make your soil so healthy and so strong that it can stave off any disease. If your food doesn't taste good, your soil's not strong. As soon as I know the product is organic, I know it's going to taste infinitely better then any of the commercial stuff that's being grown. Then it's just a matter of putting it on the plate—the farmer did all the work for me.

Here in New York there's beautiful soil all over the place. We can just grow here, keep the money here, and help the community instead of shipping it in to Guatemala or China, where nothing is regulated and you have no idea what chemicals are going into the food.

There's nothing more important to me than what you put in your body. If you're putting in chemicals you don't know about, what's going to happen to you? You're not going to stay a healthy human being…not for long anyway.

Just imagine eating beef that's full of all these growth hormones and antibiotics that it's not supposed to have. Not to mention that the cows are eating corn which is not their natural diet. Of course you are going to start getting sick, of course you are going to have repercussions. You're screwing with Mother Nature and that's not something you should really do.

I try to make green beans taste like green beans, I try to make a steak taste like a steak, and fish taste like fish. I'll spend more money than most people think is necessary to get a better product, because I know the flavor is going to be there.

Chefs have to be more committed to their career than to anything else in their life. As far as I can see, if you don't live it and breathe it, you're not going to survive it. It's something that's just in your blood.

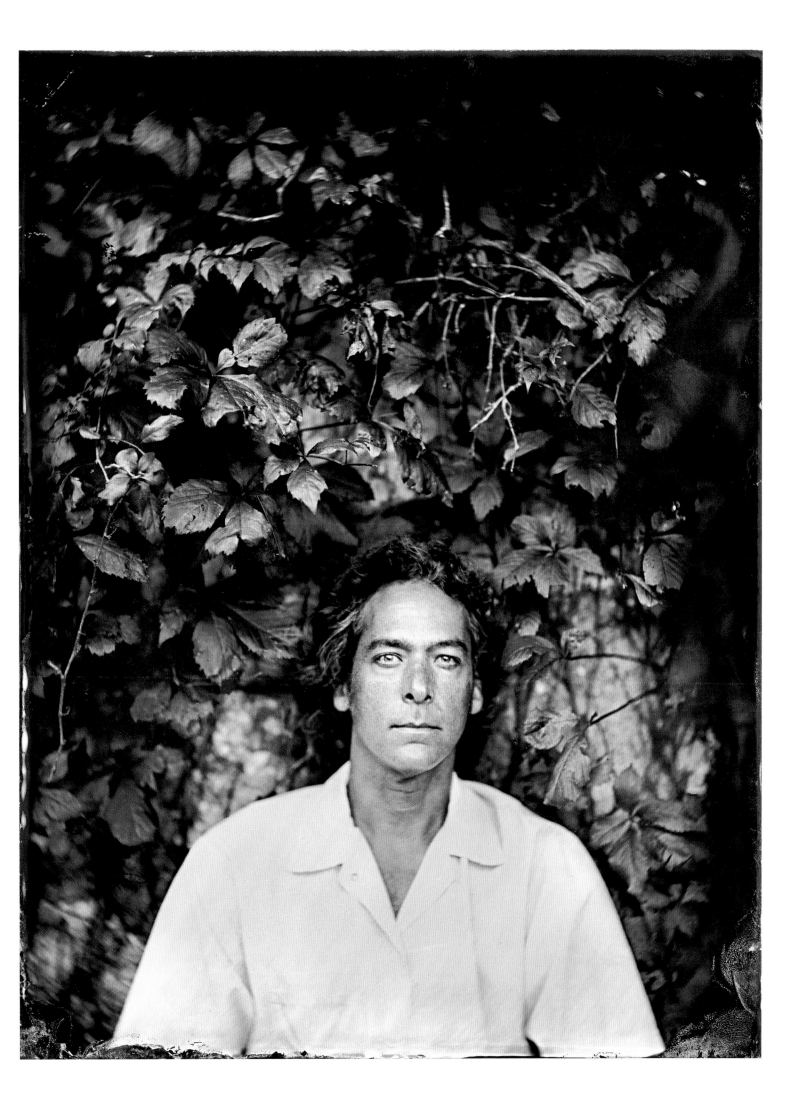

AGNES DEVEREUX
The Village TeaRoom, New Paltz, NY

I grew up in a small, family-run hotel in Ireland where my mother did all the cooking. So, I was always interested in cooking, mostly baking.

My mother grew things herself, and she bought from farmers, because that's how you did it—she didn't go to a supermarket. She bought meat directly from people, and my father was a pig farmer, so we had our own pork.

When I moved to New York I worked at the Union Square Cafe, right near the farmers market, and I became interested in local food. Then when we decided to move to New Paltz, I was really excited because we were moving to the area where farmers at the farmers market came from.

Originally I was going to open a little bakeshop. Baking is really my passion. But we changed our business plan and decided to open a restaurant, serving local food and buying from local farmers. There weren't that many people back then, nobody delivered, and you couldn't buy any meat from a local farmer. But things have changed and I have so many people offering me local beef and chicken, it's wonderful. Our chalkboard downstairs has all the farmers who we buy from, and it's not just fruits, vegetables, and meat. We also have local wine, local bourbon, local gin, and local beer.

People are confused by organic, and then they read stories in the papers and don't know what to think or what is safe. I grew up on raw milk. We didn't think of it as raw milk; we had a cow, my mother milked it, and we drank it. We didn't have to worry about the government coming to arrest us. People think pasteurization is safe. These cows are sitting in muck up to their utters, of course you have to boil it. To even see the conditions these cows are milked in, it's disgusting. The people I buy my milk from, it's like a barn palace. You go in there, it smells sweet, it smells like hay, everything is sterilized, and everything is clean. The most perfect existence for a cow that you can imagine.

If I'm going to buy vegetables, I'm going to buy them from somebody I know, like a local farm or business that's a neighbor, because they are proud of what they do. I believe it's better for you, it's better for the environment, it's better for your kids, it tastes better, and it's better for the beauty of the area to have more farms than developments.

I love food, I think food is beautiful. When I'm cooking I'm very aware how beautiful the ingredients are.

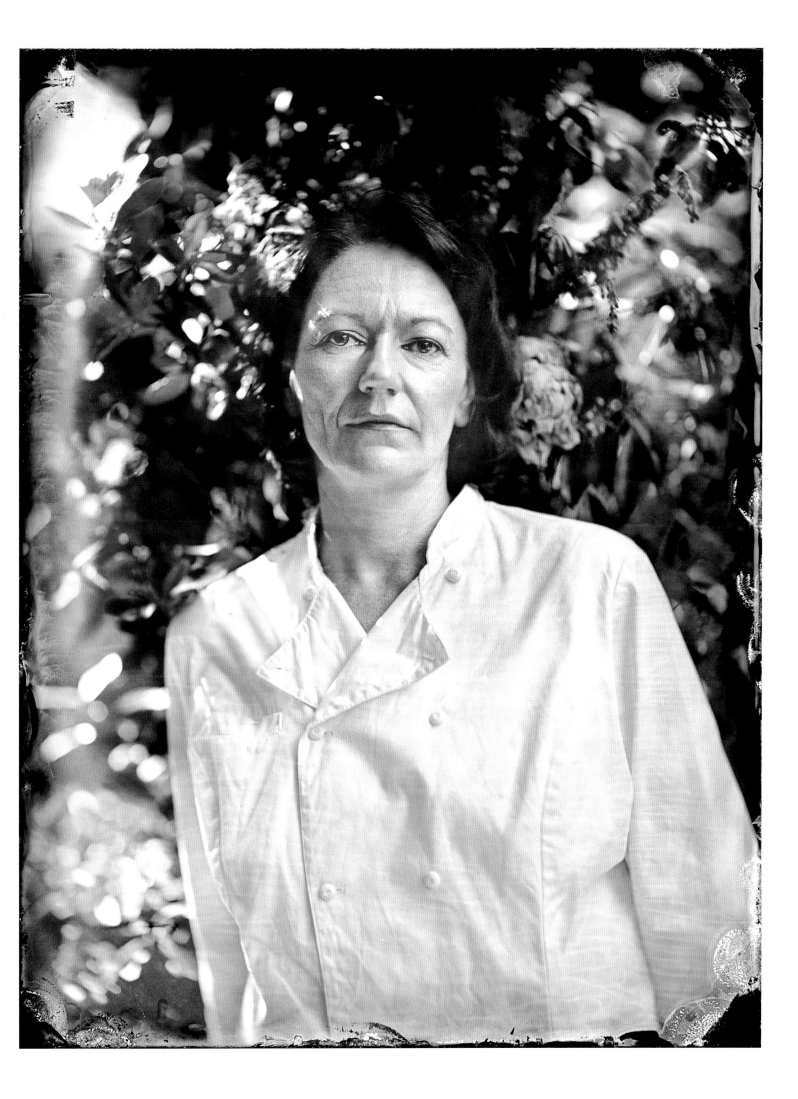

BEN SHUTE

Hearty Roots Community Farm, Clermont, NY

I grew up in New York City and didn't know anything about farming. I thought I would like to work on a farm to see what it was all about, and learn more about food and where my food was coming from. I never thought it was going to take me to actually being a farmer.

To me, organic is about trying to invest in the soil and create a productive system that is going to last for decades and generations. When you're practicing a sustainable system of agriculture, you're working with your soil and ecosystem to help it work in harmony. If you're investing in the soil's health then it's going to be giving back to you by increasing the organic matter, the nutrient balance, and the soil life.

The reason the word organic is in there is that one of the key components of healthy soil is having organic matter in the soil. That's something that takes a long time to build up. It reflects if you're being a careful steward of your organic matter and being conscious of your carbon footprint, and if you're giving back to the soil.

When doing industrial agriculture, you're fighting against the ecosystem, you're fighting against the insects, instead of trying to create harmony within the insect population. You're trying to standardize your soil rather than paying attention to how you can build it up and make it work for you, and make it give back.

We're not certified organic. If people ask, we will use the words sustainable, regenerative, or ecological. Part of the reason why we don't use the word organic is that we can get into trouble if we say we're growing organic produce, because we're not certified.

We started Hearty Roots Farm in 2004, and we grew rapidly, doubling every year for several years. That growth was really mirrored by the interest in local food. We have almost six hundred shares in our CSA now.

Our biggest challenge for many years has been how to be on land in the Hudson Valley, because the land is very expensive. There are so many competing uses for it, development for houses, and just the market rate for paying for land is above what farmers can afford given a farming income. We were able to buy this land thanks to a partnership with a land trust. We sold the development rights to the land in exchange for us giving up the right to develop it, which is what we wanted to see happen.

I like the fact that I am creating new value by taking the sun, and soil, and water, and turning into something valuable. It was three or four years into this when I realized there was no turning back.

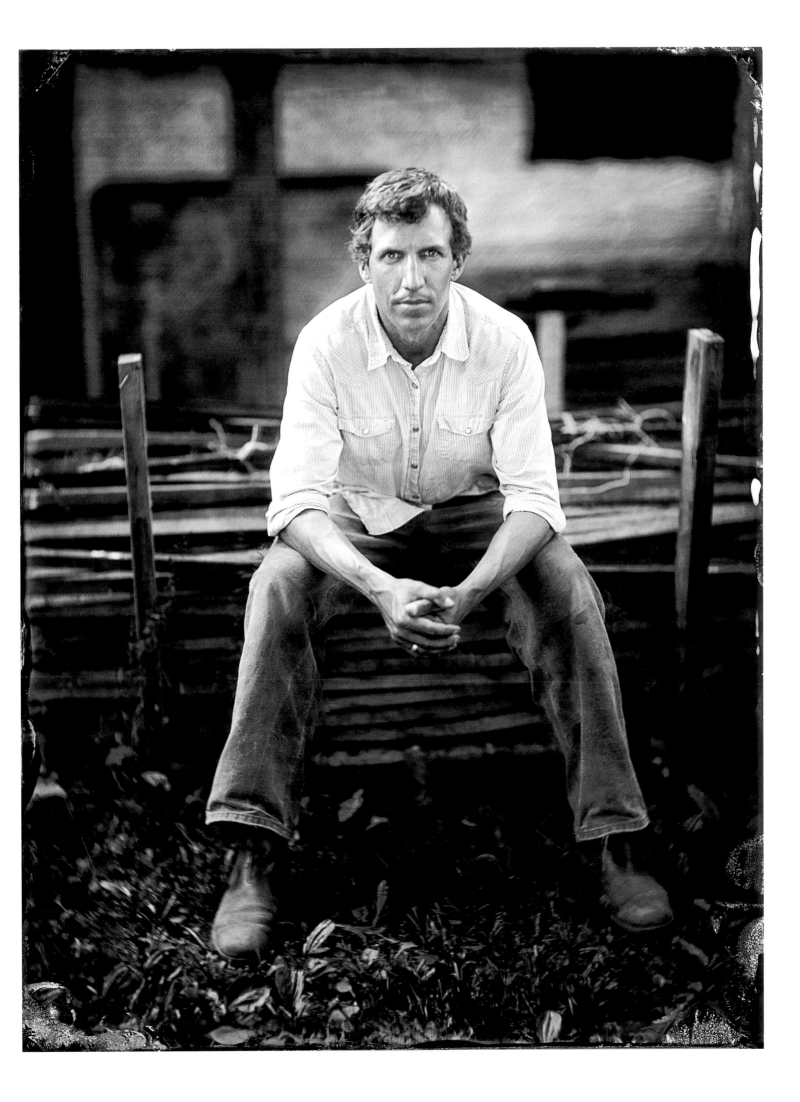

KEITH STEWART

Keith's Farm, Orange County, NY

I grew up in New Zealand. As a kid I loved to hunt and fish. I always liked nature and just wanted to be out on the land. As a young man I set out to see the world and somehow ended up in New York City where I did everything from photography, to driving a cab, to playing poker, to trying my hand at writing.

In my early 30s I went back to school and got a degree in environmental studies and natural resource management. I returned to New York City looking for environmental work. Instead I ended up in the corporate world where I lasted for six years before it became clear it was the wrong path for me. It was time to try something else and my environmental inclinations started to kick in.

In 1987 my soon-to-be wife and I bought a farm in upstate New York. At first there was no big plan to become an organic vegetable grower but it seemed like a good place to start. Soon I got hooked up with the Union Square Greenmarket. In the beginning I went down with just a couple of card tables and some crates of lettuces, basil, tomatoes, and a few other items. People came along and bought what I had. I was not an experienced grower but I could see right away there was a real demand for fresh, local food.

The idea of using chemical pesticides and herbicides, which are basically poisons, was not appealing. I knew they were unhealthy for the land and for the person applying them. There's a high incidence of different kinds of cancer among farmers and farm workers who use pesticides.

To me, organic farming is about sustainability and looking after the land. Toxic chemicals are harmful to the vast microbial life of the soil, to the ecology of the soil. Local organic, as opposed to industrial organic, is very desirable these days. Farmers markets and CSAs are proliferating. There's change in the air and the Hudson Valley has become a mecca for high quality local food produced in a sustainable manner.

This is our 28th year at the Union Square Greenmarket. We hire a crew of eight and grow over a hundred varieties of vegetables and herbs. Garlic is our single biggest crop. We plant about 75,000 each year.

My first book, *It's a Long Road to a Tomato* is a collection of stories about farm life that first appeared in the *Valley Table* magazine. My new book, *Storey's Guide to Growing Organic Vegetables and Herbs for Market* is a how-to guide for beginning organic growers.

Becoming a farmer was the best move I ever made.

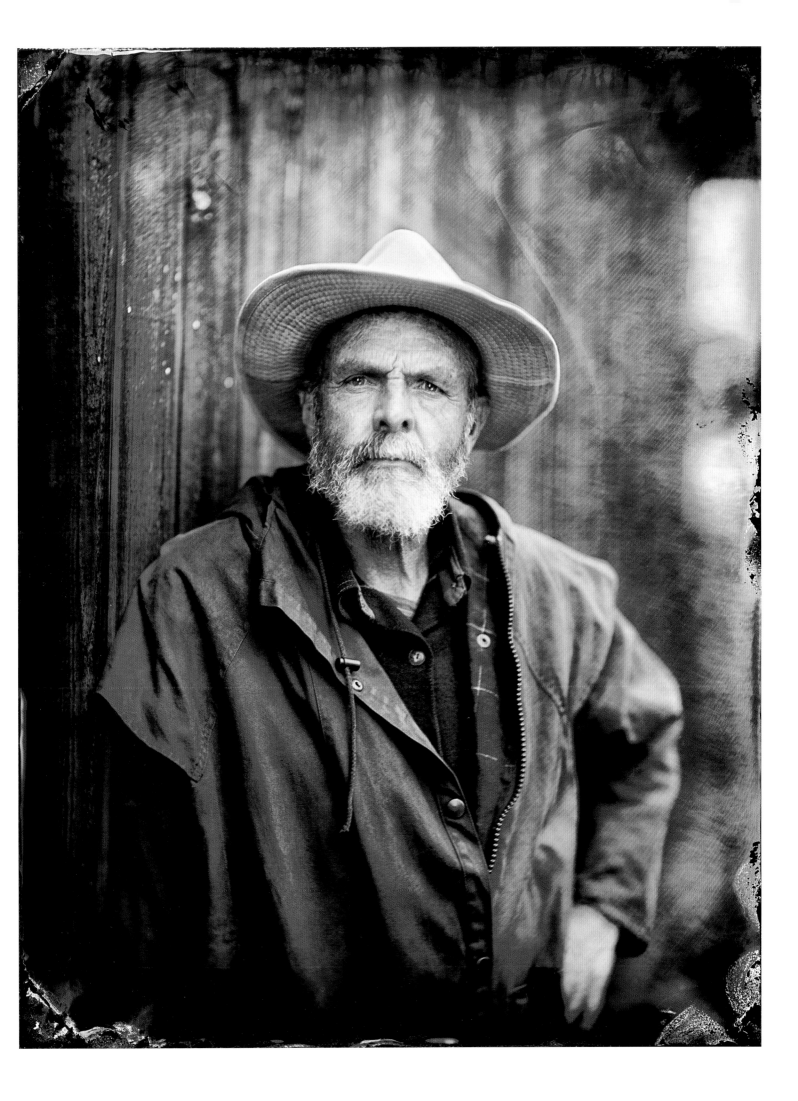

ROBERT FRANKLIN

Bethel Creamery, Swan Lake, NY

By training I'm a wildlife biologist. I learned to farm by talking to a lot of farmers. Farmers are a great group of people; we help each other out.

I was inspired to farm by my love for land, the plants, and the animals that live on it. I can't really describe what it is; the balance of nature, the symmetry, the flow of things, and how everything works together and balances each other out. Sometimes it doesn't seem like it, you have to look a little deeper. Man also has a place in this. If you can be an active partici-pant in that function, the interrelationship of all the different species, plant, animal, mineral, everything; that's what farming is.

I use to be very much against farms when I was a wildlife biologist. I saw most farms, as they seemed to me at the time, places that were disrupting the symmetry of the wild landscape in a disturbing way; and there certainly are some farms like that.

I farm the way it was always done. My cows eat grass. We make our own hay, and try to make the best quality hay possible. We change them around pastures almost every two or three days. The way it was always done.

Organic sounds like—my brother always makes fun of the term—it's carbon, hydrogen, and oxygen. It's a catchy term now. It's basically a meaningless word to me, as its used today. I don't really think of myself as an organic farmer, I think of myself as a plain, simple farmer, doing it the way it was always done.

When I was in graduate school I took a couple of seminars in food additives and agricultural chemicals, and it was a real eye opener. A lot of research that hadn't been done still hasn't been done and should be done. So, my attitude towards using chemicals was pretty negative. We never use any chemicals here, no pesticides, no herbicides, and no fertilizers. When it came time to actually think about selling milk, we wanted to make sure it was kosher, not only because we keep kosher ourselves, but because there was no commercial organic milk for the kosher markets nearby. My self and others who work on the farm are trained in the laws of kosher supervision. Since we don't ever use chemicals here it was relatively simple to certify as organic. Certifying was partly a business decision, and partly because that's just the way we live.

I definitely love farming and sometimes I say to myself, "I wish I would have known how great it was 40 years ago," I would have started then. Like most farmers will say, you're not doing it for the money; it's a way of life. You are immersed in God's creation constantly.

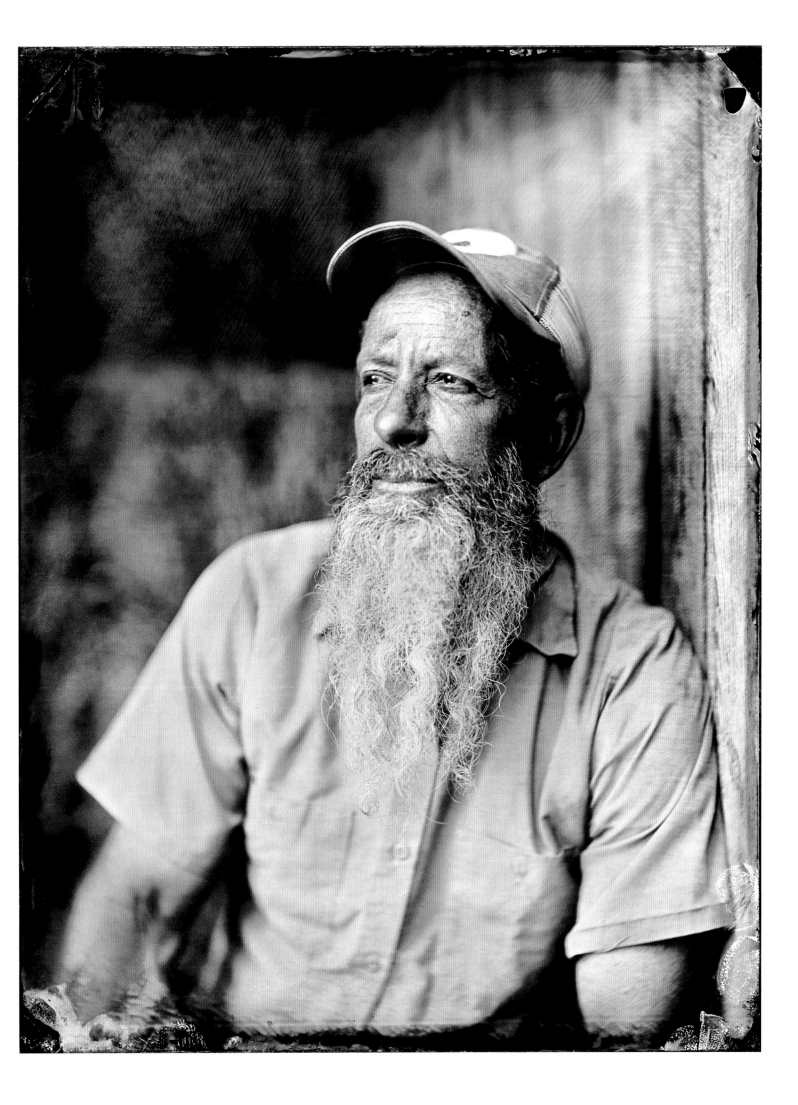

SHAWN HUBBELL

Amuzae, Goshen, NY

I found myself at a crossroads. I received a degree in chemical engineering, and throughout that entire time I hated it. After graduating I realized I needed to make a change, and asked myself, "What do I love to do?" It was cooking and fishing. Once I put them side-by-side, I decided to go back to school and went the Culinary Institute of America.

I started to get involved with organic products during my internship at the Canyon Ranch Health Spa and Resort in Arizona. That's where I started seeing the big difference between organic and non-organic.

Another big exposure to it was while working in Spain. Things were not termed organic but they were coming from small producers. They were caring for these products like they were their own kids. The utter care that was being put into growing and raising them was absolutely out of this world. It taught me to get the most amazing product and treat it simply.

Now when I hear the word organic, instead of a label, it's about the care that someone puts into it. I think of something that's very clean and good for you. As a chef, there is a significant taste difference. Obviously the health benefits are that we are not putting chemicals into our bodies. I find that when vegetables taste really good, people eat more of them and you feel a lot better.

Amuzae is a private chef and catering company. It's all based around the farm-to-table concept. My goal is to go out and find the absolute best products, from the people that have the same passion about what they are growing as I do about what I'm cooking. I always listen to the farmer first, because they know their products the best. They determine what my menus are.

My clients know and appreciate the fact that I'm always going to bring the best products available. If their menu might change last minute, they know it's because I found something better. It's all about the quality of what is being put on the plate.

I think there is a huge movement to find better quality food, and in that there is a strong correlation to organic. There are a lot of farms out there that might not be termed organic, but they are using organic practices, and in my mind that's an organic farm.

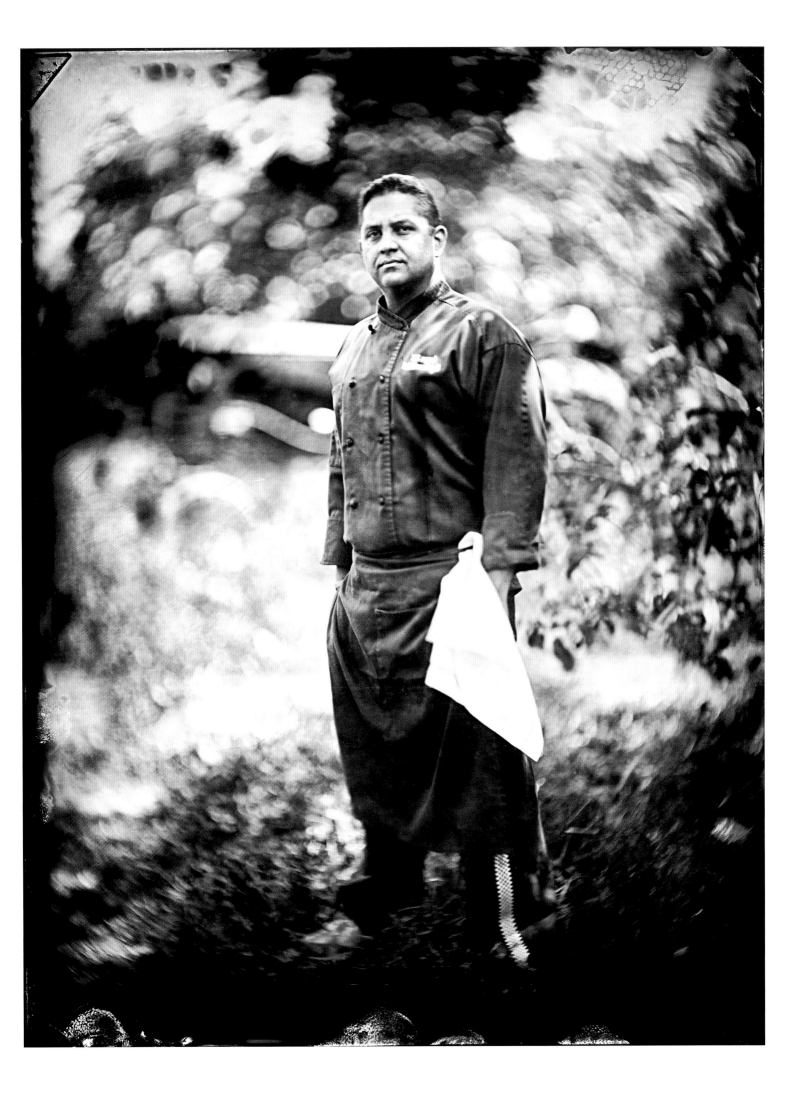

ADINA BIALAS
J&A Farm, Goshen, NY

I was always fascinated with farms and completely obsessed with the *Little House on the Prairie* books. I used to go to the playground and gather the grass after they mowed it, and pretend I was a farmer.

When we started here we didn't necessarily go into it with these strict ideas that this was how we wanted to farm. We had been moving towards a more sustainable system.

The word organic became really popular in the last 10 years and everybody wanted to be organic. You had these big farms that needed to substantiate that they were indeed organic so that they could market their product. The federal government had to have some way of dealing with that, so they came up with the certified organic program so that everybody and their brother wasn't just saying "Oh yeah, I'm organic too."

It's a marketing and branding thing for farms that are selling their products in the supermarkets and need that stamp of approval. Because we sell directly to our customers they can ask us anything they want, and we can explain to them exactly what we are doing. That said, certified organic works for some farms better then others. We're not certified so we can't say that we're organic. We call our farm softly and sustainable grown.

I always felt, if you don't need to use chemicals, why use them? The land is so much more alive and natural without them. We grow pretty much everything that can be grown in this area and a few things that you might not think you can grow here.

I love that my kids can go out and touch everything in the field and I don't have to worry about it—what's sprayed or dumped there. I feel much more comfortable with it as the mother who is the farmer, which is different then the mother who is the consumer. The mother who is the farmer is more comfortable having her kids on an organic farm.

I really love that I am doing something so basic; we're feeding people. At the end of the day you make the world a better place, because you are contributing in a positive way.

At the end of the day, there's no guilt.

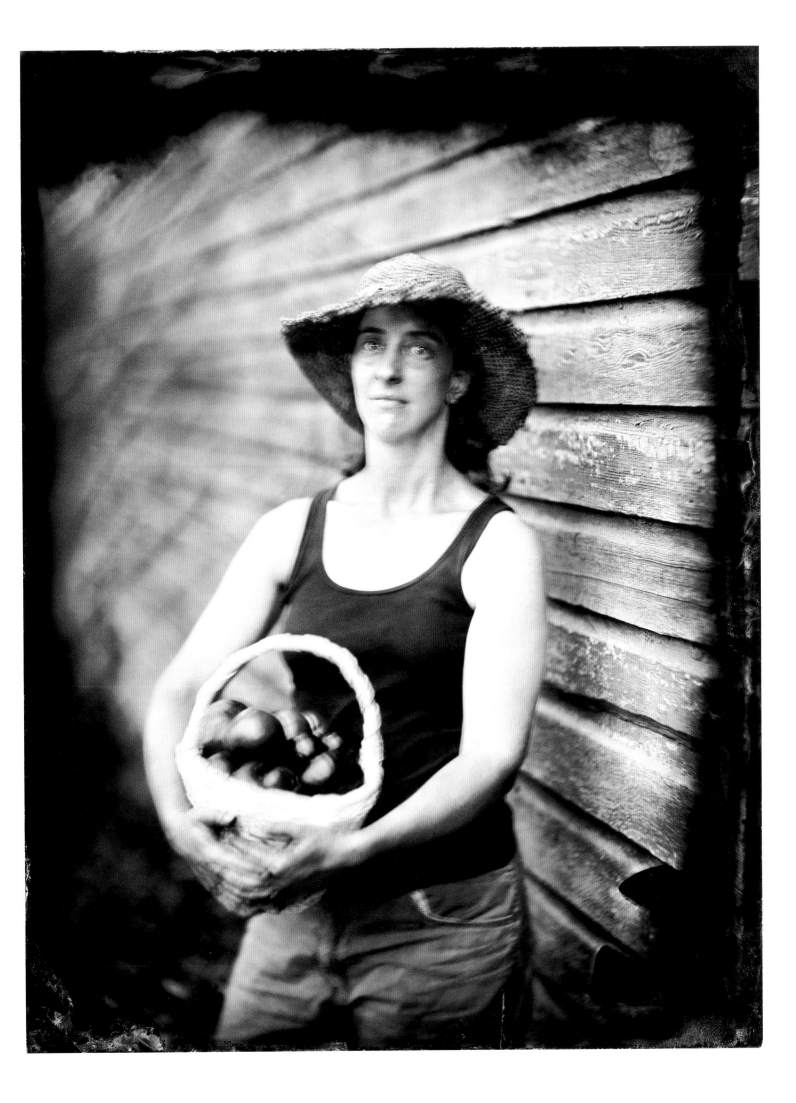

CRAIG HANEY
Stone Barns Center for Food and Agriculture, Pocantico Hills, NY

For a good part of my life I worked at a living history museum. I was doing historical work and farming part-time and I found I really liked the farming stuff better. I loved being outside and I loved thinking about raising animals; it was really engaging. In 1999 I started farming full-time.

What I enjoyed about it then, I still enjoy now; the challenges it imposes. It feels very much like a craft.

The word organic is loaded with a lot of things these days. I don't know if it's the way I approach the world, being a history major and thinking about the origin of words and how things came about. The word organic originally meant "organs and organisms." So I tend to think about it more that way, than get caught up in USDA definitions. When I think about it I think of organisms and living organisms being part of a bigger ecological whole, our cells included. I'm organic; I'm going to compost someday. Thinking about it from that perspective, we shouldn't get carried away with ourselves, and that we should stay humble.

At Stone Barns Center, we raise our animals in respect to their biological hardwiring. We've had a 10,000 year relationship with domesticated animals, and we benefit from that relationship. So, we should not exploit it. I feel like we owe the animals something.

We have 23 acres of pasture and 40 acres of woods that we utilize in the livestock rotation. We're raising cattle, sheep, turkeys, pigs, chickens raised for meat, chickens raised for egg laying, ducks, geese, and honeybees.

Just thinking about trying to do things a better way, learning more about what we do, that's what I enjoy. Trying to raise the animals in ways that make them feel comfortable while they're alive; not only comfortable, but engaged with the world.

The one thing I really like about my job is, I feel like I can still be doing it until I'm 95, and still be learning. The more we get to know about it the more we realize we don't know, it's all about that being humble part.

I realize life is full of surprises, at this point, God willing, I'll be doing this until I'm 95.

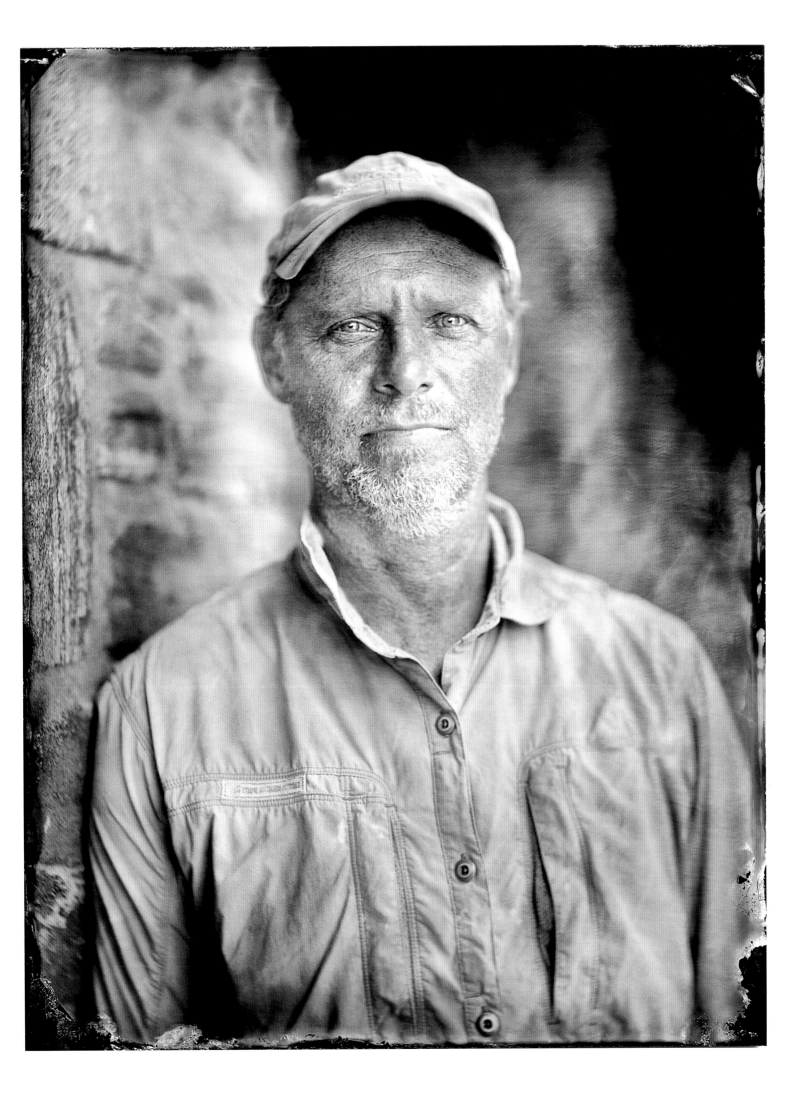

JOSH KRONER
Terrapin, Rhinebeck, NY

Right after graduating college with an architectural engineering degree, I moved back to New York City from Colorado. At that time I really didn't know what I wanted to do. This was the early 90s.

I loved to cook, so I decided to go to culinary school and went to the French Culinary Institute in SoHo. For a several years I worked in the city—I worked with Bobby Flay at the Mesa Grill—and eventually I went back to the French Culinary Institute as an instructor.

I opened the original Terrapin in West Hurley, near the Ashokan Reservoir. People thought I was insane to open up there. I brought something that was unusual to the area at that time which was New American food. New American, meaning, using the broad depth of culture that we have in this country to define America. We have immigrants from everywhere, that's what this country is based on.

Using that as a background for my food, French techniques, my Italian background, I've kind of come up with my own style. Another thing that was uncommon then, that's common now, is sourcing ingredients locally. When I opened Terrapin in 2000, I was sourcing from local farms.

The great thing about local is you can go to the farm and see what they are doing; this is what is important for me, not a label. I was aware of the word organic before the USDA stole the term. My idea of organic would be utilizing natural conditions to grow food, and that would be without the addition of modern chemistry. That's the basic concept of organic.

The farmers are coming to me now, I have dozens of people who bring foraged stuff, and I don't turn anybody away. They know if they come to my door with food, they are going to get a warm welcome. If somebody comes here that I've never met before, we are going to have a conversation about their growing practices, where they grow, how they grow, and then we can do business.

Farm to table is taking the mantel of what drives chefs. That is the message that chefs should be getting out to people: that by eating locally and supporting your local community, there's so much that you are doing that is positive.

There are farmers markets everywhere now; that's proof that there is more awareness. And CSA memberships are way up across the board. I speak to so many farmers who say they have a waiting list.

It's great to be in the Hudson Valley.

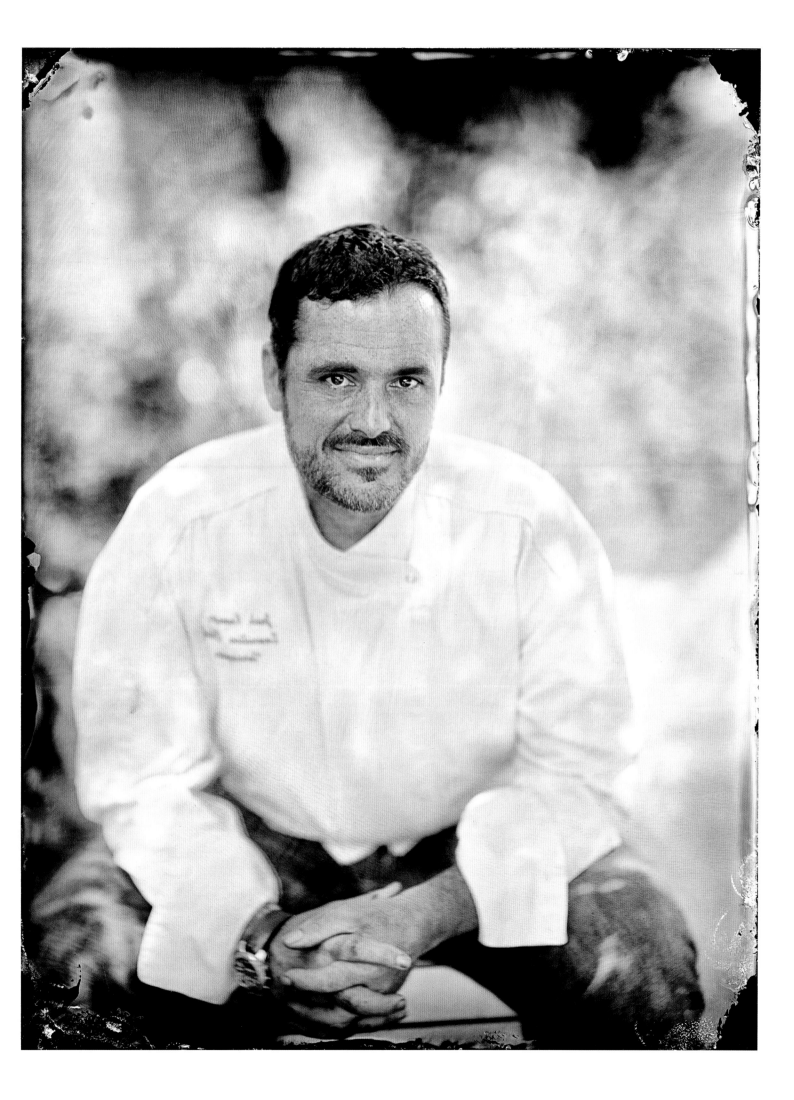

PETER X. KELLY

Xaviars Restaurant Group, Yonkers, NY

I'm from a very large family. I am the tenth of 12 children. We didn't eat anything fancy, but the meal was always important. You learn at a very young age, eating together brings you closer. My family knew at dinnertime everyone had to be home no matter where you were.

When I opened Xaviars at Garrison in April of 1983, I was only 23 years old. It was very hard then to get New York vendors and produce people to come and bring me product. I found that I had to go to locals. I was purchasing out of the back of station wagons from farmers.

In the last ten years with the resurgence of the local farmers market, things have changed. Now it's so much easier to develop a rapport with the local guy. That outlet wasn't there for them before, and that has done an incredible amount to raise the bar for what is going on our dining room tables.

Organic is a word that doesn't do anything for me. When I think of organic, I think about a farmer that is down the street or over the hill growing something. I don't search out organic products. What I search out is locally raised, and buy from people I know and know what they do. That's organic to me.

I think we should all be committed to eating well. That doesn't mean we can't eat imported food. If you love cheese from Italy, or if you are just smitten with the prosciutto from Parma, you should reach out and get it. But you should also recognize that there's a little guy in Cornwall, New York smoking his own hams at a great level. You should seek that person out too, to make the comparison. I love that spirit of discovery of artisans in whatever field. Whether it's baking bread or making cheese, we have so much of it here in the Hudson Valley, true artisans that are working at the highest levels of anything being produced in the world.

What inspires me is the opportunity to make people happy. There's nothing like the immediate gratification of feeding someone. There's something very loving and special about it—it brings closeness. If you think about all of the milestones in life, the celebrations are always food-centric. They're also celebratory in spirits and wines, but food is always at the heart.

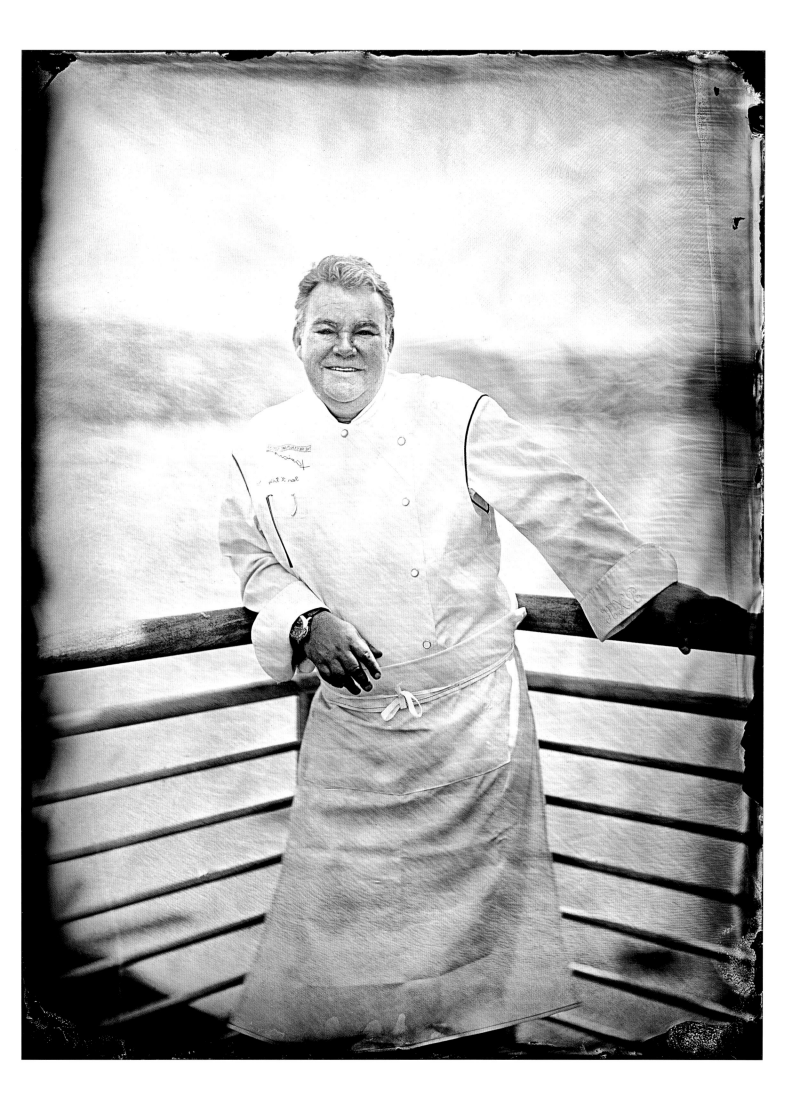

SARA LUKASIEWICZ
Red Devon, Bangall, NY

I've been a professional chef since I was 18. Everyone in my family is a big cook. I remember my grandmother had a garden and we would go out and pick tomatoes and then make tomato sauce with her.

I grew up in Wisconsin and went to college to become a vet, and I was like, "Why am I in school? I'd rather be in the kitchen making cookies for people and making dinner."

I started working here as a line cook when I was at the Culinary Institute, then I became a sous-chef, and then I was named the executive chef. It was when I moved to the Hudson Valley that I started using more local produce. Also, when I worked for David Chang at Momofuku, they went to the Green Market every day, so we were using local produce. That got me jump-started on using organic products.

I use a lot of classical techniques, but with ingredients from the Hudson Valley. I go with what my farmers use as organic, so growing things as best as possible, using sustainable practices, and not using chemicals.

People have asked me if I prefer local over organic, or organic over local. My opinion is, I'd rather use someone using sustainable practices locally than an organic product from California, because the sticker doesn't always mean what it should.

It's the mission of the owners here to use local sustainable products to support the community where we live. One of Julia's favorite sayings is to "eat the view." All the produce and animals raised here are so great. It's such an amazing environment for everything.

I call it more of a local movement than an organic movement. People are very concerned where their meat is coming from, where their produce is coming from, if it's been sprayed with chemicals, or if it's organic or not. People are much more aware of their food system now.

It's very rewarding, getting to promote local farmers and having dinners that promote them. I love getting to know the farmers and the stories behind them. Our dinner menu lists all the farmers we're buying from, and our website lists where their farms are.

The Hudson Valley is a beautiful place. Every day looks like you're looking into a picture book.

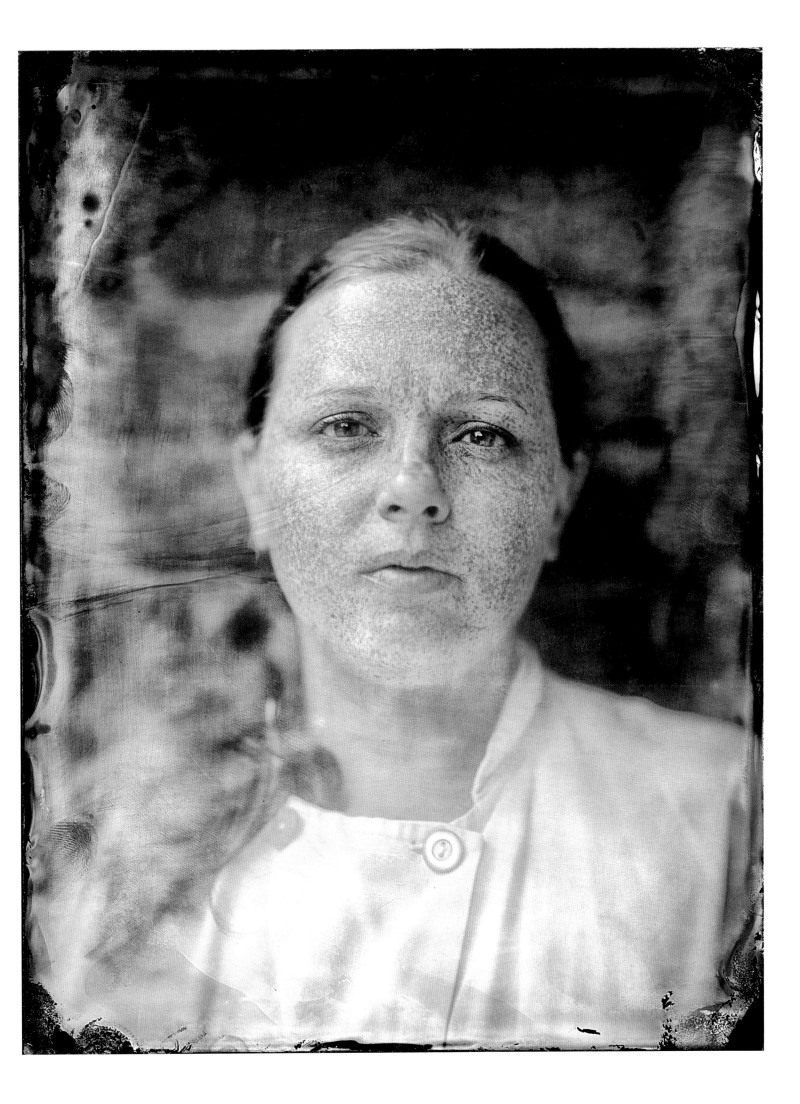

JERRY PEELE

Herondale Farm, Ancramdale, NY

I grew up in a farming community in England. My parents weren't farmers but a lot of my friends were from farming families. I spent a lot of time hanging around farms and helping out on them when I was growing up.

I've always wanted to have a livestock farm. I was in the investment business, and I wanted to make a change. We found this farm and decided that this would be the place. The grass-fed beef movement was picking up steam at that time, and I was interested in developing a herd. I was also interested in the genetics side of it, and producing healthy cattle.

Organic is a natural way of being; everything in nature's order. The real fundamental of the farm is to grow good grass so all the animals can thrive off that. So, we just try to create an environment where that can happen and that's the fundamental grassroots of the whole thing. After that, it's good animal husbandry.

If a customer asks how I farm, organic wouldn't be the first word I would say. I'd say holistic management, or sustainable.

I was originally certified, for about five years, and then it became difficult as I was expanding. It was really the consumer that drove the decision because they were really more after a grass-fed, grass-finished beef, and organic was sort of supplementary. It wasn't as important to them because they were seeing how we were raising the animals and the environment they were being raised in. Having the extra layer of organic on top wasn't really necessary.

I can see why the industrialized food system came into existence. If we could make food cheap, people would spend their disposable income on other goods. I guess that was a way of developing an economy, but now everyone's seeing the downside of it, which is poor health right across the board. It's a very serious thing, like children at a young age being introduced to so many foods that are bad for them, obesity, and other side effects that weren't thought about when it was put into existence. Hopefully as a nation, as a world actually, we'll be able to reverse that.

The most exciting time here is springtime, when we're calving and lambing, it's all very, very busy, but exciting because there's new life coming in.

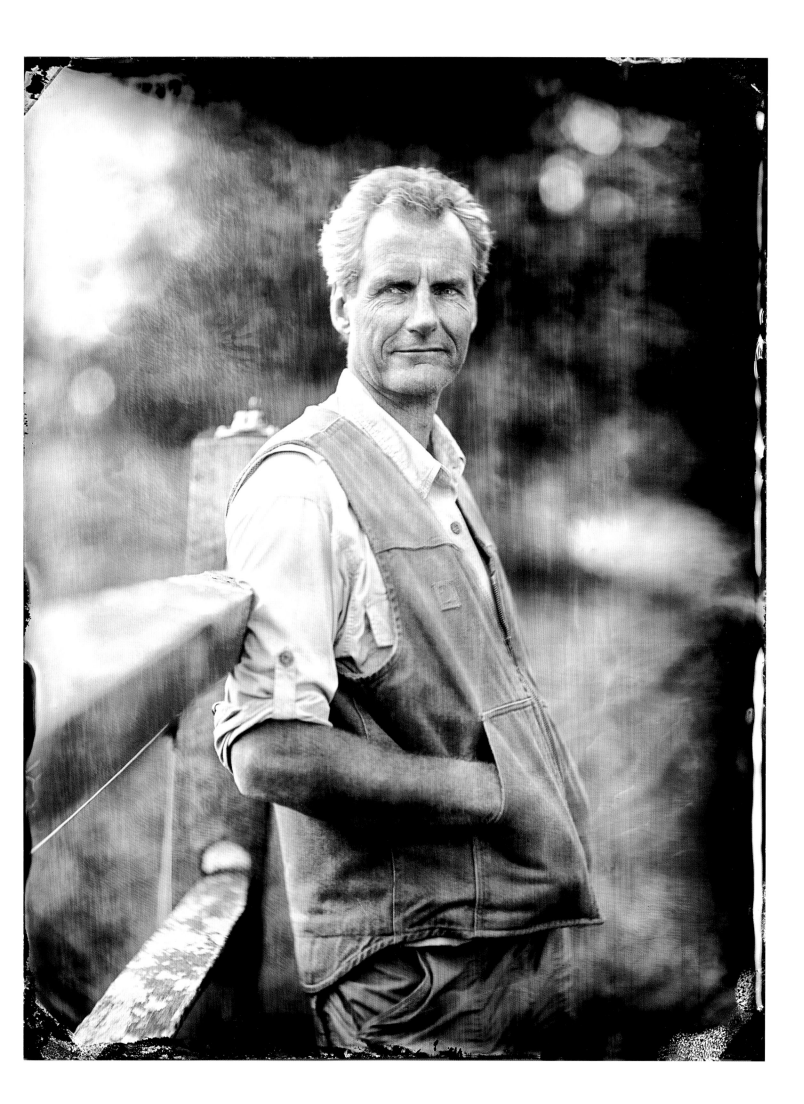

LAURA NYWENING

Peace & Carrots Farm, Chester, NY

I've lived on this farm my whole life. I fed calves when I was little, I showed cows in the fairs in the summers, and I've been farming organic vegetables for three years. This is my fourth year doing it.

Pretty much all my family are farmers. My dad grew up on a dairy farm, my mom grew up right here on this farm, my two uncles now own the farm, my cousin works here, and my grandfather works here. I'm the fourth generation on this farm. We've been here since the 1800s, and the farm is older than that. You could say farming is in my blood.

I went to college to be a history teacher, and when I graduated, I couldn't find a job. I kind of floated around for a little bit, and worked in outdoor education, which I loved. Then I went to work on an educational farm, which I loved even more, and then I realized I could just be a farmer and it went from there.

Organic is a catchphrase that people know and sort of understand. It's very vogue right now to be organic, everybody wants it, and everybody wants to be it. There was never a question for me about how I wanted to farm.

Organic is just letting nature do its thing. Trying to replicate, to a point, what happens in nature. I understand that peppers are not really a Northeastern crop, but when I stick them in the ground I want them to grow as naturally as they can. I don't want to spray them and put chemicals in the ground to make them grow better. I want to do things that nature would do to make things grow.

I think the benefit of being a small farmer in a close community is that I can explain myself and feel good about what I'm telling people. I don't have anything to hide. I tell people that we are uncertified organic, which I think is a good description, unless you know what organic means.

The industrial food system is going to be our downfall. I know that sounds really over-dramatic, but it's killing people slowly—not even that slowly—if you look at kids these days, they just look unhealthy. There are more obese people then ever before. The whole corn situation, and how it's in everything. Everybody who is eating it is suffering, and the farmers are not even making out. It's just a losing system all around.

I think the whole culture of food in America is that it's not important. We don't sit down to eat meals anymore, food doesn't matter, it's just something we have to do.

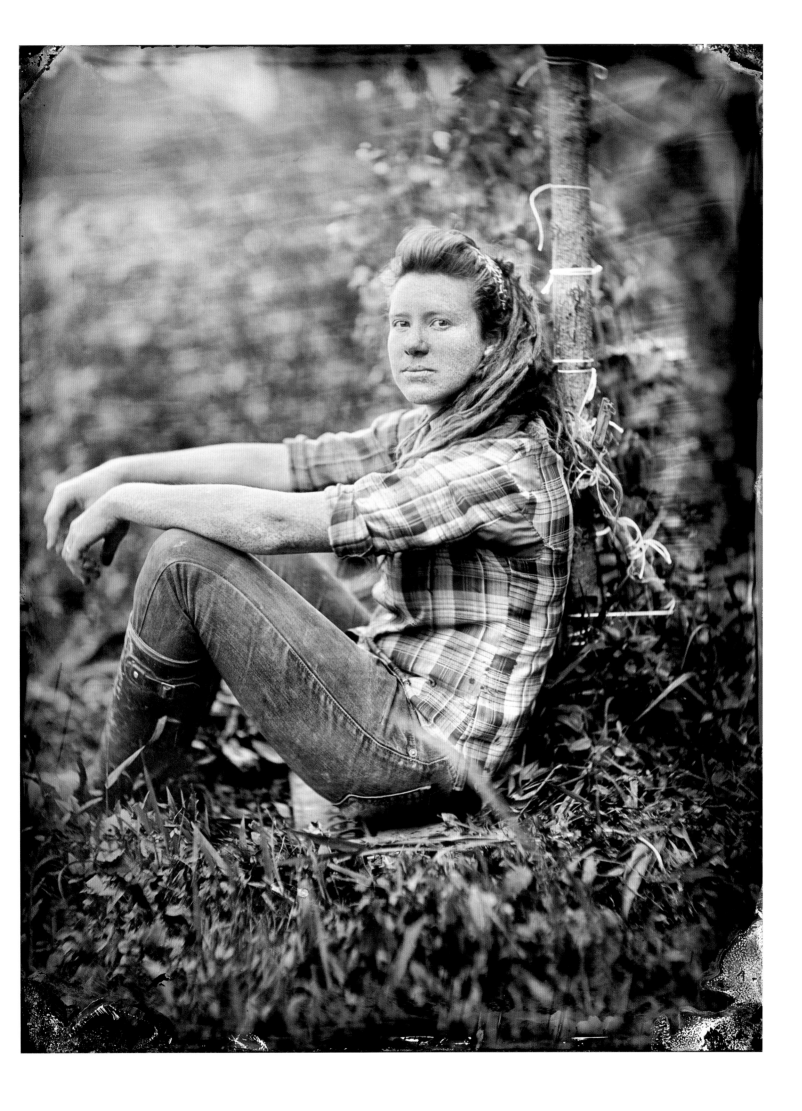

JEFFREY GIMMEL

Swoon Kitchenbar, Hudson, NY

I've been a professional chef all my adult life, since I was 18 years old. It was around 1987, I started senior year in high school working in the local pizza place, I got the bug and I'm still doing it.

The love of food was always a huge part of it for me, but also the atmosphere of the restaurant. I enjoyed being part of a team. The band of misfits you're around was always entertaining and fun.

I was very fortunate to work in the south of France with a great chef, Roger Verge' at Le Moulin De Mougin, when he was there in the early 90s. It was a very informative time for me. He was really the first French chef of that pedigree to showcase vegetables and put them in a predominant place on the plate.

They didn't use the word organic in France, because to them why wouldn't it be organic? Why would you put poison on your food? That doesn't make sense. It's like with genetically modified crops and animals: they don't allow that in Europe, for a good reason. That's not natural, it's not a normal thing.

Organic is a word that almost means nothing anymore. At one time there were very few organic farmers and you could trust what they were doing. But now, some of the biggest vegetable farms in California are certified organic, and they're the ones having the problems with different outbreaks of bacteria. They've become factory farms.

There are consequences when you pump animals full of antibiotics and you spray poison on your food. And we wonder why there is so much more cancer and all these other weird diseases in society today. We've been feeding our whole population poison for the last 20 to 30 years, and now we are seeing the effects of that.

The philosophy here is to work with the local farmers. We go to the farms, we know the farmers, we know their kids, we go out in the fields with them, we hang out, and we talk. You know what's going on.

It makes sense to start with the best product you can, and it's important to know where your food is coming from, what it looks like, how fresh it is, or how long has it been out of the ground. It's only going to make the food you're putting on the plate better. If that's not your end goal, then what are you really doing?

Here in the Hudson Valley you can't go far without seeing a farm.

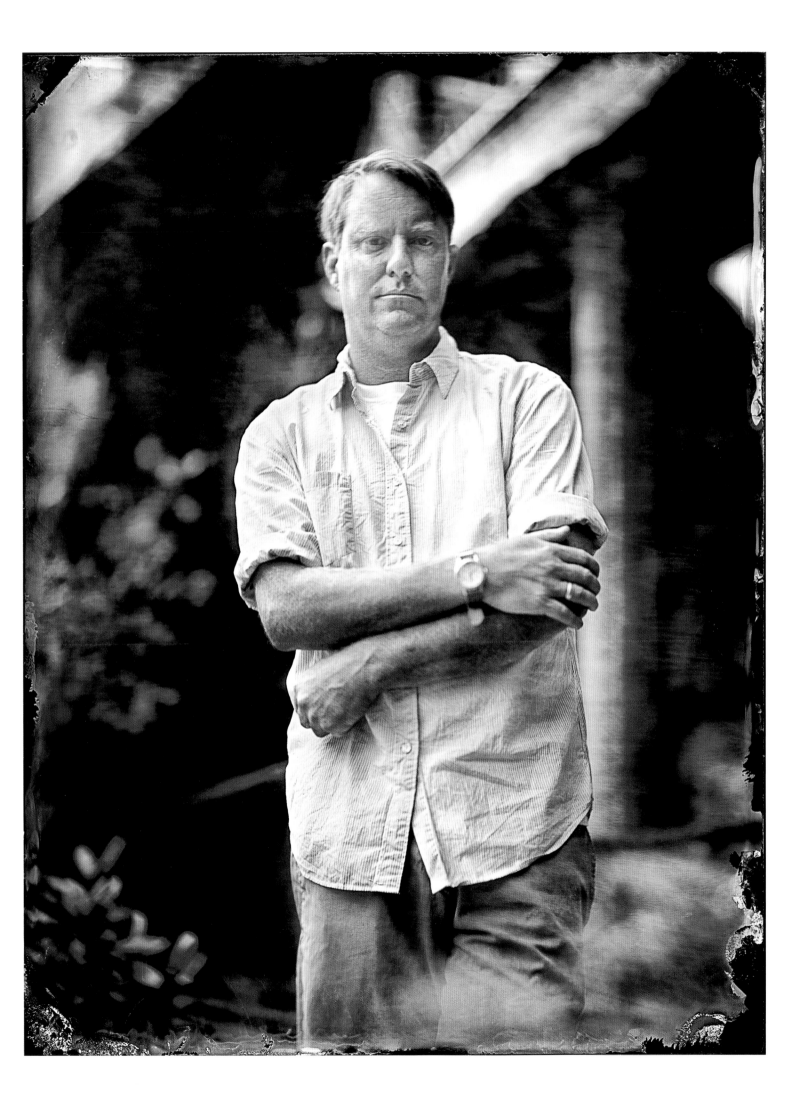

MARNIE MCLEAN
Thompson-Finch Farm, Ancram, NY

This farm has been in my family. I'm the fifth generation. It was a dairy farm and had been rented out since the war. When my grandmother lived here, we would come up every summer for vacations. And ever since I was five years old I talked to her about farming this farm organically. It was always in the back of my head that I was going to come back here, and it's been 30 years now.

Organic is about the earth: the habitat, the hedgerows that attract all kinds of birds and insects, things working in harmony, the health of the soil, health of the people, long term sustainability. It's the only way for the planet.

We've been certified organic for about 28 years. We decided to certify because there were not many people in the area doing what we were doing. We started a "pick your own" business, and selling to stores and a CSA, and people wanted to know what our intentions were. In the beginning people didn't know us and we felt it was a way of showing our integrity. We kept it in support of the so-called movement, but we're not sure if we're going to continue.

When the USDA took over we didn't like it at all. I don't think that the government should be involved in dictating anything to farmers. I think that has been the downfall of the dairy industry. We've lived in dairy country for 30 years and we've seen that it creates a farmer that doesn't think beyond the box, or beyond what the government is going to subsidize. It created a generation of farmers thinking in the box. That mentality started after the war when they started making synthetic fertilizers and giving subsidies.

The Hudson Valley is a great place to be doing small-scale farming. There are a lot more people doing agriculture here now—it's incredible the amount. We could never be here if we wanted to buy this land. We happened to come into a family farm, so my parents were very happy to have us here.

I like that every day is different; sometimes every hour is different. Sometimes, there's nobody here and it's really quiet, and I'll weed for five days. Then strawberry season hits, and there are thousands of people.

Once you get farming in you, it's really hard to get it out.

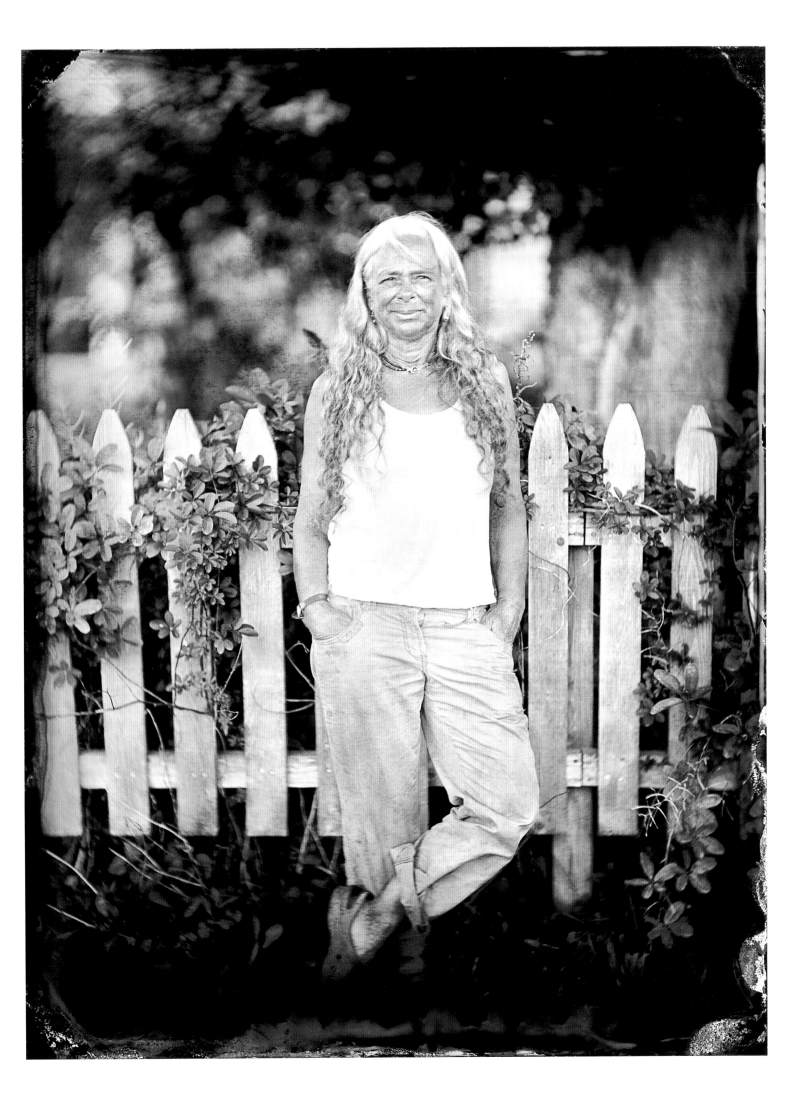

JACK ALGIERE
Stone Barns Center for Food and Agriculture, Pocantico Hills, NY

My family had a homestead in Rhode Island. We had a 100-acre farm. Most of it was woods, but we had goats, pigs, chickens, and big vegetable gardens, all organic.

The University of Rhode Island is a conventional land agriculture school, and that's why I went, to learn about the things that I didn't know: function and fertility. I felt like my role in that was the alternative.

The first thing that comes to mind when I think of organic is the land I grew up on. I think about healthy animals and healthy people. But now, in reality, the word has been swallowed. And while it's an assurance, it's hard to say what it's an assurance for.

When I talk to people about the farm at Stone Barns Center, I say "ecological practices." I like to keep people thinking about the connectivity of the whole thing. Organic just means living. It was a good word before it was redefined and now that it has such a clear legal definition, it's less potent to me than it has ever been.

I expected us to be certified here from the beginning. That's what I was asked to do, to come and run an organic farm. But once we sat around the table and talked about what we wanted to do, it just became clear, any time anyone answers the question, "Are you organic?" and you say, "Yes," it just diffuses the question. It's not really an answer. My shed and the Center are open to 100,000-plus people a year. We don't want to answer the question that way. We want to answer the question with another question that asks, "What is it that brings you to that question? What concerns you about agriculture that makes you want to know whether it's organic or not?"

We also want to show people that there's a farm within a farm, that there are hidden spots of value at this place outside of fence lines. Whether we're cultivating for food, or habitat, it all plays a role in the health of this place. Right now our vegetable variety list is around 500. It's the soil we're maintaining. It's the quality and the return to the soil, and the flavors.

My wife Shannon works with me. She and I have farmed together for years. We also have two boys that are here with us all of the time. It's like a playground for them, they don't think twice about grazing through a space, and that's not something I would be able to do if I was spraying crops, I wouldn't want them to be in there.

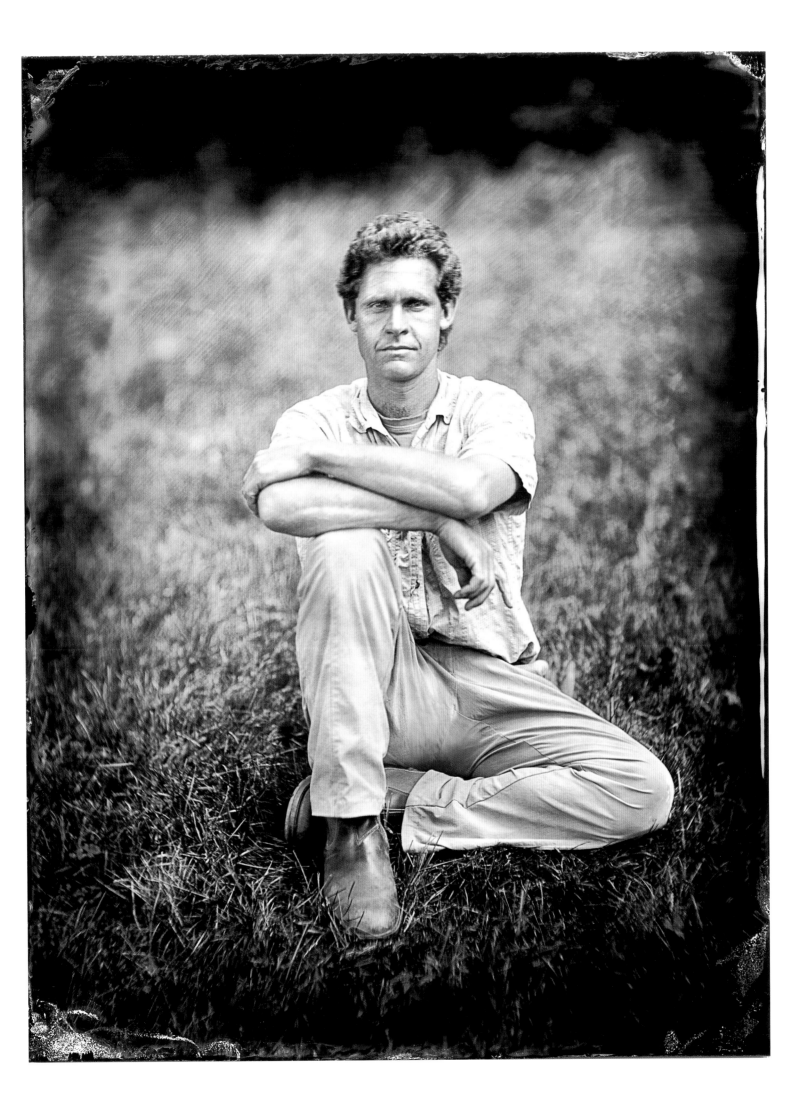

CLAUDIA KENNY

Little Seed Gardens, Chatham, NY

There was never a question of farming organic or non-organic. I wouldn't want to farm any other way. I've been farming since 1994. For me it's the work of nurture. I get to create great food for people.

We have been certified organic from the beginning. Initially when we certified, it was through our trade community, and now it's the USDA. It's a lot different. But the certification is something we do for our customers. There are a lot of mixed messages around food in the world, and it's really hard for people to figure out what they are eating. The word organic can go from a mainstream grocery store, to organic in California, and it's a much different thing. The kind of farming that we do—yes we do grow organically—but we are doing civic agriculture: small farms, small-scale, sustainable practices, and community based. That's a much different thing then buying from a 10,000-acre farm.

People are becoming more interested in good food with good energy, and taking care of themselves. Health is so highly questionable these days, and our food has gone so far away from feeling the energetics of our food system. I think people are becoming very aware that they are being lied to. I don't think our industrial food system is going to sustain us. I don't think it nourishes people, I don't think it can. And it has also created tons of environmental problems.

Organic is following biological principals, farming with nature instead of against it, being a co-creator instead of a control person. It's the whole picture of working with nature, the soil life, the life of the people we sell to. It's culture, it's the bigger picture and not just one small activity.

We have 97 acres. We have a CSA, we do some local wholesaling, but we are mostly a farmers market farm. A lot of beautiful people come and buy food from us. It's a sweet thing.

The Hudson Valley could be a model for having a sustainable food region. It's a very collaborative community, and it's growing.

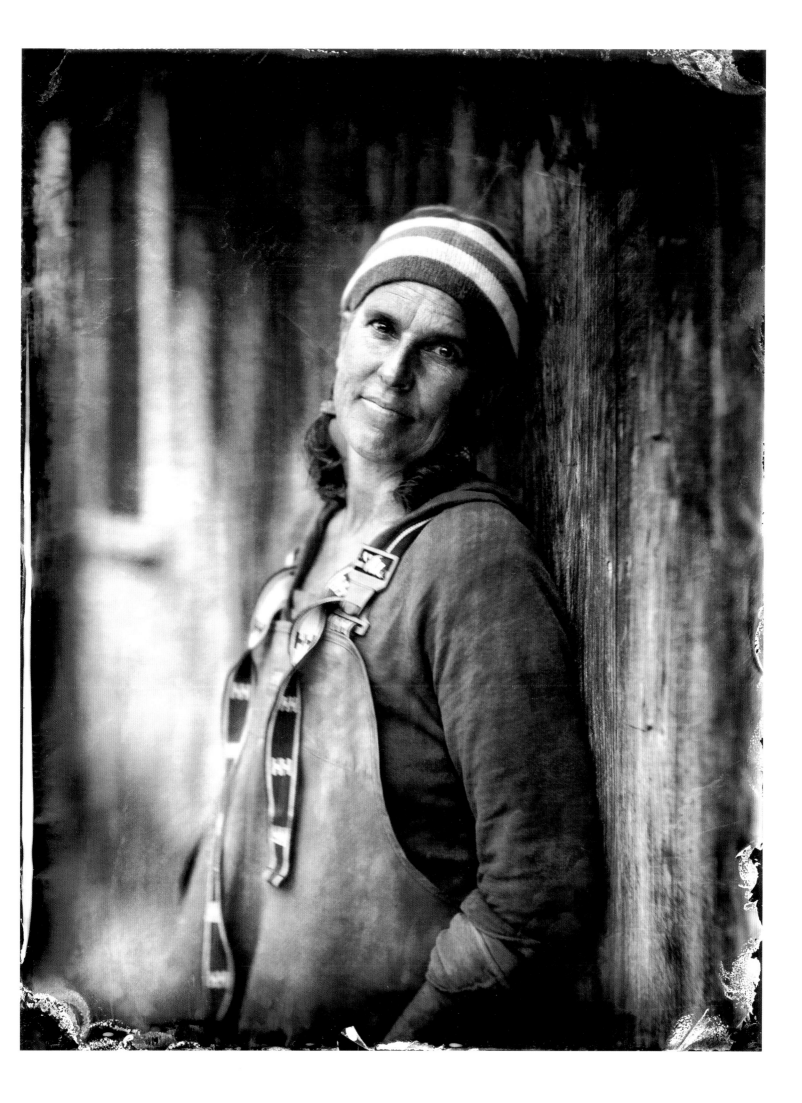

VINCENT MOCARSKI

Valley Restaurant at the Garrison, Garrison, NY

In 1999 I graduated from the Culinary Institute of America and started at the Garrison that same year. In middle school I was probably the only male out of my friends in Home Ec. I started cooking classes back in the sixth or seventh grade, right through high school.

I was introduced to organic foods at the Culinary Institute. I actually did my research project on organic farming and interviewed a lot of farmers and started learning about genetic modifications, the growing seasons, and seasonal vegetables. Researching, I found the benefits of not using chemicals and pesticides are great for the whole food cycle.

Our seasonality is a big deciding factor on our menu. We change our menus weekly, daily. We sit down with our farmer, and I tell him what I want, and he gives us guidelines of what we can and can't do. We don't mass-produce anything.

The whole chain—from coming out of the dirt, to receiving it, taking care of it, to me—we know where it's been. Coming from our garden it's a lot easier. It gets rinsed in our kitchen, right onto the stove, and onto the plate to keep all their nutrients in it, and the guests know that. They see what's going on.

I know where we source our protein. We know where it comes from and the methods of how the animal is raised. We know the animals are well taken care of, handled correctly, and are not being abused.

There are a million spins on the word organic. Now with the labeling of organic, people have misconceptions of the term. Organic is clean food that's not tampered with. Also, everyone is labeling things as "fresh" now. But everything should be fresh.

Doing it right makes the plate better, and the whole experience for the guest better. Sometimes less is more. Just keep it simple.

I love the kitchen; I couldn't see myself anywhere else. It's rewarding, and not to sound like every other chef, but I love to eat.

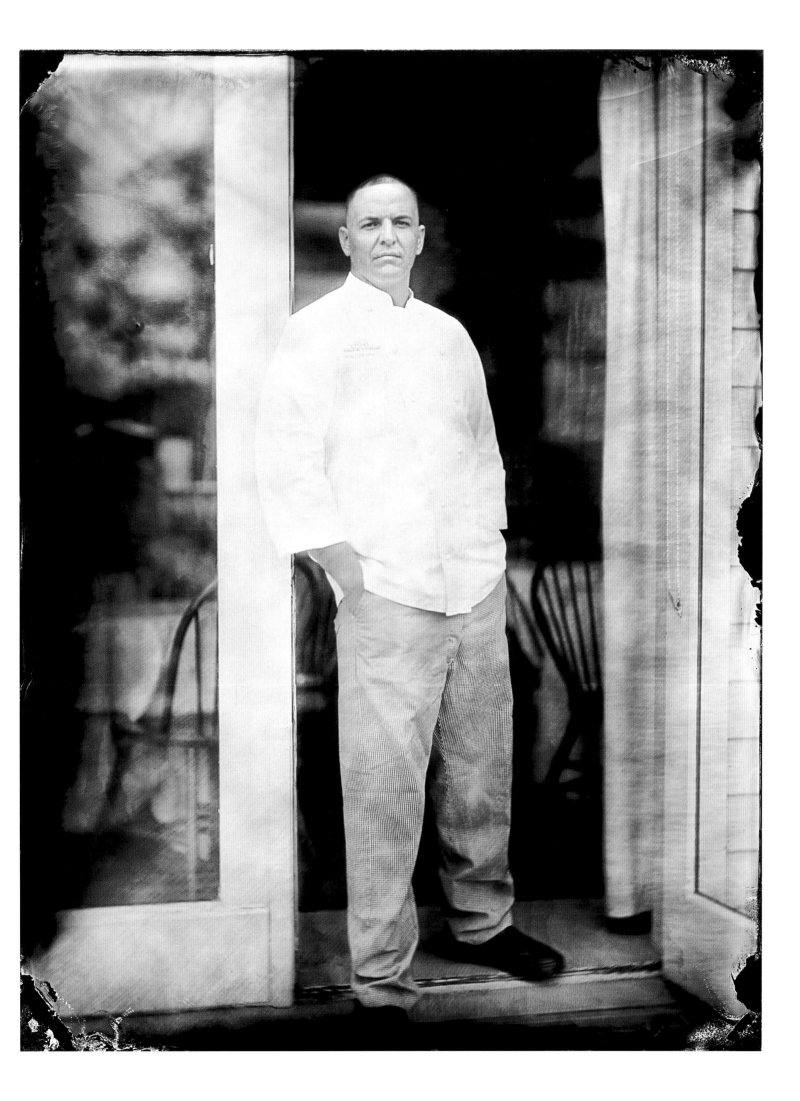

RON HAYWARD
Late Bloomer Farm, Campbell Hall, NY

For 18 years I had a direct mail advertising business that I started from scratch. Eventually, I converted it to a franchise, then sold it and started the farm.

We were certified organic from the beginning, mainly because we were looking to go into a farmer's market to sell stuff. There was really no way for us to get in unless we could distinguish ourselves in some manner. We planned to grow organically anyway, and as long as we were, certification was the way to get into the market.

Organic is something that is sustainable and chemical free. The key is good soil. You don't have to constantly bring inputs from the outside, with the exception of maybe nitrogen sources like manure. I do crop rotations. That really helps keep the disease down. Cover cropping is also very important. Things are more nutritious and the flavor is much more intense when you farm this way.

From a consumer standpoint, the benefit is that you're getting the perceived nutritional benefit without the things that most people would probably agree will accumulate in your body long-term and may cause problems.

As people learn more about inexpensive or cheap food, I think they are realizing that it's not what was promised to them. Ultimately, people want to feel better. This is the baby-boom generation and they want to live to be 100. They are figuring out if they don't change things now, it's not going to happen.

The people involved in organic farming are the type of people that just want to do the right thing. I sense that when people eat stuff produced locally by someone who cares about what they are doing, your body has some way of recognizing that energy.

For me, I wanted my daughter to be able to walk out into our field or into the greenhouse, pick something, put it into her mouth, and feel really good about it. That's what most consumers are ultimately looking for when they buy organic.

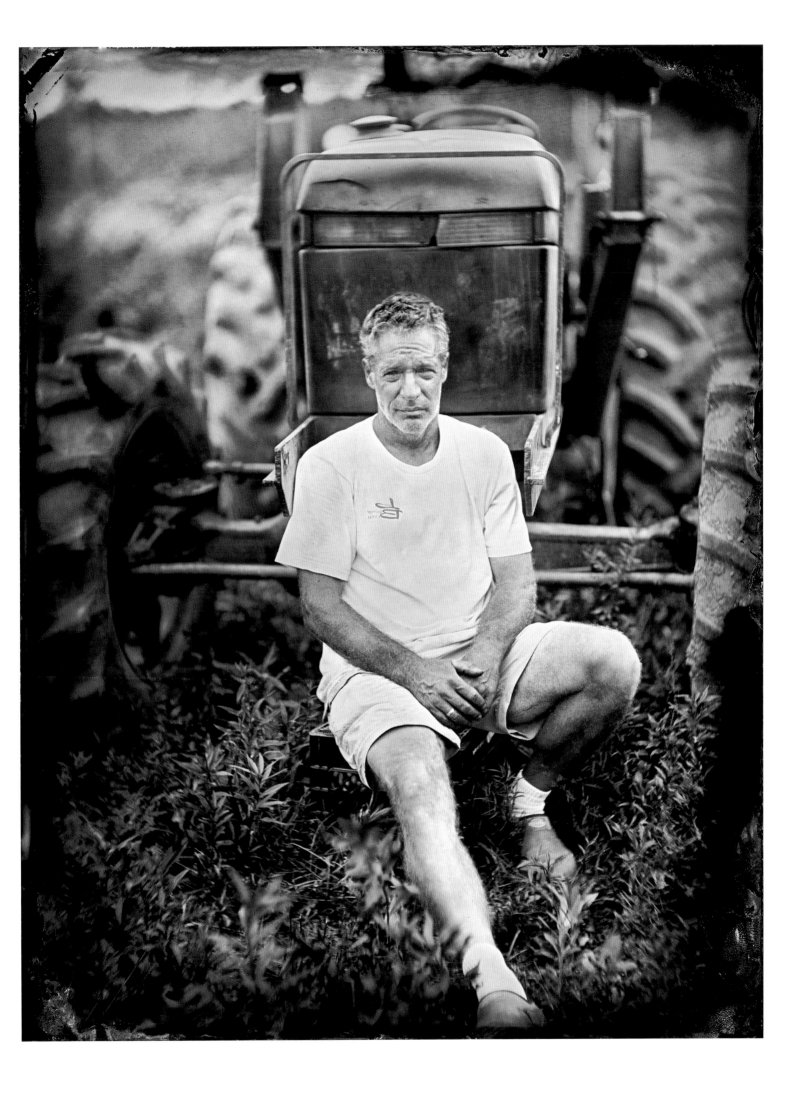

JOSEPHINE PROUL
Local 111, Philmont, NY

Originally, I grew up in California. While I was going to community college, I worked in a fast food restaurant. I ate that food for years.

My uncle opened a food distribution company for organic and local food in New York. My mom asked me if I wanted to move there and I decided to go. I went from working at this fast food restaurant to delivering produce from local and organic farms into New York City. I became engulfed in the culture of sustainability and what we're really consuming.

When working at the Hawthorne Valley Farm store, one of the kids I became friends with gave me this book to read, *Fast Food Nation*. My life dramatically changed after reading that book. I realized you couldn't trust the food system.

Organic means trusting in the system that has been farming since the beginning. It's utilizing the seasons and what grows best. Organic is that you don't compromise the season. It's not ambiguous like conventional is. Conventional is lobbied and sold to the highest bidder. That's why the farm bill has no hope. We pay taxes two to three times on food like soda, chips, and candy—those things have been subsidized. Corn has been subsidized, which we pay for, and then you pay another sales tax on top of that. It's become scary.

I don't know where we went with devaluing food, thinking it needs to be cheap. Do you know how hard it is to farm the land? But now it's so generic. You'll notice when you go to the store, the price of conventional and organic food is pretty much the same. They are realizing they've devalued the price of food for too long.

The perceived value has to be on the plate, and I don't think the perceived value is there for the consumer with the conventional products. I think it looks great, but it tastes like nothing. It just doesn't taste like it's supposed to.

The philosophy behind Local 111 is, first, to source locally and provide jobs locally. Second, is to bring food in that is honest, has a good reputation, and is within four to five miles from here. Most important, we can tell the people where the food is coming from, and we can sell it confidently.

We are lucky there is a lot of organic around here.

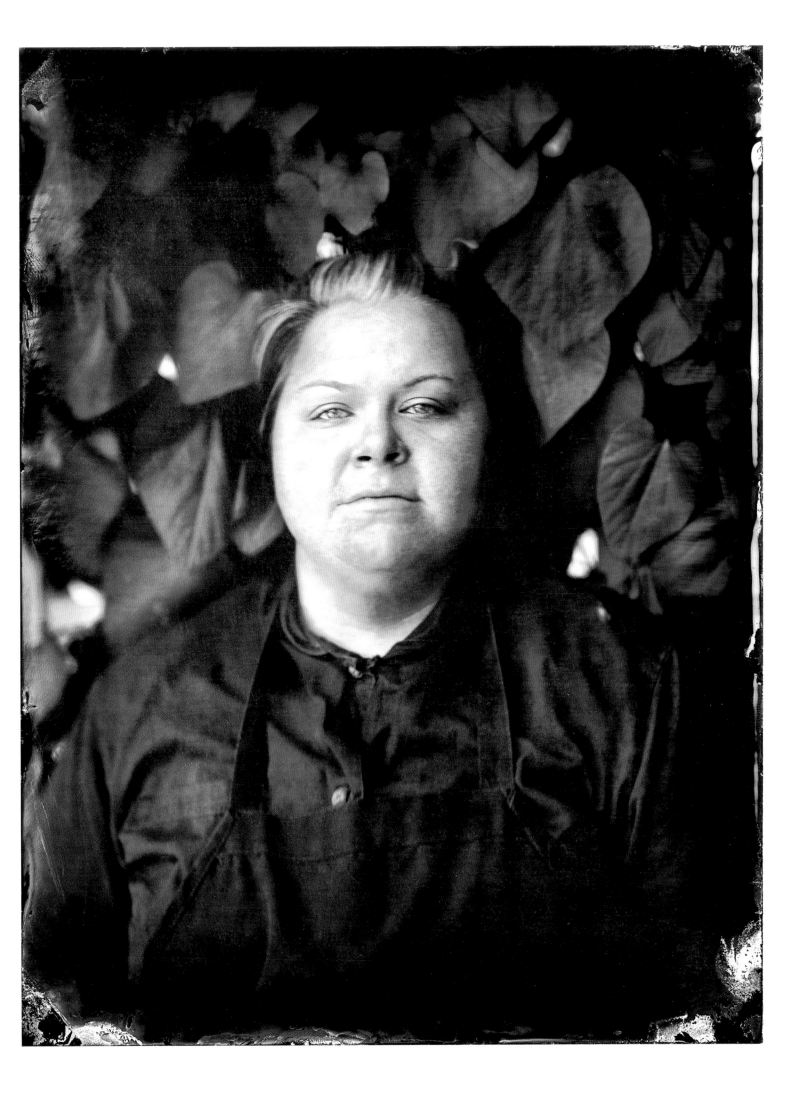

CHRIS CASHEN

The Farm at Miller's Crossing, Hudson, NY

Since I was a teenager I've been working on farms. I just liked being outdoors, driving tractors, picking, harvesting, and seeing the crops grow. I realized I didn't really want to be in an office. I did construction, I worked for a newspaper as a reporter, did some freelance writing, and came to the conclusion that being self-employed as a farmer would allow me to do a lot of the things I liked doing.

The term organic has more of a general meaning than a specific meaning. The general meaning is, you do things naturally, you avoid synthetic chemicals, you cover crop, rotate, try to mix in animals and animal manures, and do all of those husbandry things that you need to do for the land and the animals.

We've been certified organic since we started in 1994, before the USDA and U.S. government took over the term and made it an identifiable, "This is what it means."

There's a difference between doing what you think is right and doing what the law says you can or can't do. Every year the law changes, the chemicals allowed, the list of things you're permitted to use. It's very extensive, and very detailed.

In today's marketplace people really want things to be organic, and farmers and producers realize that. People will pay more if they know it's chemical free, and there's a reason. It's harder to grow, there's more labor involved, it costs more, and it's riskier for the grower.

Being consistent, and being there every year with the same product at the same time is the most valuable thing you can do for your business. And in this business being consistent is really hard. Anyone can grow a beautiful head of lettuce once or twice, but can you do it 25 weeks in a row, in this environment, in this kind of weather? We get thunderstorms, it's 95 degrees, then it's 45 degrees the next night, it's a pendulum. And to ride that out and be on schedule is an amazing feat.

This farm is about 250 acres, we're growing about 50 acres of vegetables, we have a herd of 30 beef animals, we make hay, we grow straw, and we also grow some grains.

We have a big CSA, about 1,000 members. We have wholesale accounts, we sell to stores, to co-ops, distributers, and then we sell at a farmers market in Hudson.

What it boils down to is your relationship with the customer. As long as we continue to produce a quality product, and be consistent, we feel the customer will always be there.

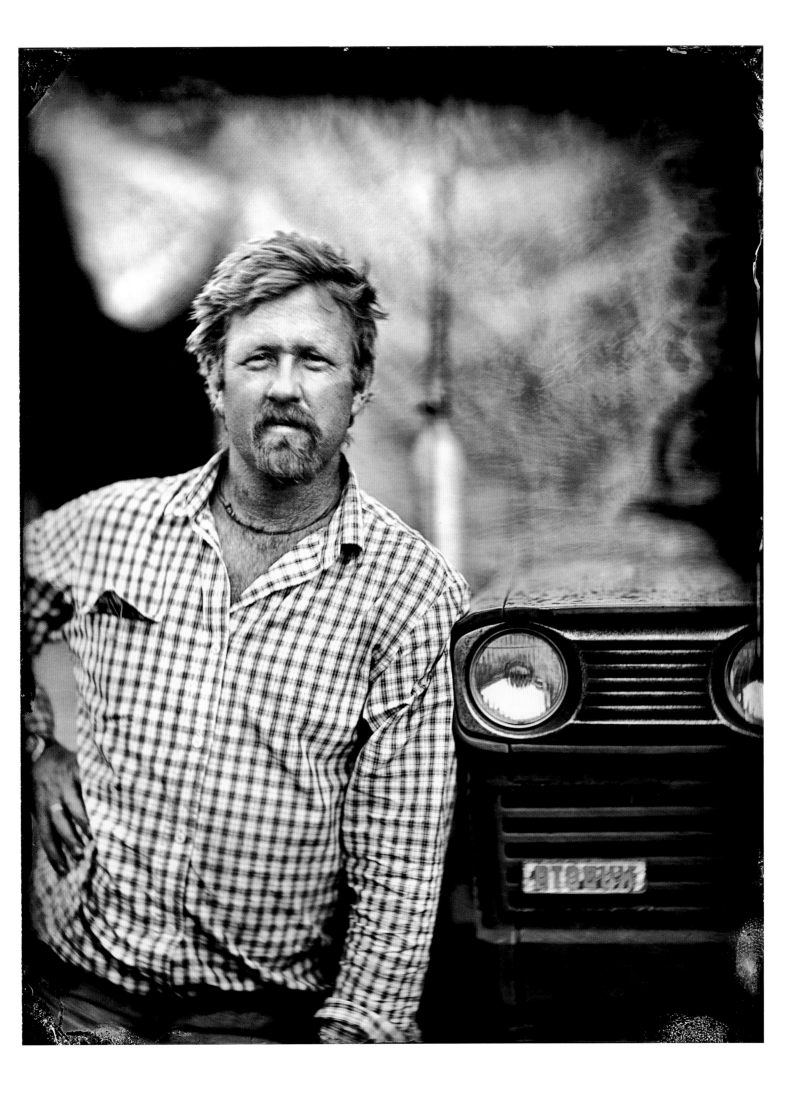

MIRIAM LATZER
Good Flavor Farm, Clermont, NY

The first farm I worked on was in New Zealand. I was 21 years old. At the time, there were four million people and ten million sheep in New Zealand, and I wondered what that was all about. I grew up in suburban New Jersey where there were zero farms. So I was curious, and went to work on a farm in a very rural isolated part of New Zealand, and I was blown away—by the land, the animals, the whole thing—I couldn't believe it.

When I came back, I finished up my college degree, and then went to work on a farm in Minnesota. I left there and ended up going down to Chile and worked on a farm there. Then I came back here to work at the Poughkeepsie Farm Project, and after that for a farmer in Pennsylvania.

Eventually I came back to New Jersey to get my graduate degree because I thought maybe I shouldn't be farming, maybe if I really love farming, I should be working on the policy end trying to protect farmland. But I found I needed to actually be farming.

When Benjamin at Hearty Roots was looking for a partner to farm with, I thought, "Yes!" So I quit the job I had and came back to the Valley again, and was at Hearty Roots for five years before starting my own project in 2011.

For a while I was obsessed about us being a movement. Then I got into thinking about a farm as a business, and evaluating it in a different way. I thought, "Do I really care anymore? How much do I really care about the soil, the health of the insect population, and the watershed?" Then one day, when we were leasing land that we shared with a conventional grower, I watched his crop duster clean his lines close to our fields. I watched this spray slightly mist a very small section of our field, and I just went crazy, I didn't think about my response, I flipped out.

I don't use the word organic. When I give a short answer, I say chemical free. I like to explain to people the differences between something that is certified by the government and a small-scale certification party like Certified Naturally Grown. CNG is organized by farmers; and when a farmer comes here and we do a walk-through and talk about practices and management, I'm actually learning something from that process. As far as I can tell, the one farm I worked on that was certified organic, I know it was a lot of paperwork and you weren't being compelled to improve. As long as you were meeting the basic standards there was no impetus to try something new, different, or better.

I am proud of the product I am selling. As a businessperson it's the most honest thing I could sell.

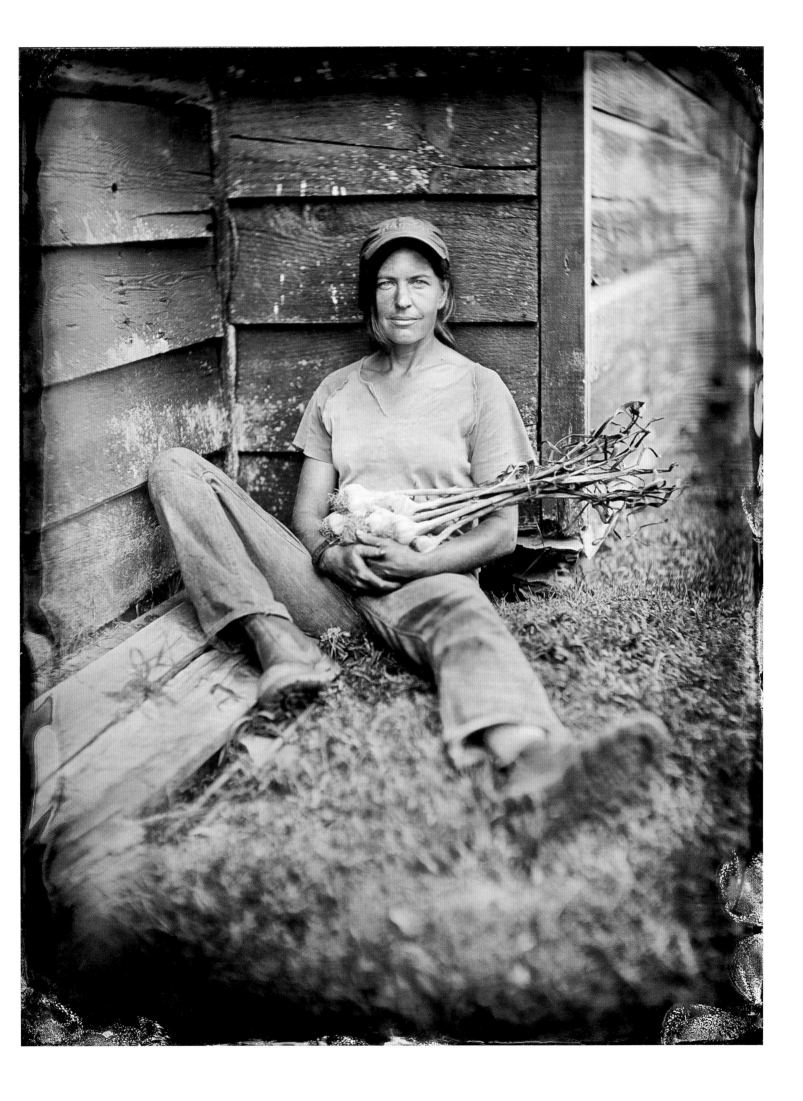

ERIC GABRYNOWICZ

Restaurant North, Armonk, NY

I have been working in the industry since I was 13 years old, and started cooking six months after that. I remember standing in the kitchen with 18 to 21-year-olds cursing and hung-over, playing with knives and fire, and there was such a beautiful dramatic harshness about it. My goal in life was to make this a career and more of a respectable profession for myself, and to educate myself.

The first time I was ever galvanized by farm fresh foods and realized the importance of organic was in 1999 when I was working for Sycamore Farms in the Union Square Green Market. There's always a battle between farmers of organic and non-organic, what's good and what's not good, and why you do or don't do organic. The constant argument educated me as to what food is, and it made me appreciate the beauty and simple nature of organic food and what it does for sustainability and the land for future generations.

I did a lot of research and asked a lot of questions about regulations and the constant battle about what is organic and what's not. I know farmers who are not certified organic that, I believe, take care of the land as well as, if not better than, some organic farmers. It's an encapsulation of care and concern from the farmer down. When you hear the word organic from a farmer it gives you this great sense of the pride and care that they put into it.

Organic foods are simple, pure foods, and if that could translate to the plate, that's what the diner is looking for. There's a certain beauty about what we do and the ingredients that we use. I try to keep the ingredients as simple as possible because they taste so good. Let them shine.

There is something about the passion in any kitchen, anywhere in the world, that's just incredible. It's the dance, there's a movement and a step, and a flow. It's an incredible thing to be a part of when it's going full speed—it's a rush.

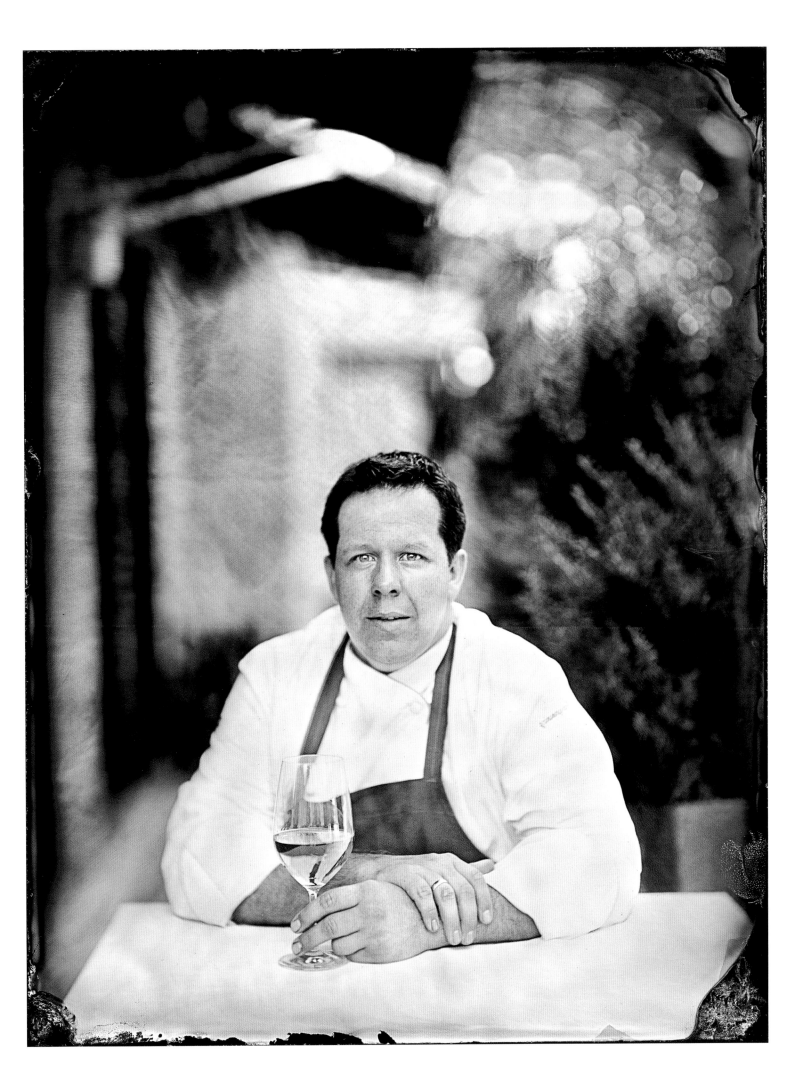

MIMI EDELMAN

I & Me Farm, Bedford, NY

My father was a horticulturalist and I grew up on an estate where I had a sustainable lifestyle. I had a bountiful local foodshed and it was my yard. It was a 20-acre estate in Greenwich, Connecticut, on Long Island Sound. We fished, hunted, and we would forage.

Before I started farming I was working in therapeutic horseback riding. I worked with disabled children and adults using the horse as a therapeutic tool to connect the animal relationship to the human need for healing and connection to nature.

I always farmed organic, my father and I would have discussions about that. But my father's demise was the chemicals, pesticides, lack of knowledge, and the lack of protection as he walked through greenhouses that were filled with smoke for 24 hours to kill every living thing.

In the 70s we began to see the impact of this industrial approach to nature and our food system. I had an understanding; we all read Rachel Carson in the 70s. That became the acceptance and understanding to keep doing organic.

Organic is about good stewardship of the land, and practicing sustainability; using what comes from the land to vitalize it and always putting back. It's using nature's intelligence to work harmoniously with the growing season. This land is agriculturally preserved, and I have a responsibility to make sure that I leave this soil fertilized and healthy, and that biodiversity is respected.

My interest has grown, not only in organic farming, but also in activism and advocacy for change through farm-based education, horticulture therapy, and making sure the food shed is available to all.

My niche on this farm is developing partnerships with chefs. I was an executive chef and understand the culinary arts and farming. I work with chef Jeremy MacMillan at the Bedford Post, and also with Eric Gabrynowicz at Restaurant North in Armonk. They are inspired by what I grow, and they appreciate the palette that I bring. For me it's not the body of the dish, it's what finishes off the dish. I love blending the texture of the salads so there's red and green, bitter, sweet, there's curly, and rounded, there's fragrance.

This food movement has more momentum then ever before. Every farmer I know is selling their harvest and working farmers markets are expanding. The Hudson Valley is a very exciting place.

I cheated death four times in my life, as long as I am above soil this is what I'm going to be doing.

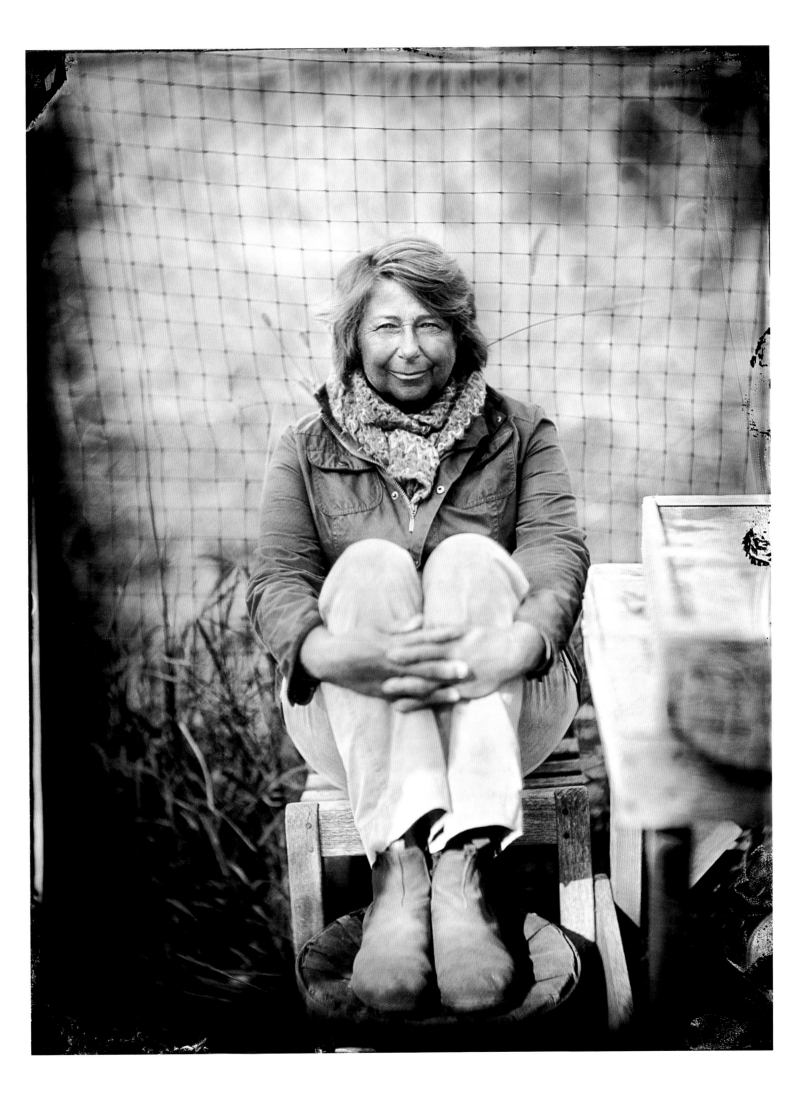

CATHY STROLL

Fresh Meadow Farm, Middletown, NY

Before we started this farm we had a garden behind our apartment in Long Island. We used to sneak in horse manure from the mounted police station. Whenever our neighbors weren't looking we would dig it in. The tomato plants outside our window grew seven feet high.

My husband Bradley and I are both chefs. We graduated from the Culinary Institute in 1978. We have a baking company called Food Gems, and a lot of what we grow we use for ourselves. The basil, tomatoes, and zucchini, that all goes into our pies.

To me, organic is chemical free, more natural, not artificial. Agriculture itself is not natural because we are trying to make nature produce food the way we want it to. On the other hand, I think that there is a way that we can do it with healthy soil. It's about feeding and building the soil, and then the soil will take care of the vegetables.

There are some chemicals that can kill an insect that are relatively safe, but the other kinds are pesticides. Those will kill an insect by just being near it. Insects have been around for millions of years, they are pretty well evolved, they're pretty tough. Whatever will kill them without actually smashing them is a little scary.

NOFA New York is our certifying agency. They are the agent for the USDA, which took over the definition of organic. That was a big revolution. First of all, we have to keep a lot of records. They basically need to know everything we are growing on every field. We have to produce, on-demand, the seeds that we use, records of seed purchases, records of soil amendment purchases (which would be all your fertilizers). You have to contact all your neighbors, and you have to document that, and let them know that you are farming organically and that they should not be spraying on your property. It's a very detailed process.

Years ago, it wasn't called organic, but that's the way it was done—crop rotation, manure, and without the pesticides.

There are so many more people who have asthma now, there is a very high incidence of autism, and no one really knows what's causing it. So we are looking back into our lifestyle. What are we doing differently now, that we didn't do before?

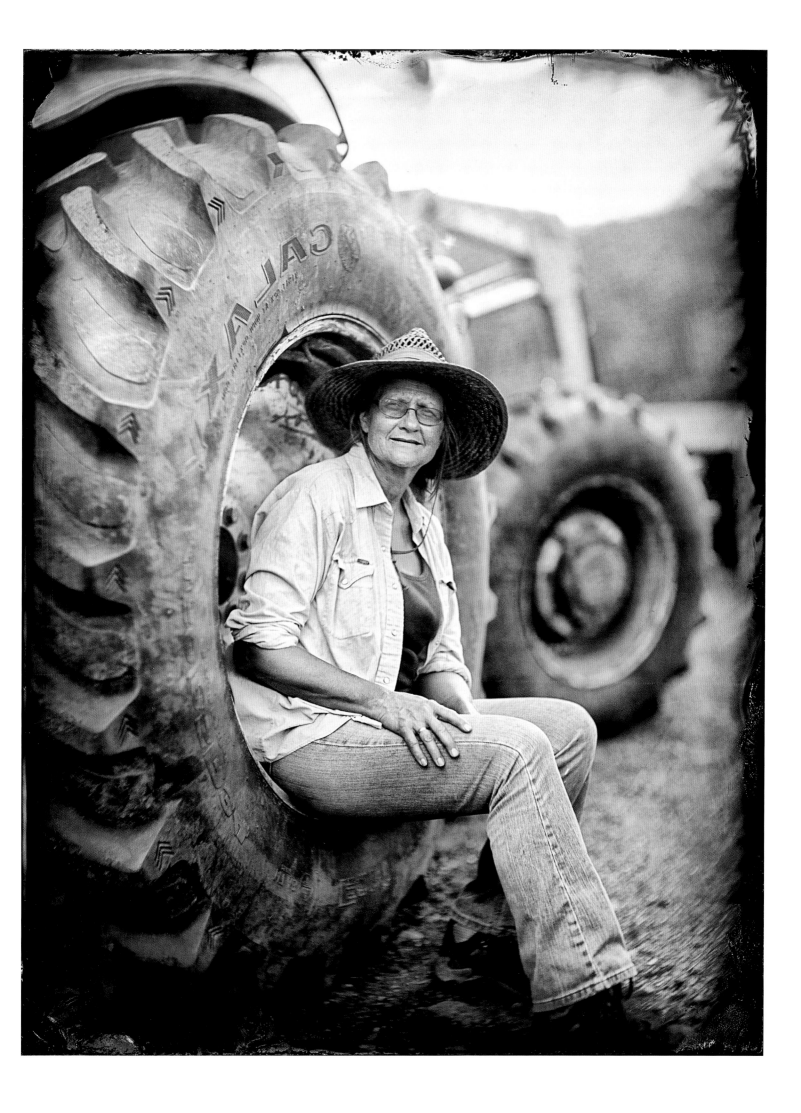

HUGH WILLIAMS
Threshold Farm, Philmont, NY

Since I was 14, I grew up on an orchard in Australia. I was very happy when we moved to our farm there. I was happy because I had been in the suburbs of Sydney and felt like I had been committed to a prison or something. As soon as we moved into the Blue Mountains, I was like, "Wow, we do this for a living?" I loved it. I had an affinity for the land, but the last thing I would have expected was to become a farmer.

After going to the university and then traveling, it came to the end of playtime and I thought to myself, "What am I going to do with my life?" Very unexpectedly, it was like a neon sign, "farming." I was 24 when I decided to be a farmer; I'm 65 now.

Shortly after that time I found Rudolf Steiner's agriculture lectures. So that was a little auspicious. I am so inspired by his concept because it is so counter to the modern idea of agriculture as an input/output system. You develop the fertility out of the inner resources of the farm—that is biodynamic. However complicated or mystical it may seem, that is the fundamental idea, that the fertility is developed out of the own inner-potential of the farm. It is a simple, wonderful idea.

Organic is a word that has been so distorted and so misused. It has been appropriated by government and corporations, and has tended to have lost its meaning now. But, to those of us who have been in it for a long time, it still has a core, fundamental meaning.

The idea of organic is approaching the closed farm system, which is the basic biodynamic idea: an ecological farm. They don't want to be buying inputs just because they are organic inputs. That may be true in the corporate organic world, but that is not true of the people I hang out with. They want the closed system, because it is so beautiful. You have crop rotation, sequencing, and composting developed on the farm itself.

The first year I was here, just for the hell of it, I got the highest level of certification, and after that I just dropped it. Anybody who gets our food knows exactly what we do. I like farming to be based on trust, not mistrust.

This farm was more or less considered a worthless upland farm. But this is some of the richest soil in the country right here. Throughout the Hudson Valley there are nutrient rich glacial till, and when we develop the inner fertility of those soils through biological weathering, the potential to produce is just stupendous.

I would say the Hudson Valley is one of the epicenters of the organic movement.

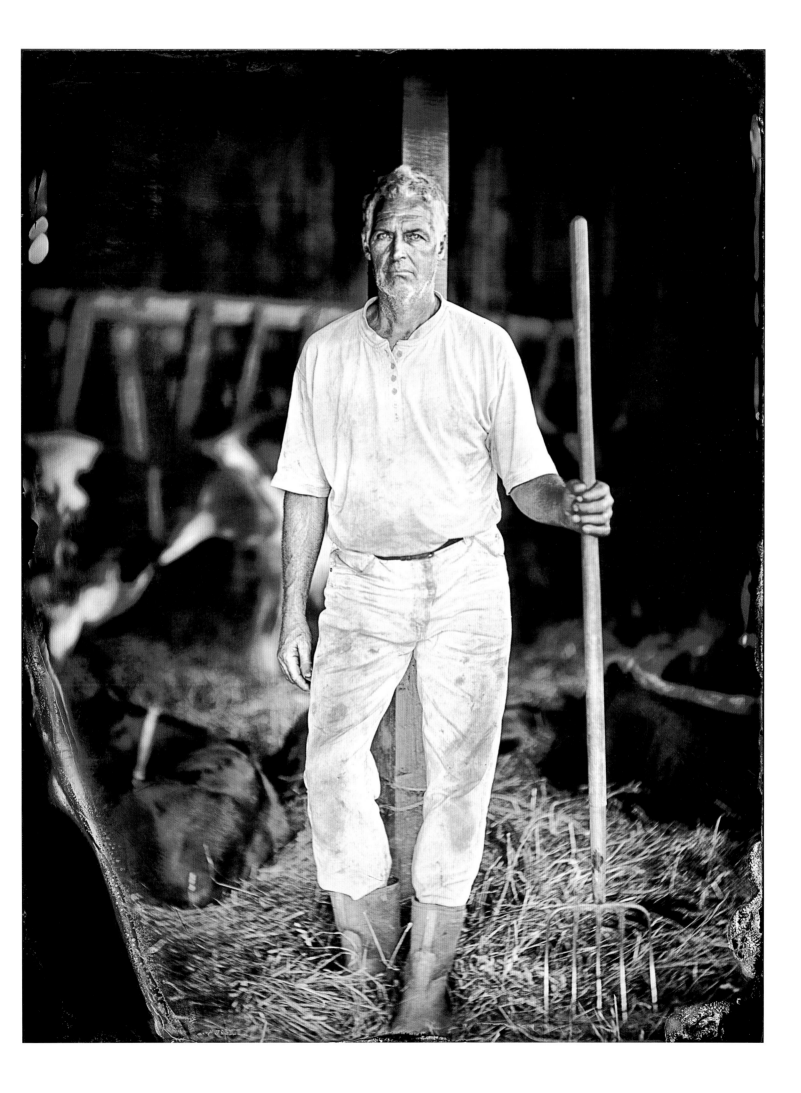

MIKE SCANNELL

Harrier Fields Farm, Schodack Landing, NY

I bought this place in 1982. The prime lending rate at that time was 21 percent. It was the very beginning of the farm crisis.

My grandfather had a farm in Ghent; he farmed until he died. We would visit and work at the farm, and I'd dream about farming.

In the 70s I read Wendell Berry's *Unsettling of America*, and it was sort of a rebirth. I understood that everything we were doing, everything I grew up to know, was not very efficient. The industrial process wasn't anywhere as near as efficient as farming with horses.

I bought a team of horses and spent several years honing skills at my parents' place, and rented land. The next big learning experience was buying this place and thinking that all you had to do is work hard, and farming happens—I was young. I worked my butt off.

I know what efficient farming is. I know that GMOs and confinement hogs, chickens, and cattle are extremely land wasteful. We could feed far more people if we farmed efficiently. An animal that has to go into 150 days of corn to put on any weight could never make a farmer any money. These cattle that come out of the feedlots, if you put them back out on grass, they would die; their livers are gone.

In a quote, Sir Albert Howard said, "Nature never works without animals, never works without diversity, and it returns everything to the soil." That's what organic really is. It's not industrial organic agriculture—that's what I call commodity organic—where you go buy organic fertilizer in a bag and have high input organic, to me that's not organic.

Our goal on this farm is to get the soil somewhere close to where it was originally, possibly even better. There are some guidelines that we go by. I want the soil to be minimum of 5 percent organic matter, and a minimum of 12 percent brix, which is the sugar content, the mineral content of the soil.

I want to see a future in agriculture. It's obviously as low as it can go. The average age of a cow-calf producer in America is 66 years old. The average farmer is 62. It's going to be gone if we don't make a change, and I hope to be part of that change.

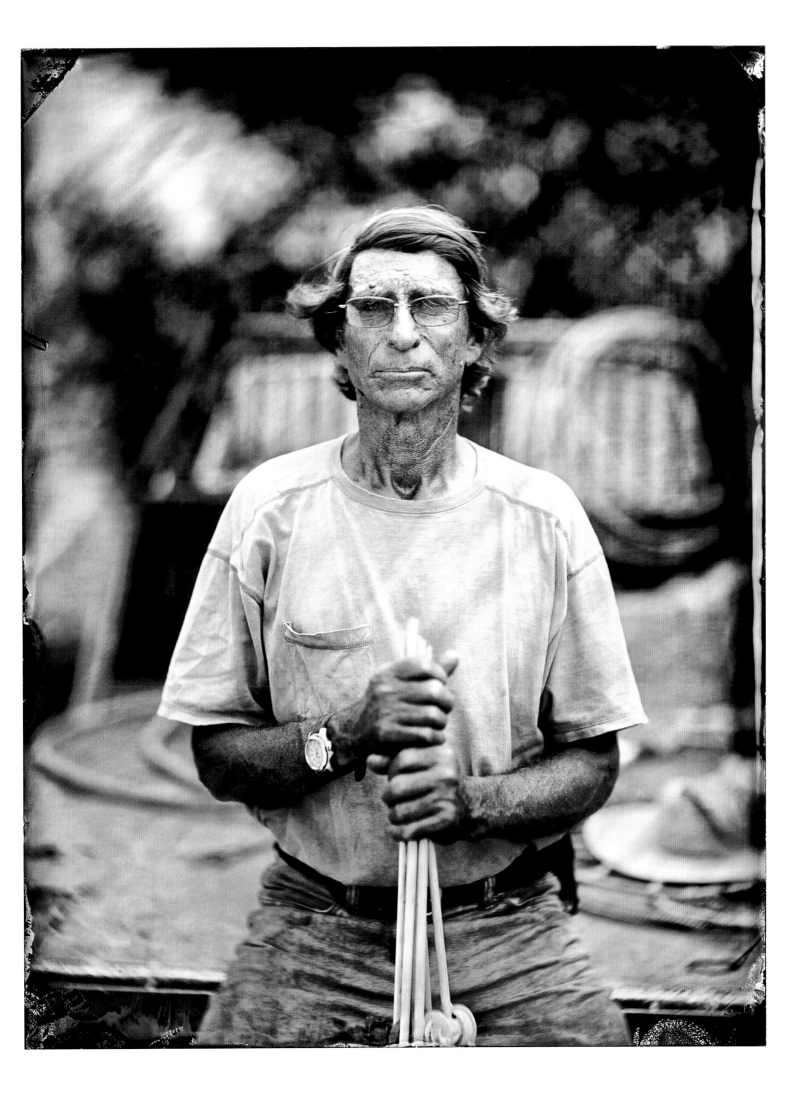

CHERYL ROGOWSKI
W. Rogowski Farm, Pine Island, NY

I grew up here on the farm, sitting on mom's lap on the OC4, the little Oliver crawler. I was five years old and she was teaching me how to use the shifter gears to steer the onion harvester down the field. My grandparents were farmers. My parents were farmers. My great grandfather was one of the first settlers here in the 1800s, and dad bought his first acre in 1955. The farm now encompasses 150 acres in the Black Dirt region of Pine Island.

I would drive my dad crazy about, let's grow this, let's grow that. Finally he gave me five acres and said, "Just go farm it and do what you want with it." That was in the 80s. I've always farmed chemical free, I didn't want to have anything to do with chemicals. I am not USDA certified, we are Certified Naturally Grown.

It really comes down to love and caring. It starts from the land, the soil, and on to the seed that you plant and how you take care of that plant as it matures, how you handle it when you harvest, how it gets put on the truck. Did someone throw it on the truck or place it on the truck? Did they drop a bunch of stuff on the ground and just pick it up and throw it back in the box, or did they do something else with it? And then, how is it presented at the market and to the chef? Every single piece of what you think and care about shows in that little leaf on that plate in the end.

People want to know what their food tastes like. When you allow something to grow at a natural pace it has time to do what it is supposed to do, grow to develop sugars and to develop all the flavors. We talk about *terroir* with our wines but we forget to talk about it with something like our vegetables.

Generally we have about 100 acres in production. We grow several hundred different varieties. At one point the count was over 300. Last year our CSA program had close to 500 members.

In 1998 I created the first low income CSA in the State of New York, in Williamsburg, Brooklyn. Then I established Senior Share of the Harvest, which was a special CSA designed for the senior citizen population. I also became a trained tutor for the Literary and Volunteers of America where I was able to bring tutors to the farm to offer English classes to the migrant farmers.

In 2004 I received the MacArthur "Genius" Fellowship for all the community outreach I was involved with.

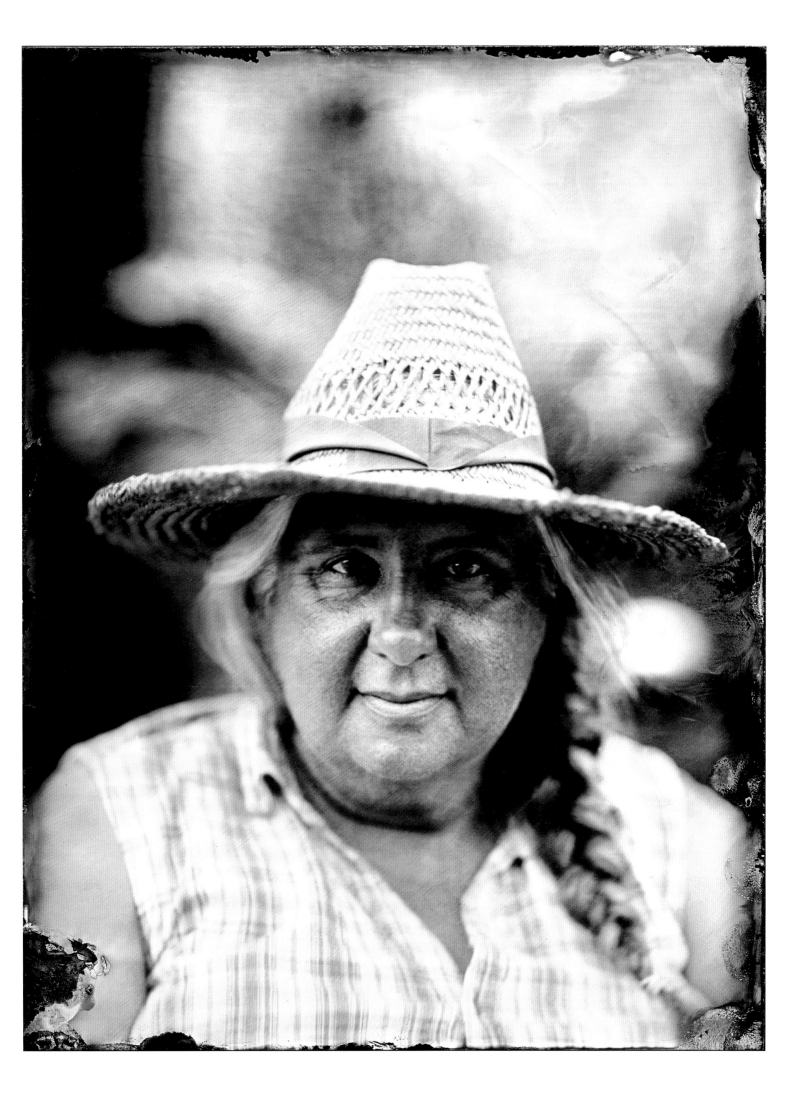

MATT HUTCHINS
The Hop, Beacon, NY

I've been working in restaurants since I was 15. I actually started out doing the books for a restaurant (really, I was plugging numbers into spreadsheets). But then I started busing tables, then washing dishes, and eventually I worked my way up in the front and back. After a couple of years I was the executive chef.

I decided I wanted to go back to school and went to the Culinary Institute. My externship was at Chez Panisse and that really changed me as a chef. It opened my eyes to a lot of things. Farmers were coming in with bags of stuff. They had a forager there and I would go out with them; that was really cool. Then I started doing butchery, which is something that I had never done before. You get these whole animals, and in order to honor that animal, you try to use as much of it as possible. I consider myself very lucky to have had that experience there. It changed how I thought about food.

A lot of my menu now is focused on the animal. I'm so meat driven, that's how my menu has become. In order for me to use all these pieces of the animal, I have to find creative ways to do it. I really like trying to take combinations of flavor, of color, and texture— whether it's sweet, savory, acidity, smokiness—and twist them into something that sometimes shouldn't work. I do a lot of comfort food because of my southern nature, but I like pushing people's boundaries.

Organic is doing it the way our grandparents did. People grew vegetables without pesticides forever. It's only been in the last half-century that it's gotten so bad, and it's not necessary. To me, it doesn't make any sense the way things are done now.

Our food system in the U.S. has been corporatized. We're shipping things all over the country. When you go to Italy, they don't buy from outside of where they are, they're not buying from the other side of Italy. They want to buy from their local guy. They are very proud of where they are from.

Thankfully there's a grassroots movement here. There are great farms in the Hudson Valley, and people support those farms. People want to know where their food is coming from. There is a real push for it, there are people fighting for it, standing up and yelling and screaming about it, and people are listening. That's why it's so exciting.

I have been completely embraced here. People say, "You're doing it the right way, thank you, we're going to support you." It has really blown me away.

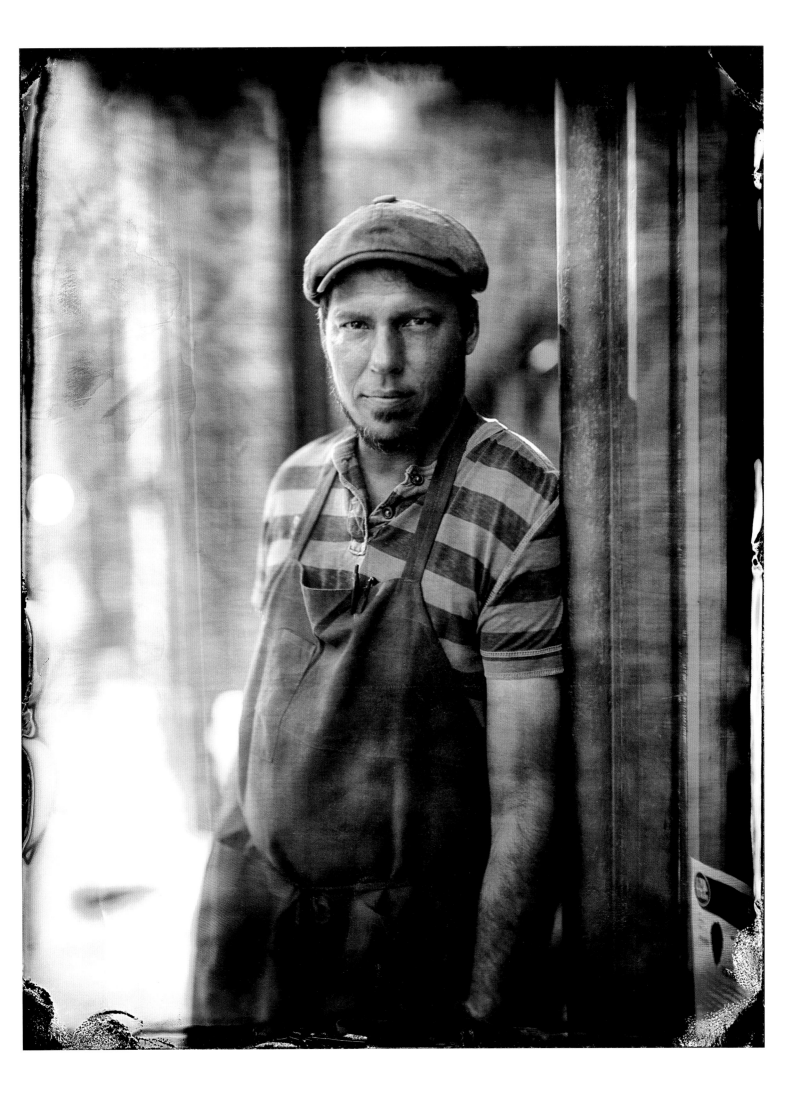

WESLEY DIER
The Local, Rhinebeck, NY

Cooking sort of found me. I had to support myself at a very young age, so I started out washing dishes. When I graduated to prep cook, that's when I found my calling.

After high school I went to the Culinary Institute of America, and right after graduating from there I started working in a restaurant. I have been cooking professionally since I was 20 years old.

My first influence was Larry Forgione. He was known as "the godfather of American cuisine." I worked with him along with Melissa Kelly, who was his executive chef, at both the Beekman Arms, in Rhinebeck, and also at American Place, in Miami. That was really the start for me.

Back then everything was called local: local this, local that. At 20 years old, what's the difference? But the local thing stayed with me.

Five years later I started my own project. It took two years of construction and red tape to open my first restaurant called Forty West. I started with local greens, local poultry, and fresh herbs that I would grow myself. Now we have about 16 farms that we source from.

I think of organic in the more pure sense of the word. Organic should be honest, authentic, true, pure, unadulterated, and as natural as it can be. Generally speaking, I don't use the word. I think it's overused. But, organic is one of our main draws here. Now, people want to know specifically where things are from, so I decided to put the names of the farms I use on our menu. We're not hiding behind a kitchen wall here, so what you see is what you get. It's another organic experience.

When I am looking for ingredients, besides the obvious freshness and seasonality, they also have to appeal to the customer. The organic I am looking for is honest and authentic. There needs to be a face behind the product. When I go to the farmers market in the height of the season, it's like being a kid in a candy store—it's hard not to buy everything. We also source 100 percent of our protein locally. It's more expensive, but I would rather pass on this awesome product to our customers.

It's pretty incredible being a chef here. Besides the small farms and the bounty that is the Hudson Valley, the region is also being recognized.

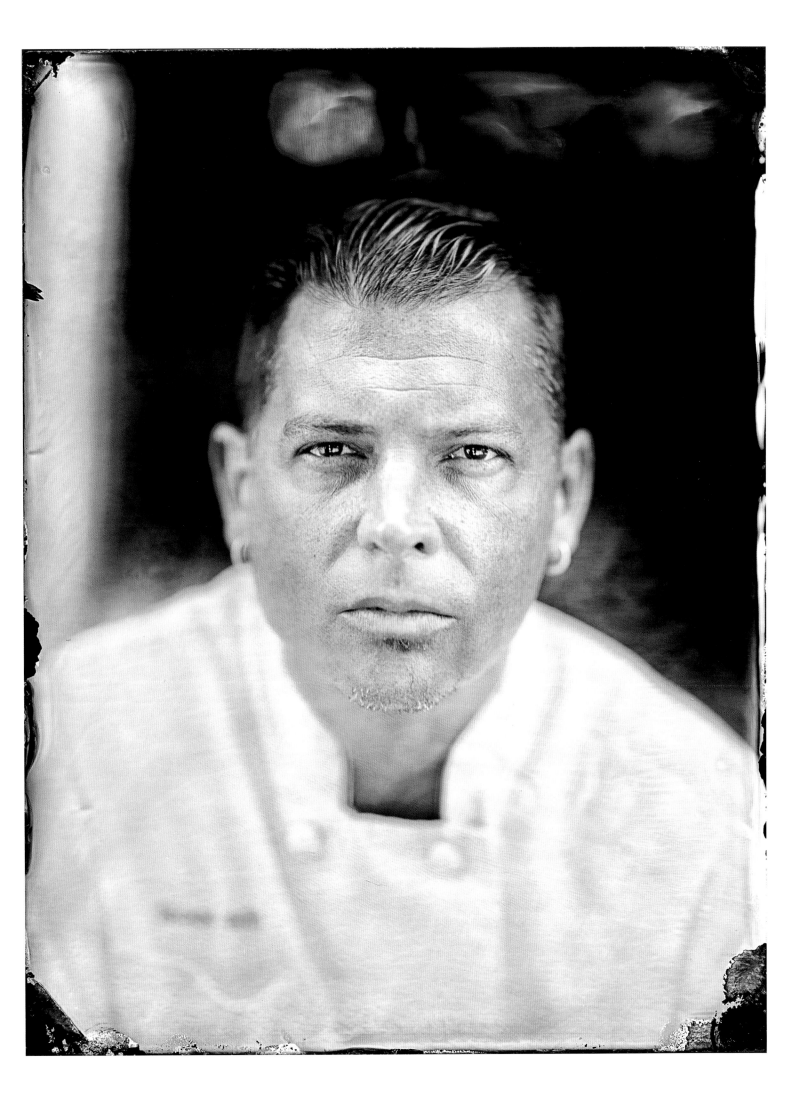

ALTON EARNHART

Lightning Tree Farm, Millbrook, NY

My background was a little bit alternative. On one side of my family, I had a grandfather who was an organic farmer, and on the paternal side, I had a grandfather who was a conventional farmer. So, farming came honestly for me.

I went to school for photojournalism. When I found out I just wasn't cut out for being a photographer I had to fall back on whatever came. In 1995 the opportunity to farm organically at Elizabeth Johnson's Lightning Tree Farm was a chance to use my background in a career I very much enjoy.

We were Certified Organic fom 1996-2011. I thought the idea of certifying was to describe to somebody what your practices were, and to put a label on what you do. Then when the rule came out, it was the idea that everyone had to do a minimum amount of achievement to become organic.

It has been a lot of work over the years, trying to figure out what organic is, because it's something that each person has a different take on. You have to show people what you're doing for them to understand. If you're not meeting that person face to face, then the certification gives you a certain amount of legitimacy. Unfortunately, it didn't develop the way I expected. Today, I don't think organic has gotten any easier to define.

For me, the largest stumbling block in this process is my realization of just how difficult it is to make an agricultural business successful. It's such a fine line between being able to make it stay current and stay popular, and on the other hand, stay true to what it is you originally supported. Most of what we do now is produce animal feed and that just keeps getting bigger, and keeps getting me grayer.

The idea of producing food for the metropolitan area has been going on for a long time, and so it's seen upswings and downswings, but it has history and there's a lot to be tapped into. One of the most important things now is how to take advantage of the land that's already here. It's best to get young people who have an interest in farming connected to that land, and how best to make it profitable to farm. Good farmland is something you want to keep going and take care of.

I like to be a part of growing what I eat and sharing it with other people. It's a natural thing to do. It's not the same experience eating out of a box as it is when you get together, create something together, and share a meal. That's why people get together.

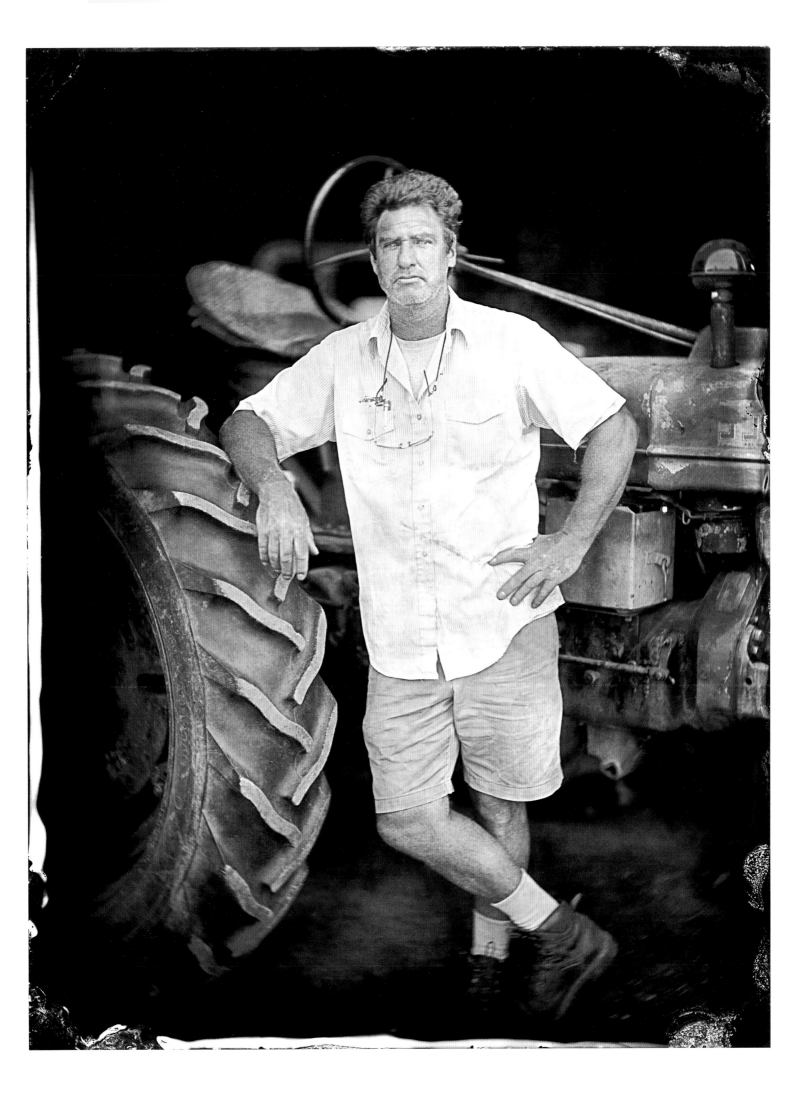

TIM HEUER

Obercreek Farm, Hughsonville, NY

When I was in college I needed a job and found a flyer in one of the halls that said, "Do you know where your food is grown?" and all it had was a phone number. It ended up being a student-oriented farm, which was a ten-acre, year-round CSA attached to the university. So I went out there and started volunteering.

The first thing that comes to mind when I hear organic is something that is pure and natural. Our growing methods are ecologically based. We've never sprayed anything. We are part of a network of farmers who adhere to a list of really sound ecological practices that are trying to put the land in a better place, and the food in a really safe place.

The marketing of food is changing rapidly right now, and that's forcing farmers to figure out what their niche is going to be. You can't just grow corn and soybeans anymore. If you are counting on two crops for the livelihood of your farm, and one of those crops is struggling, you may feel the need to help it along with whatever means you can. The ideal is a diversity of crops with really healthy soil, to help you avoid those things that are a slippery slope in terms of chemical usage.

This year we're going to be about a 100 family CSA. 95 percent of those families live within a few miles of the farm, and 100 percent of them come to the farm to pick up their food. They know who we are, and we make sure they know they can ask us anything they want about our growing practices. They have just as much right to be out in the field as I do. The gate is never closed for them, and we tell them all this at the beginning of the season. This is the reason you are part of a local farm.

I don't think there is any reason why most everybody can't have some participation in the growing of their own food. That would be a much safer, healthier, system to me. Instead of putting it all in the middle of the country, under a couple of guys' watch and saying, "Produce the most stuff, the fastest, quickest way you can crank it out." There's all these food scares now, that's another thing. Exposing that system for what it is, is hard to do, but is going to be increasingly important as people want to understand more about what they are putting in their bodies.

In my wildest dreams I can be a farmer for the rest of my life.

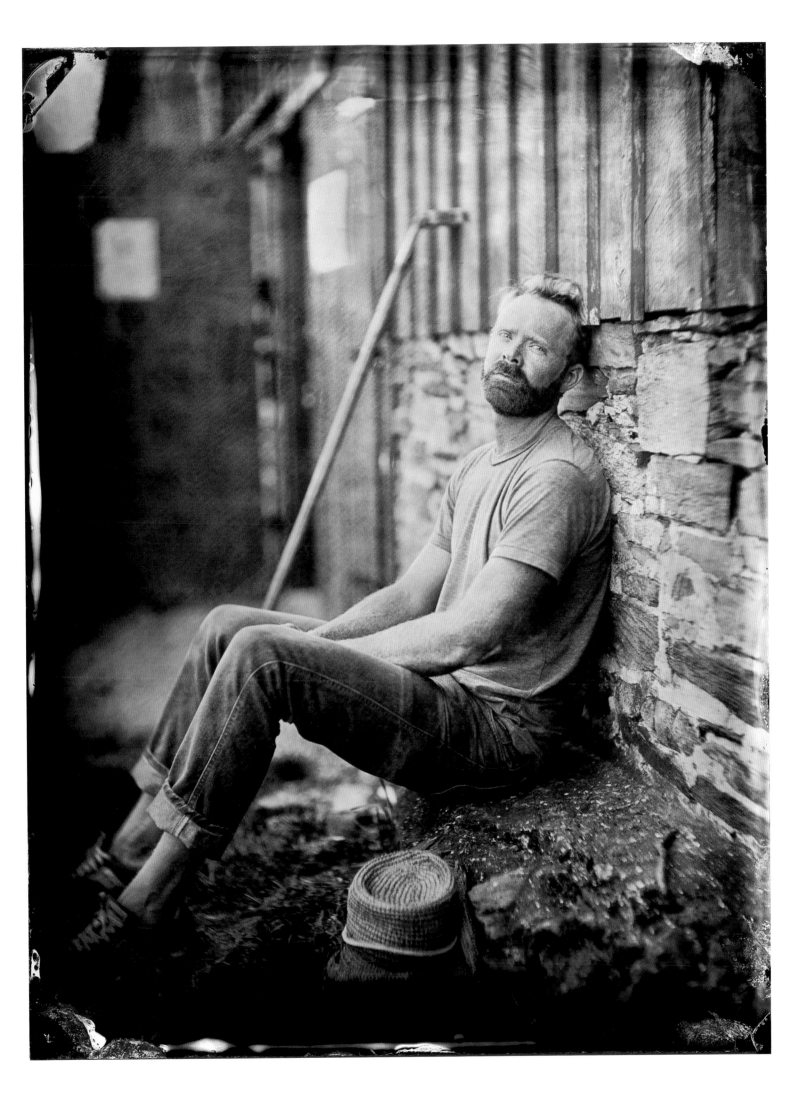

ROBERT TURNER

Omega Institute, Rhinebeck, NY

I never thought I wanted to become a chef. I went to Rutgers University for a semester. I wasn't happy there, so I left. I thought about it and applied to the CIA in Hyde Park. On March 2, 2002 I graduated with a bachelor's degree, and April 1 was my first day at Omega.

I like to say that Omega has quietly supported the local organic movement for 30 years. Omega is a holistic retreat and conference center founded by a group of people who really believe in supporting organic. My kitchen and dining hall team cook and serve over 300,000 meals a season; that's 600 people, three times a day.

Omega has enabled me to establish relationships with local and organic farmers. When a grower walks through the back door with cases of stuff and shakes your hand and looks you in the eye and says, "Let me know what you think," it's that pride that people feel. One of the great things about creating these relationships is knowing where your food comes from.

I don't care if it's stamped organic. In terms of a sticker on a piece of produce, it means very little to me. Years ago when the USDA took over the word organic it really lost its meaning. Many small farmers don't get certified because they can't afford it but are more organic than most.

These days we don't give food enough recognition for our health as individuals, our health as a community, our health as a nation. You don't have to be an expert to know that the state of nutrition in America is dismal with an over 40 percent obesity rate. We have a food system that predisposes more people to chronic diseases than any time in the history of the human race. The problem for us as individuals is that we're susceptible to marketing. We are susceptible to salt, fat, and sweet. Bigger seems to be better in that system.

There used to be a time in the urban centers and in the cities where the corner store was a grocery store, where you could go to get fresh produce. They also had guys who walked around neighborhoods with carts where you could buy whatever was fresh. Now the corner store is about selling cigarettes, liquor, potato chips, and lottery tickets. The industrialization of food, I don't know, I think we were sold on something that wasn't true.

As a chef, if I can hit a few bullet points on a list—local, organic, fresh, nutritionally sound, tasty—and my guests go, "Damn that was really good," then I'm over the moon. To do that, hopefully every single day, three times a day, that's what's exciting to me.

It's funny, for a couple years I didn't think I would continue being a chef. Now, I could see myself doing this for the rest of my life.

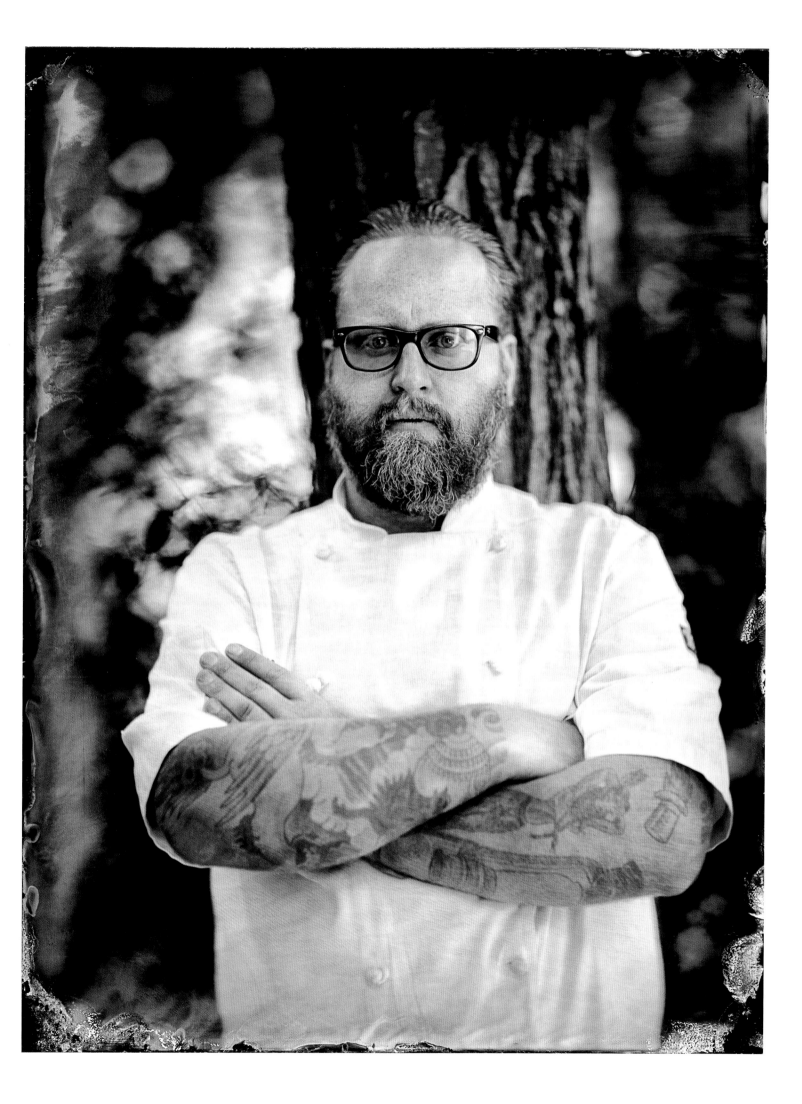

KEN KLEINPETER
Glynwood Farm, Cold Spring, NY

As I describe it, I basically fell into a farmer's trance. I grew up in rural Louisiana. I milked a cow by hand when I was a teenager. We had a big garden. We had chickens and pigs. My father and his brothers had a few hundred acres of fields and swamps behind our house, and they had about a hundred or more practically feral cattle. I kind of go that far back. That being said, I never thought I was going to be a farmer.

When I was 25, I left Louisiana and moved to New York City; that was back in 1979. I was a songwriter and musician. In 1987, with my business partner Joan Schneider, we got a farm in Columbia County, and started what was the first sheep dairy farm in the United States. In 1994 we sold that business to Tom and Nancy Clark, and they hired me to set up Old Chatham Sheepherding Company, which I did with them. I ran Old Chatham for ten years, and it became the largest sheep dairy farm in the United States.

I don't even like the word organic—we don't use that word here. Our vegetable operation is Certified Naturally Grown, and we certainly don't use any chemicals on our pastures or hay fields. We do some soil re-mineralization, and we are primarily using nutrient recycling through good composting. Basically, the base of what we are doing is building topsoil for the future, and if you are a chemically based farm, you are almost by definition not building soil for the future. To me that's the critical thing.

The conventional farms have it down. You plow at this time, you spray herbicide at this time, you plant the GMO seeds at this time, and then you come back and put on the next herbicide. It's not a biological system; it's an industrial system. I think once you start imposing an industrial system on a biological process, ultimately you are going to have a train wreck.

Instead of stepping back and saying, "Lets do things in harmony with nature and we won't have all these problems," they just say, "What's the next technological fix?" They're thinking about producing the cheapest food possible, and that is not a system that is sustainable.

I've never worked on a conventional farm and I never would. I just don't find it interesting to farm that way. I always love it when I'm talking to people that promote industrial agriculture, and we talk about our systems, and they go, "That's great, but how are you going to feed the world?" I don't have to feed the world, I have to feed my community, and someone could feed their community, and someone else could feed their community. That's how we're going to feed the world.

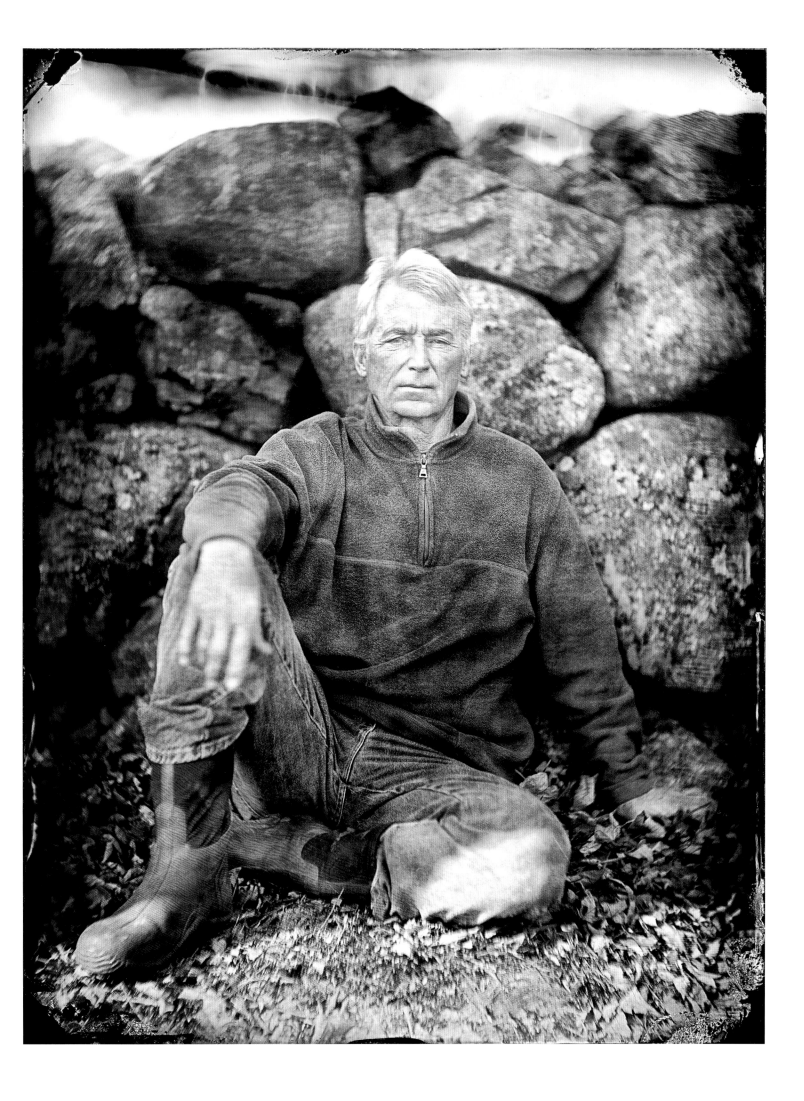

GAR WANG
Gar's Den, Warwick, NY

Ever since I was a kid, I've always preferred to be outdoors. As a child I always gardened with my father. I learned a number of things from him. Part of the importance of those years working in the garden with him was a sense of peace and time together.

I always felt in my previous life I must have been Native American. I felt a great empathy with their feelings about life and about nature, and living their lives entwined with animals and plants.

Organic is a serious issue. This is the life of the planet. When I think of the term organic, I think wholesome, healthful—not just in terms of our own bodies but in terms of the environment.

I am very sensitive about how much I take from the land. I don't use pesticides because I don't need to and prefer not to. I feel that it's OK to lose certain crops each year. It makes no sense to be putting all that energy into growing food if you are going to be consuming poison. You just follow very simple, old-fashioned methods.

Farming and gardening teaches you to be patient with yourself, and that you can't fight nature—you can't conquer nature—and you cannot control it. If you have the attitude of being able to control nature, then forget it, because you'll always lose. There's always some variable that you cannot control.

It's very, very scary, this thing about GMO seeds for soybean, cotton, canola, and recently alfalfa. These are the basic foods that we feed our animals, which we then consume. It has penetrated the entire food chain whether we like it or not. The fact is that it is destroying our environment and creating health issues: high incidences of cancer, autism in children, attention deficit. All of these things are interconnected with our food.

It is so gratifying and fulfilling to work organically, to live organically, and it is far less disruptive. Organic is fresh food, better tasting food, food that you grow with your hands so that it feeds you and your life.

Things are different every day. That's the pleasure of growing food and the passage of time. I feel that my life has now come in a nice circle, and that I am able to lead a lifestyle that is sympathetic to my understanding of the role of nature in my life.

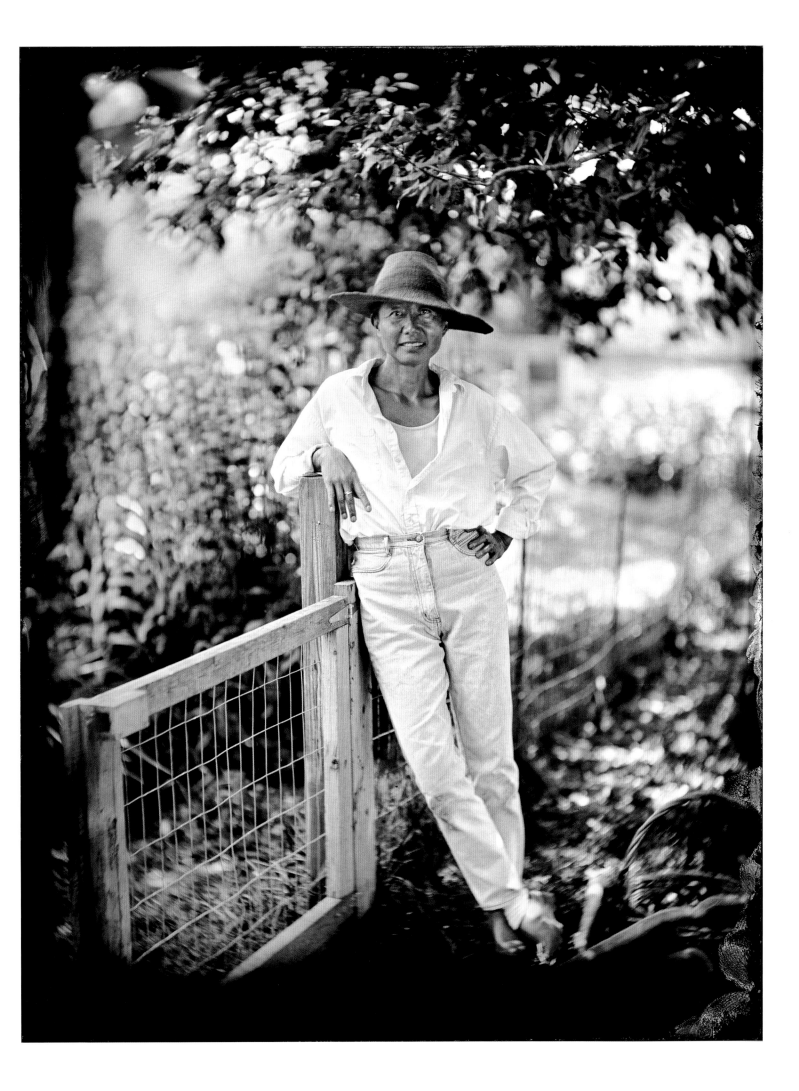

DAN GUENTHER

Sustainable Farm Developer, New Paltz, NY

It was one of my many midlife crises. I was 50 years old when I started farming; I'm almost 70 now.

I grew up in New York City and got a civil engineering degree from Columbia University. At around 50 I recalled all of the nice times I had visiting farms here when I was young. When I was eight years old, my grandfather helped me plant three tomato plants, and somehow there was something that was cast there.

Until the early part of my life everything was organic. That's what I grew up on until after World War II when the Green Revolution kicked in. I was 100 percent in favor of the organic certification process, because people were calling things organic that weren't organic. I loved the idea that now if something had organic stamped on it you could be pretty certain that it was organic. But on the other hand, I never felt a need or a desire to go through the bureaucracy of being certified. I feel the best thing for my CSA members is to know my philosophy, and my philosophy goes well beyond organic.

I will not use any of the organic pesticides, rotenone—well, rotenone isn't allowed anymore—but pyrethrin and neem. They were all accepted because they occur in nature. I could use them, but there are two problems. One is that they are still toxins; and two, they are all very broad spectrum. So, you may be killing an insect that you don't want, but you may also be killing bugs you do want. In the end you are back with the conventional in some ways. One of the things about a CSA is that if a crop fails it becomes a point of education and that's the whole idea. So, I think organic is more an aspiration and a concept to me than it is a piece of paper.

CSAs started in Japan, where land and labor was scarce. The farmers, because of the competition from the corporate farms, were leaving the villages and going to work on the big farms. The women in the villages, bless their hearts, felt that this was not a good thing to have happen, and they approached the farmers and said, "If we set up a co-operative and guarantee that all of your food would be sold here in the village, would you be interested?" And the farmers said, "Sure, we don't want to leave here and work on these big farms. So they set up something called Tei Kei, which in Japanese means, "partnership." This was in the 1960s. It came through Europe, and it was picked up by the biodynamic movement with Rudolph Steiner, and then came to the United States in 1980. Indian Line Farm in Great Barrington was the first CSA in this country.

There is almost nothing about the industrial food system that is good except that it is cheap, and even that I can't acknowledge. It's ruining our soil, it's so demanding on our water, and it's ruining our health. We are killing ourselves, and the planet, for this "cheap" food.

My dream was never to be in an office, and throughout my life I have never been in an office. The Hudson Valley is a great place to be doing this.

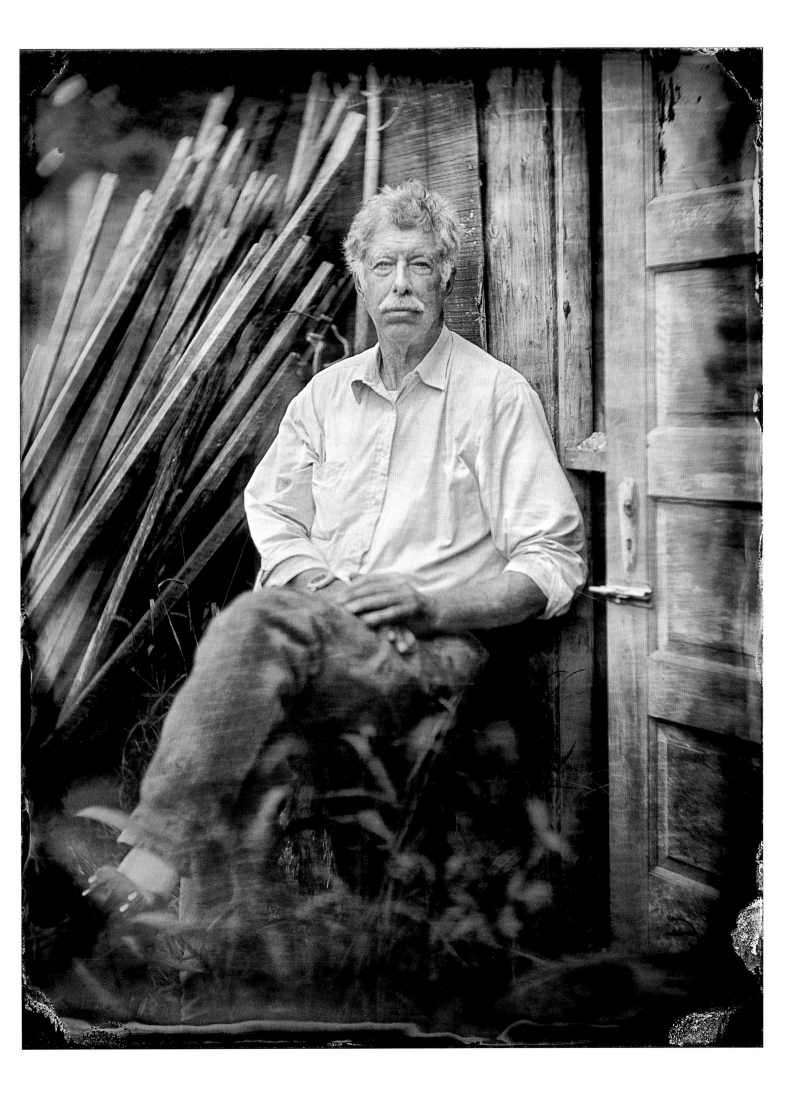

NANCY MACNAMARA

Honey Locust Farm House, Newburgh, NY

My grandparents bought this farm in 1920-something when their Model-T Ford broke down. They had a flat tire and noticed the place was for sale. So they bought it for their summer home and eventually came to live here and farm. I was born on this farm.

When my grandfather passed away my dad and his two brothers started farming. About the time I was born, they built the roadside food stand that's out in front of the place now. That's where I spent my first 15 years, selling fruits and vegetables.

I never felt comfortable using any kind of chemicals. It wasn't until I started farming with my dad that I became organic. The objective is to get nutrients into the things that we eat, whether it is plants or animals. People are starting to realize how to do that and be sustainable. It's understanding all the things that Rudolf Steiner was talking about.

You have to feed the soil and all the stuff that lives in it. All the stuff that lives in it synergistically creates your health. It sends that through the plants and then the sunshine and the air provide the rest. If you eat all of those healthy plants, you should be healthy.

At this point in time the word organic has been confiscated, to the point where anything could be organic. It falls to the responsibility of the farmers themselves. I think that when people meet the farmer it means a lot.

The information is trickling down to the mass population. They're realizing that a lot of the information they are getting in the media is false. People don't trust it, and they are getting more fearful of being lied to. I think the people coming to the farmers markets are the ones that are educating themselves about it, and are coming to meet the farmers. They want to believe in their integrity.

I have been supplying chefs of the Hudson Valley for many, many years. When I started back in the late 70s I used to go up to the Depuy Canal House, with chef Novi. Now I have been working with Brandon Collins at the Roundhouse in Beacon, and of course the Culinary Institute. Now I'm specializing in medicinal herbs.

You really can tell a farmer, because no matter what, he has hope, he has strength. He is always looking forward to the next. Whatever ruins your crop, he is always looking forward to the next crop, the next opportunity to put a seed in the ground. My dad is going to be 100 soon, and he is still hopping off his tractor and can't wait to get out the next morning to his farm.

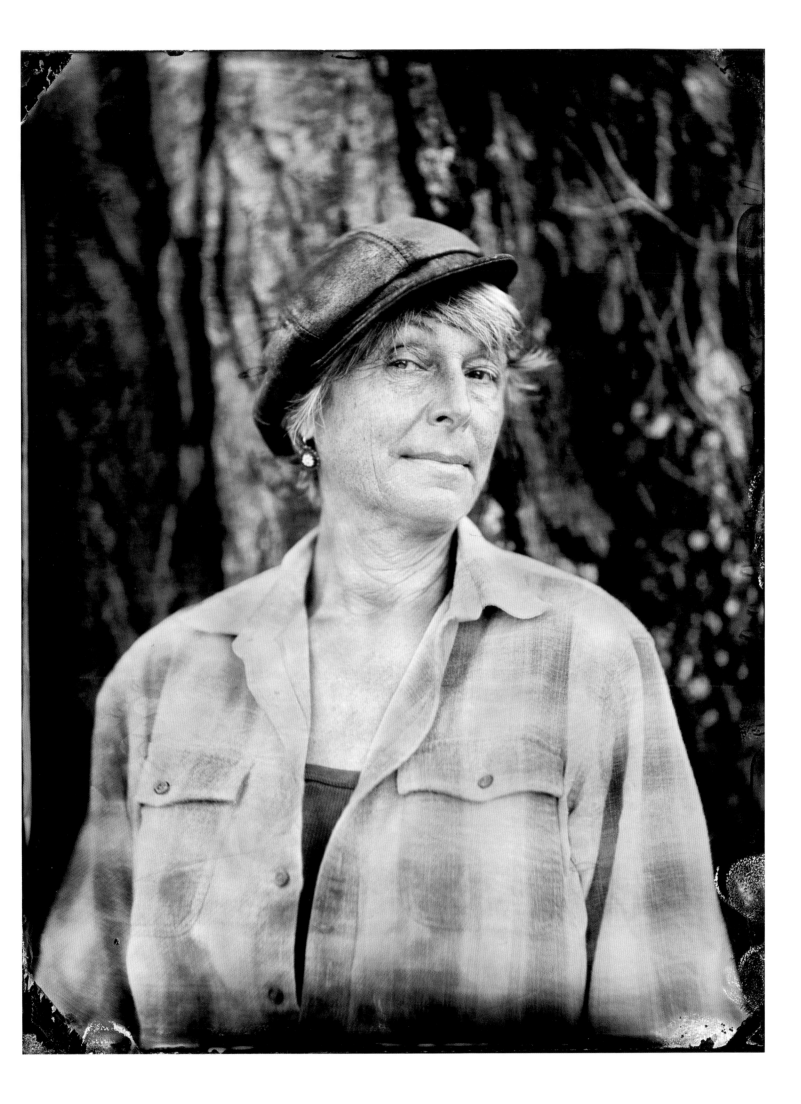

DAN MADURA
Madura Farms, Goshen, NY

All my life I've been farming. My parents were farmers, my grandfather was a farmer. They taught me how to farm. I've always farmed organic. Natural, true organic is not using any chemicals at all, whether they're certified organic or not. When the plant becomes an adult it's more resistant to pests and disease. The secret of how to do this is to cover the plant and nurture it until it becomes an adult and starts to produce on its own. Then you don't have to worry about using chemicals. Bugs will still attack it, but it has more ability to fight off its attackers. I try to do complementary farming; I call it companion farming. Tomatoes love basil, so you complement and plant them together. Beans hate onions—they'll bring the pests from each other—so you don't plant them together, otherwise you will have twice as many pests. When we pick corn, our guys eat it as they pick it because it gives them more energy. Then, you have corn that's a couple of days old where you taste a big difference and the vitamins are less. Naturally, if your food is more alive you're eating something that's going to give you more life.

We grow everything, but I love the mushrooms because of the medicinal value of them. I have been growing them since 1977. I'm getting older and I want to live forever, so I started with the reishi mushroom—it's known as the mushroom of immortality.

Mushrooms give you more energy and they help you sleep better. The reishi help protect you against all kinds of allergies and diseases. It's been known to revitalize all the internal organs in the body. If something is out of sync, it brings it back into synchronization. If you have high blood pressure, it brings it down. If you have low blood pressure, it brings it up. It's an adaptogenic form of mushroom. It helps control cholesterol, it has been known to stop cancer cells, and it boosts the immune system.

I'm not certified organic, I'm not into the titles. You can have all the titles in the world and be something else. You are what you are, no matter what titles you have.

I'll stop farming when I'm gone. It keeps you active, it keeps you in shape, and it keeps you younger.

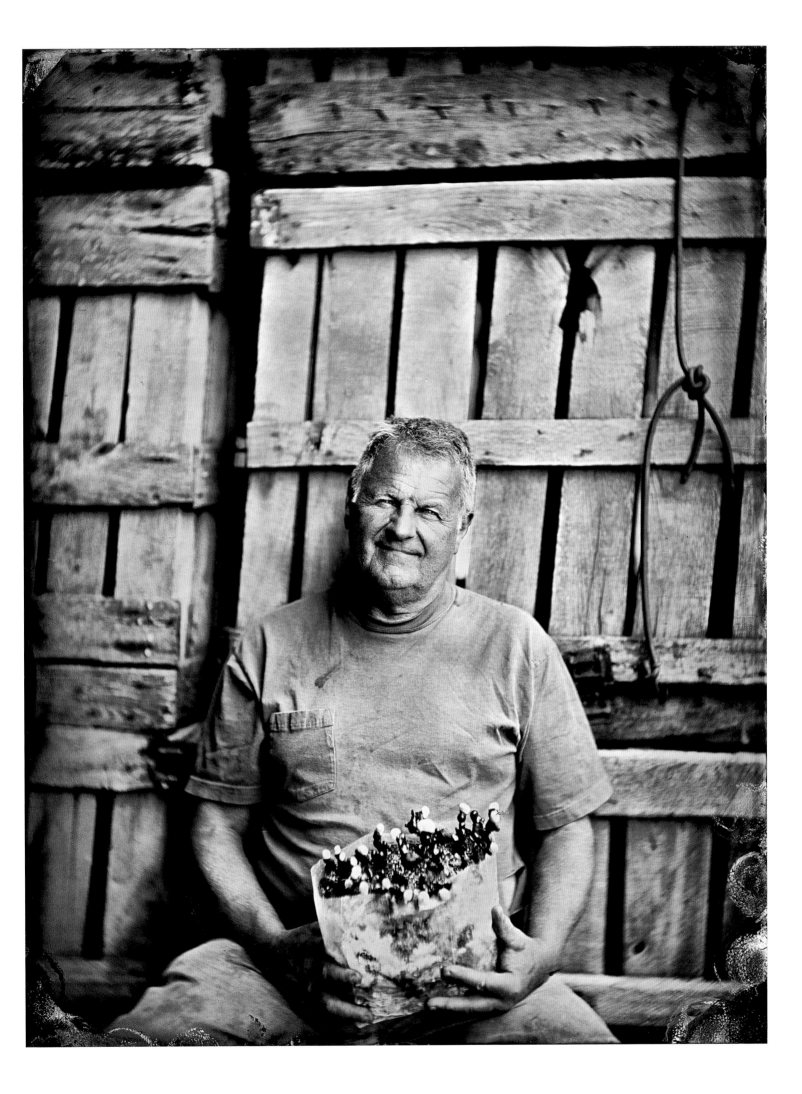

HEATHER KUROSZ
W. Rogowski Farm, Pine Island, NY

My mother and my grandmother inspired me to cook. They were always in the kitchen. Right from high school I went to culinary school—the Newbury College in Boston—it was classic French training.

As you work, you always strive to make the best food, and that starts with the best ingredients. After a while you figure out that it starts way before it gets to the kitchen. I like to cook with simple ingredients and put them together in different combinations. The same vegetables can have a whole different flavor profile when you pair them differently.

The label organic means nothing to me, because you can make it the way you want it. Petroleum is organic, so they are now saying petroleum based pesticides and fertilizers are organic. They are putting petroleum all over the food, and into the ground, and it's destroying things.

At the point when food became industrialized, we also went to two working individuals in a family. It was like a domino effect, which lead to two cars (which pollutes the air), which lead to needing to make more money to support your car, to support your children. It's a cycle that leaves less time to be in the home to prepare food, and that leads to buying industrialized food with corn syrup, and preservatives, and high sodium. I don't think the body actually knows how to digest it all. It's not natural.

Organic is a natural way of life. It's nature just bringing forth its natural goodness. The more unnatural things you put into your body, the worse off you are going be. You see the difference in sicknesses and illnesses that have come forward. There has been an increase in autism and cancer of all varieties. I think the more processed food you eat the more chance you have of developing these things.

I have been at Rogowski Farm since 2007. I'm responsible for the development of the Weekend Farm Breakfast, and the monthly Supper Club. We call it "Table on the Farm." We're not bringing in anything from anywhere else. It's literally coming from the field onto your fork. I say "field to fork." Cheryl says "farm on the table."

I could never stop cooking, it's just part of who I am.

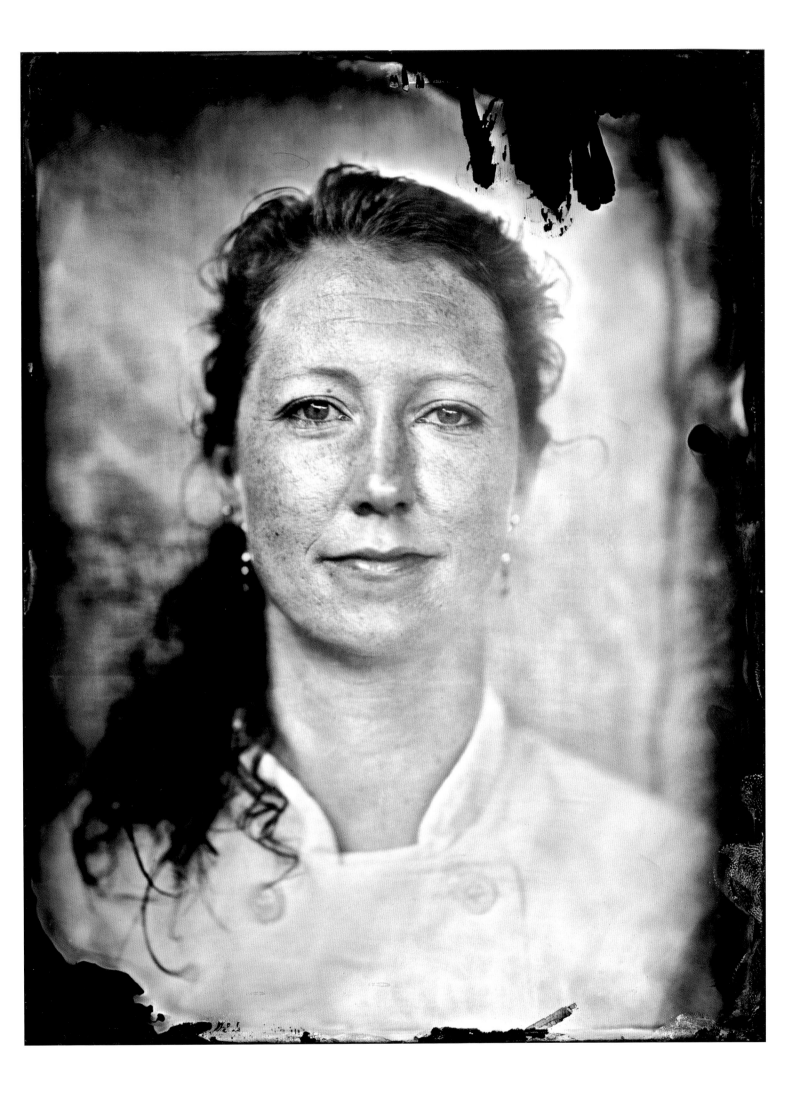

SAM ULLMAN
Bywater Bistro, Rosendale, NY

I was very lucky to grow up in a house where there was always an emphasis and importance placed on food. Dinner was always a family event, and we would always go to different restaurants.

At 17 years old I started working at a Japanese restaurant in Great Barrington, Massachusetts. They were doing a macrobiotic approach to Japanese food and it had an emphasis on local. There were some really great Japanese chefs at that establishment. That was my foundation.

When we opened Bywater Bistro we were always looking for the best products, and I really wanted to focus my support towards the local farms.

Our food is eclectic. There are classic French and old world techniques. Simplicity has been what's most effective for us: get a really great product, and don't screw it up. If I can get something just harvested and give it to you much fresher, that's what you're supposed to be eating.

I never really look at the credential organic. A number of years ago the USDA structured the organic certification and laid down the law: what is organic, what you have to do to certify organic, and if you don't do this, if you don't file, or if you don't pay, then you're not organic.

I have always wondered, even before the USDA got involved, why they chose the word organic. Organic in the scientific community has a long history. It's an old term, much older than this whole emphasis on being conscious of what inputs are going into our food production. It is carbon-based chemistry and carbon-based molecules. All the chemicals that we don't want on our food, half of them or better are organic. It's semantics.

Sometimes produce on the supermarket shelves grown in Mexico, or California, or Peru looks so perfect, it's all so uniform. And some of the stuff you might find at the farmers market has blemishes. With experience you learn uniformity is not perfection.

There's an organic movement going on in the country. I think the Hudson Valley, for a variety of reasons, is at the forefront of that. Culinarily speaking, this local stuff is outstanding. On the plate, it's the best in the world.

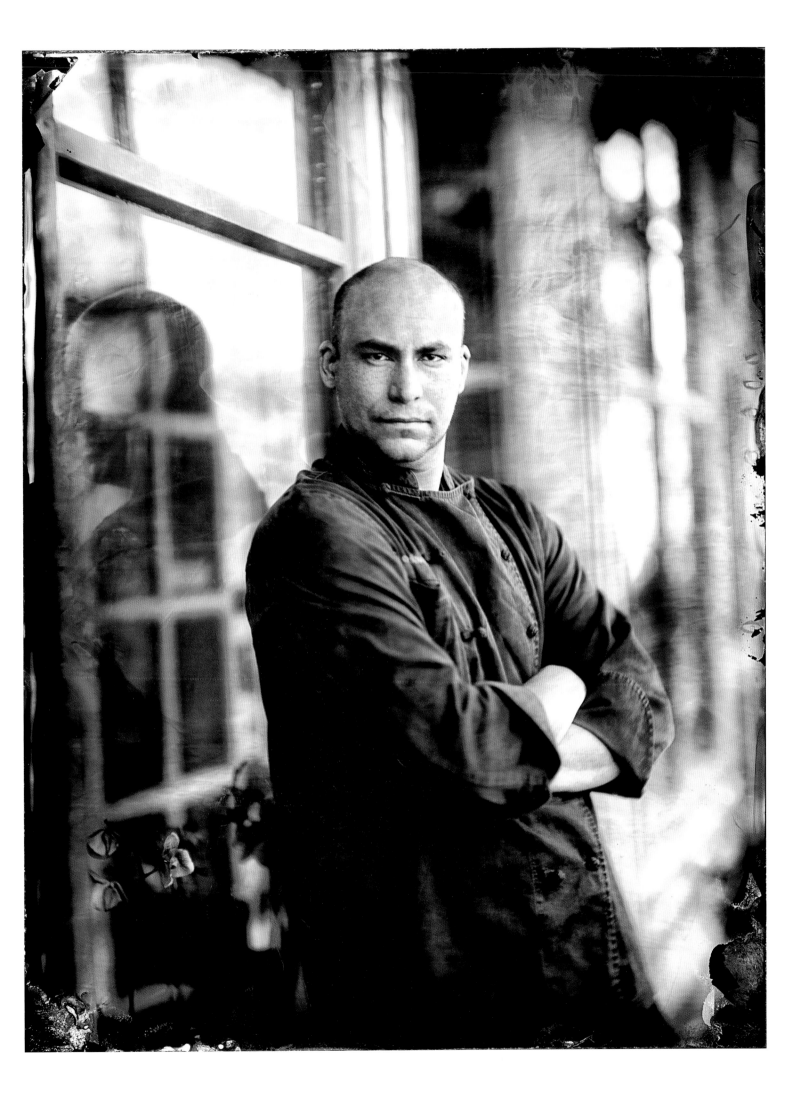

DOMINIQUE HERMAN
The Kitchen Garden, Warwick, NY

After college I started working in restaurants, and then I went to school at Peter Kump's in New York.

I've been farming since 1993. I started out growing for a restaurant. Really I went to the restaurant to cook, but they wanted a garden, and being it was an all-male kitchen, I kind of wanted to fit in. So I said I knew a little bit about it and the next thing you know I'm out in the field. I remember it was in the winter when the chef interviewed me, and he said, "We have our own garden, and we grow our own food," and I'm thinking, this place sounds wonderful, and I signed on to work for free. Since I was born in France, I was drawn to this whole idea, thinking it was going to be like Provence.

One night, NOFA New Jersey, and Alice Waters came for this big benefit, and everybody was like, "I can't believe you do this." That's when I felt maybe I knew something.

Taking care of the land is important to me. I love all the wildlife around me. Not necessarily all the woodchucks and deer, but I have frogs, hawks, even snakes in my field. That's important to me. It's much more than what most people talk about, the pesticides and synthetics. I don't use any chemicals. I use kelp and fish emulsion, things like that. I always farmed organically.

In 2001 I started The Kitchen Garden Farm and decided to certify the following year. Because I'm a small grower, I felt it would be easier to be successful if I could say I was certified organic, rather then having to explain to people.

I'm not sure who said that "a farmer's footsteps are the best fertilizer." There are farmers, and big businesses that never walk on the land. Everything is done from an office. Everything is fertilized and watered according to computers. To me, it doesn't seem like the same product that I'm growing or that small farms grow. I'm there every day with my vegetables.

GMOs are scary things. You don't know how they affect you or the animals. If you get anything with corn in it, it's hard to avoid them. As organic growers we have to prove everything we do, and the ones who are giving you all the chemicals don't have to say anything.

I have a lot more customers now, and I can sell everything I grow. In fact, I can't grow enough.

What else would I want to do as much as this? I can't come up with anything.

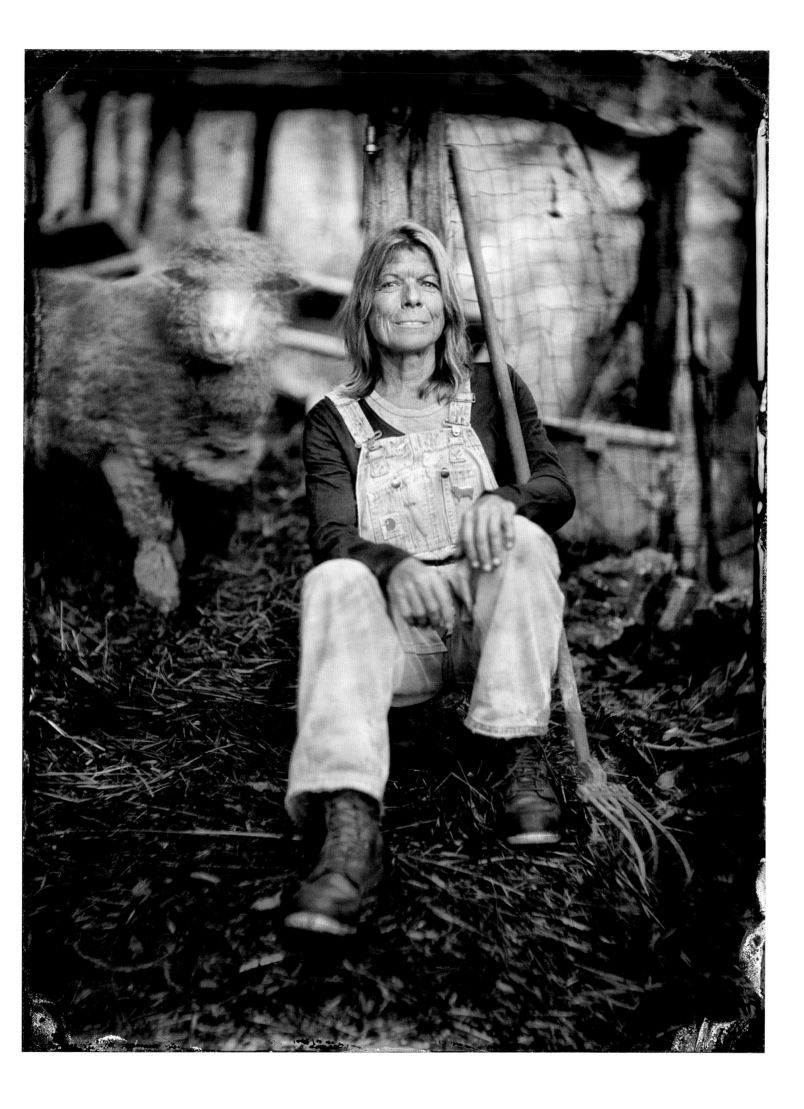

RIC ORLANDO
New World Home Cooking, Saugerties, NY

I started out playing music and was just trying to make a living on the side. I started being a chef when I was about 27 years old.

When I started cooking I wasn't really thinking about it as a career. But then I had the good fortune of getting a job at a restaurant in Cambridge, Massachussetes called Harvest. It had a daily menu with local food. It was kind of like the Chez Panisse of the East Coast. It was inspiring to me because once I worked there it wasn't just a vocation, it was kind of a whole body experience. It was intellectual, it was tactile, but it was also that intensity of cooking. That was in the mid 80s, and that's when I decided this what I wanted to do.

I opened the original New World Home Cooking on Zena Road in a little haunted stone house in 1993. We called it "global flavor, with local pride." We try to introduce people to the flavors of the world. I'm really into what the peasants have created with food and culture. We always try to incorporate as much local and organic into our products, and then turn it into global flavors.

In a pure sense when you think of something that is organic you think of something that is in its natural state. That's how it should be, and that's how I like to think of organic. Sometimes when I think of organic now I think about big corporations calling things organic and trying to make money off the name. I also think about the continual political battle over owning what organic is. When I talk to farmers locally, I want to know how they grow their food. Not all of them are certified organic, because it's very difficult. When I look at what they do and how they grow their food, how they live their life, what their providing, how they treat their land, and how they treat the people who work for them, that's organic to me.

Our industrial food system in the United States was based on not letting what happened in the Depression and Dust Bowl happen again. A lot of it was politically well meaning in the beginning, which was to supply food for people, but then the chemists got involved. From a pure take-care-of-your-people mode, I guess some altruism is in it, but it's gone way down the wrong road and now it's totally out of control.

The Hudson Valley is a great place to cook. It's a great place to be in the food world. The one thing about being an organic chef, a sustainable chef, a clean food chef, is that every day you have to weigh decisions, you have to decide what's best overall. That's the biggest challenge.

I feel that food is one of the keys to the heart.

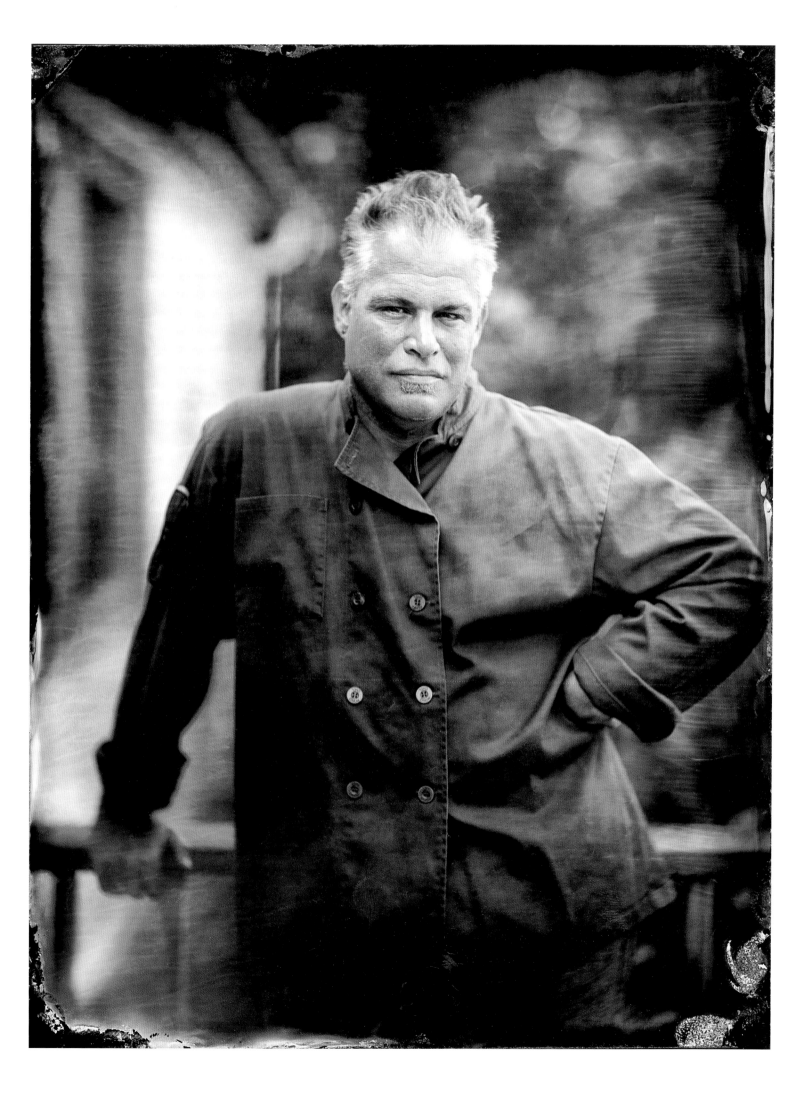

PIERRE-LUC MOEYS
Oriole 9, Woodstock, NY

I grew up in Holland and moved here in 2004. In Holland I went to the university to study international management, and I couldn't do it; I couldn't sit in those school sessions.

I wanted to travel, and said, "I'm going to be a chef." At that time I kind of looked down on being a chef to be quite honest, I was like, "I can do this." Within a day I found out the opposite. I was 20 then, and people said I was absolutely out of my mind. "You can go to the university, but you want to be a chef? You're out of your mind!"

So, I got jobs at really fast-paced restaurants where I had to work long hours. On my time off, I would step into Michelin Star restaurants and say, "I would like to work here. I'll do anything you want, clean the floors, wash pots, but I need to learn two things each day," and I did it for five years. I worked throughout Europe in all kinds of places: Raymond Blanc, Marco Pierre White, Alain Ducasse, and also in places nobody knew, because I wanted to see the whole spectrum.

In Europe, it's common knowledge: you always try to source the best products. Organic wasn't a word when I started in Holland, France, and England. It was always organic, from local farms.

The word organic here, feels like a marketing term. I think it's an important word for people who know what it means and try to express that. I tell people that it should always be good, which means it's organic and it comes from a farm where somebody cares. It's the caring part that I find is really important.

We buy a lot of organic from farmers here. I always visit the farm, because I want to know where it comes from, I want to be connected. I think that's organic, to be connected throughout the whole process.

You can't sell what you sold years ago anymore, because people are much more aware. People do ask, "Is there butter in this? Is there high fructose corn syrup in it? Is there MSG in it?" But we never sold it in the first place.

Here we make things from scratch. It's the norm, that's how I was trained.

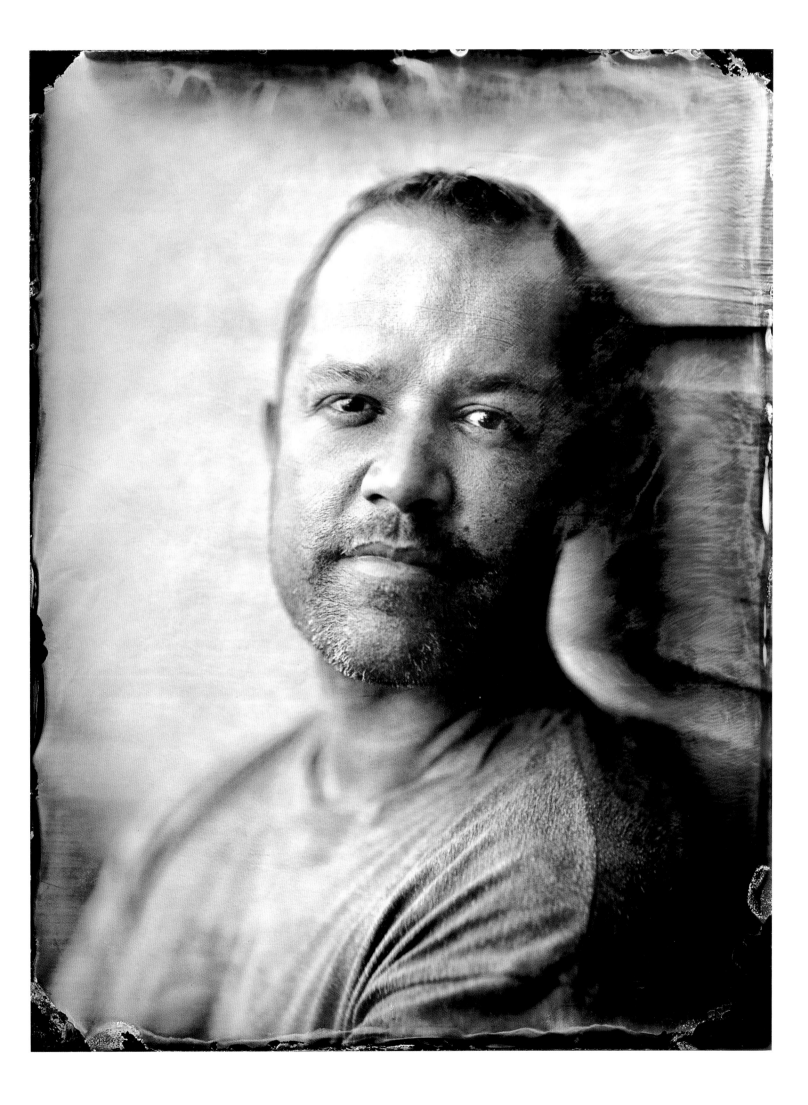

ANDY SZYMANOWICZ
Sol Flower Farm, Millerton, NY

Even as a kid, I always had a garden. I grew up in Rochester, New York. Right out of high school I went to college, and that didn't work for me, and I found myself working on an organic farm. I was hooked. Ever since that experience I've been farming. I've worked on farms in Vermont, Massachusetts, and California—always organic.

For me, the organic thing is still a grassroots movement. It's gone mainstream now but there's still the community of organic farmers that is grassroots. Now you can find organic in Walmart and all of these other stores, and it's coming from big agriculture corporations who have gotten into the organic label. But when I think of organic, I still think of a small farm, barns, and community.

I'm not certified organic, I have a direct relationship with my customers. I don't need to go through a certification agency to get the word out about how we grow our produce. I find that we just don't need it. Once in a blue moon, a customer will come to the farmers market and ask if I'm organic or not.

We're not allowed to use the word organic because we're not certified. So, we can't put an organic label on our product, or use it on a sign. I like to use other words like holistic, sustainable, or ecological.

I think the industrialized food system is scary. The way we treat our animals, our plants, our soil, and the people growing the food. I don't know how we can sustain a healthy life when we eat food that is grown that way. We're seeing a lot of health issues in our communities, and cancer is on the rise. There's so much happening health wise, that if we changed the way we grow food, we could start addressing those problems instead of just going to the doctor and buying medicine.

We're growing and adding more and more members to our CSA each year. We've seen more farms spring up so there must be a demand for it. And the younger generation of people wanting to get into farming is pretty amazing.

At the end of the day you can look back and physically see what you've done, and hopefully, you had a good time doing it.

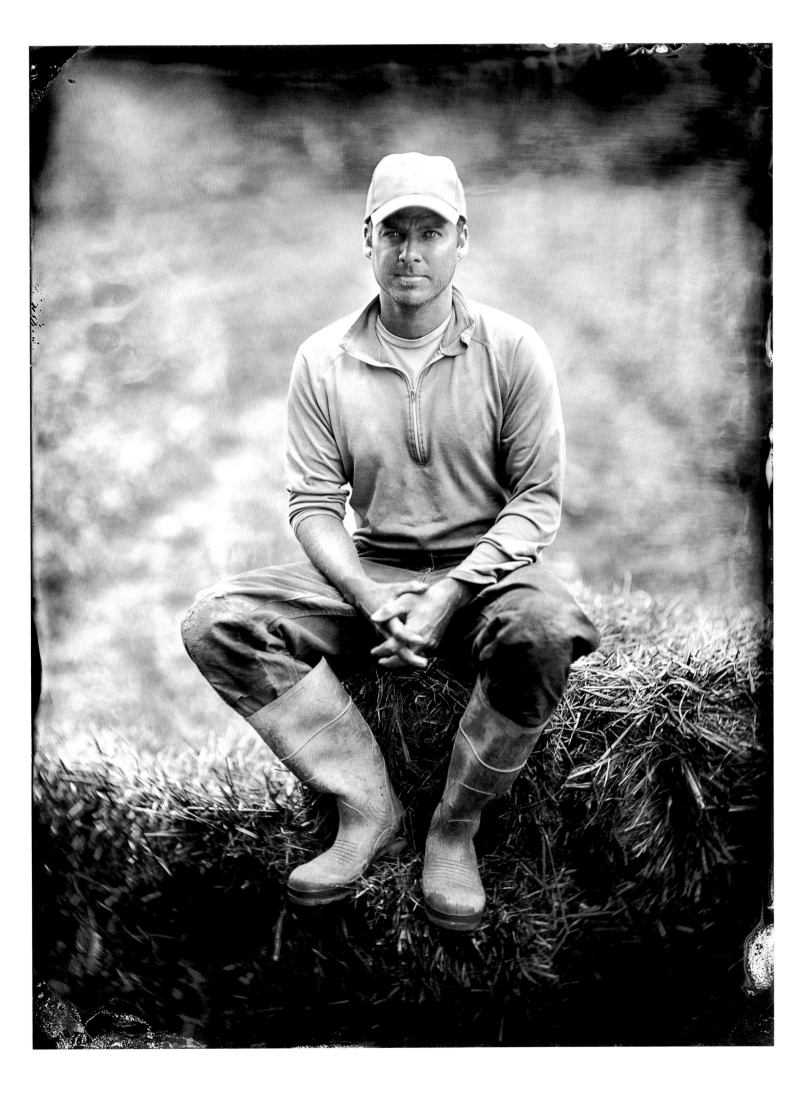

CHRISTA STOSIEK

Markristo Farm, Hillsdale, NY

I was always very close to nature, and growing food. I have a German mother, we had a garden, and I grew up in the Waldorf schools, so it wasn't foreign to me to do any of this.

When I was in college I was into theater, drama, and singing. I traveled to China, and then toured with an opera company in Germany for two seasons. That was sort of my love of life. But, I realized that's not what I wanted to do.

I met my husband Martin in 1988, and have been farming ever since. We met while I was working at the farm store at Hawthorne Valley Farm. He was there haying or doing something like that. I always thought I would marry the person I remember meeting for the first time. I saw him and that was it. I told the woman I worked with I was going to marry this guy. And I swore, when I was two years old, I would never marry a farmer.

Organic is something that's untainted by any outside input. There is a pureness to it. I have never worked on a conventional farm; I would never want to. That was just part of my upbringing.

At the farmers market we have a big sign that says, "Organic" on top, and we have signs on everything. But, sometimes there's one missing and people ask, "Is that organic?" Otherwise people rarely ever ask. They are relying on the fact that they trust us.

The industrial food system in this country is pretty awful, but I really don't spend a lot of time thinking about it. I'm the kind of person who thinks about working on my own life, and how I do things. My goal is to educate my children and give them a good foundation. It's a little overwhelming, the thought of changing the food system. I do it one day at a time; I think that's a good thing to do. I believe that I'm making an impact by doing what we do here, and by sharing that information with the public, and talking to people to inspire healthier choices.

I think this movement is already heavily ingrained in the Hudson Valley. It's here, and it's here to stay.

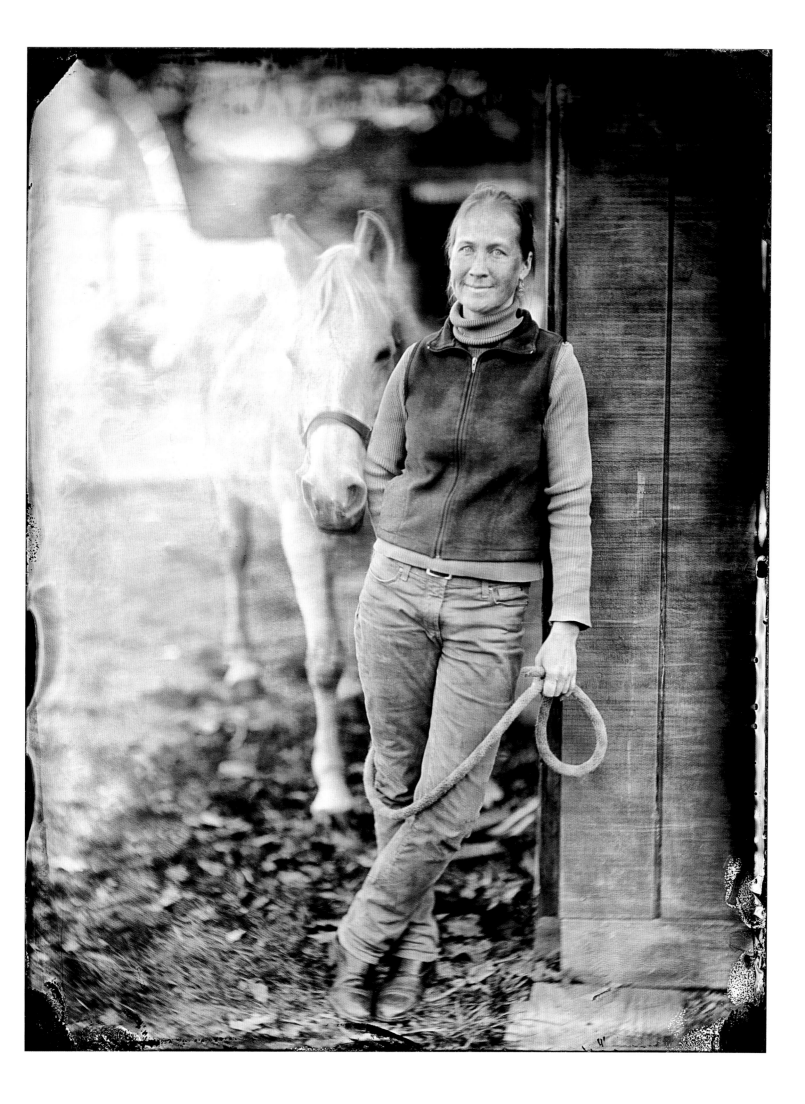

BOB WALKER
Katchkie Farm, Kinderhook, NY

It was southern California, the entertainment business; I was a rock and roll roadie. I worked as a lighting tech on national tours. I stopped drinking and started hanging out at the health food store. A lot of carrot juice, a lot of avocados, the whole scene, but I had no idea where the carrots came from.

I read a book called *Secrets of the Soil*, it was about biodynamic, occult sciences, agriculture, native Indians, the Celts. It was really interesting. Since I was on this health food kick, I said, "Where do carrots come from? I'll go look."

I went and explored Rudolph Steiner, and then Camp Hill. Camp Hill is a biodynamic farm that has residential care for disabled people. I ended up there to do an apprenticeship and stayed at another one here in Columbia County for another four to five years. I built their farm up and then never left the area. That was in 1992.

I farmed biodynamic in the beginning, and now just organic. This farm is certified organic. Organic farming is not using chemically based fertilizers, fungicides, or pesticides to grow food. The health benefits of organic are we are not consuming any of the residues from many of the sprays used conventionally, and then there's the cosmic thing about a plant that is growing healthier. The things you can't quantify.

The organic thing has definitely grown in the last 15 years. There are a lot of people who have apprenticed in the area and never left. When I came here in 1991-92, there were maybe five or six growers.

This farm was built from scratch, there was nothing here; not even plowed ground. Being able to design and build this from scratch was a really great project. It's still going, we're not done. That keeps it interesting, instead of planting the same head of lettuce over and over again.

This property is 60 acres, the open fields are 12, and there's about 9,000 square feet in the greenhouses. Most of our food is primarily for CSAs in the city, we have 400 or so members. Then there is the farmers market, and also our catering business Great Performances.

This is one of the best jobs anywhere.

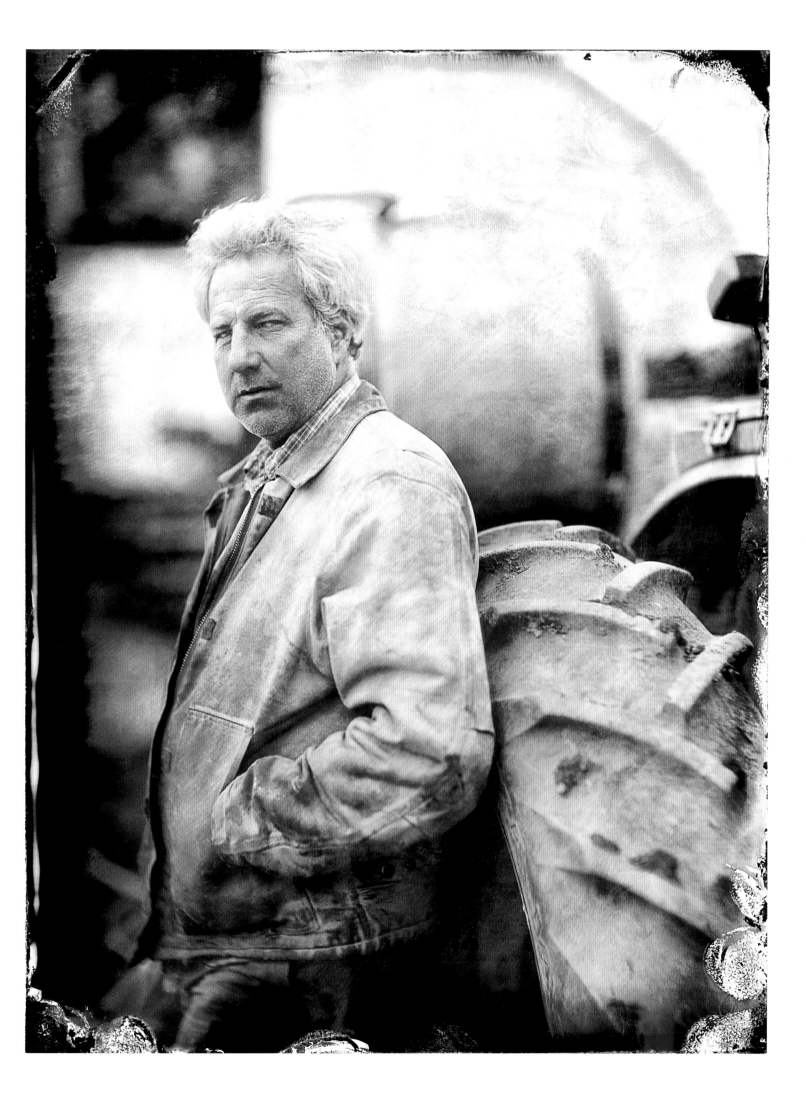

SU LAMETTA
Windfall Farm, Montgomery, NY

I was always drawn to farming. A lot of it has to do with the whole outdoor aspect of it.

I have a Bachelors Degree in Fine Arts. I was studying textiles, surface designs, and decorative arts. When I graduated I worked in the textile industry for a few years. After living in the city for about ten years I decided to move out. I wanted to farm, it's something I just wanted to try.

The first year I moved out of the city I was able to get a farming apprenticeship on an organic farm in Connecticut.

It has always been organic for me, there is no other option, otherwise I wouldn't do this. Organic is free of toxins, it's healthy food and healthy living.

What we're doing here is really ideal farming. We don't use any chemicals, we just bring in manure and it works for us. We till under the weeds, and the weeds feed our crops. And it works. We proved that. We do intensive farming. We really don't have to add much else to the ground in order to produce vegetables. What we're doing here is minimal application farming, it's ideal to organic farming.

I'm involved in a little bit of everything on the farm; I don't have any specific job. I harvest, I do field work, and whatever needs doing. Everybody is here to get things done.

As people are more aware of organically grown, local food, there becomes more of an awareness of eating healthier and more naturally.

I just don't see myself going back to the city anymore.

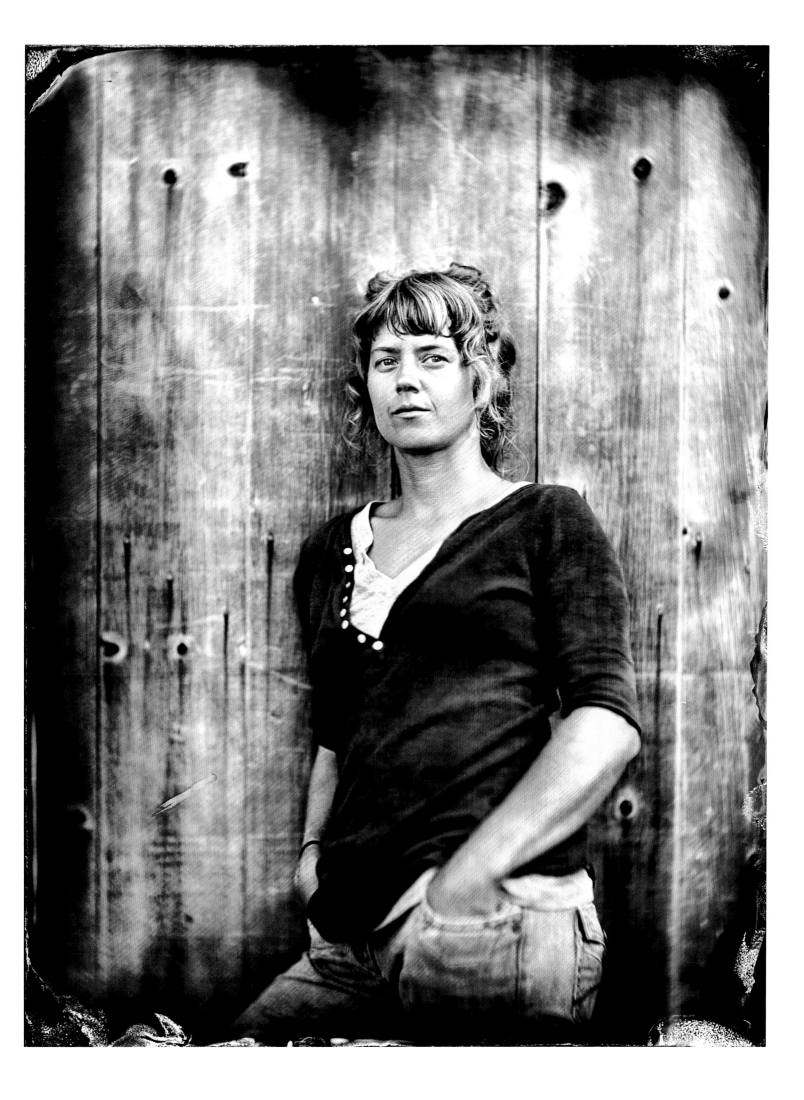

JACKSON H. BALDWIN

Jax Berry Farm, Marlboro, NY

Since I was 17, we had the farm and we didn't have any money. It was the Depression, 1931. I was in school then and there was nobody to run the farm.

It's a long story. We bought the farm in 1919 all because of a flat tire. We got a flat tire right in front of the place down on 9W. My mother, grandfather, and grandmother got out of the car and walked. They came back and said, "There was a sign up, and it's for sale." It ended up with my father buying the farm. It was 80 acres, 40 on each side. We lived in Rockville Center, Long Island at the time. It was a run-down farm and my father came up and hired two men, bought horses, and set the whole farm up. He planted the whole thing with peach trees and apple trees. Things didn't work out because the Depression came, but we harvested what we could. Then a farmer we knew who had a green house sent a man over with some tomato plants. We planted those and took good care of them. Finally we went to the Newburgh market at four o'clock in the morning, we were the first ones there. I think we had 25 to 30 12-quart baskets and all we got for them was 25 cents, that's how bad things were. Then we had a crop of peaches and they brought 45 cents from some peddlers who took them all. Then we took one load down to Rockville Center and I went peddling house to house, and we got a dollar and a quarter for them.

My daughter Nancy got me interested in this magazine *Agriculture USA*, and I got some books and learned all about organic farming. I haven't used any chemicals since the early 80s. Organic doesn't have any pesticides and herbicides that ruin the ground. By the way, I bought many, many, trailer truckloads of compost. That's what I enrich this ground with and it's still producing. I'm farming about 10 acres by myself now. I grow purple raspberries, black raspberries, black caps, fall raspberries, and blackberries. I'm more or less a berry farmer.

I sell to the Culinary Institute, and Adams Markets in Newburgh and Poughkeepsie. I have a very good reputation over at the Culinary Institute. They're very particular there with everybody that comes in. They go through their whole load and check to see if everything is up to snuff. I took stuff over there for years and I'm the only one they never bother checking.

I'm 99 now. I work about four to five hours a day, every day, even Saturday and Sunday. I work because I love it. When I'm not working I go bowling and I play golf once a week.

That's the story of the farm.

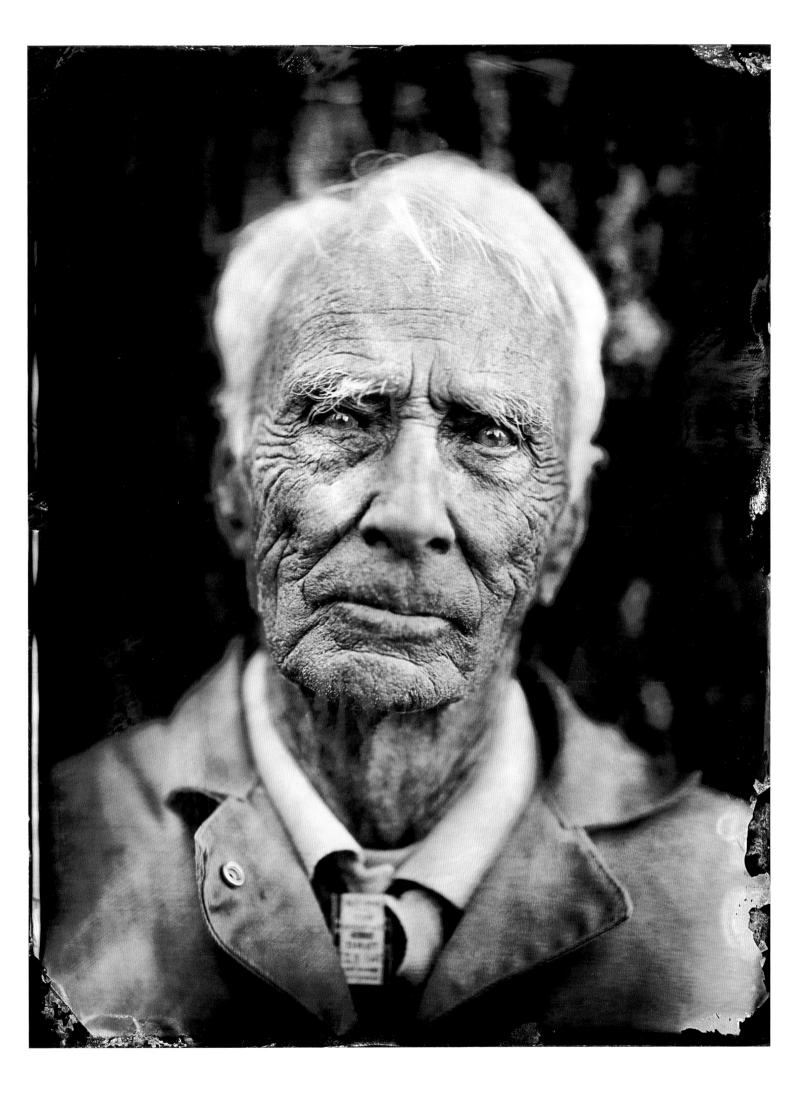

ACKNOWLEDGEMENTS

Dedicated to the farmers and chefs of the Hudson Valley.

With gratitude to the following:

Richard Rothschild, Joan Dye Gussow, Gail Buckland, Mark Ruffalo, Gar Wang, Colleen
Emery, Erica Rosen, Robert A. Lewis, Nicholas A. Penkovsky, Esq., Brother Victor-
Antoine D'Avilla-Latourette, to my family and friends whose support never expires,
to Susan who was there every step of the way, and to Craig Cohen, Will Luckman, and
Krzysztof Poluchowicz at powerHouse Books.

ORGANIC

Photographs © Francesco Mastalia
Preface © Joan Dye Gussow
Foreword © Mark Ruffalo
Introduction © Gail Buckland

Published in the United States by powerHouse Books,
a division of powerHouse Cultural Entertainment, Inc.
37 Main Street, Brooklyn, NY 11201-1021
telephone 212.604.9074, fax 212.366.5247
e-mail: info@powerHouseBooks.com
website: www.powerHouseBooks.com

First edition, 2014

Library of Congress Control Number: 2014942956

Hardcover ISBN 978-1-57687-710-4

Printed by Toppan Leefung Printing Ltd

The paper used in the production of this book was made from
trees grown in independently inspected forests, and certified
as meeting the highest standards for environmental, social,
and economic responsibility.

Book design by Krzysztof Poluchowicz

10 9 8 7 6 5 4 3 2 1

Printed and bound in China